CONTENTS

CONTENTS

ILLUSTRATIONS

Every effort has been made to trace copyright holders of the illustrations. In the event of any queries please contact Routledge, London.

ACKNOWLEDGEMENTS

I began this book when many of the events which I chart were first breaking. The writing of it continued longer than I had originally intended! Over a number of years I discussed ideas with many people and presented my work at countless conferences and seminars. Let me thank the University of Portsmouth, whose various research committees generously provided sabbatical time and resources to allow me to complete the project. Colleagues at that institution, notably Graham Davies, Sue Harper and John Oakley, listened to a number of my arguments and always proffered good advice. Successive generations of Portsmouth students were remarkably patient when I used them as a sounding board for the themes of the book. Students at other institutions, notably in the Graduate School of the History Department at the University of Michigan, where I spent part of 1991, also gave me intellectual stimulation and I am grateful to them. Librarians and libraries loomed large in the research, especially the staff of the British Library, British Newspaper Library, Science Reference Library, British Library of Political and Economic Science, National Art Library, the Westminster Archive Centre, the Advertising Association, Companies House, the West Yorkshire Archive Service, Leeds, and The History of Advertising Trust, Norfolk.

A number of friends and colleagues offered me analysis of the book as it was developing and often shared their own work with me. Peter Jackson, Lynne Nead and Peter Thompson commented on various manuscript drafts. Lucy Bland, Becky Conekin, Anna Davin, Philip Derbyshire, Geoff Eley, Nick Harrigan, Robert Kincaid, Michelle Lowe, Sean Nixon, Adrian Rifkin, Raphael Samuel, Valerie Swales, James Vernon, Chris Waters and Bruce Wood gave their help and advice. Peter Thompson worked with me on a project on the post-war menswear industry and some of the results of that collaborative research are reflected here. I also wish to thank Tony Bagnall Smith for allowing me to read his unpublished history of British advertising in the post-war period. Rebecca Barden, Claire L'Enfant and Margaret Deith at Routledge were thoughtful and extremely patient editors.

Finally, Daniel Virgili, who lived with the final stages of the book, offered much practical and emotional support and a considerable intellectual contribution, especially on the various financial aspects of the research. The work is dedicated to him.

INTRODUCTION:
Narratives of Consumption

The budget which Nigel Lawson delivered to Parliament as Chancellor in the spring of 1988 was his most spectacular; it was also his most controversial. 'A provocative budget' was how he described it in his memoirs.[1] The centrepiece of his programme was daring, even by the standards of a radical Conservative administration. Sweeping tax reforms, aimed at slashing the top rates of income tax and reducing the basic rate, lay at the heart of the government's fiscal message. The Chancellor's defence of his strategy was characteristically robust. His parliamentary speech was a hymn to Britain's new-found economic puissance. The strength and durability of the upturn in the country's economic fortunes, he proclaimed, had exceeded every post-war record. Outstripping all competitors, the nation was poised to enter its eighth successive year of sustained growth. Prudent financial policies had given business and industry the confidence to expand, while public finance had secured a virtuous circle. The plain fact was, Lawson concluded, that the economic life of the country had been transformed.[2]

Waxing sociological, the Chancellor went further. Warming to his theme, he believed that his budget would accelerate a number of important cultural changes taking place within British society. These transformations highlighted a project which was familiar to all followers of radical Conservatism. It involved nothing less than a social revolution, which would be set in train by delivering 'prosperity to the many'.[3] And it was precisely the cultural meaning of prosperity – focused on the dense symbolism of personal consumption – which lay at the heart of the drama surrounding Mr Lawson and his budget. The majority of the tabloid newspapers were euphoric. Not known for understatement, *The Sun* delivered a triumphant message in one of its most notorious headlines: 'Lots A Lovely Lolly!' while the *Daily Express* announced its own version of economic populism: 'We're *All* In The Money'.[4] Franklin's accompanying cartoon for *The Sun*, which appeared the day after the budget, conjured up an image of the Chancellor as financial genie. Bursting out of his bottle, turbaned and corpulent, Mr Lawson winked at his audience, as he displayed his overflowing treasure chest of goods.[5] In other articles reporters profiled those individuals who made up the new democracy of wealth. Pride of place was reserved for the 'high fliers' who were driving the country's resurgence of consumer prosperity: doyens of the advertising industry, such as Maurice Saatchi, or leaders of retailing, like Sir Ralph Halpern of the Burton group, or George Davies

from Next. It was these figures, along with a rising generation of younger 'whizz-kids', who were leading the way in the new Britain.[6]

This self-confident display of commercial optimism did not of course go uncontested. In the attack on the budget mounted by the government's opponents, it was precisely the issue of consumption which was subject to the fiercest criticism. The first protests were sounded during the Chancellor's parliamentary statement itself. Alec Salmond, the Scottish Nationalist MP, spoke out against the government's tax measures in moral terms as 'an obscenity'.[7] Most of the subsequent criticisms fixed on the theme of personal wealth, delivered to the already rich or prosperous, as the point of contention. Bryan Gould, Labour's trade and industry spokesperson, drew on the language of ethical socialism to denounce the budget for deliberately promoting policies of greed and immediate gratification.[8] Other colleagues on the opposition benches sounded similar criticisms. For Roy Hughes, Labour member for Newport East, the present state of affairs were symptomatic of Britain's tinsel economy. The government had spawned a 'candy floss society', in which consumer spending had been allowed to run riot.[9] The worship of money, coupled with what Hughes depicted as an uncontrollable demand for goods, was forging a new civilisation of banality.

Despite the deep-seated political differences, all of the players in the budget debate shared a common thread of argument. This was their expansive view of consumer society. In Nigel Lawson's panegyric, as in the opposition's attack, consumption featured as a whole way of life. In the light of subsequent events, it might well be argued that such an emphasis was misguided – the product of either naive optimism or misdirected critique. The failure of neo-liberal economics, coupled with the onset of a prolonged recession in the early 1990s, make the heated claims and counter-claims for and against consumption appear overblown. Yet the inclusive discourse which surfaced on budget day 1988 was characteristic of more general accounts of British society in the 1980s. For a brief period the goods and services of the private sector came to occupy a very high profile indeed. Visible across multiple layers of the social fabric, the world of consumption was spoken about in a wide variety of registers and endowed with multiple meanings. It appeared to function as what Lévi-Strauss once called a communication system for understanding social life.[10] From the language of politics through to academic commentaries, from economic analysis to popular imagery, perspectives proliferated endlessly.

This book is about unravelling a number of these narratives. It is about a specific domain or field of culture which was shaped by the dynamics of the market. But it is also about gender and more specifically about men. For the consumer transformations at work during the period were specific rather than general. They sought out particular markets and targeted distinctive personalities.

One effect of these entrepreneurial programmes was to produce an extended interrogation of masculinity, which scrutinised the character of young men. Commerce and masculinity feature as linked themes in the account. How do such gendered issues relate to the broader debates which were rehearsed about the nature of consumerism in the 1980s? To explain how and why we need to examine the ways in which consumption systems have been understood. We also need to open up the question of masculinity, in relation both to commercial regimes and to contemporary sexual politics.

Understood purely in economic terms, the boundaries of our account are fairly precise. Framed by the end of one recession and the onset of another, the chronology covers the years between 1982 and 1989, though we shall also have cause to take in a broader period of cultural history which extends back to the 1950s. Measured against many of the standard economic variables, this was an extremely truncated consumer boom. Far shallower than earlier post-war upturns in domestic demand, it was unevenly orchestrated, both across different sectors of the economy and in terms of the geographical distribution of household and personal wealth.[11] Yet despite this patchiness, the 1980s generated a vast literature which sought to explain or theorise various aspects of present-day consumption. Much of it did not wholly originate during the period, but there was a noticeable intensification of debates over the course of the decade. Though some of this material concentrated specifically on Britain, a far larger proportion was pitched at a high level of abstraction, identifying general trends at work within contemporary western societies. Analysis straddled both the academic and the commercial spheres. Commenting on an earlier moment of industrial change, the historian, David Cannadine, has noted that while economic and social theories cannot be collapsed back into the historical circumstances under which they were produced, they do not remain wholly independent of these conditions.[12] During the 1980s, consumption in theory and in practice existed in a complex, but interconnected, relationship. It is worth revisiting for a moment some of the most significant approaches, in order to say what is distinctive about my own account.

For the entrepreneurs and the intellectuals of the consumer industries – retailers, advertisers, marketers and the rest – the changes introduced during the 1980s were heralded as highly auspicious. The greater importance awarded to those businesses and forms of expertise centred on consumption marked nothing less than an epochal shift in Britain's industrial organisation. The leading edge of economic processes, it was announced, had moved away from manufacturing and towards the sites of exchange.[13] Retailing in particular demonstrated this sea-change most clearly. Sir Terence Conran, chairman of the Storehouse group, argued that merchandising systems were now the most important component of any company. It was the point of sale, methods of

stock-control and delivery schedules which mattered, quite as much as the actual manufacture of commodities. Conran contrasted 'the old days', when shops had simply been just warehouses, with today's advanced conditions. Retailing was a test-bed for the economics of the future.[14]

Such a transformed situation, it was noted, greatly enhanced the prestige of all of those professionals who dealt in the symbolic representation of goods and services. The claims were often monumental. The Henley Centre for Forecasting, a prestige market research organisation specialising in long-term planning, insisted that commercial changes were structural in a deep sense. Involving nothing less than a profound reorientation of beliefs, they marked a movement from production to consumption-led values. Henley maintained that the new consumption was driven by the appearance of intensified forms of individualism. Responding to this situation, advertisers called for a radically different under-standing of commercial communications. Designers and display artists made a similar point about shopping. But as significant as their detailed arguments was the concept of historical change which underpinned the analysis. Taken together, commercial explanations of the significance of the 1980s drew on a familiar motif. This was the idea of the 'consumer revolution'. Such a model understood contemporary shifts as epochal and totalising, breaking with what had gone before. It was a modernising logic which dominated. With its constant search for innovation, it was claimed that the commercial sector would transfigure not only the realm of economics, but would have far-reaching effects on social and cultural life as well.

It was notable that academic voices paralleled business commentators, in awarding consumption a privileged place in their assessment of the qualitative transformations at work within contemporary industrial societies. Here the terms of reference of the debate were more nuanced, yet there was a growing consensus among economic analysts that the 1970s and 1980s had seen extensive disloca-tions to the international economic environment, which sustained the conditions for growth in the immediate post-war period. The ensuing volatility of markets had given rise to profound changes in the criteria for business competitiveness and economic success. The plethora of concepts which were assembled to grasp the nature of these developments reflected differences of position: post-Fordism, disorganised capitalism, Japanisation, flexible specialisation and just-in-time production. But in almost all of these explanations the recomposition of markets, resulting from fundamental changes in consumer demand, was seen to be an important factor shaping the new systems of production.[15] Like their commercial counterparts, academics also viewed these transformations as epochal, not perhaps in the sense of the classic transition from feudalism to capitalism, but certainly as extensive as the movement from entrepreneurial to organised

capitalism which occurred in the late nineteenth and early twentieth centuries. In the case of Britain, it was again argued that the groundwork for the new economic system was laid not in manufacturing but in retailing. Those industries most directly concerned with the management of consumption were not only generating innovations in production, they were frequently credited with creating different forms of material and symbolic culture.[16]

Commentaries of this sort did not claim to be politically neutral. More often than not they moved from economic and social analysis to political prescription. In so doing, they addressed a new phenomenon: the rise, on an international scale, of reformulated versions of Conservatism and their apparent success in dismantling established political orthodoxies. In Britain, the success of 'Thatcherism', especially at the level of popular politics, drew attention to the sustained use of the languages of consumption. The rhetoric of the marketplace, which equated the freedom to spend money with broader political and cultural freedoms, was identified as a key part of this political vocabulary.[17] Elsewhere, consumption was understood as the negative consequence of free-market ideologies. In exacerbating problems of import penetration and intensifying a narrow politics of the electoral cycle (obsessively focused on a succession of mini-booms), consumption became associated with a longstanding debate about short-termism within British economic management and about the politics of industrial decline.[18] More broadly still, the current allure of consumer society was highlighted in growing anxieties which were expressed about the future of politics itself. As the sociologist Zygmunt Bauman argued in 1988, depoliticisation involved a growing disaggregation of 'life' from 'politics'. Increasingly, it was in the world of privatised leisure, removed from the sphere of collective social action, where large sections of the population chose to invest their energies and aspirations.[19]

There were two further areas in which consumption figured prominently. These were the fields of cultural analysis and human geography. Concepts such as consumer culture, consumerism and the related couplet of postmodernism and postmodernity referenced a disparate set of discussions about the position and meaning of market-based goods. If the majority of these projects involved a critical reassessment of an older model of popular culture, which spoke only about the morbid and degrading effects of commercial society, then the routes out of this paradigm were extremely varied. At one level, the homogeneity of mass culture gave way to endless studies of taste systems, consumer choices and fashions. These interests were of course not altogether new. Social anthropologists had long been concerned with the rituals associated with the traffic in goods.[20] However, cultural attention to this area involved a growing emphasis on the symbolic significance of consumer forms. Cultural studies was also distinguished by a desire not merely to map commercial systems of provision, but also to intervene

in them by legitimising the activities of the consumer. The gendered dimensions of this work, influenced by the insights of feminism, added a further ingredient. From the valorisation of popular pleasures, to reassessments of women's involvement in the femininity of the marketplace, cultural politics, as it became termed, centred on the meanings and values generated by consumption.[21] At times such a stance degenerated into the celebration of human diversity as market diversity. At other moments it posed an important ethical question; namely, the issue of how to live a moral life in societies which appeared to be wholly dominated by secular rituals.

Partly differentiated from these culturalist models was the appearance of consumption within the repertoire of postmodernism and postmodernity. Inasmuch as theories of the postmodern presented a thesis about cultural classification and cultural change (which at times featured as a sort of latter-day *Weltanschauung* or *Zeitgeist*), then the importance of consumer society loomed large. Frequently, the approach pin-pointed certain styles or aesthetics, which, it was claimed, now predominated within key sectors of consumption. The overproduction of signs and images associated with the media, which had led to a simulated rendering of reality, the obsession with parody or pastiche running through much commercial architecture, or the representation of history as nostalgic retrospective in the heritage industry – these were some of the recurrent themes.[22] More sociological readings suggested a structural appraisal of the heightened importance awarded to consumer conduct. Carrying the significance which once had been ascribed to work, it was argued that consumption had now come to occupy the 'cognitive focus of life'.[23] 'Market-dependency' advanced its own strategies of regulation. Abandoning the disciplinary panopticon of modern power, consumer surveillance was quintessentially about strategies of self-regulation. Taken together, these various interpretations tabled a set of arguments about the relation between commerce and the constitution of identity. Self-reflexivity – the cultivation of the self, physically as well as psychologically – was understood to be enshrined in the current orchestration of consumption.[24] This presented a more complex picture of the individual's participation in the marketplace than that projected by rational choice theories of consumer sovereignty, or by the notion of duping contained in the concept of cultural manipulation.

A related agenda was present within human geography. Geographers had repeatedly identified how the development of industrial societies had been punctuated by intense phases of spatial reorganisation. Contemporary forms of economic restructuring, it was pointed out, were producing new spatial divisions of labour and new maps of power and inequality, on a global as well as a local scale.[25] In terms of consumer practices, this landscape was multi-dimensional. It

was seen to include symbolic and metaphoric territories as well as physical domains. Whether it was the spectacular environments of redeveloped city centres, or the more localised milieus of shopping malls and retail parks, space and place were understood as representational systems. The various environments associated with contemporary consumption (understood as time-dependent and time-related) were nodal points for the constitution of identity, and for the production of meanings which gave shape to everyday life.[26]

The purpose of rehearsing these widely differing theses is not to engage in a detailed appraisal of their approaches. The book has drawn selectively and critically on various aspects of such work and their influence will be detected throughout. At stake here is a more fundamental point. Despite their sophistication, there is a general difficulty which shadows almost all of the perspectives. This is the recurrent tendency to over-abstraction. Consumption is evoked as a meta-concept, used to explain the most disparate phenomena. At once part of a debate on industrial and commercial restructuring, over the language and meaning of contemporary politics and about the reordering of identity, space and place, consumption is glossed as a composite and synthetic term. What is at issue is the persistent tendency to generalise about particular cycles of demand and their social and cultural significance. The problem is by no means specific to Britain in the 1980s. Aided by similar master-narratives, *commerçants* and entrepreneurs, as well as historians and sociologists, have been busy identifying successive revolutions in consumption, across Europe and North America, from the eighteenth century.[27] Notions of the birth and subsequent growth of modern consumption have been dogged by a lack of analytical clarity. It is argued that the search for a general theory to define the meaning of consumer societies is part of the problem, rather than its solution. Dissatisfaction with generalisations of this type has driven my own account towards a more precise and grounded focus.

Cultures of Consumption is particularist in its concerns. It does not attempt to tell the whole story about the commercial transformations which took place in the 1980s. The book explores one specific system of provision; the creation of a distinctive market aimed at young men. Such an approach treats consumption practices as differentiated and distinct. It explores what the economist Ben Fine has termed the 'commodity specific chain connecting production, distribution, marketing ... and the material culture surrounding these elements'.[28] Distinguishing between the various practices which shape the circulation of goods, this framework enables meaningful comparisons to be made across different sectors. It also encourages a more precise understanding of historical change than is covered by the perennial idea of the consumer revolution.

But that is not the whole story. Particular networks of provision are not self-contained entities, neatly sealed off from other areas of economic and social

life. As Paul Glennie and Nigel Thrift have suggested, consumption chains are 'leaky'.[29] There are interactions across different demand cycles and between these and other discourses outside the sphere of consumption. Exchanges of this type occur at numerous levels. Advertisers and marketers inevitably work with a wide variety of goods and make ongoing comparisons between them. Interrelations between these professionals and other experts, in adjacent areas, result in frequent overlaps of knowledge. Moreover, there is strong evidence to suggest that consumers themselves do not view their activities in the marketplace as wholly isolated. The rituals of shopping, or the display of personal goods, collide with other fields of social action, especially at the level of everyday life. Many of these interconnections become obvious once consumption practices are explored concretely, in particular spatial environments. It is, therefore, not adequate to understand consumption in any given period as simply the agglomeration of different consumption chains. There are broader social and cultural histories to be written, in association with more specific narratives. *Cultures of Consumption* follows both lines of development.

The book opens by exploring how and why the habits and behaviours of young men figured so prominently in British visions of the future of commercial society in the 1980s. For if the 'new man', as he became labelled, carried specific connotations, he was also endowed with more general significance as a beacon for the future. This icon of commercial masculinity was the product of multiple forms of knowledge and a complex set of professional alliances. Parts One and Two investigate their conditions of existence. We begin, not on the obvious terrain of mainstream advertising or large-scale manufacturing, but with a clutch of more esoteric personalities. What is uncovered is the way in which a number of talented individualists exerted a strong sense of authority in the search for new markets. The habitus of these cultural professionals was overwhelmingly metropolitan. Notions of taste leadership have featured prominently in debates over the dissemination of goods. Part One explores the influence of the *cognoscenti*, in the context of the quest for a new type of consumer journalism for men. It uncovers a coalition between independent journalists and designers, photographers, models and urban *flâneurs*. These experts claimed to provide answers to a set of pressing questions about the disintegration of established consumer patterns and the emergence of new ones. As significant as the theories of this self-proclaimed taste-élite were the particular cultural resources they drew on to represent young men to themselves. A dense visual symbolism projected an exotic range of personas. Tracking the emergence of these representations takes us towards an exploration of the commercial cultures of sexual dissidence. For the growing visibility of the homosexual marketplace began to exercise its own influence over more mainstream versions of masculinity during the period. In the context of

men's consumer journalism, one important result was the consolidation of a particular culture of homosociality, targeting the bodies and lifestyles of young men.

Part Two pursues this narrative of gendered commerce into the worlds of advertising, marketing and retailing. The spectacular growth of these industries in the 1980s registered a confidence and optimism which was reflected in the expansion of their knowledge base. One important part of their programme involved developing a commercial language capable of speaking to young men. Consumption experts drew heavily on the rhetoric of style and fashion to shape this project. The resulting alliance between the mainstream and the avant-garde was a complex rather than a simple tale. Advertisers and marketers held to their own agenda for masculinity. The move into the mass market did not exemplify the 'trickle-down' theory of cultural transmission, whereby goods beginning life at the pinnacle of the taste pyramid eventually influenced more lumpen consumers.[30] Different audiences demanded different patterns of taste.

These opening sections of the book involve an extended engagement with the commercial professions. In that sense *Cultures of Consumption* continues the concerns of my earlier work, *Dangerous Sexualities*, not in its empirical focus, but in the analysis of forms of professionalising knowledge as discourse.[31] Yet in dealing with what might be termed commercial rather than official experts, the historian faces a number of difficulties. At a practical level there is the problem of a lack of any codified archive. Rarely do we encounter the systematised records which are preserved for the law or medicine. There is still no effective institutional account of advertising, marketing or retailing in Britain, either from within the ranks of the entrepreneurs themselves or from academic historians.[32] Commercial savants differ in a number of important ways from the intellectuals associated with the domains of public administration or scientific expertise. Usually cited as belonging to young or embryonic professions, their genres of knowledge are not always neatly demarcated, as in more prestigious systems. Boundaries between paradigms frequently overlap, or are deliberately blurred. Moreover, commercial briefs are typically generated by intuitive hunches, or by the energy of particular practitioners, rather than through the supposedly more rigorous procedures of professionalising practice. And yet, turning the pages of an advertising journal such as *Campaign* reveals a world-view quite as expansive as that encountered in *The Lancet* or in the *British Medical Journal*. *Cultures of Consumption* is very much about coming to terms with the forms of knowledge generated by these consumer professionals.

Yet, as should now be clear, the book is also about men and their relationship to consumer culture. In this respect my choice of market was not entirely innocent. Though a number of other constituencies were targeted in similar ways

during the 1980s, the commercial address to men provided a way into posing a number of broader questions about contemporary changes to masculinity. After almost total neglect, this topic has begun to receive serious attention. As Lynne Segal noted, throughout the 1980s the shifting nature of men's lives, their behaviours, fears and anxieties were scrutinised with a new intensity.[33] It was no accident that all this occurred at precisely the moment when feminism was defining men as an object of political and intellectual concern. In this context it has recently become fashionable to talk about a contemporary crisis of masculinity.[34] While such an idea may appear overblown (often erroneously contrasting perceived present-day rapid change among men with past stability), it does pose the sharp end of questions about the shifting nature of gender relations and gendered power.

How does this debate, essentially derived from sexual politics, impinge on the sphere of commercial culture? In the most obvious sense, the probing of young men's relationship to traditionally feminine areas, such as shopping or consumer journalism, which took place during the decade, did produce an extended inquiry into the nature of masculinity. This initiative was not as new as was claimed at the time. It had its origins in earlier moments of consumer expansion, notably in the 1950s and early 1960s. But the 1980s did see an intensification of these processes. One theme to emerge out of a study of the material is a by now familiar, but nonetheless important, point. Masculinity is multiform, rather than unitary and monolithic. The object of inquiry is masculini*ties*, not masculinity. Late twentieth-century promotional culture has been extremely active in the construction of more plural versions of identity for men.

This emphasis has the capacity to produce a more subtle account of the multiple dynamics governing masculinity. But an exclusive focus on men projects a distorted picture. Equally important are the positions they occupy within the total ensemble of gender relations – understood as relations of difference and power. Masculinity needs to be interrogated in conjunction with its feminine counterparts. The history of commercial culture in the post-war period has been punctuated by gendered struggles about access to goods and the meaning of consumption. In the 1980s the formation of new consumer identities coincided with an upsurge of feminist pressure on the professional fields of advertising and marketing. Women's growing impact on these institutions – as well as that of gay men – contributed substantially to the strategy making masculinity more self-conscious. And yet the intensified scrutiny of men often resulted in the consolidation of a world-view which marginalised or excluded femininity, let alone feminism. Cultural progressivism did not necessarily imply progress for women. Masculine and feminine divisions feature in the book, alongside men's differentiated power relations to each other. What is needed is a more plural model of

gender, which grasps these multiple lines of force. Such arguments have been set out most cogently by Joan Scott and others in relation to the discursive production of women, but their relevance is just as important for the analysis of masculinity.[35] They point not towards the total dissolution of gender but towards its more historically differentiated exploration, and towards a more nuanced version of sexual politics.

Part Three examines these questions of identity and selfhood in relation to a particular social geography of masculinity, centred on London. In the 1980s the fabric of the metropolis was subject to a series of dramatic redevelopments. Many of these shifts were associated with the capital's role as a financial and commercial entrepôt. Linked to these changes was the re-emergence of London as a city of spectacular wealth – a place of wordly delights – with its population defined as consumers rather than as makers of things. It was these material and cultural features of late twentieth-century urban experience which shaped the appearance of a range of masculine personalities. Particular zones of the city and their commercial facilities – shops and cafés, restaurants, bars and a plethora of night-time venues – became privileged sites for this drama. Such spaces functioned not simply as a backdrop, they were active in the construction of men's identities. What took place in areas such as Soho, in London's West End, was the formation of particular taste communities, with divergent and often competing claims on social space. The tensions which were played out between heterosexual and homosexual men, and the hybrid personalities who existed in between, were some of the most significant features of this contemporary panorama of city life.

Yet identity is not simply a space formed as an effect of discourse. Individuality is also constituted through the interiority of experience, as it is shaped by the historically specific languages which are available for self-dramatisation. Existential questions about the meaning of the self are bound up with an even wider issue; the unstable and contingent nature of subjectivity. Recent work, on historical as well as contemporary forms of masculinity, has demonstrated that even the most apparently unified personalities have been troubled by this sense of potential incoherence.[36] Part Three concludes with an ethnographic project which profiled the consumer spaces of the city. Here the world of goods appeared in another guise; as part of the symbolic narratives which young men drew on to represent themselves in the world of everyday life. Commodities featured as recognisable signposts in the processes of self-enactment demanded by society. They were important in their capacity to keep a particular story about the self up and running. Yet the meanings attached to consumption were diverse. In the autobiographies charted in the book, the social differences between men intersected with more personal markers of taste to produce conflicting identifications with commercial culture.

One critical response to my appeal for historical specificity in approaching consumption – for the avoidance of over-generality and the focus on particular markets and their associated forms of identity and experience – might be to point out that such a call to detail loses sight of what has been most productive about the more abstract debates. Since Thorstein Veblen's treatise on the *Theory of the Leisure Class*, a significant achievement of these general sociological studies has been to place consumption as a constituent part of the power relations integral to modern societies. Does the type of historical archaeology I propose vacate the terrain of power, implicitly returning commodities to the comfortable sphere of freedom, leisure and self-fulfilment? My emphasis on the need for concreteness is partly driven by a scepticism about the existing models of power which have been employed to address consumption. Simply put, the problem is that consumer systems have repeatedly been theorised as a power effect of something else. Whether this appears as the unequal structures of production, and their attendant forms of alienation and false consciousness, or as status inequality, or as the degeneration of cultural values, what characterises such accounts is less an interest in the power dynamics of consumption, than in consumption shedding further light on forms of authority which are essentially exterior to it.

Michel Foucault's discursive model of the specificity of power – its immanence and irreducibility – provides a useful alternative framework with which to address consumer systems. As Foucault insisted, relations of power are not in a position of exteriority with respect to other types of relationships (economic processes, knowledge relationships, sexual relations), but are inherent in the latter. They are the immediate effects of the divisions and disequilibriums which occur in these domains.[37] Following Foucault, we might add that power relations in the field of consumption are not simply the reflection or mediation of other networks, they are integral to this arena; the product of the combined effect of its knowledges and strategies, alliances and social movements, resistances and forms of experience. The historian's task is to map the changing nature of these relations, not to search for the motor or engine of consumption elsewhere. Foucault did not of course apply his insights on the dispersed archaeology of power to the sphere of commercial or market-based transactions. His principal object was the genealogy of modern structures of governmentality, associated with the emergent field of 'the social'. Consumption points the historian towards a different object and territory. This is an area which I would provisionally classify as the commercial domain. Less systematised than the traditional public sphere, it has been formed at the intersection of commercial and intellectual entrepreneurship, involving the management of persons and families and, crucially, the cultivation of the secular self.[38] *Cultures of Consumption* maps one recent strand of this history.

The Cultural Authority of Style

1 New Men and New Markets

The French sociologist Pierre Bourdieu, in his study of the academy and its intellectuals, has given a particular definiton of cultural crisis.[1] Crisis moments, Bourdieu has observed, are essentially struggles over rival systems of classification. Positions are staked out, producing a number of clearly distinguishable camps and forcing participants to endow their arguments with a coherence which would not be required under more normal circumstances. Such moments are for Bourdieu not simply negative; they act as *developers*, stimulating knowledge and sites from which to speak. Bourdieu's paradigm has principally been used to analyse intellectual systems in the narrow sense. Yet his understanding could usefully be applied to the eruption of discourses about masculinity which occurred in Britain during the 1980s. Just in case anyone still doubts it, observed Judith Williamson, writing in the *New Statesman*, in the autumn of 1986, 'men are the most marketable category of the year'.[2] It was, she noted, all part of the mood of the moment. As a feminist film critic, Williamson was far from positive about the flurry of interest in this long-ignored subject. But her remarks were part of a growing crescendo of argument. In journalism and fashion, in commercial and manufacturing culture, as well as in the political and social arena, men were at the centre of a wide-ranging debate. The forms which discussions took were as varied as their conclusions. Amidst all the energy, one motif occurred repeatedly. This was the figure of the 'new man'. A hybrid character, his aetiology could not be attributed to one single source. He was rather the condensation of multiple concerns which were temporarily run together.

For the advertising and marketing industries, the appearance of such a personality was a symptom of growing commercial and cultural confusion. Journalist Phillip Hodson explained to the women's magazine *She* in July 1984 that this new form of masculinity was principally defined by self-doubt. Confronted by the loss of traditional gender certainties, many men were now being forced to question their social roles.[3] Such a sense of disorientation was having repercussions on traditionally stable consumer markets, especially among the young. 'So what on earth is the young British male?' queried an exasperated television production consultant, Steve Taylor, to the advertising world's in-house journal, *Campaign*, two years later.[4] 'Advanced' market researchers claimed to have solved the problem. Marketing consultants McCann Erickson's *Manstudy Report*, produced in 1984, hailed the new breed of man as the 'Avant Guardian'. Claiming statistical exactitude, their report insisted that the group covered precisely 13.5 per cent of all British males. With an 'optimistic outlook on life' and

a strongly contemporary view of masculinity, these individuals were associated with premier consumer brands. But the report noted that they were also at the forefront of more serious discussions about the changing experience of gender.[5] Other commercial commentators offered different, but equally specific, accounts. The new man was linked to the more progressive and caring versions of fatherhood, portrayed in the marketing of stores such as Mothercare. In a different vein he was defined as a metropolitan phenomenon, supposedly visible in a number of London locations associated with consumer style. 'He's a good first-tier fashion person' enthused entrepreneur Bruce Isaacs, himself the owner of a successful West End restaurant, in 1987.[6] Attacking these commercial posturings, media consultant and man-about-town Peter York was much more critical. A highly contemporary personality, York reported in *The Times* the following year that the figure of the new man was nothing more than the advertising industry's dramatisation of its own self-image. His ethics and morality were based only on a 'mean chic', which was driven by 'greed, competition and treachery'.[7]

The fashion industry believed that this confusion over representations of masculinity was entirely positive. For a sector in which diversity was its lifeblood, new personas were always to be welcomed. They were essentially a result of the growing proliferation of tastes and styles for men. The origins of the change were seen to lie in the current renaissance of British fashion, after the lean recession years of the late 1970s and early 1980s. 'Are You Gauguin, New Colonial, or Savile Row?' inquired *Men's Wear* journalist Thom O'Dwyer archly, in his preview of the spring and summer menswear collections in *The Guardian* in 1987.[8] It mattered little which image his readers selected, the point was that a greater number of choices were now on offer. Such a celebration of individualism was often simply reduced to the level of fashion trivia. But at times the arguments strayed into more political territory. O'Dwyer proclaimed that men's fashion was 'coming out of the closets'.[9] Deliberately evoking the language of homosexual liberation, he implied that the appearance of the new man had much to do with the breaking down of sexual stereotypes, which was the direct result of a decade of gay politics. Journalists Brian Kennedy and John Lyttle, assessing the significance of the phenomenon for urban life and leisure, in the London listings magazine, *City Limits*, in 1986, took up the same point. They argued that in Britain, as in North America, the new masculinity had its origins in the growing power of homosexual men, who had at last forced a grudging recognition from the gatekeepers of public culture.[10] This dissident reading was strenuously denied in more mainstream areas of popular taste, especially in the tabloid press. Forever on the look-out both to incite sex, and to police the perverse, *The Sun* produced its own interpretation of the new man, as part of a rhetoric of normative, but liberated, heterosexuality.

From 1986, 'page seven guys', with unbuttoned flies and bared torsos, competed for attention with established female pin-ups: the famous 'page three girls'. The paper announced that the new visual erotica of men's bodies was available for the enjoyment of modern, fun-loving young women.[11]

The debate continued in a more serious vein within the arena of sexual politics. For progressive men, working in anti-sexist organisations and consciousness-raising groups, the growing concern over masculinity, however confused and chaotic, was to be supported. It was viewed as the culmination of a series of much broader initiatives, which were breaking open masculinity's best-kept secret; forcing men to look self-consciously at themselves and their identities, rather than as the concealed norm of power and privilege.[12] It revealed a point of vulnerability which was a potential source for change. For those men who also held some allegiance to more traditional forms of politics, especially to socialism, the implications went further still. In microcosm, the problem of men was bound up with the contemporary crisis in political culture itself. Inasmuch as formal politics was underpinned by a particular version of gendered privilege, the question of masculinity raised the long-repressed issues of subjectivity and language, and the ways in which such factors shaped political allegiances. A day conference in London, organised in the summer of 1987 under the auspices of the Communist Party journal *Marxism Today*, debated these and other themes. Yet the enthusiastic tone of the discussions was not shared by the majority of women. Feminist responses to the new men's politics were invariably more mixed. For those who rejected a biological or social essentialism about men, the process of shifting masculinity – crucially in relation to women – was seen to involve extensive and often painful change. It was, as Lynne Segal termed it in the title of her book on masculinity published in 1990, inevitably men in *slow* motion.[13] *The Guardian*'s feminist columnist, Polly Toynbee, doubted that the transformations which had taken place in men's experience were sufficient to merit the title of new man. Summing up the current debate in 1987, she remained wholly unconvinced:

> I have heard tell of the new man. For many years now there have been books and articles proclaiming his advent, even his arrival. I have met women who claim that their sons will be he, or that their daughters will marry him. I have met men who claim they are he. False prophets all, the new man is not here, and it does not seem likely that we shall see him in our lifetime.[14]

If the new scripts about masculinity had not changed the lives of the majority of men, as Toynbee argued, the new man was certainly not a mere chimera. In the 1980s the debate over men's changing roles was concretised in a wide variety of settings. But it was in one area in particular that the issue was given its most extended hearing. This was in the sphere of consumer culture. In all the

exchanges, commercial debates over the identities and consumption patterns of younger men loomed large. Such discussions were urgent and energetic, and they competed for attention with the more sententious claims of sexual politics. For during the decade the dynamics of the marketplace occupied a privileged place in shaping young men's wants and needs.

Commercial interest in young men was canvassed across many different sectors. But attention was most intensely focused around one specific commodity. This was the attempt to produce a general-interest, or 'lifestyle', magazine for men. The quest to crack this product became something of a *cause célèbre*, especially for the media industries. Frequently referred to as the 'holy grail' of publishing, the search for a successful formula was approached with all the vigour of a latter-day masculine crusade. The urgency which surrounded this project was an expression of large-scale ambitions, which extended well beyond the media. Successfully established, a men's magazine could provide the anchor point for a huge variety of goods and services. It could present the vision of masculine consumer society, in much the same way that the women's press had long done for female readers. The implications of this initiative were not lost on advertisers and marketers. As Zed Zawada, advertising director of East Midlands Allied Press Metro Group (EMAP) and an influential player in the debate, saw it in 1986:

> Publishers look at women's magazines, their circulation figures and bottom line and they think: 'If we put together a road test of a new Porsche with an in-depth interview with Giorgio Armani and some stuff about personal finance, then we'll hit some sort of composite male who has all these interests.' If that were possible, it would be like finding the Holy Grail.[15]

Zawada's cynical analysis was both shrewd and practical. Focused on prestige consumption, it emphasised the need to assemble a type of synthetic male personality out of the flotsam and jetsam of contemporary commodities. This, he insisted, was the key to unlocking the men's market. Yet as he pointed out, competitors in the race needed to beware of growing uncertainty in the world of publishing.

Strictly speaking, the idea of a general-interest publication for men was not wholly new. The claims to innovation made in the mid-1980s need to be qualified in the light of much earlier post-war experiments. The most important development in this genre was *Man About Town*. Established in 1953 as a gentleman's tailoring magazine, it was restyled and renamed in 1960, on its acquisition by publishers Michael Heseltine and Clive Labovitch. *About Town*, later abbreviated to *Town*, ran until 1968, with an ambitious mixture of photography and journalism. Paralleling the newspaper colour supplements of the period, the title blended fashion, politics and arts coverage, along with reports about international

celebrities.[16] In the late 1960s the picture was further complicated by the brief appearance of three publications aimed explicitly at homosexual men: *Timm*, 1968, *Spartacus*, 1969 and *Jeremy*, 1969. Picturing the world from a gay point of view, the magazines worked with a similar focus on upmarket consumption.[17] Yet these precursors were rarely acknowledged by later editors. What was emphasised in the 1980s was the supposed originality of the men's magazine format.

Reviewing the publishing sector at the end of the 1980s for the advertising journal *Media Week*, Brian Braithwaite pronounced the decade as having been the most turbulent since 1945.[18] As publishing director of The National Magazine Company, he argued that the origins of this instability were both economic and cultural. The enforced introduction of new work disciplines and technologies, first seen at Rupert Murdoch's News International press at Wapping, had been coupled with significant shifts in retailing and distribution. The growth of supermarkets as major outlets for magazine titles, the rise of postal subscriptions, along with an upsurge in the number of free local papers, had radically reshaped the expectations of many consumers. But Braithwaite also drew the industry's attention to more specific influences. These were driven by the recomposition of key markets and their styles of journalism. Most especially, it was among the publications for women and young people that change had been most hectic. Anxieties about falling sales and magazine closures had been offset by a series of spectacular breakthroughs. The successful launch of a number of women's weekly and monthly general-interest titles across the market range, coupled with the influx of foreign competitors (notably from Germany, France and Spain), had posed fresh questions about the future direction of consumer magazines. Editorial format and visual style, as well as journalistic content, were all under scrutiny. Shifts in women's publishing had been paralleled by transformations in the teenage market. A fresh generation of magazines, targeting girls and young women, were in the forefront of publishing change. What was significant about the newcomers in this area was that they had not emerged from the publishing leviathans, which had hitherto dominated the field, but from smaller regional and independent concerns. EMAP, which was based in Peterborough, scored a major victory for the independents with the launch of its pop music paper, *Smash Hits*, in 1978. It was followed by *Just Seventeen* in 1983, aimed more specifically at teenage girls. Both publications thumbed their noses at the staple format of a youth magazine. Their style of journalism and visual layout broadened the coverage of young women's lives, introducing some ironic distance on traditional cultures of femininity.[19] Taken together, these two publications, and their many imitators, functioned as a tangible symbol of a new type of journalism.

It was into this rapidly changing market that the publishing giant, the International Publishing Corporation (IPC), launched their magazine, *The Hit*, in

September 1985. In-house advertising surrounding the new title, which was strategically placed in *Campaign*, rang the familiar tropes of radical innovation associated with any new product launch:

> Never before has there been a magazine, a paper, or any other publication so specifically targeted at teenage 15–19 year old males. Never before has there been anything like the HiT. It's the only ... magazine to ZAP the core male youth market between the eyes.[20]

Beyond the advertising hype, the launch of the new magazine was an ambitious venture. Attracting substantial financial backing from IPC, who were keen to reassert their pre-eminence in the youth sector after the challenges from EMAP, the publishers assembled an experienced editorial team. This was headed by Phil McNeill – a journalist with a successful track record on the teenage music paper, *New Musical Express*. With an initial print run of 350,000 and an estimated settle-down target of half that figure, *The Hit* appeared to justify the £650,000 pre-launch advertising campaign, which was handled by the first-ranking Yellow-hammer agency. Carrying a glossy, full-colour format, its journalism was wide-ranging. There were consumer items on fashion, sport and the latest media celebrities, social discussion of drug abuse, as well as more standard features on the music charts and pop bands. Prior to publication carefully prepared statements from the publishers pointed up the underlying strategy, for the benefit of manufacturers and advertisers. *The Hit* was aiming for a general-interest format. IPC's Holborn Publishing wing explained in the press release that the title was 'the result of a growing need among young men ... for a magazine to express their own tastes in the Eighties'.[21] As editor, McNeill looked towards the success stories in the young women's sector to justify his formula. *The Hit*, he claimed, sought to 'open up a new kind of market in the way that *Smash Hits* ... did for girls'.[22] Influential groupings within the advertising industry appeared to need little convincing. Prior to the launch, agency interest was running so high that IPC brought forward the publication date by a week. For Dave Porter, associate director of Yellowhammer, who worked closely on the plans, the new magazine pro-claimed an individualistic message. It shouted to young men: 'this is for you.'[23] Back at IPC, Jane Reid, the ex-editor of *Woman* and managing director of the Holborn Group, was convinced that the enthusiastic reception awarded to *The Hit* meant that a men's magazine was now imminent.[24]

But *The Hit* was a failure. The almost total collapse of the title, after only six issues, prompted some hard-hitting comment from publishers and advertisers alike. What went wrong? The basic snag, as Porter ruefully confessed, was that despite the enthusiasm of the experts, all too few 15 to 19-year-olds were tempted to buy the new publication.[25] The post-mortem on *The Hit's* collapse was

wide-ranging. In essence it reflected publishers' continuing confusion over the identities of their young male readers. According to IPC's audience research survey, the lifestyle coverage and layout of the magazine were correct. What surfaced, however, were reservations about the potential of a general-interest magazine to speak to young men. Mark Ellen, from EMAP, believed that, unlike girls of the same age, who identified strongly with a community of women, young men baulked at being addressed collectively as men. As Ellen expounded to *Campaign* a week after the title's closure, the difficulties were social and psychological. Young men 'might like BMX bikes, waterskiing and the Jesus and Mary Chain, but they don't like a magazine to suggest that other men within their age group feel the same way'.[26] In other words, addressing young men *as men* was seen to be a risky business, because it raised the troubled question of identity as gendered. Self-consiousness was perceived as permissible, even attractive, in young women, but weak and effeminate in men. Simon Marquis, media director at the advertising agency Fletcher Shelton Delaney, hinted that such problems appeared to be specific to British men, given the established male readership for consumer magazines in France, Italy and increasingly in the United States.[27] In Britain, the rules seemed to preclude any discussion of masculinity as a gendered community.

The demise of *The Hit* provided the ideal opportunity for a disgruntled professional coterie to break cover and attack the whole concept of a general-interest title for young men. Among this grouping were the editors and publishers of the well-established hobby press, with vested commercial interests at stake. Cars, bikes, music and pornography, they insisted, were far more effective ways of speaking to the youth market than some vague psychological notion of consumption. Mark Revelle, editor of *Bike* magazine, was particularly caustic. As he gloated in the wake of *The Hit*'s collapse: 'Modesty should prevent me (but it won't) from pointing out that one of my titles, *Bike* magazine, attracts 175,000 15–19 year old young male readers.'[28] The soft-porn publication *Mayfair* was even more triumphalist. Their editor claimed that the 'naturalness' of the male sexual urge would arouse young men far more effectively than any general consumer title: 'Boys will be boys ... *Mayfair* delivers the young male market more efficiently than most other colour magazines. So if you've got toys for the boys. You'll sell them in *Mayfair*.'[29] Opponents of the lifestyle format were of course defending their own corner, which they felt might be threatened by a more all-inclusive newcomer. But professional objections were intertwined with more privately felt anxieties. Worries recurred about the ways in which the lifestyle format had the potential to disrupt conventional ideas about masculinity. As so often in these debates, professional and personal beliefs went hand in hand.

What does this vignette reveal about commercial attitudes to masculinity in the

mid-1980s? Market failures often provide greater insights into business strategies than successful products. Despite the obvious difficulties, there was a strong alliance of publishers and advertisers who backed a lifestyle magazine for men. The search for a youthful male consumer was a quest for a more stable icon, in the context of increasingly capricious trading conditions. Such an undertaking was also bound up with the projection of new types of male identity. If this provoked opposition, it was because the area was recognised to be a disputed terrain, not simply in economic terms but in a cultural sense as well. Yet the closure of *The Hit* was by no means the end of the story. There were other players at large in the race to break open the men's market, who ultimately proved to be more successful in their quest. For these we move outside mainstream publishing and into a more cryptic and allegorical world.

2 A Guide to Modern Living or 'I bet you haven't heard of *The Face*'

'I bet you haven't heard of *The Face*', purred *The Sunday Times* columnist, Barry Ritchie, to his weekend readers in March 1982.[30] Most likely they had not, for *The Face* self-consciously addressed a more discerning public. In the 1980s the magazine was glossed in grandiose terms. Described as the 'Ur text' of a set of symbolic rituals, it was cited as a manual of taste which laid down the ceremonial of contemporary metropolitan life. More expansively still, *The Face* was read as symptomatic of an emerging postmodern sensibility within popular culture, the enactment of a structure of feeling which made sense to an influential minority.[31] A sense of philosophical mission was certainly present in the pages of the magazine. But our interest in *The Face* is more specific. The significance of the publication lies in its special claims to authority on matters of consumption, together with the forms of knowledge which made such claims possible. It was this repertoire which generated a number of important conditions for the take-off of a transformed understanding of masculinity within commercial culture during the 1980s.

The term 'style magazine' or 'style press' was first used within the publishing industry as a trade-shorthand for the trio of publications all launched in 1980: *The Face, I-D* and *Blitz* published by Wagadon, Time-Out and Jigsaw respectively. Despite subtle variations in design and editorial policy, all three magazines displayed a characteristic type of journalism. A sophisticated mixture of 'pop, fashion, style and art' was how Simon Ludgate, television editor for the London

leisure magazine, *Time Out*, described the titles in 1984.[32] These were self-avowedly 'independent' concerns, created by a dedicated and close-knit band of entrepreneurs. The founders had their origins in the creative turbulence of youth and music culture which emerged in the late 1970s, in the aftermath of punk. Judged against the scale of the large publishing houses, the three publications were shoestring enterprises. The origins of *The Face* entered publishing mythology. It was launched almost single-handed by its editor, Nick Logan, with as little as £5,000, withdrawn from his local Halifax Building Society in east London. For much of the early 1980s it was run by only two permanent journalists, while Logan's wife, Julie, handled the accounts and subscriptions from home. The magazine's first offices were the depths of a 'cubby hole in Soho'.[33] Logan later confessed that for the initial nine months he paid himself nothing and it was only 'stubborness and pride' which carried him through. One edition was reputedly put together in transit, out of a suitcase shuttled between Wanstead, Soho and Kilburn. Even after the move to larger premises in Marylebone in 1986, the whole of the full-time staff could be fitted into the back of a London taxi![34] *Blitz* began life from the flat of an Oxford student, Carey Labovitch, with 'zero funds'.[35] Yet unlike *The Hit*, these were publishing success stories. Monthly circulation figures for *The Face* began to grow significantly in the second half of 1984, rising by 20 per cent to 80,000.[36] Logan's achievement was in part the result of novel sales methods. *The Face*'s distribution company, Comag, had cornered only a small share of the magazine market. But this firm's new distribution schedule involved statistically monitoring the speed with which wholesalers delivered their titles to newsagents, together with measuring rates of sale. The scheme reflected broader contemporary changes taking place in retailing, associated with so-called just-in-time production. As early as 1982, Phil Harris, Comag's managing director, boasted that his attention to distribution information was showing through in bigger market shares.[37] Though still very modest (when judged against the standards of the men's hobby press or the women's magazine market), by the mid-1980s all three style magazines were significant enough to command a small advertising revenue.

The importance of the style press was not to be found in its quantitative impact. Rather, it lay with the influential position these titles began to carve out, both in the publishing world and in the wider debate over consumption and young people. Appearing monthly, they were 'upmarket' from the teenage papers, in terms of their projected audience and in their vision of consumer goods. Readership was clustered at the upper end of the 15 to 25 age range.[38] Quality production values were enhanced by full colour, art photography, quarto size and the introduction of perfect binding. Features of this kind positioned them close to long-established magazines trading in fashion and de-luxe consumption, such as *Harpers and*

Queen and *Vogue*. But the style publications distanced themselves from such titles on a number of counts. They were not predominantly feminine, either in outlook or in their projected readership; nor were they conceived as fashion magazines. Reid confided to *Campaign* in 1985 that the new publications were indeed different. They spoke to the 'serious-minded, style-conscious consumerist'.[39] She went on to hint that it was these titles which held the key to a new type of male consumer. It was the innovative scrambling of readership identities and journalistic genres which made the *The Face*, *I-D* and *Blitz* so pivotal in the debate over the aetiology of young men and their gendered rituals of consumption.

The Face was the most successful of the new publications. Pre-eminence was not purely the result of its claims to originality, nor was it grounded only in higher circulation figures. It was above all its distinctive discourse which established the position as a market leader. While *I-D* and *Blitz* were not simply 'me-toos', or copies, *The Face* remained as a model. Its recognised success led directly to Logan's launch of *Arena* in the autumn of 1986, which was, arguably, the first in a fresh generation of general-interest magazines for men. Many of the other embryonic men's titles which appeared between 1986 and 1990 strove to distance themselves from *The Face*, but they all acknowledged the magazine's formative influence. It is time to unlock its most crucial cypher, its code of style.

'Everything is style.... Style is our status system, our guide to what is right in the world and all-in-all we're getting better at it', proclaimed freelance journalist Robert Elms in the *The Face*'s new-year issue for 1985.[40] Elms 'disinformed' readers every month with a bricolage of social and political counter-gossip. He was optimistic about the possibilities which could be marshalled under the banner of style. There was a world to be won in the fast approaching 'style wars'. The established order would be turned upside-down, for the future belonged to a different type of democracy. Listen to the same theme, proclaimed with tongue-in-cheek missionary zeal in the article, 'New England', which appeared in the August edition for 1986:

> ... in the long-fought civil wars of style, everything is up for grabs. The multi-ethnic society of Britain has brought rich cultural pickings; a common market of exotic goods, a common wealth of fresh ideas ... in the following pages there are no elite sects or cults or tribes and no second class citizens.... No need to ignore the difference between peoples, simply revel in the diversity. Revel in your diversity (say it loud and proud). The wealth of a bankrupt nation lies in *ALL* its people. Nothing is sacred.[41]

Here in microcosm was the credo of *The Face*. A number of key signifiers were run together. Overwhelmingly style was identified with the consumer marketplace. Commodities were the principal medium of cultural exchange. But this was

not the world of everyday consumption. It was an exotic celebration of goods. In more symbolic terms style was projected as the site of a protracted struggle over new forms of politics. For if the country was currently seen as 'bankrupt', the commonwealth of the future would be truly egalitarian. The nation was envisaged as a plural and multi-ethnic utopia, composed of diverse and jumbled identities. To underline these commitments the 'New England' article introduced an eccentric fashion spread. Featured first on the catwalk were 'Scotland's tartan army'. Yet this was not the usual male horde of Scottish football fans – it was young lassies who were pictured drinking McEwan's ale. Then came 'Raj', a beautiful, turbaned Indian lad, followed by 'Rasta', a muscle-bound hunk with bare torso, sporting Jamaican colours. Between them were two young urban professionals – a besuited couple who gazed out aggressively from the corporate steel and chrome interior of London's new Lloyd's Exchange building. The penultimate image in the sequence was captioned 'Boystown'. It profiled a young, gay urbanite, with earring and baseball cap, rucksack and blue jeans, dressed for the urban struggle.[42]

What cultural resources did journalists draw on to depict this montage of contemporary life? The question is important because it directs attention to the specific languages out of which style culture was assembled, which in turn inflected the agenda for consumption. The most striking feature was the positive commitment to the world of goods. This was understood to be a site of cultural as well as of economic transactions. Such a confident stance on consumption went hand in hand with a radical reworking of the category of youth itself. Questions of consumer culture and young people's identity were seen as intimately linked. If established players within magazine publishing bemoaned the growing instability of the youth market, at *The Face* journalists celebrated this new-found volatility. In a rhetorical flourish, the classic icon of post-war youth consumption – the teenager – was pronounced dead. As Elms pontificated, in reviewing the exhibition on British youth culture at the Victoria and Albert Museum's Boilerhouse exhibition in 1986: 'the teenager was a historical quirk born out of post-war turmoil and has finally passed away.'[43] In the *Observer Magazine*'s month-long enquiry into Britain's youth, which appeared the year before, members of *The Face*'s team polemicised hard for the disintegration of traditional categories. In 1964 it might have been possible to talk in terms of a single teenage style, journalist Jon Savage argued, but today such rigid classifications had given way to extravagant and aggressive pluralism. Fashion had become a hydra![44]

Polemic of this sort was not lost on influential sectors of the media. John Cummins, youth commissioning editor at Channel Four television, confessed in 1985 that his job description increasingly worried him. It was nonsense to pretend that 'youth' was still a tightly defined group, all with the same priorities and

preferences, 'lining up against the grown-ups'.[45] Neville Brody, graphic designer at *The Face*, warmed to a similar theme. The magazine had been among the first outlets to identify a sea-change in young people's interests, which were attendant on the demise of youth culture in the mid-1970s. Brody believed that the previous linchpin of the teenager's identity, pop music, was now seen as overwhelmingly boring. It urgently needed to be mixed with other objects of desire. He announced that *The Face* had broken the stranglehold of the music industry, opening the way for a greater diversity of cultural forms: fashion and *objets d'art*, personal bric-à-brac and food, books, night-life and the thousand-and-one artefacts which comprised the contemporaneity of everyday living.[46] In publishing terms Logan recognised that keeping pace with these ever-changing cycles of consumer leisure posed practical problems, especially for a monthly magazine. *The Face* had a deliberately short production cycle, with features written only four weeks prior to publication, in order to capture the feel for stories as they broke. His understanding was that, in order to survive, the style magazines needed to give the illusion of being as immediate as the weeklies.[47]

With studied nonchalance, Logan commented in 1983 that this bricolage of attitudes and objects signified nothing in particular. Denying that *The Face* led with any editorial policy, he saw his journalists as cultural scavengers, simply picking up on the things other people ignored.[48] He was disingenuous, for 'the things' chosen for coverage in the magazine were highly selective. It was the binary opposition between taste and the mass market – the line separating discrimination from what was cast as the superficiality of mere fashion – which shaped the stance of the new titles. This was the bottom line of style culture. It was an approach which set the tone for many broader rituals of consumption in the 1980s. Despite a fixation with commercial society, *The Face* marked out a critical distance between the *cognoscenti* and the mainstream. Underpinning such distinctions was an unashamed belief in the power of a taste élite. Once again it was Logan who was most intellectually coherent about this concept of cultural dissemination. The model of consumption he envisaged was one familiar to many de-luxe markets. It centred on an osmosis or trickle-down theory. In an interview with the advertising magazine, *Direction*, in 1988, Logan expounded his approach. It was his belief that an influential group of 'style innovators', or 'opinion formers', were in the vanguard of key market sectors. Logan's conception of the consumer process was informed by his own involvement in an earlier taste hierarchy – the mod culture of the early 1960s. He observed how the things originally covered in the pages of *The Face* subsequently became part of 'the general culture', in the high street or on television, via a process of absorption. His readers were not 'trendies', just people who were interested in the ways in which taste and style were formed.[49]

The arrival of Rod Sopp from *Smash Hits*, as *The Face*'s advertising manager in 1984, gave Logan's hunches a more professional gloss. Sopp was heavily influenced by contemporary marketing theories which divided audiences into a hierarchy of psychological categories. Such classifications were not governed by traditional economic or demographic criteria, but principally by personally held values. For Sopp, readers of *The Face* were individuals who were at the top of the consumer pyramid, far removed from those he scornfully referred to as 'the cretins' of the mass market.[50] It was concepts of this sort which fed into the marketing strategy of the style press. In practical terms it made editors highly discriminating about the overall look of their titles. This was especially true about the type of advertising they were prepared to tolerate. Labovitch told *Campaign* about her code of practice at *Blitz*:

> I turn down ads if they don't look good.... Our readers are so critical that if we took an ad that didn't blend in with the rest of the magazine they would spot it a mile off and it would reflect on us.[51]

Logan made a similar point. Though acknowledging that *The Face* was dependent on advertising revenue, he admitted that there were some commercial inquiries which his team simply turned away.[52]

Taken straight, such a stance on the transmission of culture would have read as a tired reworking of the familiar vocabulary of élitism. But what gave the style press a more endearing slant was its humour. Comedy came in various forms in *The Face*. It featured as high camp, in the reports about Parisian couturier Jean-Paul Gaultier and his catwalk antics. These featured men in skirts along with mock housewives sporting giant cone breasts and headscarves.[53] Or the jokes came black, as in the infamous 'Beirut' fashion spread of July 1986, which profiled Christian Phalangists, Shiite Muslims and Druze militiamen as victims of fashion: 'Black summer diving suit in neoprene rubber22 Beretta in black leather holster ... compass and depth gauge worn on wrist.'[54] Or the comedy came full of bile and invective, as in contributing journalist Julie Burchill's monthly polemic.[55] Articles drew on cultural and artistic strategies of shock and outrage, weaving them together with more traditional brands of English burlesque humour. By turns the mixture was witty, insolent and rude.

It is tempting to read the discourse of style through a simplified prism of social history, as a particular reflection of socio-economic conditions in Britain in the early 1980s. For some commentators, the emergence of a form of youth culture obsessively focused on élite consumption can be directly related to the realities facing young people at this time. The discipline of mass youth unemployment and the Conservative government's promotion of a restrictive set of social policies, coupled with the ascendancy of neo-liberal philosophies of secular reward and

self-advancement, have been understood to have produced their own sea-changes among significant numbers of the young. Within this account, style has been defined as the product of 'Thatcherism', inasmuch as it involved capitulation to the marketplace.[56] Magazines such as *The Face* have been negatively compared to the spectacular manifestation of resistant youth culture which immediately preceded them – namely, the punk phenomenon of the late 1970s. With its vanguardism and its self-professed hostility to mainstream commerce, punk has been celebrated as the authentic reference point, against which later developments have been found to be wanting. A more complex explanation has worked with the notion of recuperation. Here the shift from punk to style has been understood to have involved a dilution of the initial impetus of an organic youth movement by the commercial industries.[57] Both accounts have delivered an over-simplified reading of the relationship between youth and consumerism during this period. They have ignored the way in which such cultural forms were part of a much longer-term history. As Simon Frith and Howard Horne have demonstrated, connections between pop culture and art-based discourses dated back at least as far as the 1950s.[58] From the art school traditions which fed into the boutiques pioneered by Mary Quant and Alexander Plunkett Green in the middle of that decade, through to the styles of pop art which shaped the performances of Bryan Ferry and David Bowie in the early 1970s, the history of post-war British youth culture displayed an ongoing association between commerce and popular aesthetics. This combination was hardly antithetical to punk itself, particularly in its interpretation by entrepreneurs of the calibre of Malcolm McLaren and Vivienne Westwood. They operated at the interface of fashion and artistic avant-gardism. The emergence of the style press in the 1980s continued these alliances, albeit in a different form. And it was among a range of visual practitioners that market-based aesthetics were most clearly on display.

3 A Visual Philosopher: Neville Brody

Style was the common currency used by the diverse range of freelance journalists and aspiring critics who jostled for attention in the pages of *The Face*. But it was an agenda which was encoded in multiple languages, rather than in a single system of representation. Most significantly, the practice of style privileged a visual perspective on culture, quite as much as a written format. At a practical level, in their foregrounding of visual items the editorial team were merely

following established publishing policy. Fashion spreads, celebrity photographs, snapshots of urban living, as well as advertisements, were standard components for any prestige, consumer-led title. In that sense *The Face* simply aimed, in the words of its own tag-line, to be the world's 'best dressed magazine'.[59] Yet here again journalists sought to move beyond traditional wisdom. In the 1980s both *The Face*, and later *Arena*, carried a set of philosophies about the role played by visual systems within contemporary society – especially among the young. It was this emphasis which exerted a major impact on the influential images of masculinity which were circulated in these publications. It also opened the space for a range of visual experts to stake their claim to authority in the area of consumption. Paramount among such professionals was the graphic designer Neville Brody. The identity of both magazines was in large part the result of Brody's input. His design transformations, which were identifiable across a range of other titles at this time, enhanced and deepened the meaning of style. They also endowed these publications with enviable reputations.

Born in Scotland in 1957, Brody grew up in Southgate on the edge of north London. Recollections of his early years drew on the standard autobiographical trope of the fine artist, with art cast as the organising principle of his personality. Reviewing his career in 1988, Brody recounted that his sense of personal identity as a creative artist had been with him from childhood: 'Ever since I had any self-awareness, I've wanted to do art or painting. . . . I don't remember a time in my life when I was going to be doing something else.'[60] Missionary dedication of this sort seemed to suggest a conventional route into one of the branches of fine art. Yet, as he went on to recall, more pluralist influences, derived from contemporary mass culture, were also pivotal to his development. For Brody, as for others of his generation, it was these two competing agendas – of traditional aesthetics and commercial practice – which came into conflict during a foundation year spent at Hornsey College of Art in 1975. At the time, Hornsey had a reputation as a national centre for debate about art and design education, after the student sit-in of 1968. With its progessive pedagogy in graphics and other applied arts, dating back to the inter-war period, the college integrated a strong theoretical strand into the curriculum.[61] It was this attention to the conceptual underpinnings of art practice which distinguished Hornsey from other more celebrated centres of art training, such as the Royal College of Art. Yet Brody was unimpressed with the career trajectory offered to him during his foundation year. As he saw it, his growing awareness of the élitism inherent in the art world, together with a desire to engage critically with the communication industries, was forcing him to choose between a career in either fine or applied art:

I wanted to understand the everyday images that were around me at that

time, and the processes of manipulation particularly within commercial art. By understanding the mechanism at ground level, I hoped to produce the opposite effect by turning them on their head.

The big decision I took at this stage was whether to follow Fine Art or to pursue Graphics. I felt that the Fine Art world had become élitist and would appeal only to a specific gallery market; my time at Hornsey did nothing to dispel this feeling, so I thought Graphics would offer the better possibilities. I thought 'why can't you take a painterly approach within the printed medium?' I wanted to make people more aware rather than less aware, and with the designs that I had started to do, I was following the idea of design to reveal, not to conceal.[62]

The tension between pure and applied art has been a recurrent motif in British cultural debate since the emergence of the question of industrial design in the mid-nineteenth century. From at least the 1950s this cultural dualism was dramatised as a tension between the principles of avant-garde aesthetics and the more democratising influences of applied art.[63] Successive generations of both practising artists and cultural entrepreneurs worked across the divide. Brody's desire to expose the hierarchical nature of fine art practice, while at the same time preserving a painterly approach to the graphic medium – to mount a strong attack on the manipulative effects of commercial art, but to subvert and expose its character from within – placed him squarely within this hybrid tradition. His characteristic philosophy was to build bridgeheads between the artistic and commercial domains. But as a practising designer, the tensions inherent in these different models of cultural production confronted Brody in an acute form.

Brody's decision to train as a graphic designer, enrolling on a BA course at the London College of Printing in 1976, did little in the short term to resolve the contradictions he perceived between commercial and artistic practice. While his stated aim was to work with graphics as an accessible art form, Brody found the atmosphere at the London College to be 'repressive and stultifying'. His reactions were couched in the classic language of avant-garde rebellion. Condemned by his tutors as 'unconventional', he recalled that he was encouraged to stay with 'safe economic strategies', rather than to explore more experimental approaches to design theory and practice.[64] The cultural distinctions institutionalised in British art education, between fine art students, with their latter-day cult of romantic individualism, and graphic designers, produced as pedestrian and tied to commercial priorities, had negative effects on Brody's educational experience at this time. His solution was typical of many other disenchanted young designers of his generation. It was to turn to youth subculture – and especially the art-derived variants of punk – as a creative resource. In its version as an art school

experience, punk's attempts to keep in play both the avant-garde ideals of authenticity and the playful aesthetics of artifice generated by pop music produced a fertile creative mix for Brody. After leaving college he took jobs in record design in London, working first for the company Rocking Russian, and after 1979 for two small independent labels: Stiff Records and Fetish Records. In the period after the impact of punk music, record cover design was a growth industry. At all of these early placements, Brody encountered supportive personal networks, fostering his belief that 'the record shop was just as valid a showcase' for his work as the 'formal environment of art galleries'.[65] He later summed up these formative years in extremely positive terms: 'My designs went in for servicing and came out supercharged.'[66]

Alongside influences from contemporary culture, Brody's visual philosophy continued to be shaped by more formal artistic traditions. Here Dadaism and Russian Constructivism, as well as Pop Art, loomed large. By his own admission, it was these particular twentieth-century movements which foregrounded the creative problems which obsessed so many of his circle. At a theoretical level, Brody grasped such issues via one of the perennial questions of modernism: what artistic language to adopt in an era which had 'embraced the means of destruction of art' by the industries of mass culture?[67] In practical terms it was modern art which stimulated his unconventional interest in typography. As reviewers of his output were later to point out, Brody was among the first generation to have escaped initiation into the craft-based regime of metal typography, which dominated graphic design training until the late 1970s. Brody himself expressed contempt for what he saw as this rigid conventional apprenticeship. He remembered that even in the early 1980s he had hated type: 'I thought typography was a boring field to work in. . . . I had no respect for the traditions.'[68] This relative lack of formal skills generated its own sense of creative freedom, though in the eyes of his critics it also revealed a severe limitation. As reviewer Robin Kinross argued, in his assessment of Brody's exhibition work in 1988, the designer's output was not so much a style, rather a set of 'eccentric mannerisms'.[69] Attacks of this sort worked to crystallise Brody's own oppositional philosophy for visual design. Refusing a functionalist, problem-solving aesthetic, which heavily influenced commercial graphics in the 1970s and early 1980s, he underlined the need for an essentially visual – and with it an emotive – approach to design. Both Dadaism and Russian Constructivism appealed to Brody because of what he termed their traditions of 'emotional weight'. This commitment to the affective possibilities for graphics was also twinned with a broader humanistic ideal. His aim was to reintroduce what he termed 'human markings' into commercial art.[70] Brody set great store by moral commitment, rejecting the simple stance of a detached ironist. This affirmation of cultural value, in the face of what he

perceived to be its repeated denigration by the contemporary media, was a recurrent theme in his own practice, as it was in the journalism of many of the contributors to the style press.

Brody joined Logan and *The Face* team as its designer in 1981, eighteen months after the magazine's launch. He always worked freelance, even on long-term commissions, operating with his own studios from 1987. Editor and designer had first met in the late 1970s, when Logan was employed at *Smash Hits*. Brody had entered Logan's office with his portfolio, looking for work. But Logan had no immediate use for him. As Logan remembered: 'I thought [he] . . . was really good, but not for *Smash Hits*. I made a mental note however.'[71] When the two men met again the immediate situation was not auspicious. From Logan's point of view the design format of *The Face* was not working well. The original visuals and layout looked tired, while the editor's own attempts to redesign the title had not proved particularly successful. Brody, for his part, had never before remotely considered working in magazine publishing. His new brief posed a number of typographical challenges – about the choice of text settings as well as the overall formal coherence of the magazine – which he had rarely encountered in previous commissions. Nevertheless, it was Brody's work at *The Face* over the next five years, together with his impact on other publications, which not only established his own reputation, but also substantially changed the style of magazine publishing.

Logan awarded Brody an open brief to reshape the visual culture of *The Face*. The designer's task was made easier by the unusual professional routines which the editor instituted on his title, and which were later carried over to the running of *Arena*. Rather than imposing a corporate editorial policy, Logan gave the visual technicians, and especially the photographers, a free-hand. He believed that such a system of delegation was the best way to achieve innovative and adventurous publishing results.[72] Brody profited from this arrangement, which would never have been tolerated at any of the large publishing houses, where editorial control was paramount. He was able to polemicise for a strong visual input at every stage of the magazine's production. Material resources at *The Face* throughout the early 1980s were extremely tight. Brody admitted that in the first years he was turning out forty designed pages in as many hours. This feat was performed almost single-handed, because financial constraints ruled out the posssibility of employing a full design team.[73] Brody's colleague at the time, Jon Wozencroft, remembered the routine vividly. Their first studio was a small second-floor office on London's Tottenham Court Road, sandwiched between hi-fi stores, record shops and fast-food outlets. Work schedules were frenetic, Wozencroft recalled. It was a pace which was strangely mirrored by the activity outside. For this was the period when many of the retailers, banks and services which straddled nearby

Oxford Street were changing their logos and advertising strategies 'in a frantic effort to appear "youthful"'.[74]

The hectic character of the monthly production schedule encouraged a highly disciplined approach. As Brody saw it, *The Face* had two narratives: the written text and the visual organisation. The basic design issue was consequently to manoeuvre the eye together with the intellect. But the conventional publishing dictum, which insisted on the predominance of the printed word over the image, no longer entirely applied.[75] Brody asserted that the modern communications industries had created a culture in which visual spectacle now predominated over the written message. Ongoing since the 1950s, these cultural trends were heightened among 'today's younger generation', who had been acculturated by the media in ways which their parents had never experienced. Brody argued that if the concept of youth had any current coherence at all, it was now derived from the visual languages of the commercial media. In editorial terms, the implication was that visual imagery needed to carry far greater weight in magazine publishing directed towards younger consumers, because, as he put it, 'we're living in such a visual age'.[76]

Brody's conceptual thinking engaged with successive generations of critical media analysis. These ranged from Vance Packard and Marshall McLuhan's writing in the 1950s and 1960s on the growing corporate power of the commercial media, to emphases on the 'virtual' or 'hyper-reality' of contemporary systems of communication, such as those outlined by postmodern commentators Jean Baudrillard and Paul Virilio.[77] Unlike many other polemicists, Brody's theoretical reflections were pursued in relation to his own experience as a designer. At *The Face* the practical implication of this conceptual engagement was to centre the page layout around the photographic images, through a flexibly designed grid system. Brody's intention was to avoid a superficial reading of the magazine. His plan was to encourage readers 'to look twice at a page'.[78] Responding to criticisms that *The Face* was visually difficult, Brody insisted that his deliberate intention was to problematise the transparency of so much of the mainstream media. His notion of the importance of creating 'negative spaces' in the magazine's layout, in order to slow down the pace and allow readers to 'consider, feel and think', was part of the same strategy.[79] The initial choice of typefaces – the sober Swiss Helvetica for titles and captions, with its suggestions of 'elegant authority', and Garamond for the body text on account of its 'warmth' and simplicity – deliberately cut against the grain of contemporary design theory, though they were later copied extensively.[80] From 1984 Brody began creating his own graphics to fit specific moods. Working with *The Face*'s newly appointed art director, Phil Bicker, Brody totally redesigned the magazine for a second time. His aim was to produce a more journalistic feel, introducing the language of

corporate logos and informational signs into the title's layout.

Brody's career after leaving *The Face* in 1988 continued to straddle the worlds of fine art, style and more mainstream areas of commerce. Work for the sportswear company Nike, and for Swatch watches, was interspersed with commissions from fashion designer Katherine Hamnett, and for New York's Museum of Modern Art. With partner Stuart Jensen, Brody formed the agency FontWorks UK in 1990, to cater for the fast-growing demand for digital typefaces. He was by no means unique in his career trajectory, nor in his success. Other design contemporaries benefited from a similar combination of art school or polytechnic training, with its mixture of avant-garde emphases, commercial practices and influences drawn from contemporary youth culture. Such figures included Brody's 'pupil' Ian Swift, designer and art director at *Arena* from 1986 to 1988, Peter Saville, of Factory Communications, together with Terry Jones, the founder of *I-D*, from an earlier generation.[81] In most cases, a period of work at one or other of the style magazines consolidated the reputations of these graphic artists. The growing importance of independent magazine culture in providing a launchpad for a number of new talents was recognised by the judges of the W.H. Smith Illustration Awards in 1987. As the committee commented, it was magazine illustration which was now pointing the way forward for British design.[82]

4 A Gallery of Talented Individualists

Neville Brody's contribution to the style press was critical. Voted magazine of the year in the magazine publishing awards for 1983, *The Face* received many other accolades from the design and media industries. 'The barometer of pop style' was how *Campaign* introduced it to the advertising profession.[83] In 1985 the Photographer's Gallery in London organised a five-year retrospective for the title. Three years later Brody himself was the subject of a solo exhibition of his work at the Victoria and Albert Museum. But behind Brody lay a gallery of other talents who were instrumental in proclaiming the publication's intellectual agenda. Despite low pay and chronic job insecurity, there was no shortage of recruits to this world. Freelance journalists, designers and photographers were among the many hopefuls who aspired to sought-after accreditation in the list of the magazine's contributing editors. Many of them followed Logan loyally on to *Arena*. Who were the men and women who assembled this masquerade of style?

Is it possible to identify them as a group, with their own modes of social cohesion? Did they share a collective habitus and similar origins? Such questions are important, because they point to the professional cultures which sustained these networks of consumption. They also begin to highlight the gendered dynamics of the obsession with style and more especially with its project for masculinity.

In the autumn of 1986 *The Face* reported back to its readers on the 'party of the year' in its 'Trivia' column.[84] There was no doubt about the winner. A night of 'unrivalled midsummer madness' had been thrown by the magazine's staff to celebrate the opening of a new London nightclub, The Limelight, close to Leicester Square. Parodying the overblown rhetoric of current tabloid journalism, *The Face* announced that gossip columnists had filled their pages for days afterwards with reports of nothing else. Along with the 'really famous' (pop stars George Michael, Boy George and Patsy Kensit), the party's guest list had drawn together six hundred 'interesting people', which included, of course, every one of the title's contributors, past and present. Dick Hebdige has identified the people of *The Face* as a motley gang of bricoleurs and ironists, designers and publicists, pirates, dandies and *hommes et femmes fatales*.[85] These were certainly some of the favoured self-images. A metropolitan landscape was also characteristic. Parties, first nights, record launches and all of the other paraphernalia of the glitterati provided important venues for the fashionable and famous. They were the sites at which the style culture could be affirmed and reproduced, and where contacts (and contracts) could be cemented. As with more established professional groupings, such informal networks also acted cohesively, giving their participants a sense of cultural belonging. But members of the style community also carried a legacy from more prosaic social worlds with them to the urban scene. Here we can observe how public personas meshed with life histories structured by gender, generation and regional positioning – often in teeth-gritting harmony.

Logan himself was the quiet, but profoundly charismatic, leader of *The Face*'s circle. Not exactly a young man, he was 39 in 1986, and admitted to feeling out of place in many of the night-time venues covered by his magazine. Logan reflected with wry amusement that while his publications were 'faddish, colourful and frenetic', he was 'diffident, mortgaged, married and the father of three children'.[86] What he brought to style journalism was a deep-rooted knowledge of commercial publishing. Originating from Leyton, on the eastern side of London, he left school at 16 to work on his local paper, the *West Essex Gazette*, when he was still a mod in the early 1960s. It was this combination of publishing nous and an inherited vocabulary of style, which he developed first on the *New Musical Express* as its editor, and then after 1978 at *Smash Hits*. Logan created around him a circle of young aspirants who included Burchill, Elms and music journalist Tony Parsons. Elms later testified to Logan's capacity to inspire loyalty, with all the

affection of the pupil for the master. 'He's simply the best person at doing his job that I've ever met ... he's a complete gentleman and there's absolutely no meaness about him. . . . People remain loyal to him ... he's a joy to work for', Elms enthused.[87]

Logan's dedication to quality, together with his staunch refusal to compromise on matters of editorial principle, lay at the heart of his ability to command respect. In age and social position, as well as in his legendary dedication to taste, Logan had much in common with the successful Nottingham fashion designer, Paul Smith. Both men were committed to the notion of creative independence, which they believed gave them the freedom to pursue commercial ideas outside the stranglehold of large corporations. Logan's period working for the music press had been depressing and frustrating. Echoing the views of so many who are driven to create their own business, he glossed his career in 1988 in the following terms: 'The only reason I'm an entrepreneur, if I am, is because that's the only way you can have the freedom to follow your own instincts.'[88] Though eventually tempted to sell a major share of his company to the international publisher Condé Nast in 1988, for a long period in the 1980s Logan epitomised the virtues of the autonomous craftsman.

Many of the values espoused by the editor of *The Face* were also echoed by his apostles. Yet Logan was not a member of the generation who formed the core membership of the magazine's editorial team. The majority of this grouping were more than ten years younger than their mentor. They adhered to a different world-view, which was tied to a very particular understanding of their own personalities as a source of authority. The legacy of the artistic avant-garde was highly influential in providing a composite role-model for the leaders of style culture. Historians of the avant-garde have identified a classic profile which has been drawn on repeatedly by a wide variety of cultural dissidents since the mid-nineteenth century. This has been the figure of the marginal or the outsider. Renato Poggioli noted that strategies of 'exile', as well as of cunning, have been part of the self-imposed code of the avant-garde. The adoption of these liminal personas has contributed to what Rosalind Krauss demonstrated to be the persuasive myth of avant-garde originality.[89] Self-projections of this sort have taken various forms, involving both material and imaginary dramatisations of otherness. They have included the marginality produced by status or regional positioning, by the exclusions of gender, together with more individualised renderings, defined by pose and self-presentation. For many members of the style coterie such cultural codes were central to their public image. We can observe these strategies in operation in the personalities of two of the most significant members of the team at *The Face*: Julie Burchill and Robert Elms.

Burchill obsessively rehearsed fragments of her life story in almost every genre

of her creative output from the mid-1980s onwards. A deliberate and often ironic use of the autobiographical mode encouraged philosopher Roger Scruton to celebrate her as a postmodern individual who rejected the conventional markers of character and identity.[90] Yet the coherence with which she told her story (to the extent of relating almost every social event to her own life history) suggested that her act of personal testimony worked to consolidate her subjectivity, rather than producing it as split and fragmented. As she expressed it in an interview for *The Sunday Times* in 1993: 'I was taught at an early age that what we believe is us. If we're wrong, then everything in the world is wrong.'[91] The basic tropes of her account were generic. Born in 1960, childhood and adolescence were spent in a working-class family in a Bristol suburb. It was this restricted milieu which drove Burchill to escape into the metropolitan world of ambition and fame. Fleeing to London at the age of 16, and landing a journalist's job at the *New Musical Express*, her earliest writing registered the cultural impact of punk, which she later described as a 'marvellous career opportunity'.[92] Her first book, published in 1978, was *'The Boy Looked at Johnny'*, co-authored with her then husband, Parsons. It took the form of a venomous obituary for rock and roll, which she damned as a cultural swindle foisted on the young since the 1960s. From there a series of astute career moves took Burchill from *The Face* in 1980, to *The Sunday Times* in 1983, and finally to tabloid journalism, as female columnist for *The Mail on Sunday* in 1986, consolidating her reputation as a 'professional controversialist'. Later projects included screenplay scripts and plays, together with two blockbuster novels. But as important as the detail was the language Burchill used to tell her story. Her narrative provided one paradigmatic account of style culture. She recounted a version of it as the essay 'Excerpts from the Julie Burchill Story' in 1992:

> All I ever wanted from life was love and money, and from a very early age ... I realized that fame (even of the mildest type) would prove the most pleasurable and profitable shortcut to both.
>
> I think of my youth ... as a long series of waiting rooms, one opening into the other.... I waited in my room, waited to be Somebody; then and only then would I be Myself. *That*, I think, is the modern experience – that you don't really exist until you see your name in print. That you are simply *not yourself* till you are famous. That, then, was my youth ... the house in a Bristol suburb where I ... [lived] with my parents and the dog.... The dog whimpers in its sleep; it's having a bad dream. So am I. It's called LIVING IN FUCKING BRISTOL.
>
> 1976, so far, is a terrible year for pop music.... A few things lighten my darkness. One is the thought of suicide.... The second is the One Good

Teacher that every Bad Teen has, Mr S, who is dedicated to making me see how special I am.... The third is my *NME* [*New Musical Express*]; a miracle which drops through the letterbox once a week.... I have a typewriter – after Mr S's encouragement, some vague idea of being a writer has mesmerized me, so I get my parents to buy it for me by pretending I'm planning to be a secretary; a *nice* job.... When I heard I'd got the job, a couple of months later – I believe there were some 15,000 applicants – I felt, for the first time in my sentient life, *relaxed*. At last I could be myself, because now Myself would be Somebody.... It was bliss to be young in the second half of 1976, but to be young and working at the *NME* was like dying and going to heaven.[93]

And as her tale continued into the 1980s:

I was twenty-four in the summer of 1984, back in London after being married alive for five years in the home sweet home counties ... it was everything a great city should be: short-tempered, nasty and British, with careers starting to loom over the skyline like King Kong ravishing Manhattan. Medialand and West Wonderland were being written up in the glossies and the Sundays.... In those years, projects, plans, CVs and calling cards filled the ... sky like tickertape.... London had more egomaniacs, monomaniacs, nyphomaniacs, dipsomaniacs, dreamers and deranged than any city in the world, including New York.... We were in a *freefall* – a few truly modern souls, such as myself, revelled in the chance to live life at this most gorgeously chaotic of new frontiers.... But this attitude takes a strong stomach and a stiff upper lip.... There was a gradual realization that cultural freefall would have losers as well as winners; and for the first time, the losers looked highly likely to be white and male, for a change.[94]

Burchill's personal testimony worked with a number of recurrent motifs. Paramount among them was the self-proclaimed commitment to professional and commercial success. The quest for fame, and its twin drive, ambition, lay at the heart of her universe. Childhood and adolescence spent in Bristol were not only provincial in a material sense, they were living arrangements which were peripheral to the imagined projection of herself as a metropolitan *auteur*. It was only by journeying to the centre – by arriving in London – that she was able to affirm her individuality. Burchill repeatedly celebrated the incoherence of contemporary culture which had produced her as a star. In picturing the world of 'medialand', she evoked less a postmodern landscape than the earlier modernist panorama of Scott Fitzgerald's portrait of 1920s Manhattan in *The Great Gatsby*. For Burchill, existence revolved around fortune's wheel; only this time, as a

provincial working-class girl, she was determined to remain at the top, at the expense of more established game players. In the scramble for success, it was precisely the understanding of herself as being on the outside which gave her an edge over the competition. These credentials provided her with a major reserve of cultural capital. Throughout the 1980s Burchill spoke in a variety of tongues, which drew heavily on the the language of popular culture. Informing much of her early journalism was the self-image of a jumped-up 'shopgirl', the 'daughter of two factory hands who had given up school as a bad job at fifteen and flounced off to sell scent in swinging London'.[95] Burchill always claimed it was her low origins which gave her writing its cutting edge.

Such motifs of ambition were hardly original, they had figured repeatedly in the narratives of working-class heroes since the literary phenomenon of the 'angry young man' in the 1950s. However, Burchill's sense of exclusion was double-edged. It was her experience of femininity – in addition to her knowledge of provincial underprivilege – which increased her appetite for success. In this sense her masquerade was more complex than that of many of her male counterparts. A pivotal part of Burchill's feminine persona was her image as a latter-day 'bitch'. When Jean Rook, the women's columnist for the *Daily Mail*, died in 1991, journalist Kate Saunders assessed the contenders for Rook's crown as 'the first lady of Fleet Street'. Prominent on her list was Burchill. The qualities needed to be a first-class 'lady columnist', Saunders insisted, were legion. But above all else she had to speak as the 'commonsense voice from the other side of the garden fence, who elevated gossip and bitching into an art form'.[96] Ideally, Saunders went on to explain, women journalists working in this genre needed to be of humble origins, celebrating a world-view in which, ultimately, the heart always ruled over the head. In addition to her cynical pose and her reputation for vitriolic copy, Burchill also drew on this more traditional image of the assertive woman journalist. Rook provided one exemplary prototype; the inter-war New York writer and specialist of the wisecrack, Dorothy Parker, was another. At the level of social beliefs, Burchill's much proclaimed views on morality drew their strength from a store of feminine wisdom. As she summed up in a chat to *The Times* in 1991: 'My own politics are basically populist ... with the same mixture of views as most people in this country.'[97] Defining her agenda involved ritualistic attacks on both male homosexuals and the sexual revolution of the 1960s. She depicted the former as a contemporary manifestation of Sodom, the latter she believed was the root-cause of much of Britain's cultural malfunctioning. The positive side of this critique was a celebration of the power of heterosexual sex and love.

The corollary to Burchill's populism was her awkward relationship to contemporary feminism. In the manifest content of her journalism Burchill denounced feminism in the strongest terms. 'Feminists' were her particular pet hate. As she

made plain in the essay 'Born Again Cows', which first appeared in *The Sunday Times* in 1984, these women were simply the debris washed up from the 1960s and 1970s – wreckage which was continually blocking the channels of truly creative culture.[98] Burchill's distance from feminism was partly generational. It was driven by her need to carve out an identifiable market-niche; to differentiate herself from an older group of women journalists, such as Jill Tweedie and Toynbee, who had established feminism in the quality press in the 1970s. But her stance was also shaped by a class critique. Burchill collapsed feminism into liberalism, thereby portraying the women's movement as driven only by moral righteousness and self-interest, which she caricatured as hallmarks of the progressive middle class.

Yet there was a countervailing subtext to Burchill's anti-feminist stance. In both her language and her social analysis she drew heavily on the insights made possible by the theory and politics of the women's movement. As a writer she was acutely aware of the networks of gendered power which criss-crossed her own fields of activity – in journalism and the music business, as well as within the supposedly advanced sphere of style. Much of her writing in the 1980s revolved around a double set of themes: the marginalisation of women from the dominant structures of cultural power and a shrewd assessment of the strategies available to redress this inequality. She concluded her attack on feminism in 'Born Again Cows' with an important qualification. As she asserted: 'real active, practical organized feminism is still NEEDED; the world is far from post-feminist.'[99] Burchill's elaborate manoeuvrings around the issue of gender politics closely resembled the tactics of another intellectual populist, the American art critic, Camille Paglia, Professor of Humanities at the University of Arts in Philadelphia. The two women were locked in an intellectual feud in the early 1990s, yet despite their personal rivalry, they shared a common agenda. Neither woman was in any real sense conservative, but both were lionised by the intellectual right for their attacks on liberals and sexual progressives. Burchill and Paglia were the beneficiaries of feminism, yet each of them postured as anti-feminist.[100]

Burchill was awarded a privileged place in the pages of *The Face*, as she was later in *Arena*. She was a contributing editor to both magazines, writing regular features which set the agenda for many of the debates foregrounded by the style press. Yet in one sense hers was an uncharacteristic voice. She was by no means the only woman attached to these publications; others included the music critic Sheryl Garratt and photographer Cindy Palmano. But the space allotted to Burchill was unusual. Her stance on contemporary culture was disruptive in a double sense. Not only did she cast the usual ironic gaze on the urban scene, but she also gestured towards the gendered forms of self and identity which underpinned the poses of the style élite. In a telling piece published in *The Face* in 1986, Burchill

drew critical attention to the various forms of masculinity which had been thrown up by the changes in popular culture since the 1970s. Prominent among these was 'the lad', the archetypal product of democracy and affluence, who was 'on the make' in both a social and a sexual sense.[101] Though Burchill did not point the finger directly, her portrayal might have been used to identify one of the dominant scripts adopted by the men who joined *The Face*'s circle. We can observe this type of character in action in the persona of Robert Elms.

Elms acted out a more familar version of the outsider, which was also shaped by the interaction of class and gender. His journalistic voice was informed by two separate genres of writing. Elms was obsessed with classic post-war narratives of British bohemia; notably by the work of the fictional documentor of early youth culture, Colin MacInnes, whose style and subject matter he used repeatedly. At the same time he was drawn to the icon of the proletarian hero, made visible in literature and sociology, as well as popular culture, since 1945. Born in north London in 1959, Elms came from a working-class background, which he described as the world of 'council estates and football stadiums'.[102] A meritocratic education at the London School of Economics was followed by work at *The Face* and *Arena*. Throughout the 1980s Elms combined journalism with travel and novel writing. He also worked as a freelance television and radio presenter and on various aspects of advertising analysis concerned with youth. His novel, *In Search of the Crack*, 1988, was a thinly veiled piece of autobiography. The book's hero was Tony Ross, a lad with decent O and A levels, living in a north London suburb, who cast himself as a latter-day Dick Whittington: 'London Town'll be my fame and fortune, and it's only ever been a tube ride away.'[103] Like Elms, the novel's main character strove to take the city by storm, from his vanguardist outpost of suburban style. He was accompanied by 'numerous occasional wastrels' and 'ne'er-do-wells'. Between them they sought to 'exploit the night' and make 'the city rock'.[104]

Elms shared with Burchill a strong sense of cultural mission, which was dramatised in individualist terms as personal ambition. He, too, understood that style was a valuable asset in forcing an entry into a variety of milieus, thereby challenging established intellectual positions. If Burchill's *bêtes noires* were feminists and progressives, Elms' target was the traditional British left, in both the Labour Party and the trades unions. He deployed the style agenda to launch an assault on the forms of middle-class puritanism which, he claimed, had dominated socialist politics since the 1960s, with disastrous results. Writing in 1986 in Brody's redesigned version of *New Socialist* magazine (which in this period briefly became a forum for debate on the cultural future of the left), Elms championed the desires of 'ordinary people'. He concluded that the post-'68 generation basically despised the material aspirations of the working class. As a

consequence they were now roundly despised themselves.[105] Drawing on his experience at *The Face*, he insisted that there could be no division beween the form and the content of politics; good things looked good. Popular conservatism had always grasped this critical point, Elms argued, and the socialist tradition needed to be infused with style once again. Elms was not of course the only voice polemicising for a reformulated version of socialist culture at the time. The preoccupations of journalists on *The Face* intersected with broader municipal and intellectual projects. These included the experiments in popular politics spear-headed by the metropolitan authorities, such as the Greater London Council, in addition to the expanding analysis of culture foregrounded in *Marxism Today*. In these other arenas the commentaries were more overtly political or academic.[106] But what was distinctive about Elms' position was that his polemic was carried by his own public image.

It was in their carefully cultivated public profiles that Elms and Burchill revealed personalities which were sharply differentiated by gender. While Burchill's stance was invariably cool and detached, Elms' outlook was more sentimental. He heroised various wild men of the city, celebrating their hedonistic pleasures in the language of latter-day romantic revolt. Football hooligans on the terraces of north London, black gangsters and petty criminals in Brixton, these were among Elms' favourite personalities. As one reviewer of his novel was quick to point out, empathy of this sort quickly degenerated into an unselfconscious celebration of male pursuits; a form of dandyism, without the irony of the dandy.[107] Elms' writing style for these portrayals drew on a journalistic variant of the sociological techniques of participant observation. It was his belief that his own working-class origins gave him a privileged point of identification with men from other subaltern and marginal groups. A particular favourite with Elms in the mid-1980s was the Irish band, The Pogues. With a Gaelic name which translated as 'kiss my arse', these 'boys', and especially their vocalist, Shane MacGowan, were notorious for their drunkenness and brawling, as well for a particular rendering of Irish dance music. Profiling the band in *The Face* in 1985, Elms quoted approvingly from their song 'Transmetropolitan'. The tune was executed in a fast waltz, slow jive time, with lyrics which ran:

> From Brixton's lovely boulevards to Hammersmith's sightly shores
> We'll scare the Camden Palace poufs and worry all the whores
> We'll go where spirits take us, to Heaven or to Hell
> And we'll kick up bloody murder in this town we love so well.
> Going transmetropolitan yip ey ay![108]

The Pogues' song was not of course naive, it was a clever parody of more than a century of English racism about drunken 'micks' and wild Irish 'paddys'. Yet what

the band also deliberately played up, and what gained Elms' approval, was a particular dynamic of collective masculinity, driven by alcohol, violence and sexual threat.

The bitch and the cockney loudmouth, both of these crafted personalities loomed large in the journalism of the 1980s. Their significance extended beyond the reputations of a number of prominent individuals. In different forms, figures such as Burchill and Elms pointed to the ways in which gender informed the comings and goings of the taste élite. It is this issue which lies at the heart of our argument about style, and its contribution to the debate surrounding masculinity and consumer culture during the period. It takes us to a very particular reading of sexual politics.

5 The Sexual Politics of Style

At the moment when the arguments over men's magazines were breaking in the British media, journalist Rosemary Bailey drew publishers' attention to sharp differences between the situation in the USA and in Britain. Writing in *Media Week* in 1986, she noted that the editors of American men's magazines, such as *GQ* (*Gentlemen's Quarterly*) and *Esquire*, always referenced feminism as a major factor in the growth of a new genre of journalism for men.[109] As Lee Eisenberg, editor of the American magazine *Esquire* put it, in the wake of the contemporary women's movement 'a different type of male came about', who was both more mature and reflective. Art Cooper, editor-in-chief at *GQ*, saw the issue even more forcefully. Feminism had effected a major social transformation, which was reflected in the changing taste patterns of the American publishing market, and increasingly in the consumer choices made by many men.[110] Both editors were agreed that rising sales of their magazines since the late 1970s were attributable to the emergence of a new personality, who was responsive to feminist demands.

In Britain, however, the situation was altogether different. British journalists, working to develop a general-interest title for men, were much more reticent about acknowledging any debt to the women's movement. Such references were either made obliquely, or more typically publishers and editors carefully distanced their projects from feminism altogether. These national contrasts related to the differing stance taken by feminism towards business and commerce on either side of the Atlantic. Since the early 1970s the American women's movement had flexed its muscles in large part through an engagement with consumer culture. British feminism for the most part refused this type of encounter. Powerful

critiques of commercial society, especially from socialist and radical feminist tendencies, meant that any more positive acknowledgement of consumption was for the most part defined as beyond the boundaries of sexual politics in Britain. This situation began to change in the mid-1980s, as a number of feminist writers, such as Rosalind Coward and Williamson, began to elaborate a more complex analysis of women's participation in commodity culture.[111] But the refusal of British publishers of the new men's journalism to acknowledge feminism had much to do with their perception that the women's movement continued to be uninterested in the workings of of the marketplace. In contrast, the project for masculinity championed in the magazine press was overwhelmingly commercial.

What were the contours of this consumption-led discourse, and how did the new form of magazine publishing hope to intervene in men's lives? Publishers and journalists confronted these matters not as ethical or political dilemmas, but as business questions demanding practical solutions. Shifting the boundaries of masculinity, defining new identities and styles of life were intimately bound up with the search for markets, as well as being linked to a wider sense of social mission. We can observe these strategies at work in the style press. In purely quantitative terms style culture was highly gender-specific. Evidence drawn from contemporary market research surveys registered over 60 per cent male readership for The Face in 1987, though the gender breakdown was spread more evenly on rival titles such as Blitz.[112] Production context also displayed a heavy male bias. On Arena and The Face men held the principal positions of publisher/editor, assistant editor, art director and advertising manager, while in 1986 well over 70 per cent of contributing journalists were male. Moreover, with the exception of Burchill, most of 'the boys' had higher public profiles than the women. Of the men themselves, a number were relatively 'out' homosexuals, including music critics Chris Kirk and Jon Savage, as well as the stylist, Ray Petri. This overall combination of professional forces did not simply produce a culture in which men dominated; it tended to confirm the fact that the object of journalistic interest would primarily be men.

Yet it was not only in the social relations of the editorial teams at The Face and Arena that men exerted the major influence. A masculine vision of the world was also massively present in the textual organisation of these magazines. In line with the philosophy of style championed by both Brody and Logan, this was simultaneously a visual and a written repertoire. Furthermore, though such meanings were in a literal sense textual (encoded in fashion plates and interviews, consumer journalism and film reviews), their frame of reference was usually inter-discursive. The iconography of style cast its net wider than the printed page of the magazine. It gestured outwards, to the way in which men's identities were dramatised within broader networks of social life. In that sense the concern with

men amounted to more than a narrow media interest; it claimed an expanded cultural significance.

The single most important point about the representations of masculinity presented by the style press was that they were plural and diverse, rather than unified and monolithic. Sean Nixon has demonstrated how the fashion plates appearing in these publications during the late 1980s encoded numerous looks or poses. Edwardian fops, carrying nostalgic connotations of Englishness, rubbed shoulders with Italianate or 'Latin' classics, contemporary versions of the English city gent appeared alongside a plethora of street styles, and so on.[113] During this experimental period diversity was the keynote. No one look was endowed with special significance as the bearer of symbolic authority. Logan himself identified 'irony' as the key to success in the British men's market, thus avoiding what he saw as the 'po-faced', static images which were the hallmark of the American fashion magazines.[114] Representational closure was avoided on both commercial and aesthetic grounds. In this fledgling market for men's commodities the emphasis was on keeping options open, until such time as a successful consumer prototype could be discovered. For the editorial team at *The Face* pluralism was also part of their overall understanding of contemporary sensibility. This combination of factors worked to produce *The Face* and *Arena* as polysemic texts about masculinity. Taken together, the two magazines suggested a flurry of discourse around the subjectivity of younger men, with little movement towards stabilisation. Successive generations of post-war boys' comics, together with the teenage music papers and the hobby press, had usually worked to anchor men's identities around a set of stable icons, such as the sporting hero, or the collector. In contrast, what the style magazines appeared to offer was a seemingly endless variety of choices. We can begin by examining one highly influential strand of this iconography.

6 A Homosocial Gaze: Ray Petri

The cover story for *The Face* in March 1985 was 'Hard' (plate 1).[115] Shot in sepia half-tones, and bearing all the hallmarks of Brody's design format, it profiled 'Felix', a young tough who glared straight to camera. Sporting a trilby hat, replete with exotic accessories of 'killer' label and feather, white polo-neck sweater and herringbone tweed jacket, this model's brilliantly lit face stared out to challenge readers' attention. Felix and his audience exchanged a look of recognition via direct eye contact. The look was both innocent and knowing. His smooth-skinned

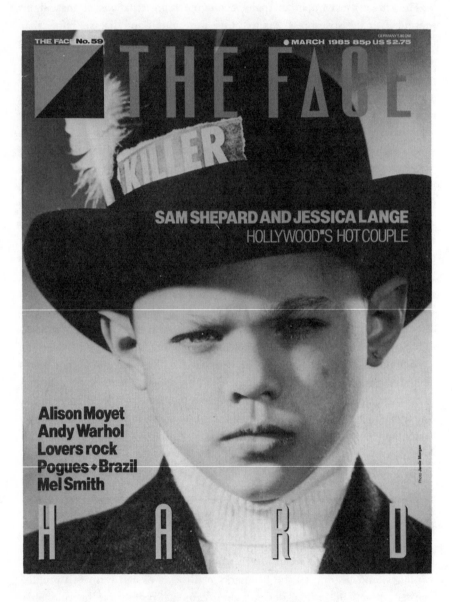

Plate 1 Front cover of *The Face* magazine, March 1985

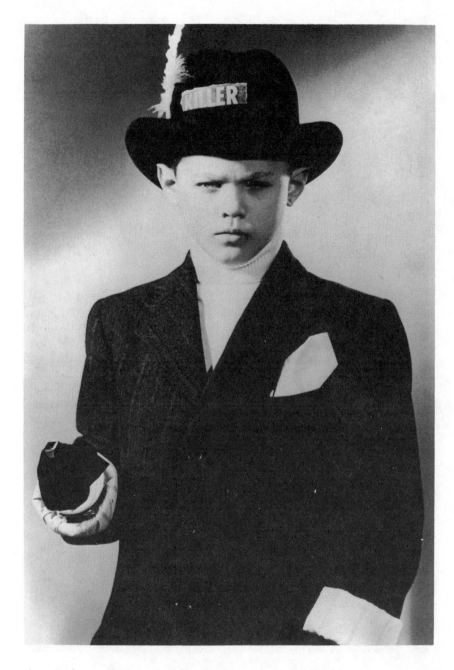

Plates 2–8 'The Harder They Come', fashion sequence, styling Ray Petri, photography Jamie Morgan, *The Face*, March 1985

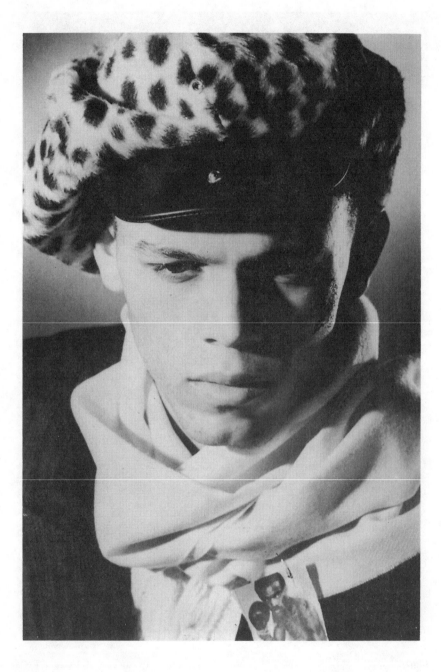

Plate 3

Plate 4

Plate 5

Plate 6

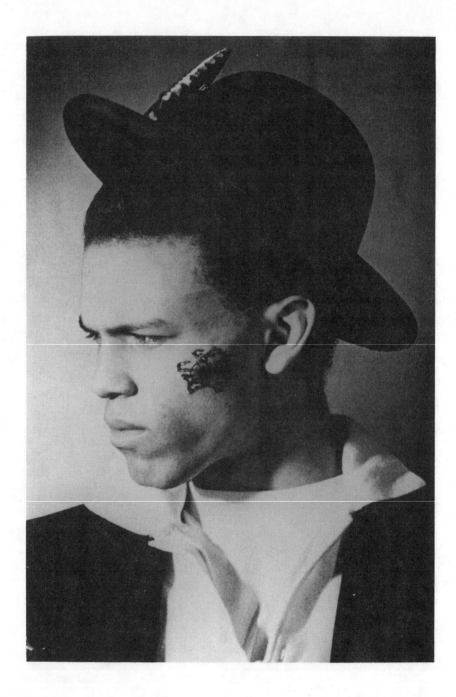

Plate 7

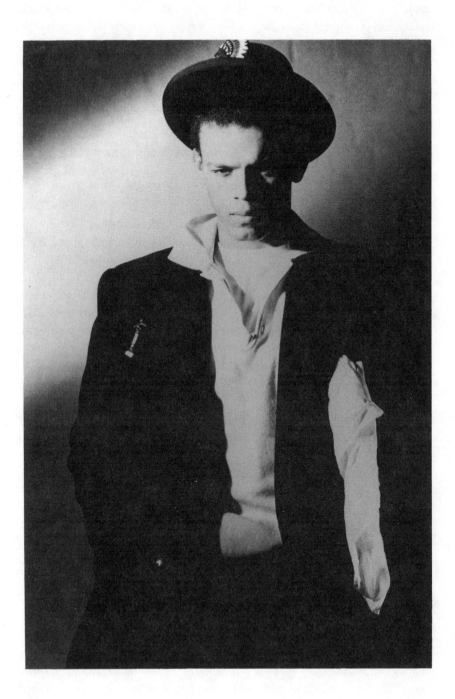

Plate 8

baby face seemed to exude a knowledge of the world, while his costume gestured to the forms of contemporary life which were rehearsed inside the magazine. Yet any empathetic dialogue between cover-boy and audience was substantially curtailed by his bizarre aggression, dramatised in the hardness of his posture and the stiff, brightly lit fabrics – to say nothing of his pursed lips and the 'killer' stare.

This theatrical image was the entrée to a loosely constructed narrative which ran inside the magazine as the main fashion sequence that month. Entitled 'The Harder They Come', it featured five images of solo male models and two of androgynous women (plates 2–8).[116] The note of eccentricity announced by the cover story was reinforced and extended on these inside spreads. Felix featured again (plate 2), this time masquerading as the gentleman – caught in a three-quarter pose, with gloves, fob-handkerchief and trilby hat. But these signifiers of traditional masculinity were massively undercut by the disruptive line of the jacket (with cuffs overturned to display the silk lining), the repeated 'killer' hat label and Felix's gaze. From Felix the fashion sequence moved to the other models whose presentations intensified a sense of confusion. Three of the plates featured 'Simon' (plates 3, 7 and 8). In one shot he appeared as a young tough, whose chiselled, ethnic looks were caught in semi-profile, drawing attention to his taut muscular physiognomy. In the other photographs the meanings were softer. Full, sensuous lips and liquid eyes (both enhanced by lighting and the subtle use of make-up), together with the model's slightly bowed head, suggested a more sensitive character. Soft and exotic fabrics, such as a fur cap and silk scarf, reinforced the sense of masculine ambiguity. Most significant of all was Simon's gaze. Neither challenging nor confrontational, it invited readers to explore his body and his person, to recognise an unstated knowledge which both he and his viewers appeared to share.

'Lynsey' and 'Pim' (plates 5 and 6) bent gender from the other side. Heavily tailored jackets and bowler hats suggested latter-day versions of early twentieth-century music hall role reversals, such as Vesta Tilley's female counterfeit of the 'gent' or 'swell'. But these were not conventional drag acts; there was no attempt to impersonate the other sex. Both models retained their femininity; lips and eyes were vulnerable, the skin was perfect. The effect was again to scramble a range of gender signifiers together in the same frame. The whole of this photo-spread was anchored by some exotic personal accessories. Spider facial tattoos and paper emblems of muscle-men and boxers completed the ensemble. Prefacing the sequence was a paragraph of disinformation from the pen of 'Buffalo Bill': 'Hard is the graft when money is scarce. Hard are the looks from every corner. Hard is what you will turn out to be. Look out, here comes a buffalo! "The harder they come, the better" (Buffalo Bill)'.[117] The buffalo pose played up exaggerated toughness as the prerequisite for contemporary survival. In a world of scarce

resources, superiority was to be gained by a sharp, confrontational stance.

These photographs were the opening salvo in a long series of fashion images which ran on the 'buffalo' theme in *The Face* and *Arena* throughout the mid-1980s. They were not fashion plates in any conventional sense. Earlier in the decade *The Face*'s editorial team had taken a decision not to replicate the standard fashion format which was the hallmark of the de-luxe consumer magazines. In established titles such as *Vogue*, fashion imagery had become a seamless advertisement for the collections of famous designers, for the looks of particular super-models, or a showcase for celebrity photographers. In contrast, *The Face* and the early editions of *Arena* sought a more experimental fashion genre. As Wozencroft saw it, 'style' replaced the word 'fashion' in these publications.[118] Such a rethink became part of a broader radical impetus which characterised the British fashion renaissance of the 1980s. Many of the new wave of designers, such as John Galliano and Wendy Dagworthy, had their first public showings in the pages of the style press. The majority of the fashion sequences which appeared in the magazines were hardly clothes' advertisements at all. They functioned as narratives to be 'cruised', alongside all of the other expressions of style culture.[119] This reading of fashion called for a particular type of expertise. In addition to the photographer, it privileged the role of the creative fashion stylist, who could imaginatively co-ordinate a specific look or image for the camera.

Models as well as journalists have drawn attention to the complex range of skills which feed into contemporary fashion photography. A battery of editors and art directors, hairdressers, make-up artists and technicians have testified to the way in which the final image is always the product of collective endeavour. The language of the fashion plate – what Roland Barthes termed the 'fashion system' – is underpinned by an elaborate commercial infrastructure.[120] In the 1980s the rise to prominence of the stylist signalled the influence of a particular aesthetic on the production of the fashion image. What was prioritised was a notion of artistic talent. This was understood to include the co-ordination of a variety of technical skills in order to enhance the total creative effect.

Styling has conventionally been associated with product design, involving the application of surface details to augment the relationship between a commodity's form and function. But within the fashion industry the term carried different connotations. The stylist acted as the agent and the director of the photographic shoot. The *Careers in Fashion* guide, 1994, in its advice to students, acknowledged that the stylist's world was glamorous. However, the manual also sounded a word of warning, pointing out that scarce job opportunities had resulted in a fiercely competitive market. Above all else the stylist needed to possess 'flair', matched by a thoroughgoing professionalism and a sound knowledge of the industry. As the guide pointed out, such individuals needed to be 'in with the crowd, absolutely up

to the minute and beyond'. In short, they needed to know 'everything and everyone'.[121] At a more prosaic level the stylist shouldered a whole series of specific responsibilities: booking both the models and the photographer, viewing collections, locating hair and make-up artists, as well as organising these elements prior to the shoot. Increasingly in the 1980s it was stressed that the stylist, quite as much as the photographer, needed to exercise an imaginative input, involving the projection of mood and atmosphere.

Logan, writing together with *Arena*'s assistant editor, Dylan Jones, in *The Face* in 1989, argued that creative styling was now beginning to take its rightful place alongside fashion photography as a valid art form in its own right.[122] A number of the prominent names in styling, such as Judy Blame and Mitzi Lorenz, began their careers working at *The Face*. Pre-eminent among these talents was Ray Petri (1948–89). As a stylist it was Petri who was responsible for formulating the hard but disruptive images which appeared in *The Face*'s 'buffalo' shoots. Working with his main photographic partner, Jamie Morgan, but also with Martin Brading, Marc Lebon and Cameron McVey, Petri assembled the most experimental visual repertoire around masculinity which featured in the style press.

Ray Petri marketed himself as an eccentric. The original 'buffalo boy', his preferred pose was yet again that of the marginal or the outsider. The persona bore some relation to the realities of his own life. Like so many members of this journalistic community, he was a migrant to the metropolis. Born in Dundee, he emigrated with his family to Australia in 1963, where he formed and sang in a rhythm and blues band.[123] Returning to London in 1968, he drifted through a variety of jobs in the clothing trade and the antiques business, with a spell at Christie's auction house. Attracted to photography, he began working as a photographer's assistant and subsequently as an agent. His friend Morgan introduced Petri to *The Face* in the summer of 1983. Their first fashion assignment for the magazine included a number of characteristically idiosyncratic touches to the photography, such as stylised postures and the disruptive use of jewellery and other insignia.[124] In the six years before his death, Petri worked across the range of the style press, taking up commissions for *I-D* as well as for Logan's publications. His images exerted a major influence on fashion's avant-garde, as well as speaking indirectly to a much broader audience. Despite widespread acclaim, Petri maintained his outsider stance throughout. Always working as a freelancer, he was never tempted onto the commercial fashion circuit. Buffalo not only functioned as the Petri trademark, but it also became the name of a loose business venture of independent stylists, performers and designers. This informal network, which included the singer Neneh Cherry, the models Nick and Barry Kamen and fellow stylist Blame, was cemented by the bonds of friendship and a shared nonconformist outlook. As Blame put it in

retrospect: 'Buffalo was ... like a sound system.... Everything was flexible, everyone could put in ideas.'[125]

Petri's buffalo signature became celebrated for its creation of mood or attitude. Such atmospherics were inextricably bound up with the handling of masculinity. Logan described Petri's skills in modernist terms, as involving a 'streamlined classicism, tough-edged and Brandoesque'.[126] Jamie Morgan was more specific. For him, Petri's images: 'were strong and sensitive – they showed you didn't have to drink beer and beat people up to be tough. He gave men a sense of pride in the way they dress which has been hugely influential.'[127] It was in the space opened up by these codes of toughness and sensitivity that Petri was at his most authoritative.

Let us analyse Petri's visual agenda in one of his later fashion sequences, which appeared in the spring issue of *Arena* for 1987, this time with photography from Martin Brading. The photographs were prefaced with the elliptical caption: 'ragamuffin hand me down my walking cane' (plates 9–13).[128] The focus was again on young men, shot against a variety of grainy urban backdrops and blurred naturescapes. Petri's choice of models for his first appearance in *Arena* was for boys he had used before in earlier commissions. He placed strong emphasis on correct casting as the key to artistic success. As he insisted: 'The important thing in good styling is casting ... once you have the right face, it all falls into place.' Nick Kamen, one of the models so often featured in these sequences, testified to the way in which Petri invariably created a 'personal chemistry' between himself and his models which was both productive and pleasurable. Reminiscing about their collective work in 1989, Kamen recalled: 'We used to have a ball, and so we got a feeling across that no-one else could; a chemistry that you can feel looking at the pictures. Ray brought out the best in everybody.'[129] Petri's preferences, which he displayed in the ragamuffin photographs, were typical. His usual choice was for young men whose physiognomies suggested a hard visual presentation. In the double-page spread captioned 'The Herbsman' (plates 10–11), the models' faces were strongly lit, characteristically accentuating jawline and cheekbones, as well as beard stubble. Their bodies were held taut and expectant. Connotations of physical manliness also informed the choice of many of the props and the general setting. There were the rigid, steel toe-capped work boots of one of the men, and the half-smoked cheroot, hanging from the mouth of the other. The former, complete with a gold-topped walking cane, rested warily against a pile of wooden sleepers in a derelict urban scene.

The 'ragamuffin' project combined these images of strength and virility with more unstable meanings. Ambiguity was caught linguistically by the anchoring title of the sequence 'ragamuffin', with its historical connotations of half-formed and uncouth masculinity. A 'Ragamoffyn' featured as a demon in William Langland's Middle English poem, *Piers Plowman*, of 1393. The term later acquired

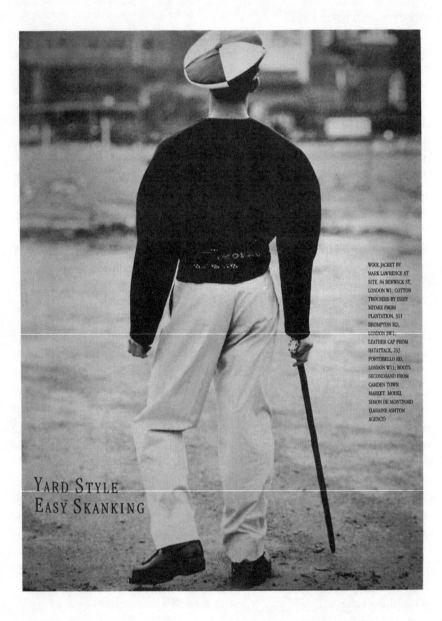

WOOL JACKET BY
MARK LAWRENCE AT
SITE, 84 BERWICK ST,
LONDON W1; COTTON
TROUSERS BY ISSEY
MIYAKE FROM
PLANTATION, 311
BROMPTON RD,
LONDON SW1;
LEATHER CAP FROM
HATATTACK, 253
PORTOBELLO RD,
LONDON W11; BOOTS
SECONDHAND FROM
CAMDEN TOWN
MARKET. MODEL
SIMON DE MONTFORD
(LARAINE ASHTON
AGENCY)

YARD STYLE
EASY SKANKING

Plates 9–13 'ragamuffin hand me down my walking cane', fashion sequence, styling Ray Petri, photography Martin Brading, *Arena*, March–April 1987

broad suggestions of marginality and disreputableness: a ragged or dirty man or boy who was associated with the street, or with a roving band of urchins and vagabonds.[130] Yet the ragamuffin could also be endearing, friendly and full of boyish energy. A further definition suggested the concealment of true identity, especially that of a child in masquerade costume. Suggestions of visual and linguistic·disguise ran throughout Petri's account. In the first image, 'Yard Style Easy Skanking' (plate 9), identity was refused, for the model was shot from behind. He was surprised, in motion, promenading on a gritty square in exaggerated walking costume. Faintly striped, cotton trousers and a tightly fitted wool bolero jacket, set off with an embroidered cummerbund, drew attention to the model's waist and bum. A two-tone, squared leather cap and silver-topped cane completed this unknown dandy's costume. As always, the ragamuffin was portrayed solo, in the company neither of women nor of other men. Yet these icons were not untouchable. Taken as a whole, the sequence did ultimately work to establish contact between the model and his viewers.

In Petri's photographs the dialogue between men characteristically centred on the reciprocity of their gaze. They worked with a visual narrative which moved from an initial deflection and evasion of reader contact to its full consummation. Simon and Marco, the models in 'The Herbsman', averted their eyes, deliberately avoiding any exchange with the audience. The first image in the sequence which followed, 'Tough Me Tough' (plate 12), continued the same strategy of visual dodging. The 'tough' was caught knife in hand, in the mock-frenzy of pursuit of a combatant, with his eyes running off the page. But the next image (plate 13) halted the visual inconclusiveness. The young man confronted readers directly, via eye contact and a knowing half-smile. Clad in another iconoclastic costume – yellow V-necked football shirt and shiny black jacket, with a straw Panama hat worn over embroidered Peruvian wool headgear – his gaze went out as an implicit form of masculine bonding. The suggestion that this was a mode of address shared between men was reinforced by the 'Tough Me Tough' caption. The dynamics of this look were those neither of simple aggression nor of flattering fashion statement. The gaze was at once confrontational *and* gentle, startling *and* caressing. Above all it implied knowledge about masculinity. The caption reinforced the double syntax. 'Tough Me Tough' fixed primary meaning through the signifiers of aggression. Yet the form of identity implied by this phrase also pointed towards a different scenario. It was framed as a request, even a longing, from one 'tough' to 'tough' the other 'tough' up. There was the invitation to enter a world of butch homosocial contact. It was what Petri referred to when he spoke of his desire to mingle creativity with the hardness of the street.[131] In so doing he threaded together an idiosyncratic series of masculine scripts.

There was one further ingredient in Ray Petri's styling. This was his

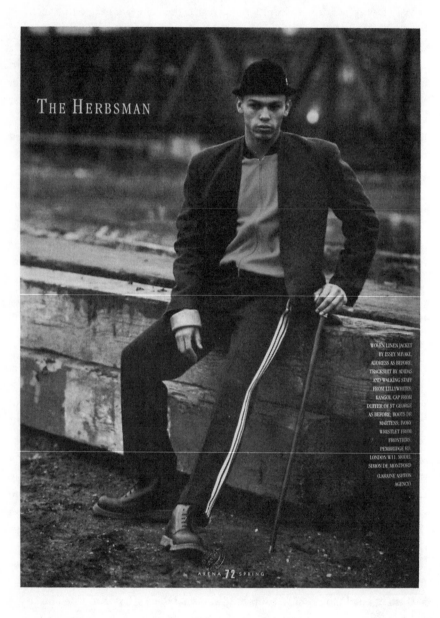

Plate 10

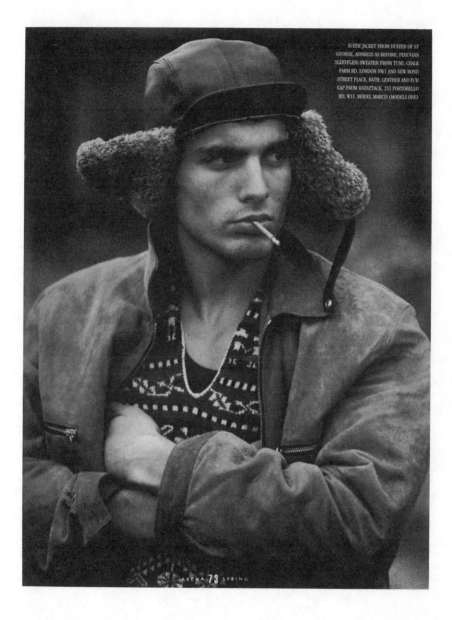

SUEDE JACKET FROM DUFFER OF ST
GEORGE, ADDRESS AS BEFORE; PERUVIAN
SLEEVELESS SWEATER FROM TUMI, CHALK
FARM RD, LONDON NW1 AND NEW BOND
STREET PLACE, BATH; LEATHER AND FUR
CAP FROM HATATTACK, 253 PORTOBELLO
RD, W11. MODEL MARCO (MODELS ONE)

ARENA 73 SPRING

Plate 11

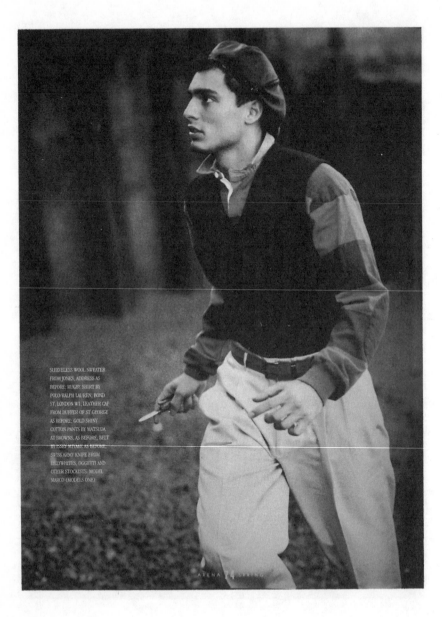

SLEEVELESS WOOL SWEATER
FROM JONES, ADDRESS AS
BEFORE; RUGBY SHIRT BY
POLO/RALPH LAUREN, BOND
ST, LONDON W1; LEATHER CAP
FROM DUFFER OF ST GEORGE
AS BEFORE; GOLD SHINY
COTTON PANTS BY MATSUDA
AT BROWNS, AS BEFORE; BELT
BY ISSEY MIYAKE AS BEFORE;
SWISS ARMY KNIFE FROM
LILLYWHITES, OGGETTI AND
OTHER STOCKISTS; MODEL
MARCO (MODELS ONE)

Plate 12

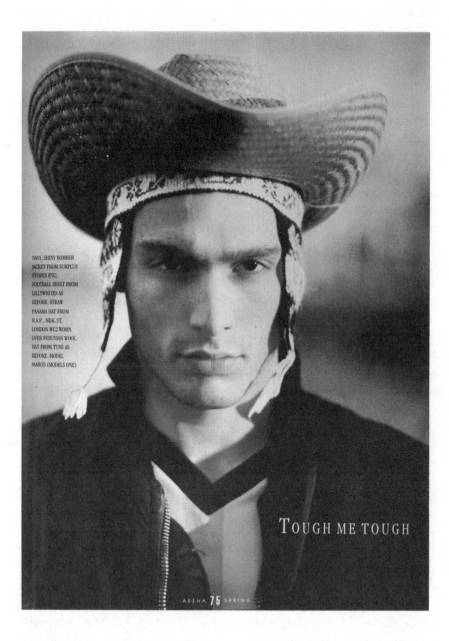

NAVY, SHINY BOMBER
JACKET FROM SURPLUS
STORES ETC;
FOOTBALL SHIRT FROM
LILLYWHITES AS
BEFORE; STRAW
PANAMA HAT FROM
R.A.P., NEAL ST,
LONDON WC2 WORN
OVER PERUVIAN WOOL
HAT FROM TUMI AS
BEFORE. MODEL
MARCO (MODELS ONE)

TOUGH ME TOUGH

ARENA 75 SPRING

Plate 13

characteristic handling of ethnicity. Petri generally avoided models with blond, clean-cut good looks (of the sort preferred by American fashion photographer Bruce Weber), unless they could be used to suggest eroticised innocence or touch-me-not sensuality.[132] His bias was for young men who were Latinate, Afro-Caribbean, chicano, or of mixed-race origins. Such preferences were not merely a pandering to ethnic fashionability. They meshed with Petri's visual philosophy of social and sexual plurality. A Caribbean theme was caught in one of the caption titles of the *Arena* sequence: '*Yard* Style Easy Skanking' (my emphasis). In West Indian dialect the term 'yard' was suggestive of home, or home territory, but it also carried connotations of a 'yardie', the member of a gang.[133] The fashion plates which followed the 'ragamuffin' photographs were slyly entitled: 'the boys in the band' (plates 14–18). With their homosexual punning on the American dramatist Mark Crawley's 1960s play of the same name, the images profiled trumpeters and drummers, bouncers, guitarists and vocalists *in situ* in a nightclub setting.[134] Shot on location at Delirium, in the Astoria nightclub in London's Charing Cross Road, the photographs featured black models Craig, Miles and Tony in varying moods of cool. Craig (plate 15) was the archetypal dude, introspective but self-possessed. Clad in a white linen suit, he was pictured drawing on a cigarette while relaxing at a jazz musicians' break. Miles (plate 16) was black and proud – his fine-boned features and braided hair were caught in semi-profile. But his composure was undercut by the gigantic lizard diamante pinned to his tuxedo, with its suggestions of camp or overblown brilliance. Tony (plate 18), the lead singer who was featured as 'king creole', was shyer. Hooded like a rapper, and clad in an oversize jacket, he bowed his head as he clutched the microphone close to his body. The light played across his softer features to produce a sense of insecurity. In a different cultural mould there was Marco (plate 17), simultaneously acting out both the part of the nightclub bouncer and the uninvited guest, in 'members only'. With olive skin, deep dark-set eyes and full mouth, his looks were classically Latinate. Marco's body posture and his face were deliberately set at variance. His physical demeanour was threatening, suggesting the confrontational stance of the bouncer. Yet his face was soft and questioning, even passive. In sequences such as these Petri was not averse to playing with ethnic stereotypes and their accompanying *frisson* of racial difference. Black skin tones were often highlighted and poses exaggerated. But his ironic combination of props and narrative format avoided the fetishisation of racial otherness, which was a feature of the other contemporary documenter of black masculinity, American photographer Robert Mapplethorpe.[135] Petri's images refused the tight fixing of race, partly because his photo-shoots juxtaposed a plurality of ethnic looks in adjacent frames. The images moved rapidly from one type of masculinity to another. The effect was

Plates 14–18 'the boys in the band', fashion sequence, styling Ray Petri, photography Marc Lebon, *Arena*, March–April 1987

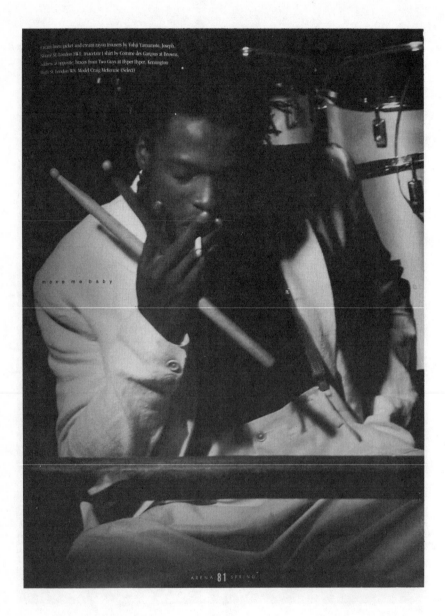

Plate 15

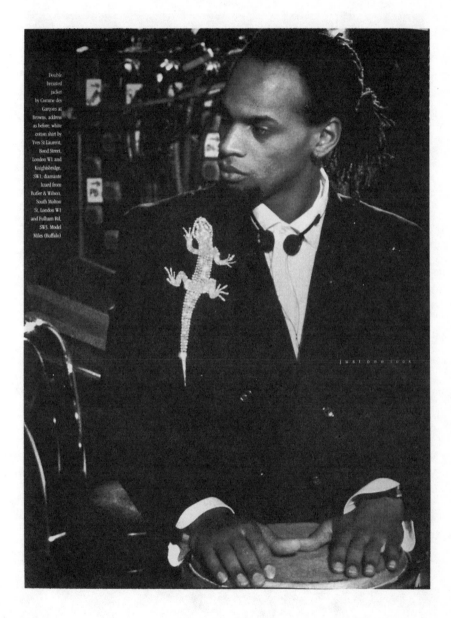

Double breasted jacket by Comme des Garçons at Browns, address as before; white cotton shirt by Yves St Laurent, Bond Street, London W1 and Knightsbridge, SW1; diamante lizard from Butler & Wilson, South Molton St, London W1 and Fulham Rd, SW5. Model Miles (Buffalo)

just one look

Plate 16

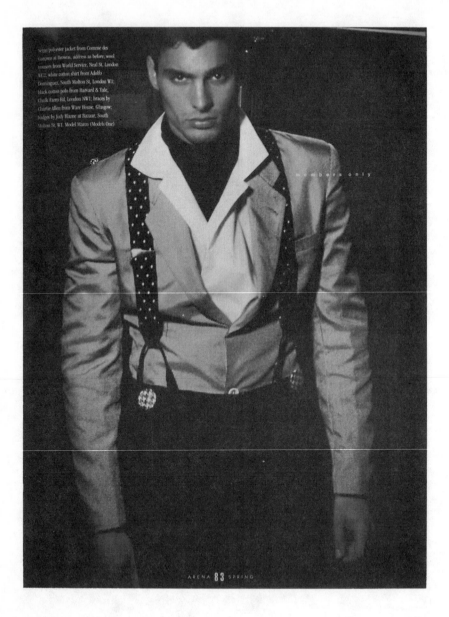

Serge/polyester jacket from Comme des Garçons at Browns, address as before; wool trousers from World Service, Neal St, London WC2; white cotton shirt from Adolfo Dominguez, South Molton St, London W1; black cotton polo from Harvard & Yale, Chalk Farm Rd, London NW1; braces by Charlie Allen from Ware House, Glasgow; badges by Judy Blame at Bazaar, South Molton St, W1. Model Marco (Models One)

members only

ARENA 83 SPRING

Plate 17

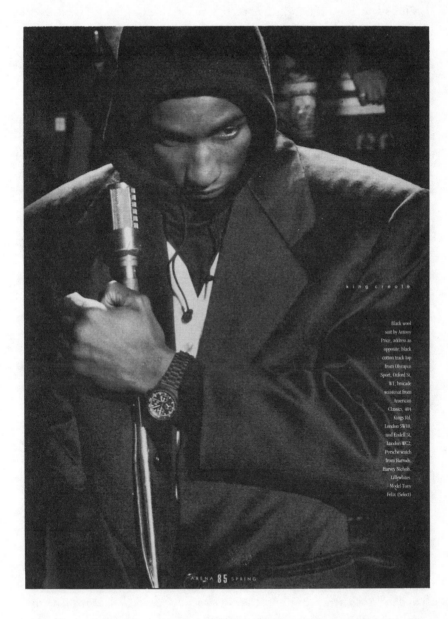

Plate 18

to promote the idea of cultural diversity as part of a diaspora of style.

Petri and his collaborators ran sequence after sequence of these visual experiments in both *The Face* and *Arena*. 'Float Like a Butterfly Sting Like a Bee ... Check Out The Beef!', which appeared in *The Face* in June 1985, once again with photography by Morgan, rehearsed mock dramas on the theme of prize-fighting, picturing models in lycra, fur and silk. 'The cowboy, the indian and other stories', from the October issue of the same year, spliced images of black and Latinate gunslingers with more about ragamuffins and boxers, while 'Buffalo a more Serious Pose', appearing a year later, featured tales of quirky spivs and wide-boys, along with black American prayermen.[136] All these visuals ran according to a similar format. There was the continuing use of Petri's favourite models, who were usually shot solo. Also repeated was the bricolage theme; the scrambling together of aggressive emblems of masculinity with more ambiguous signifiers. The net effect was both seductive and challenging. Readers were invited to enter this world of visual spectacle without the reassurance of a coherent grammar of meaning.

Read purely in formal terms, as texts in a frame, fashion images such as these can tell the historian little. But decoded socially, they can point to the referents which stylists and photographers drew on to shape their vision of the world. Petri's images were part of an identifiable cultural ensemble, which he mobilised repeatedly during the 1980s for his account of masculinity. Some indication of his favoured materials was suggested by the fashion plates themselves. Many of the artefacts and visual scenarios which he utilised originated in the world of urban style. There was the characteristic scrambling of *haute couture* design with street fashion. Belts in the ragamuffin spreads came from Japanese designer Issey Miyake, leather and fur caps from Hatrack in London's Portobello Road. But other items were picked up from chain-store retailers, or from second-hand and market traders. The majority of Petri's images, like the overall stance of the style magazines, were unapologetically metropolitan. They drew their impetus from the ambience of city life, from the looks and glances of the street and the urban spectacle.

This was the general context for Petri's visual experiments. Commentators on his work have pointed to more specific influences, notably the continuing impact of punk in shaping the montage effects, together with a retrospective reading of 1950s youth culture.[137] When Petri himself was asked by *The Face* in 1985 where he found his buffalo look, his nonchalant reply was, 'Oh, just around'.[138] Such a non-committal answer was not entirely accurate. The most significant influence on Petri's creative output was contemporary forms of gay male culture. Petri himself was homosexual. His sexual orientation was not significant in itself, in any simple authorial sense, for his work cannot be

understood as the unproblematic product of a 'gay sensibility'.[139] Rather, Petri's knowledge of homosexual life equipped him with a set of competences with which to visualise masculinity. More generally, his styling for *The Face* pointed to the ways in which the cultures of sexual dissidence left their mark on more normalising images of men during the period. As we shall see, consumer culture involved an elaborate series of negotiations between homosocial and heterosocial accounts of the male self.

In the mid-1980s variations of Petri's buffalo look were circulating in specific zones of London which provided the space for younger gay men to experiment with style culture. Soho and its environs, in London's West End, was a particular site for these displays of fashionability. Permutations of the same look were also visible in the new homosexual quarters of Paris, notably in the Marais and Les Halles districts of the fourth *arrondissement*, and in the increasingly chic streets to the north of the Bastille, in the eleventh. Shops, cafés, bars and nightclubs provided the commercial infrastructure in these urban spaces. We shall have much more to say about the social geography of such areas later. Suffice it to note here that the visual styles assembled by younger gay men resonated heavily in Petri's fashion spreads. The dress code of the urbanites revolved around a razored 'flat-top' haircut, or 1950s quiff, worn with a black American Air Force bomber jacket, red neck-bandanna, Levi's jeans, white socks and Doctor Martens shoes or boots.[140] The look mutated several times during the latter part of the decade. Yet the precise artefacts and accessories were less important than the general coding of gay identity. This contemporary representation was relatively fluid in its treatment of homosexuality. It drew on a range of signifiers which were not specific to gay culture, but which featured as part of the consciousness of a generation of young people who had been educated into consumer style. The overall image was one of fashionable sexual ambiguity.

The influence of homosexual culture was present in various aspects of Petri's output. But it was most evident in the visual language which anchored so many of his sequences. We have noted how these photo-shoots frequently crescendoed in an exchange of looks between the model and his audience, which was redolent with the excitement of sexual sameness. This contact was fixed on a dialogue of the eyes, which produced the effect of sharing a secret knowledge. Petri's paradigm for this form of reciprocal spectatorship drew on one of the most important structures of recognition between homosexual men: the visual contact involved in 'cruising' for casual sex. 'Homosexuals recognize each other – the way Jews do. The mask dissolves, and I would venture to discover my kind betweeen the lines of the most innocent look.' French poet and dramatist Jean Cocteau was commenting in 1930 on a form of visual communication which has featured prominently in the reproduction of modern homosexual culture since its

71

inception in the late nineteenth century.[141] An exchange of looks, working to confirm a shared identity, as a possible prelude to sexual contact, has been a hallmark of this homosexual gaze. A specific version of the look was recurrent in gay pornography in the 1980s, in magazines such as *Him* or *Mister*, where the interplay between model and audience was suffused with desire. However, in Petri's output these visual codes were more subtly nuanced. His images did not work to delineate homosexuality as such; their remit was more diffuse. They suggested the intimacy of a bond betweeen men – a homosocial rather than an exclusively homosexual gaze. Fixed sexual signifiers were refused in favour of the repeated differal of meaning around masculinity. Petri's sequences were 'camp' in the sense defined by photographic theorist Susan Sontag. They worked with a flamboyant iconography, which was susceptible to double interpretations, with one idea offered to a knowledgeable audience and another, more impersonal frame of reference, given to outsiders.[142] Petri was not the only contemporary image-maker to deploy this type of rhetoric. A similar version of homosexual innuendo informed many of Gaultier's fashion collections during the 1980s, with their raiding of the sartorial fetishes of the homosexual wardrobe. Gaultier always acknowledged his debt to the inventiveness of stylists like Petri. He believed that such individual talents could be found more easily in London's creative urban environment than in Paris. As Gaultier explained to *Arena* in 1987: 'London stimulates me. It gives me energy. It's something about the ambience.'[143]

Ray Petri's portfolio was influential at two different levels. Like Brody's designs, his work confirmed the reputations of *The Face* and *Arena* as being in the vanguard of creative fashion styling. The buffalo theme was ideal material for these magazines. The flexibility of its scripts guaranteed it a prime visual place in the pages of the style press. When Brody announced in 1988 that art direction had replaced graphic design as the organising principle of *Arena*, he implicitly paid tribute to Petri's influence.[144] But Petri's images also reached out beyond the fashion leaders. The importance of Petri for our argument lies in the way in which his account of masculinity was drawn on by mainstream advertisers and retailers working on young men's consumer markets. Petri was not the sole author of these visual philosophies. His representations co-ordinated a set of themes which had their origins within broader fields of urban culture. In that sense Petri and his team operated as creative facilitators, whose talent lay in translating the looks and poses of the street into an identifiable language of style.

Yet though Petri's visual statements were applauded by the leaders of style culture, they did not go unchallenged by more mainstream players in the fashion world. In the mid-1980s such representations – and the culture on which they drew – provoked a moral tirade from the gatekeepers of the men's clothing industry about the damaging effects of 'street style'. The leading trade journal,

Men's Wear, railed continuously both against the excesses of what it termed the 'youth cult', with its preference for throwaway clothing, and against the downmarket 'yobbo influences' which had 'our culture in its grip nowadays'.[145] These diatribes condensed deep-seated economic anxieties about the state of the British clothing market. Badly hit by the recession of the late 1970s and early 1980s, manufacturers were worried that recovery was being sabotaged by the taste patterns of an esoteric élite. *Men's Wear* went on to complain that top designers were turning their backs on classic styling, such as suits and smart casual clothes, which were held to be the key to the regeneration of the industry. Instead they favoured an instant fashion ethos, with a preference for the outrageous and the bizarre.[146] Such complaints from the mainstream section of the trade against the antics of its avant-garde were not new. But in the climate of the mid-1980s they took on a moral as well as an economic critique. *Men's Wear* editorials not only echoed the entrepreneurial values of the Conservative government, they also adopted an evangelical tone in relation to the gender ambiguities which they believed were damaging men's fashion. Taking the offensive, the journal began to point the finger at the 'high-camp' images of homosexuals, who, it claimed, had infiltrated the fashion scene.[147] In 1986 this sense of outrage at the catwalk displays in the London menswear shows stung some writers into going still further. Journalist John Taylor led the attack. A number of the new British fashion talents to emerge at this time were homosexual men. Jasper Conran, John Flett and Galliano were the most prominent among them. Without directly naming individuals, *Men's Wear* hinted darkly that the upper floors of London tenements were spawning a generation of 'sad, sick transvestites' who paraded as 'new wave' designers. Professional androgyny was now applauded. Fashion had begun to stink![148]

Invective of this kind was the direct result of what the clothing trade perceived to be deliberate provocation. The moral critique of journalists like Taylor challenged the upsurge of an explicit discourse of sexual politics in the men's fashion industry. At the style press Petri was responsible for some of the most dramatic representations of men within this genre. With their deliberate strategy of disruption, his images worked to destabilise masculinity by invoking the power of homosocial relations. However, Petri's project marked a limit position. In the magazine culture of the period it was qualified by more cautious approaches. There were other languages which continued the scrutiny of men's lives, but which did so less via the dynamics of transgression than by turning their journalistic gaze on more conventional patterns of life.

7 A Community of Men

It was the appearance of a series of fledgling men's titles between 1986 and 1988 which consolidated the experiments in masculinity first made visible by the style press. While most of these publications were heavily influenced by the success of *The Face* and its competitors, their more explicit mode of address to men intensified the publishing debate about gender and consumption. Here we return to the issue which first surfaced in the discussions which followed from the failure of *The Hit*; the possibility of speaking to men as a community, or interest group, collectively shaped by retailing. Despite their differences, this was the theme which circulated endlessly among the editors and journalists who strove to break into the embryonic sector. As so often in the early stage of a product launch, these professionals were driven mainly by the adrenalin of excitement. They possessed little detailed information about their audience. Informed guesswork, coupled with boundless enthusiasm, were the most significant factors in the exploration of men's consumer patterns at this time. Each of the new entries into the publishing arena projected subtly different accounts of their readership. This was partly influenced by practical considerations, especially the need for product differentiation in a tight market. But it was also informed by competing accounts of the role played by commercial culture in the organisation of men's lives. More often than not these differences were argued out as disagreements over taste and editorial policy. But it was taste understood as a significant marker of social discrimination.

Among the most prominent of the new titles was Logan's own venture. Launched as Britain's first magazine for men, *Arena* appeared in November 1986. Rising circulation figures for *The Face* confirmed Logan's view that there was a potential audience for a men's general-interest title. His decision to embark on the new publication was also influenced by a desire to keep together his tightly knit editorial team, who he believed needed fresh challenges. Glossy and perfect bound, *Arena* was pitched at an older market than that of its more established companion. Billed by the advertising industry as the key to reaching 'the stylish, well-heeled' consumer, the magazine was aimed at the 24 to 35-year-old reader.[149] It was initially bi-monthly, with a projected circulation of between 45,000 and 50,000. Awarded *Media Week*'s accolade of 'launch of the year', *Arena* found immediate favour with publishing professionals. Brody believed that its quality finish exuded an air of confidence and authority.[150] Logan and Sopp carried over from *The Face* the concept of taste leadership, which remained the organising principle behind their new venture. They were emphatic that *Arena* was not a

'mainstream magazine'. This aloof profile was confirmed when Sopp declined to enter the new title for the National Readership Survey, which worked with conventional definitions of social class in its analysis of magazine audiences. Sopp claimed that such traditional categories needed to be transcended, especially with a title which targeted not groups but *individuals* who were at the cutting edge of new social trends.[151] A superior model of consumption also shaped the choice of products which were featured between *Arena*'s covers. Articles on fashion and a plethora of *objets de luxe* were the standard journalistic fare. Interior design, wine and gourmet food were other favourites. There were pieces on the latest exotic sports, such as windsurfing and scuba-diving, together with the accessories which were *de rigueur* for these leisure pursuits. Each month journalists grouped the various goods and services together in its 'Arena Recommends' section, which ran on the penultimate pages. The magazine functioned explicitly as a consumer manual, selecting those films, books and other items which were the current emblems of fashionability.

However, *Arena*'s claim to pre-eminence as the first magazine for men was not factually correct. It had been preceded in September 1986 by the appearance of *Q* from EMAP. *Q*'s approach to men as consumers was radically different. With the widest projected audience (men in the 18 to 35 age range), the editorial stance was to anchor readers' interest via traditional music coverage. EMAP's strategy was to avoid becoming another casualty in this fragile market by smuggling in the consumer journalism format, rather than foregrounding it. Music was used as the bait. As journalist Alkarim Jivani put it somewhat sceptically to the advertising industry at the time of *Q*'s launch: 'the theory is attract music-loving men to buy the magazine and what you end up with is *de facto* a men's magazine, although to call it that would probably turn off potential readers.'[152] In the same month Condé Nast stepped even more tentatively into the field. A version of a men's magazine had appeared as a supplement to *Vogue* for fifteen years. But the publishers announced that they were considering the launch of a free-standing title, *Vogue Men*, separated from the main publication. Dummy runs were in preparation, the publishing world was informed, which would be assessed against more precise research in the months ahead. Condé Nast's cautious decision to test the state of the market at this time was clearly prompted by the activities of its publishing rivals. It was also underpinned by a perceived shift in the personas of British men. As Richard Hill, Condé Nast's deputy managing director, put it: 'People are always saying that men are becoming peacocks and while this is certainly true ... I'm not sure whether we've got the full plumage ... yet. But we are almost there.'[153]

The appearance of a new teenage-focused title in April 1987 gave further depth to the new publishing strategy. *Sky*, a collaborative venture from the News

International/Hachette consortium, pitched for a younger and more mainstream reader. Bidding strongly for yet another niche, publisher Peter Jackson and editor Ian Birch announced to the advertising world that *Sky* was meant for 'normal 15 to 25-year-olds who want to be informed and entertained in the broadest sense'.[154] Claiming to speak from the centre of publishing, rather than its margins, Jackson accused the style press of being 'narrow, mannered and obsessed with males'. In contrast, *Sky*'s consumer journalism would be quintessentially mid-market. Their choice of fashion coverage, Jackson insisted, would select from retail chains such as Next, Hornes, C&A, 'with perhaps one more expensive thing like Katherine Hamnett thrown in'. *Sky*'s search was for a more median consumer at the younger end of the market, touched by fashion, but also occupying a conventional masculine role. As in the menswear industry, fears about the eccentricities of the style press encouraged caution among the larger publishers.

The search for a more socially orthodox profile was underlined by the appearance of the British bi-monthly version of *GQ* in 1988. Previewed to the advertising industry in May, with a prestige champagne reception at London's Claridge's hotel, the overt address was to 'successful stylish professional men' between the ages of 20 and 45.[155] The new title's editor, Paul Keers, believed that the current economic forecasts were auspicious. *GQ*'s market had been strengthened, Keers claimed, in the wake of the Chancellor's tax cuts for high earners announced in the March budget.[156] The magazine's appearance was again the cue for the publishing industry to debate sexual politics. With another sidelong glance at the style press, *Campaign* reassured advertisers that *GQ* was 'not for the hermaphroditic magazine buyer' but for 'those relentlessly thrashing chaps now enjoying the new low high rate of tax'. Heterosexual potency and financial virility were confidently linked. The arrival of Stephen Quinn at Condé Nast, from his role as publisher at *Harpers and Queen*, consolidated the venture. Involved in a self-confessed 'love affair' with prestige consumer journalism, dating back to his time at *Nova* in the late 1960s, Quinn believed that the economic and social climate of the 1980s was favourable to the introduction of an up-market magazine for men. His tone was buoyant: today's culture, he claimed, was one of enterprise, the pursuit of success, and the 'acquisition of status with high financial reward'.[157]

Yet behind the upbeat publicity, journalists and other marketing experts continued to guard against over-excitement. Mark Boxer, editorial director at Condé Nast, with a similar longstanding history in men's consumer journalism, was especially cautious. Younger professionals, he argued, were already very well served for sport, the City and politics by quality newspapers and the specialist press. They were now also being bombarded with a range of free magazines sent out to affluent consumers, like those from credit card agencies such as Diners

Club and American Express. Boxer pointed out that these men already had too much reading material rather than too little. There might be a gap in the market for a style magazine, but, as he remarked: 'in that area Englishmen are uneasy'.[158] Boxer's words of warning were influenced by his feeling that English males were still not as advanced as their European counterparts in the niceties of consumer culture. He was also worried by the ambiguous results of Condé Nast's research into the reading habits of the professional classes, carried out by the Parker Turner partnership in 1988. A London-based survey of men in socio-economic groups A and B identified at least two potential audiences for the new publications. 'Cautious conservative professionals', including lawyers, account-ants and estate agents, the study revealed, were still extremely uneasy with the idea of a men's fashion magazine. While for more contemporary professionals, such as architects, designers and advertising executives, the concept presented 'no problem at all'.[159] GQ attempted to woo both markets. Prior to the launch Keers outlined the type of journalism readers could expect. The magazine would include features on 'where to eat, keep fit, stay in Milan (not Spain) and where to choose a tailor'.[160] The projected coverage aimed to weave together representations of a dynamic international lifestyle with more stable images of the English gentle-man.

In spite of the differences and disagreements over the precise contours of readership and content, what linked the different titles was the distinctive stance on consumer culture. This was the base-line underpinning all of the various projects. How did the assumptions about men's identities and the workings of the market inform this publishing commitment? In the new journalism readers' personalities were probed and dissected by the commodities they were encour-aged to consume. Purchasing decisions were understood to be intimately bound up with decisions made about the self. Bodily appearance was the main target, but the magazines also exended the range to cover the psychology of their audiences. Henceforward, everyday life was to be governed by a type of heightened self-consciousness. Yet these publications were collectivising as well as individual-ising in their address to men. The unique life-experiences of each and every reader were understood to be part of broader histories. Men were defined as members of a group, with shared interests and problems. It was the rituals of consumption which bridged the individual and the collective modes of address. Take the advice proffered in issue number 4 of Arena, in its practical hints on skincare and good grooming:

> Face the facts. Healthy skin depends on much more than a splash of soapy water and a dash of aftershave. . . . Skin needs to be indulged to promote a healthy complexion. Treat skin to a regular workout, just as you would treat

your body to a reviving swim or an invigorating session at the gym. There's always room for improvement, so start with a booster of skin-nourishing vitamins.... The next step is to combat the problem areas. As oil and sweat glands are at their most active between the ages of 18 and 35, they can create havoc and produce unwanted spots and blackheads.... As part of a weekly routine, pep up circulation with an exfoliating scrub.... Next check that skin is getting sufficient moisture. Summer or winter skin needs moisturising creams and lotions, and it is now accepted that this luxury is not only precious to women. Choose moisturisers rich in soothing ingredients which help keep skin supple and soft.[161]

Articles such as these proffered information and advice familiar from almost a century of women's magazines. Personal hygiene was defined as pleasurable labour. The skin and face were to be explored and cultivated with a practical regime of aids and accessories available in the consumer marketplace. The rewards to be gained by following these routines not only centred on the aesthetics of looking good, they also resulted in the satisfaction of greater self-knowledge. All of this was sympathetically guided by the advice and help which was advertised in the magazines. Information was given out not from distant experts, but by journalists who themselves identified with the collective 'we' of masculinity. Like the equivalent women's titles, these publications addressed their readers through a shared bond of friendship. Striking a mock evangelical pose, writers frequently claimed that they were 'speaking out' about those aspects of men's lives which had for too long been repressed. As Steve Taylor put it about shaving, in a piece written for *Arena's* opening issue: 'Shaving is one of those mass, everyday social phenomena which are utterly taken for granted: nobody ever really teaches pubescent males how to do it properly.'[162] Much of the journalism adopted a style of comic openness. The overall effect of such declarations was to render masculinity available for public discussion.

Arena's journalism encouraged men to enter into a consumer wonderland with the promise of pleasures accessible only to the initiated. The magazine's occasional series, 'Shopping for Clothes', divulged sought-after information about where to shop for those authentic 'penny loafer' shoes, leather flying jackets and chino trousers. Specialist suppliers needed to be located. Readers were reminded that they should avoid the main consumer thoroughfares populated by undiscriminating audiences. It was much better to take time out and explore more authentic retailers. One such outlet was John Simmons, a clothes shop in London's Covent Garden. As the magazine gossiped: 'the shop is tucked off Bow Street opposite the Covent Garden Piazza, a step further than most tourists tend to take.'[163] Historical interludes on the evolution of particular items of taste also

reinforced the idea that men of style possessed a history and a shared culture. Jon Savage's polemical account of the male image in twentieth-century advertising made the point that the 'new man' had his antecedents in earlier moments of consumer affluence.[164] Steve Beard and Jim McClellan's analysis of bikers' culture since the 1950s reviewed the changing forms of male bonding associated with the technology and power of the motorbike.[165] While their story of the military influence on post-war men's fashion revealed how uniforms had been worn by generations of stylists.[166]

In *Arena*'s features and major articles such perspectives on the world of goods were presented as relatively seamless and coherent. The aim was to establish a consensus about the meaning of consumption and style. The letters pages told a different story. Some readers voiced strong reservations about the magazine's dominant mode of address. Regional objections to the metropolitan élitism implicit in much of the coverage was a prominent theme. As Lee Buckley, from Bury, Lancashire, complained: 'although *Arena* is a London-based magazine, we do buy it here in the north and we're not all made of money. Would it be possible to slip in the odd affordable item of clothing?'[167] Or as another correspondent from Whitley Bay pointed out: 'I would like to bring to your attention the North East of England. It seems that . . . Newcastle upon Tyne . . . has a poor name where fashion is concerned. . . . This city is . . . one of the most fashionable . . . in the United Kingdom.'[168] Such criticisms asserted regional independence from the capital, foregrounding competing versions of masculinity which challenged London's claim to be at the centre of the world. They also drew attention to the more prosaic realities of many readers' lives, which were often far removed from the fantasy world of wealth projected in the magazine.

If the mood and collective voice of *Arena*'s journalism was predominantly upbeat, there were times when coverage ventured into more awkward areas. *Arena*'s first discussion of male sexuality carefully mixed a confessional tone with the language of schoolboy humour. The topic for debate was not any of the variants of heterosexual lovemaking, but masturbation. The 'ultimate male pursuit' was extolled on the grounds of both pleasure and safety. As journalist Kevin Sampson explained in 'One from the wrist. In praise of the hand-job':

> In these risky times . . . in the wake of AIDS hysteria, bachelors are doing it for themselves . . . one suspects that more and more are coming out. They're finally admitting that high on the list of great male pursuits is the regular enjoyment of a darned good tug. . . . It's the sense of doing something implicitly *naughty* that makes the whole mucky business of masturbation implicitly worthwhile.[169]

The choice of masturbation was not accidental. Again, it worked to confirm a

masculine community through the disclosure of shared knowledge. And as a tongue-in-cheek reply to the article insisted, the intimate physical pleasures of the male body could really only be known by men. At last here was 'something totally masculine' that could 'never be mimicked properly by a female!'[170]

A rather different exploration of men's identities was promoted in the interviews and profiles of male stars, which were a standard feature of each issue. In the first edition of *Arena*, Irish-American film actor Mickey Rourke appeared on the front. Smiling outwards to his audience and gesturing with his hands in the manner of a female cover-girl, Rourke invited prospective readers to enter the world of the magazine. Rourke specialised in thriller roles, playing sensitive but violent romantic heroes – parts which journalist Jessica Berens, in her interview with the actor, described as variants of 'the complex man with the gun'.[171] This type of tough but psychologically developed personality featured prominently in the gallery of celebrities who were profiled month by month. A different version of the same character was explored in an article about the American heavyweight boxer Mike Tyson. Photographed in grainy black and white, to emphasise his physical bulk and size, Tyson was described as 'built like a truck, with a shock absorber for a neck and arms like diesel pistons'.[172] Yet the interview which followed was at pains to discuss the mental complexities of men who lived and worked with violence, testing the 'strength of their will and the limits of their courage'. Tyson himself admitted that fear was an integral part of the boxer's make-up, to be welcomed like a 'buddy'. As he explained: 'you realize that fear's your best friend.... It makes me feel secure and confident, it suddenly makes everything explosive. It's like: "Here it comes again. Here's my buddy today."'[173] Writing of this sort had its origins in the literary genre of male romance fiction; the physical and mental tales of endurance which were epitomised in Ian Fleming's James Bond novels of the 1950s and early 1960s. The style of *Arena* journalism drew on this language to speak to its readers.[174] In doing so it projected a type of hero who had his origins in tradition, but who was also emphatically contemporary.

8 Feminine Exclusions

The new magazines prided themselves on being at the cutting edge of cultural life. Yet in one important sense such claims to innovation need qualifying. The limited nature of their imaginings is brought into sharp focus when their treatment of women is contrasted with the handling of men. The female counterpart to the new

man was a much paler creation. Not only were the representations of women in these publications restricted in terms of actual print and visual space, more importantly, the language used to represent femininity was heavily restricted and confined. It was no accident that the expansive coverage of masculinity simultaneously produced a relative closure when it came to women.

As a 'magazine for men', *Arena* profiled femininity much less frequently than its male heroes. A large part of its journalism implicitly worked to construct a homosocial space, 'liberated' from the other sex. At times this perspective degenerated into overt misogyny. Robert Ryan's enthusiastic article on the bachelor apartment in issue number 12, insisted that the 'bachelor pad' remained a strong element in any male fantasy. Such a 'perfect environment' was free from 'mascara', 'comfortable furniture' and other such intrusions of domesticity. It was essentially a place where a man could relax and where his personality could be individually stamped on every surface.[175] When writers did address women, they tended to replicate many of the standard tropes of mainstream journalism, rather than working for any more imaginative effects. Girls were usually positioned as part of a traditional gallery of talent. Up-and-coming actresses and starlets, endless features about 'the most beautiful girls in the world', and latterly soft-porn pin-ups, made frequent appearances. The language in such features was frequently static, sometimes downright uninterested. Jeff Ferry's profile of actress Charlotte Lewis, who made her Hollywood debut in 1987 in the film *The Golden Child* opposite Eddie Murphy, was characteristic: 'She glides silently, darkly elegant, luxuriant black hair caressing Eurasian cheeks. When she smiles, mysterious eyes sleek like Chinese schooners sparkle brightly. The mouth – unmistakably English – is girlish and mobile.'[176] This was clichéd writing, in this case working with the rubric of mixed-race exotica. The point was that such formulaic imagery – girls 'darkly elegant' with 'mysterious eyes' and 'luxuriant hair' – was spun across article upon article and issue after issue. For Charlotte Lewis read vocalists Sade or Dianne Reeves. The permutations were endless.[177]

The mysterious feminine beauty was one type of *Arena* portrait. Other representations raided copy from the pages of the popular press. Gordon Burn's gossipy feature written in 1987 about Mandy Smith, the current girlfriend of Rolling Stone Bill Wyman, worked with suggestive titillation. 'Mandy', Burn revealed, had begun her career as a 'north London convent schoolgirl'. Overnight she became 'the toast of the tabloids'. It was, he quipped, just 'an everyday story of a suburban sex kitten'![178] Then there were 'ladies' who were famed for their outstanding sense of 'class'. These women were often cast as latter-day artists' models, the objects of men's creative inspiration. One such was actress Isabella Rossellini, daughter of the late Ingrid Bergman. When film-maker David Lynch first met her she was, readers were told, playing the 'beautiful model' in commercials for Lancôme cosmetics. It

was Isabella's air of 'vulnerable sophistication' which inspired Lynch to pick her for the female lead in his film *Blue Velvet* in 1987.[179] Again the reportage followed a standard blueprint. There was none of the restless inquisitiveness which characterised the interest in men's personalities.

It was significant that Petri's own forays into the world of heterosexuality visibly failed to produce the same creative effects as those which characterised his photographs of men on their own. His sequences 'Urban Cowboys' and 'South of the Border', featured in *Arena* issues 5 and 6, were shot on location in New York, Texas and Mexico, with photography from Norman Watson.[180] For the first time they announced an overtly heterosexual theme, organised around stories of youthful romantic love and its attendant sexual frustrations. What was noticeable about Petri's images was that they fell back on well-tried visual codes to depict sex and emotion. He styled his girls via a series of established genres. They were either depicted as conventionally pretty, as childlike innocents, or as sultry sex goddesses. Placed alongside these portrayals, his male models now appeared as much more traditionally masculine. In photographs of this sort there was none of the gender ambiguity which was the hallmark of Petri's work with solo male models.

Occasionally these habitual representations of femininity were disrupted, usually by women. Burchill's journalism was always incisive. Frequently she placed male posturing about women directly in her line of fire. One of her wittiest pieces covered men's relationship to their own bodies. Debunking the myth of female penis-envy, Burchill pointed out that it was men who had always been fixated on the size of their own and other men's vital statistics![181] From time to time *Arena* also carried experimental visuals, like the sequence by German photographer Ellen von Unwerth, 'tender is the night'. Her photo-spreads pictured a world of female prostitutes, in an attempt to visualise heterosexual desire from a woman's point of view. As von Unwerth explained: 'male images of sexuality dominate our culture, the female alternative less frequently gets a look in.'[182] However, such efforts were rare. Hegemonic in the style press was the portrayal of the world as a masculine playground. At times readers' anger at the limited depiction of women erupted violently. Again it was the letters pages which revealed the strongest discontents. As one Manchester-based woman fumed to *The Face* in 1986:

> Your magazine has for many years now relied on a stilted and perverse view of women as artless and mindless, who only crop up in the fashion pages, wearing clothes designed by men. You relegate us to the role of clotheshorse and concentrate on male artists, designers and musicians. Similarly the majority of your staff are male. Contemptuously ignoring femininity ...

doesn't have the air of modishness. It is systematic. And your disingenuous-
ness is something more than a crushing bore.[183]

Or as Brighton-based correspondent, Tasha Fairbanks, put it more sardonically
the following year:

> The last issue of 1986 ... and not a woman in sight. ... Boys, boys, boys and
> yet more boys. Working-class on-the-make and made-it boys; fey boys,
> pre-faded boys; self-obsessed, self-congratulatory, self-very-well-packaged-
> and-doing-nicely-thank-you boys; designer-made boys with their boy-made
> designs filled the page on page. ... Oh boy, don't you ever get sick of
> yourselves. I do.[184]

What such outbursts pointed up was not simply that young men were awarded
pride of place within this expanding genre of magazine publishing. The criticism
was more complex. Women readers were agreed that the endless pirouettes
around the male identity systematically worked to exclude femininity. Any
discussion of gender as relational – as a series of associations between men and
women – was massively overlooked. This was the contradiction which lay at the
heart of the new journalism. The commercial dynamic which bound masculinity
into consumer culture was grounded in the marginalisation of women. Genuinely
creative experiments aimed at men as consumers were made possible by virtue of
the fact that women were largely absent from the field of vision.

Such feminine exclusions were reinforced by the particular sexual ideology
which the majority of male journalists subscribed to. Dominant among the style
cognoscenti was a libertarian thesis on the question of men. 'Really liberated males'
will leave the magazine 'lying around their hi-tech studios', was the idea
championed by *Campaign* at the time of *Arena*'s launch.[185] Yet, unlike the
counter-culturalists of the 1960s, for whom private consumption was viewed as
a block or barrier to personal and sexual freedom, liberation was now given an
entrepreneurial emphasis. Men who had long been hidebound by convention
were being set free by the workings of the market. Steve Taylor was expansive
about the possibilities which were beginning to be opened up. Writing in
Campaign in 1987, about the recent spate of advertising for men's toiletries and
perfumes, he argued that these promotional images had made a positive
contribution to men's social roles. Feminism had only produced a 'wimp' when
it came to masculinity; now things looked more hopeful.[186] The argument was
that men were changing, not because of sexual politics, but thanks to the
thousand-and-one commodities which patterned everyday life. As Geoff Deane
continued in his comments on grooming for men in *Arena*, narcissism was now
legitimate: 'old taboos had disappeared'.[187] The model was developmental and

evolutionary. Men were moving from 'repression' to 'freedom' as a result of the power of commercial society. This emphasis defined 'men's liberation' as an issue for themselves alone. 'Freedom' was guaranteed by the acquisition of a specific range of goods and services. Awkward questions about the relationship between the sexes were not addressed.

A progressive commitment to market forces was not of course confined to consumer journalists. It was part of a more general world-view held by many entrepreneurs and financiers, who responded postively to the short-lived economic boom of the 1980s. But for the style press arguments about masculinity and enterprise had a highly specific rationale. Young men were encouraged to make a commitment to consumer culture via a selective choice of commodities. Goods were awarded a totemic status by writers and cultural critics, precisely because they were understood to be emblems of progressive taste. The formation of this taste-field was accompanied by a good deal of nervousness about the accompanying representations of masculinity. Despite considerable vocal opposition, such commercial experiments were celebrated as progressive via a modernising logic. They were, in essence, seen to be good because they were new. These undertakings produced a series of imaginative exercises, which were focused on the lifestyles and identities of younger men. But they were exclusive concerns, which drew strength from the marginalisation of women. It was this gendered contradiction which lay at the heart of style culture.

9 Moving into the Mainstream

In the early phase of its expansion this cultural project for masculinity was commercial in a limited sense only. The rhetoric of the market was a language which enthused a generation of young journalists and cultural savants. Yet viewed as a business proposition the opportunities opened up by the concept of style were extremely circumscribed. The fledgling magazine sector illustrated the extent of the problem. The majority of the new men's titles had circulation figures of between 50,000 and 100,000. While these statistics were respectable, and testified to the viability of the genre, they also underlined the point that such concerns were still very much minority ventures. Despite all of Logan's claims about the power wielded by style leaders, in quantitative terms the sphere of influence of the new magazines remained slight.

Difficulties were not simply due to the fact that these types of men's commodities were part of an experimental market, addressing specialised

audiences. Problems were compounded by the deep reservations held by many style professionals about speaking to a broader public. As we have seen, for many creative entrepreneurs the sphere of mass taste was antithetical to their own values. More often than not their agenda continued to be linked to specific avant-garde commitments. As ventures began to proliferate in the mid-1980s the issue of whether it was possible, and appropriate, to speak to a broader base of male consumers began to be discussed more urgently. To what extent was it viable to translate the publishing successes of the style press and the men's magazines into other media? Had the world of advertising recognised the potential of such initiatives? If not, could they be convinced? These were the types of questions which began to be posed. Different sections of commercial culture threw up particular responses to this challenge, but for all those involved the issue of reaching beyond a minority audience became more and more pressing.

The tensions thrown up by this increasingly business-orientated approach were played out acutely among the community grouped around *The Face* and *Arena*. Their expansive vision of style as socially transformative gave these journalists an evangelical sense of mission; a yearning to educate and to exert cultural influence in a broad sense. And yet their self-image as a taste élite made many of them hesitant about dabbling in the mainstream. At one end of the spectrum was Logan, comfortable with the aura stemming from his marginal status. We have noted how the whole development of his professional career during the 1980s involved a disengagement from what he saw to be the restrictive practices of corporate publishing, in the interests of creative freedom. Elms, who by 1987 was already showing signs of discontent with life at the margins, honoured Logan as the gentleman of style, but he also voiced a suspicion that his editor's conception of enterprise was ever so slightly tinpot. *Campaign* reinforced this image, describing Logan as an 'affable low key person', while Logan himself publicly acknowledged that he would never conquer the world of advertising.[188] Petri cast himself in a similar mould. Standing aloof from the antics of the fashion industry, he too preferred to work from his fringe position, which guaranteed a high degree of respect. However, for Labovitch at *Blitz* the issues appeared in a rather different light. Only recently out of university, at the age of 22 she was suddenly a sought-after editor. The greater opportunities opened up by this success were attractive. Labovitch was quick to spot how well her venture had been received by the advertising world. 'The agency people' love *Blitz*, she announced to *Campaign* in 1984.[189] Like Logan, she found herself bombarded with requests for professional advice from PR companies and other businesses, who believed that in her lay 'the secret of the so-called youth market'. As she saw it, her dilemma now centred on the logistics of expansion: 'what to do next and how to finance it'.[190] Labovitch's response was twofold; stubbornly resisting pressure to sell her title to

a mainstream publisher, she moved to diversify. Her plan was to secure an entry into more conventional markets. With that aim in mind she began to work on a music magazine for the retailing chain HMV.

Labovitch's strategy was more typical of the younger generation of entrepreneurs. At one level they were driven by quite orthodox economic and professional imperatives; the desire to generate wealth and acquire status. But these conformist motives were nuanced by their specific cultural commitments. As so often, Burchill was particularly incisive about this issue. She aired the problem in reviewing her own career moves plotted during the decade:

> ... you can sink or swim in the mainstream, but all you'll ever do in the margins is tread water. I could see no point in preaching to the converted for the rest of my life. And so at twenty I was working for *The Face*, at twenty-three for the *Sunday Times* and at twenty-six for the *Mail on Sunday*.... And as for selling out, boys, let me tell you this. The only people who never sell out are those who have nothing anyone wants to buy.[191]

Burchill's response to accusations of incorporation was to justify her desire for a 'big noise career', not simply in terms of economic advancement but also through a notion of vocation. This centred on a desire to speak to a public wider than the converted. Her move into popular journalism, as well as into fiction, exemplified such ambitions. Elms and Parsons attempted similar shifts. Motivating all these commercial intellectuals was a fascination with the power of the media. Like Burchill, Brody was emphatic about the issue. Reviewing his own career prospects, as they confronted him in 1985, he commented: 'I realized that the people I would have to aim at' were 'the people ... in control of the media'.[192]

In fact, sections of the communications industry were already extremely interested in the style coterie. The success of magazines such as *The Face* and *Blitz* was enthusiastically charted by the house journals of the media, while the experiments with men's magazine publishing were watched with equal attentiveness. Above all, it was advertising and marketing professionals who observed the comings and goings of this group of independent entrepreneurs with the greatest interest. The reasons were not difficult to unravel. In the mid-1980s a number of influential advertising agencies were excited by the experiments underway in this sphere of minority culture, precisely because in embryo they suggested a possible solution to the stalemate within key consumer markets. In the wake of the perceived disintegration of the teenager, advertisers and marketers looked towards style culture on two counts. For many companies what was at issue was the search for more precise information about an extremely volatile sector. Advertisers believed editors such as Labovitch and Logan, along with their journalists, were in touch with the taste patterns of this post-teenage audience, in ways that their

own market researchers were not. The priorities of the advertising agencies were not simply informational. They also centred on the meaning and vocabulary of style. The visual and design solutions pioneered by Petri and Brody suggested an original perspective for understanding contemporary life. The consumption rituals of particular groups of young people, living in the city, was the lens through which these visual images could be centred. In the latter part of the 1980s commercial experts entered into an active dialogue with the representatives of style culture around the knowledge of new markets. The resulting alliance of expertise produced an extremely influential discourse of consumption. It reached out beyond the minority of a self-contained taste élite and penetrated more mainstream versions of youth-related popular culture. Young men were not the only group to be targeted by this approach, but they were one of the most significant. It is to the advertising industry's take-up of the creative repertoire of style that we now turn.

Commercial Epistemologies: Advertising, Marketing and Retailing since the 1950s

1 Advertising: The Dynamism of Commercial Society

Come to the edge
 We might fall
Come to the edge
 It's too high!
COME TO THE EDGE!
 And they came
and he pushed
 and they flew.

(Christopher Logue, quoted in Saatchi & Saatchi Company plc, *Annual Report*, 1985, p. 18)

The mid-1980s was a period of spectacular expansion for British advertising which was accompanied by an equal degree of professional excitement. 'It has been an action-packed ... tough year,' hymned *Campaign* in its Christmas editorial for 1985, 'and the pace will not let up.'[1] At the time, practitioners tended to gloss the changes as part of the unstoppable evolution of commercial society, itself a powerful image of economic puissance during these years. Yet the transformations were precise and historically specific. Since 1976 advertising had demonstrated 66 per cent real growth, with expansion of almost 10 per cent in the financial year 1985–6 alone. The upswing was consistent across the various media, with especially high revenues generated in television and in the quality press.[2] Revitalised company profits after the 1979–81 recession, together with the government-promoted boom in domestic consumer spending, provided the general economic conditions for expansion. The result was an upsurge in advertising revenue, especially from durable goods and financial services. Growth was also stimulated by the emergence of new markets. The rapidly expanding advertising budgets of the main political parties, and the communications burst associated with the share flotation of many of the major public utilities, beginning with British Telecom in 1984, were among the most notable developments.

Growing economic confidence within the larger agencies was visible in a variety of ways. The public quotation of many of them on the Stock Exchange was associated with a wave of mergers. British advertising has finally convinced itself that big is beautiful, noted *Campaign* again, in its opening issue for 1987.[3] One effect of the trend towards corporatism was that the top agencies significantly broadened and diversified their facilities, incorporating new services, such as sales

91

promotion and design consultancy, into their portfolios. But change was not simply domestic. A further feature of the new scenario was the aggressively international image projected by leading players in the field. The world hegemony of the American agencies, built up before and after the Second World War, no longer seemed unchallengeable. American multinational companies had begun to dominate the upper echelons of the British advertising business in the 1960s. Yet in the mid-1980s the supremacy of the United States was checked by a small group of highly dynamic and financially adept British firms. In a series of abrupt reversals, the traditional headquarters of world advertising, New York's Madison Avenue, was subjected to a spate of takeover forays by London-based agencies. This new-found feeling of British self-confidence generated its own professional chauvinism. As a media pundit crowed at the time: 'no other nation produces ads worth talking about – not even America, the former United States of Advertising.'[4]

One company more than any other symbolised the process of professional aggrandisement. This was the Saatchi & Saatchi agency group. The dramatic rise and subsequent troubles of the firm and its founders, the brothers Charles and Maurice Saatchi, have been read as symptomatic of the commercial instabilities of the 1980s; a potent narrative of unbridled financial systems running loose and finally out of control. Founded in 1970, within a decade Saatchi's was established as the largest advertising agency in Europe, through a series of astute mergers. But it was in the period after 1982 that the company enhanced its international role. 'We believe it is good to be big, it is better to be good, but it is best to be both', proclaimed Maurice Saatchi to shareholders in his Chairman's statement for 1987.[5] In quantitative terms alone the firm's claims to status were indisputable. The previous year a spate of American acquisitions had made Saatchi's the premier advertising agency group worldwide. With enviable figures for profitability, offices in fifty-eight countries and an expanding range of subsidiary operations, such a record seemed to vindicate their organisational approach. A substantial proportion of the leading corporations were, or had been, clients of the firm.[6]

Saatchi & Saatchi's impressive record was underwritten by a strong commitment to contemporary business philosophies. What was emphasised was the globally based nature of the communications industries. A key intellectual mentor for the Saatchi brothers was Ted Levitt, doyen of marketing theory and Professor of Business Administration at Harvard University. Levitt insisted that advertising agencies had to learn to operate as if the world were one large entrepôt, ignoring what he termed superficial regional and national differences.[7] Saatchi's echoed the point when they called for the world's advertising media to dissolve national boundaries. The competitive intensity of maturing consumer markets

reinforced the economic logic of a co-ordinated international approach to selling, Saatchi's insisted.[8] Yet for senior management, success within the company was underwritten by their belief in something more than policies of size and scale. Their chief executive, Anthony Simonds-Gooding, argued in 1985 that the organisation had managed to build the one type of agency which eluded all others. Saatchi's, he maintained, held the competitive advantage because it retained an innovative, youthful and, above all, imaginative approach to promotional culture.[9] Simonds-Gooding was moved to quote from the poet and playwright Christopher Logue, to represent the energy and dynamism inside his agency. It was an ominously Faustian metaphor of vaunting ambition which spiralled ever upwards.

The mushrooming of Saatchi's international empire inevitably produced its own strains. Against a background of general economic deterioration, the company's problems of over-investment and client dissatisfaction, together with a failure to sustain growth targets set in the golden years of expansion, were the principal causes of Saatchi's difficulties after 1987.[10] Nevertheless, in the earlier part of the decade, the firm's reading of the need for advertising agencies to retain their competitive edge through conceptual innovation was judicious. It formed part of a broader shift in entrepreneurial strategies of investment and profitability, especially in the high technology and service-related industries. Outlay on knowledge, rather than simply on asset investment, in brains rather than brawn, was a critical factor in the race to secure what Tom Lloyd, editor of the *Financial Weekly*, termed 'added value'.[11] There were numerous interpretations of these ideas circulating during the 1980s. Many industrial and business leaders placed the greatest emphasis on a diversified approach to production and management. Flexibility was frequently embraced as the key term, projecting a way forward beyond the rigidities of Fordist manufacturing and the hierarchical culture of corporatism. Within the advertising world a different concept dominated. This was the idea of 'creativity'. Under its rubric was subsumed a set of particular hypotheses about how advertising and marketing needed to operate in a changed social, as well as business, environment.

The concept of creativity signified a shift in knowledge, in what might be termed the epistemologies of the consumer process. This conceptual transformation – in the estimation of demand and the dynamics of markets – was focused on a wide variety of sectors. Amidst all the interchange of energy and enthusiasm one object recurred almost obsessively. This was the idea of the youthful male consumer. It was precisely the repertoire aspired to by the editors of the fledgling men's magazines. Commercial professionals consolidated their philosophy via a working partnership with those other leaders of creativity, the coterie of independent journalists and metropolitan *flâneurs*. Such a convergence of

expertise opened the space for an understanding of masculinity which embraced not only the advertising industry, but also the adjacent spheres of marketing and retailing. The vision was of broad-based economic and cultural change. It is the mapping of this domain – its professional alliances, knowledges and codes of gendered competence – which extends our history of consumption in the 1980s.

2 The Age of Creativity

... the second half of the twentieth century might be dubbed 'The Age of Creativity' ... it is difficult to imagine how, now that it has gathered such momentum, the development of creativity could ever stop; and those already large industries which simultaneously depend upon and foster its growth will inevitably expand still further, for as far into the future as anyone can foresee ... the creative industries have mushroomed.

(Winston Fletcher, *Creative People*, 1990, p. 6)

Like the vocabulary of style employed by journalists at *The Face*, the concept of creativity was a loose umbrella term which was open to multiple interpretations. Its function was often symbolic or metaphoric. Fletcher was chairman of the agency Delaney Fletcher Delaney and President of the Institute of Practitioners in Advertising, the industry's professional body. As a self-appointed intellectual, he believed that the issue of creative awareness was nothing short of epochal. The horizon was now limitless. At the opening of his book he announced that history would applaud his own era for ushering in a qualitatively new approach to advertising.[12] Creative director at Bartle Bogle Hegarty, John Hegarty glossed the idea in more traditionally artistic terms. Creativity, he believed, was an expression of personal insecurity, for it was in a climate of self-doubt that the 'creative spark was forced and cajoled into fire'.[13] Speaking for the Burton retailing group, Sir Ralph Halpern was more prosaic. He insisted that creative people needed to be seen in employment terms as an essential part of any enterprise.[14] Halpern was referencing the sustained expansion of a whole range of experts, concentrated in the consumer industries, whose work involved the imaginative handling of goods and services.

Yet in the midst of these multiple definitions the creative idea was also developing more precise connotations in the mid-1980s. It was among so-called 'creative advertising agencies' that the term was used to argue for a specific reading of future consumer trends. Such claims were not universal; they were set

out by a particular grouping within the profession. Most of the key advocates were younger recruits within established companies, or members of newer firms, eager to gain recognition. Institutionally they sought to argue their case via a logic of progressive modernisation. Their polemic dramatised a number of important intellectual distinctions currently being made within the industry. It was these debates which were to have far-reaching effects on commercial perceptions of the consumer process.

Advertising agencies emerging in the mid-1980s frequently styled themselves agencies of the 'third wave', as opposed to those of the 'first' and 'second' generation. Leslie Butterfield, planning director at Butterfield Day Devito Hockney, one of the new breed of firms, argued quite precisely that the notion of the third wave was associated with networks set up in the boom year of 1987. Surveying the London advertising scene in the period, Butterfield distinguished between two camps.[15] There were the 'traditional agencies', often in American ownership, which had been the pioneers of British advertising in the 1930s, or in the immediate post-war years. Their attention to service was impressive, but they were associated with what he termed the 'gin and tonic' ethos of the old school (a reference to the establishment origins of a number of early British firms, through their links with the City and finance capital). The marketing campaigns of these organisations lacked analytical depth, while their creative output was professional but uninspired. It was structural weaknesses of this sort, Butterfield recalled, which had led to the emergence of a new wave of agencies in the late 1960s and early 1970s. Businesses of the calibre of Saatchi & Saatchi and Boase Massimi Pollitt had been founded on a strong creative ethos and their reputations had become the envy of the world. However, even here there were difficulties. Butterfield noted that creativity among second wave companies was often interpreted instrumentally, with consumers or end-users defined very narrowly indeed. The upshot was that, instead of advertising working to identify opportunities and open doors, options were unnecessarily restricted. It was against this background that the third wave agencies had made their mark. Butterfield argued that the newcomers had a clearer understanding of the overall business context within which advertising formed part of a total marketing package. They also interpreted the consumer on a wider basis than the user of a single product or product range. As he summed up: 'We think in terms of a broadly defined consumer target, which may include any number of potential audiences for our advertising.'[16] The discourse was expansive, with consumer markets conceived on an exceptionally wide scale.

Butterfield's characteristic reading of institutional developments within London's advertising world was one which saw successful business culture responding to, or anticipating, new consumer trends. His claim was that the third

generation agencies had a more effective product for 'the times' than traditional firms. As we shall see, such arguments rested on a highly particular, and often eccentric, reading of post-war advertising history. But the importance of this professional viewpoint did not reside in its claims to historical accuracy. Its significance lay in the way it provided a conceptual map for those sections of the industry which were eager to assert their reputation for interpreting the signs of commercial and cultural change.

What were the characteristic modes of advanced thinking within contemporary advertising theory? And how was this information used to reshape those commodities and retailing sectors associated with young men? There were different styles of analysis operating here, the product of particular specialisms. These forms of expertise were not always neatly demarcated, as in more academic practices. Commercial knowledge was frequently produced in *ad hoc* ways, dependent on the guesswork or personal enthusiasm of specific individuals. We have already seen how this type of intuitive energy drove the embryonic men's magazine market after 1986. Such a combination of factors makes the task of identifying the discourse of these professionals more problematic than in an analysis of more established experts. Nevertheless, a substantial part of the debate over creativity centred on two interrelated issues. The first of these addressed the question of how the world of goods was to be represented in the future; in other words, on the predominant *form* which commercial communications would have to take in recognition of shifting patterns of demand. This in turn raised a further set of speculations – about the new dynamics of consumption and, most importantly, about the changing aetiology of consumers themselves.

'What will the advertising of the nineties be like?' queried Stuart Bull, planning and business director at KHBB agency, in the spring of 1987.[17] His reflections paid tribute to Neville Brody's own analysis of the changing nature of information systems. Like Brody's, Bull's framework was exceptionally broad. He talked up a perceived shift in the whole meaning system attached to commodities – what he termed a movement from sense to sensibility. Rational argument, centring on the written message, was in the process of being displaced by what Bull described as 'emotional imagery'. Today there was more and more reliance on sounds and shapes, which tapped into the feelings of consumers, rather than on logical propositions. Such a qualitative shift in emphasis was justified on the grounds that the meaning of late twentieth-century consumption had itself fundamentally altered. The majority of consumers now affirmed their individuality through differentiation from the group, rather than via traditional patterns of status emulation. As a result, social statements were increasingly encoded as emotional symbols, rather than in the language of rationality. As Bull went on to explain: 'to be different, the consumer purchases a product on or around . . . signals that make

a statement about him or herself – about what *kind* of person they are in society, or would like to be.'[18] The retreat from meaning, to the expression of trust in feelings, symbolised the search for a 'style of life' rather than for a place in the social hierarchy. A challenge for the consumer industries, it demanded a much greater use of visual stimuli in commercial transactions. This was, Bull insisted, because visual culture enabled consumers' identities to be represented in far more complex ways than the language of written communication. These systems were not confined to local markets. Bull pointed out that they could reflect the emotional needs of individuals living as far apart as Brazil or Belgium, Norway or North America.[19]

Bull's blueprint for a new consumer was reinforced later the same year in research for the 'Project Badge' campaign, co-ordinated by Ogilvy and Mather. Organised as a piece of long-term forecasting, the project claimed to have mapped the different consumer generations of the post-war period via in-depth group discussion. Richard Auton, co-director of the research, noted that the 'new individualists' of the 1980s were far more critical and discerning about the wiles of manipulative advertising. They were also far more visually sophisticated than earlier cohorts of consumers. Auton concluded that the days of the 'hard sell' approach, with the adman cast as a social engineer, were numbered. Echoing Bull, as well as Hegarty's own definition of creativity, he concluded: 'The real analogy is with art. Art is benevolent. . . . We want to make advertising as much like art as possible.'[20]

Such professional assertions, on the nature of commercial aesthetics and the ways of speaking to the consumer, were characteristically grandiose. Hyperbole of this sort was a recurrent feature in debates about the rapidly changing nature of market-based societies at the time. Yet the creative concept did dramatise a set of more concrete changes underway within the advertising and marketing industries in the 1980s. As the third wave agencies saw it, the core problem confronting the whole profession was the massive increase in the levels of material provision since the Second World War. Bull put it succinctly. In a society in which large sections of the population now possessed basic consumer durables, such as fridges, televisions and washing machines, product awareness could no longer be based merely upon the acquisitive desire for possession. Traditional messages, of social improvement or price competitiveness, needed to be replaced by an approach which was more in tune with the demands of a generation of advanced customers. Today's advertisers needed to suggest philosophies of living and styles of behaviour, rather than simply pushing the product.[21] Arguments of this type were reinforced by a revitalised and expanded genre of market research, which profiled the psychological aspects of consumer behaviour and in particular the irrational determinants of choice. As Peter Sampson, an associate managing director of

Burke Marketing, explained to the profession in 1986, a quiet revolution was underway in qualitative research in Britain. Sampson's analysis echoed the marketing stance adopted by Sopp at *The Face*. The old cognitive map of motivation had been 'reasoned, rational and socio-normative'. It was being displaced by what Sampson referred to as a 'conative' project, which was diagnostic and aimed to get inside the mind of individuals. Emphasis was placed on those emotions and feelings which explained the 'why' of choice. The door was wide open for a more affective address to the consumer.[22]

Lifestyle advertising, or lifestyle consumption, was the concept most frequently employed to describe these reformulated principles of professional knowledge. The impact of this idea was most immediately visible in the imagery of a whole series of advertising campaigns. The privileging of visual and emotional systems of communication also meant that lifestyling was embraced by other adjacent experts, especially those associated with retailing. As Rodney Fitch, the director of Fitch and Co., the consultants responsible for promoting the retail chain Next, put it in 1985:

> ... the consumers' ideas, expectations and attitudes towards retailing, towards how they will buy, let alone what they will buy ... are all in a state of flux. ... High street shopping simply mirrors changes in our society, and one of the main changes is an increased expectation of quality.... To be successful, you have to be cognisant of the changes going on in society, and demonstrate that you are responsive to them ... design has become a part of these competitive retail strategies. Design is a visual thing, and therefore the end result is a visual change.[23]

Fitch's emphasis on design as an essential ingredient in the lifestyling package promised enhanced status for all those practitioners who claimed competence through their credentials of visual literacy. Stylists of the calibre of Petri, shop-fitters, window-dressers and the rest were all included in the revised code of consumption. Underlying such wide-ranging formulations was a series of specific institutional shifts in the power relations governing commercial culture. It was these changes which lay behind the redesigned advertising images and the re-dressed shop windows. Above all, it was the relation between advertising agencies and their paymasters, the clients, and between the various competing interests within the agency teams, which were transformed in the debate over lifestyling.

3 Creative People Mark Two

In his anecdotal profile of the advertising world, published in 1987, Martyn Forrester placed creative people at the top of the agency pyramid. In particular, it was the art directors, responsible for the production of sophisticated visual campaigns, who were awarded pride of place. Bought and sold like footballers, with transfer fees to match, Forrester confided that such individuals these days might earn as much as £75,000 a year. They were easy characters to spot, with their immaculately crumpled suits, or adopting the more casual style of leather jackets, Levi's jeans and designer stubble.[24] Fletcher's narrative of day-to-day life inside an agency, presented in his novel *The Manipulators* the following year, awarded similar status to creative teams, among the interest groups competing for the managing director's attention. In Fletcher's fiction, creatives, as they were usually known, were the real voice of authenticity, in a world otherwise peopled by charlatans.[25] Accounts such as these were circulated as part of the informal culture of the industry. They also projected the caricature of a recognisable advertising type. But the discussions touched on more than simply questions of image. What they referenced were the shifting contours of commercial and organisational power.

John Hegarty was explicit about a number of these professional changes. He declared that the most successful agencies of recent years (and here of course he included his own) were those which forced a separation between the advertising product and the corporate culture of the client. Agency directors needed more freedom of movement to interpret their brief. Customers were continually hemming him in, Hegarty complained. Clients were obsessive about issues which mattered little to the end result. Lifestyle imagery, he insisted, had everything to do with the assertion of the independence of the advertising profession, which ultimately was in the interests of both the agency and the clients.[26] Adhering to this philosophy, Bartle Bogle Hegarty was one of the first firms to abandon the costly but time-honoured procedure of client pitching. This was the system whereby agencies competed to present examples of their work to prospective companies before final selection. If the track record of a firm was sufficiently distinguished, Hegarty maintained, such pandering to customers was unnecessary. David McLaren, managing director of Collett Dickinson Pearce, underlined Hegarty's point: 'there are clients ... who think they have to crack the whip. In fact, they're missing the whole point.'[27]

This move towards greater autonomy by a number of prominent agencies was accompanied by a series of internal realignments within the culture of advertising.

It was no accident that the lifestyling discourse crystallised and rearticulated professional tensions within many businesses. The greater use of what Bull termed 'emotional imagery' called for the enhancement of certain forms of expertise above others. It was the creative team – and in particular the art director, versed in visual codes – which was now seen to triumph. 'Late eighties advertising is clearly trying to establish its own era,' enthused Peter Nowlan, managing director of the Image Factory, about the lifestyle concept in 1987. Again echoing Brody's design ideas, he went on: 'It is an era which belongs to art directors rather than to writers, primarily because we're all privileged to be living through the Design Age.'[28]

The most immediate casualty of this growing ascendancy of visual experts was the copywriter – the purveyor of the written message. Inasmuch as the new forms of advertising claimed to disavow rationality in favour of aesthetics, the role of the written communicator was cast as secondary. Other more powerful players within the firm were also temporarily dislodged, as a result of the enhanced role of the creatives. Here the partial losers were the financial managers. Throughout the post-war period account personnel had been viewed as the backbone of any company. Their claims to authority were guaranteed by their control over the firm's balance sheets. They were also entrusted with the critical financial negotiations between an agency and its clients. In advertising argot they were 'the suits'. This was the slang deployed chiefly by creatives to denote not simply the executives' sartorial style, but also their symbolic power. Tony Brignull, joint creative director at Collett Dickinson Pearce, recalled how his own apprenticeship in the advertising business in the mid-1960s had involved a stern education by the accounts team. An account director sat him down and drew a circle, describing the role of the financial managers: 'It was like Galileo's view of the universe, with him at the centre and other functions radiating off it.' As Brignull complained, despite all their claims to uniqueness, in the 1960s and 1970s creatives were still perceived as: 'the proverbial mushrooms – kept in the dark and fed on shit!'[29]

In the 1980s the ennobled status of the creative team was made possible by the demand for a different style of advertising, which promised added value through what was perceived to be a more sophisticated approach to commercial communications. Inside the firm, agency directors also drew on élite definitions of creativity, originating in fine art, in order to bolster their claims to rank. Like the style leaders, advertising professionals claimed an aesthetic pedigree. As Paul Arden, joint creative director at Saatchi & Saatchi, made clear at the beginning of 1987: 'Advertising is just as pure as any other form of creative work.'[30] This insistence was usually made to counter familiar accusations from fine artists that advertisers were simply hacks, who had 'sold out' in matters of principle, driven only by the prospect of material gain. Creatives responded by pointing to the

growing number of established photographers, television and film directors who were moving into advertising. Figures of the calibre of fashion photographer David Bailey, and Terry Green, director of the TV series *The Sweeney* and *Minder*, were attracted to agency work, it was noted, not simply by the cash rewards, but because of the potential opened up by a challenging advertising brief. As an established commercial practitioner himself, Bailey spoke out in 1987 against the division between advertising and art as a false dichotomy. His most recent promotional work had been for the environmental group Greenpeace, in its anti-fur trade campaign. Poets and painters had been paid throughout history, he declared, there was no difficulty in reconciling creativity with the market for goods.[31]

Rhetoric of this sort was deployed not only to enhance the role of the creatives; it was also used to consolidate a professional aura. The argument was that creative people were different; that their brief demanded styles of life and modes of behaviour separate from the stiff business culture of managers, account directors and their clients. It was an argument which did not go unchallenged. Many figures within advertising's senior management found these demands frustrating. They associated such claims with the perceived irresponsibility displayed by some creatives (including a failure to meet commercial deadlines) and their disruptive effect on office routines. Wally Olins, chairman of Wolff Olins, complained from bitter personal experience that: 'The most irritating aspects of working with creative people are their arrogance, their egotism and their total self-centredness, their feeling that the world has to revolve around them, that time doesn't exist'.[32] David Ogilvy, chairman of Ogilvy and Mather and father-figure to the British and American advertising worlds, was even more scathing in his attack. Agencies on both sides of the Atlantic, he fumed, were now infested with characters who regarded advertising as simply an avant-garde art form. Never having sold anything in their lives, they bamboozled unfortunate clients into parting with millions of pounds a year to exhibit their feeble originality.[33] However, other executives counselled patience and forbearance. Michael Grade, chief executive of Channel Four television, believed that criticism was not the best way to maximise the efforts of creative teams. Greater understanding was needed – of the imaginative processes and their function within commercial enterprise.[34] The issue came back to what Fletcher consistently referred to as the uniqueness of the creative product. Creativity could not be mechanically produced to a formula, for each and every idea came into existence on a one-off basis.

The rise to prominence of the creative team was stimulated by the demand for a different style of advertising. It also related to the fact that the new forms of communication were perceived to be marketing a distinctive type of product – what was referred to as the 'creative commodity'. These were goods which led the

field in terms of innovation. They were especially important in the clothing sector and in other areas of personal consumption. Yet they presented their own problems for traditional conceptions of market research. Fletcher acknowledged that the textbook definition of marketing was one which began with consumer preferences and then worked back to the manufacturer. But creative products were in the business of *initiating* taste changes, rather than simply following them.[35] Forecasting patterns of demand was notoriously problematic, Fletcher went on to argue, not least because the majority of consumers were hopelessly vague when it came to predicting their own future preferences. At this point Fletcher drew on the concept of taste leadership, familiar from Logan and Sopp at *The Face*. Most creative goods, he insisted, were first acquired by 'tiny minorities of the population', or *cognoscenti*. Established procedures of market research were not sufficiently nuanced to map the subtle shifts within these product fields. The most powerful sales generator was often word-of-mouth publicity. Under such circumstances the creatives within the advertising agency became privileged as powerful communicators, linking retailers and manufacturers with élite purchasing groups. They were understood to function in precisely the same way as the talented individualists at the style press. Creatives' views and opinions were therefore sought on two counts. Viewed as possessors of the necessary flair to shape the new forms of advertising imagery, they were also cast in the role of opinion formers themselves, by virtue of their own patterns of lived culture.

The language of creativity was a powerful ingredient in the revised code of advertising in the 1980s. Enshrined in its rhetoric were a number of concrete changes – at once commercial, aesthetic and professional – in the organisation of the industry. A new generation of agencies celebrated these developments, both as the key to their own success and as the way forward for advertising as a whole. Yet change was not simply driven by business dynamism. It was also generated by arguments about significant transformations taking place in the nature of consumer demand itself. It was in the adjacent field of marketing that such debates were particularly urgent. How did commercial culture grasp these shifts? And what effect did their theories have on perceptions of the male consumer?

4 Splinter Groups, Factions and Tribes

The most expansive statements about the future of consumer society came from one particular sub-domain of marketing. This was the field of predictive research,

or forecasting. Pronouncements about the changes currently affecting consumption patterns were pitched at the highest levels of abstraction. Concepts of this type often involved incursions into areas of contemporary social theory. Researchers raided a number of academic disciplines – most notably sociology, anthropology and the burgeoning interdisciplinary field of cultural studies – to advance their cause. Semiotic analysis and linguistic deconstruction, together with up-to-date thinking about the structures of postmodern or post-industrial society, were recurring themes. Rupert Howell, managing partner of Howell Henry Chaldecott Lury, applauded this new intellectual agenda. He confided to *Campaign* in 1988 that all businesses needed 'lessons in cultural studies', for business gurus now spoke of culture as a key component in gaining the competitive edge.[36] The crossovers between commercial and academic forms of knowledge were themselves stimulated by the growing number of social science and humanities graduates entering marketing. New recruits were attracted to the profession not only by the promise of high salaries, but also by the atmosphere of glamour accruing to this sector of commerce in the 1980s. One important effect of the theoretical *putsch* was to intensify a debate about the changing nature of the consumer process. A number of these ideas were rehearsed by The Henley Centre for Forecasting. Their influential report, *Planning for Social Change*, released in 1986, canvassed many of the arguments:

> Something very important is happening to the authority structure of our society.... It is our view that deference to traditional authorities in Britain has now hit an all-time low. After years of the ideology of individualism ... 'production side values' have fallen into low esteem.... Nowadays, we no longer know our place.... But does this imply the absence of any authorities at all? The answer is no. Whilst the authority of class, of the production side of life, has declined, that of the consumption side has risen ... we talk of a more discriminating form of materialism in which, in essence, the motive has changed from one of seeking to keep up with the Joneses to one where we are seeking to keep away from them (so to speak). The authority we tend to use for this is from within rather than external.[37]

We have already encountered Henley's work in our preliminary survey of the consumer industries. The Centre was founded in 1974 and rapidly gained a reputation as an ideas-based business consultancy. Throughout the later 1980s Henley produced quarterly studies of leisure usage, analysed sector by sector. But their accounts were always framed by broad structural arguments about the nature of economic and cultural change. It was this fusion of empirical detail with general theory which made Henley's findings so important for other marketing and advertising businesses. Under a general argument about the ascendancy of

consumer-led value systems, the Centre ran together a series of speculative hypotheses about the decline of collective solidarities. The demise of the ethos of production, together with a corresponding rise of a reformulated code of individualism, was generating a more internalised hierarchy of authority. It was the self, Henley claimed, which now functioned as the highest court of appeal.

Shadowing these arguments, as it continued to shadow much contemporary marketing theory, lay the vexed question of social class and its declining relevance for the positioning of goods. Two years after Henley's report, one of the agency's research team, David Bradbury, ran a special feature on the subject. Again based on the findings of an empirical survey, Bradbury's conclusion was that British people no longer viewed class as a source of pride. It now figured as one of the least important social priorities respondents used for running their lives. Well beaten by concerns over health, family, physical appearance, clothes and education, the assertion was that as class declined other more sectional interests dominated.[38] Bradbury's research echoed sociological writings on the character of 'post-class' societies, pioneered by intellectual figures such as Daniel Bell and André Gorz. His analysis also registered more immediate political influences. Bradbury noted the growing impact of aggressive Conservative government policies promoting individualism and curbing collective forms of association, especially in the aftermath of the miners' strike, 1984–5. Overall, however, Henley's priorities were commercial. Their claim was that economic, demographic and social change had shattered the established principles of consumer knowledge. Shifts in population spread, in income, class structure and gender relations, together with a rapid recomposition of cultural aspirations – all of these things were forcing marketers to revise a model of consumption based on the comfortable fixity of social roles.

Such edicts claimed authority by virtue of their statistical proof. In fact they were extremely speculative, driven by a mixture of popular sociology and crystal ball gazing. To what extent did Henley's arguments inform marketing analysis closer to the ground? Here we need to move to more specific genres of research. In April 1987 *Campaign* announced the programme for a one-day seminar at the Cavendish Conference Centre in London, entitled 'Classifying People'. Discussion at the event turned on the changing way in which consumer profiles were being mapped.[39] Like The Henley Centre, speakers insisted that the stable building-blocks of post-war consumption had broken down. Solid identities had fragmented into a bewildering array of tribes, which many of the recently established agencies hyped as splinter groups, or interest constituencies. In today's 'lop-sided world' the advertising team was left with the problem of how to address these new commercial personas.

One of the guest speakers at *Campaign's* seminar was Peter York. With York

we return to the central position occupied by youth in this reformulated discourse of consumption. A self-appointed guru of the concept of market segmentation, York first rehearsed his theory about a new breed of consumers in relation to the break-up of the teenage sector. His series of essays, *Style Wars*, 1980, and his outrageous treatment of the London gentry in *The Official Sloane Ranger Handbook*, 1982, polemicised for a wholesale reassessment of youth culture. The contemporary scene, York argued, was no longer unified by a coherent sense of what it meant to be young. In west London alone there were: sloanes and macho gay clones, yuppies and puppies, preppies, young fogeys, retro-rockers and rockabillies, rude boys and born-again skinheads. Identities were being continually reformed around an ever-expanding number of icons.[40] York's ideas were part of the cluster of concepts drawn on by the style entrepreneurs. What was institutionally significant about his position was that he bridged this world and the more commercially oriented sphere of marketing. He was precisely the type of intellectual who carried information about the changing contours of the youth market from an avant-garde coterie into mainstream business.

York was an iconic figure for the younger generation of hopefuls working at the youth magazines. In manner and appearance he traded on a baroque presentation as the last of the English gentlemen. York began his journalistic career in the mid-1970s, writing for *Harpers and Queen*. Slightly later he penned occasional articles in *The Face*. By the middle of the following decade he had forced an entry into marketing, with his own management consultancy network, SRU. At *Campaign*'s seminar he produced an innovative reading of consumption, based around the idea of diversified markets. York was upbeat about the possibilities inherent in the new situation. Agencies needed to respond to the challenge with a radically different approach, attuned to late twentieth-century consumer profiles. Along with the traditional socio-demographic maps, research into styles of life and cultural attitudes now needed to feature far more prominently on the agenda of marketing and advertising businesses. We have seen how Elms, who was himself one of York's acolytes, traded similar explanations. As Elms never tired of repeating, youth had disintegrated into splinter groups, factions and tribes.[41] Both Elms and York drew the same conclusions from the fall-out. The future lay with sophisticated niche or placement marketing, directed at the proliferating identities. Used effectively, such an approach could deliver endless retailing possibilities.

York and Elms advanced their cause by ambitious polemic. They claimed professional attention on account of their much-vaunted grassroots contact with contemporary youth trends. But such analysis was also underwritten by more cautious commentators, working inside mainstream marketing organisations. 'You need an interpreter to talk to kids these days', quipped the London planning

consultancy Holder and Scorah in 1984, an agency specialising in youth research.[42] Nick van Zanten explained to the advertising world that the splintering of this market into numerous sectors, divided by age and social position, meant that brand loyalties were now extremely volatile – especially among boys.[43] A year later, the managing director of Holder and Scorah, Susan Holder, underlined the point. Among the 13 to 19-year-old age group alone there was a plethora of consumers: individuals in school, within higher education, living at home, single and independent, married or even parents. Speaking to so many diverse constituencies, via any one single consumer category, was impossible. Difficulties were exacerbated by research findings which pointed to the transitory commitments of these young people to the various major media. Holder, who had co-authored the report on the youth sector, *Too Much Too Young?* in 1981, concluded that it was no wonder the teenage marketplace was increasingly littered with failures.[44]

In the late 1980s these debates about market segmentation were given enhanced credibility by the publication of a series of in-depth research studies, which claimed to detail major changes taking place in the attitudes and behaviour of young people. The marketing organisation Mintel published its special report, *Youth Lifestyles*, in 1988. This inquiry charted the ascendancy of what was termed a new personality type. Advertisers and retailers were told that young adults who had grown up in Mrs Thatcher's Britain adhered to a value system in which enterprise, achievement and self-help were the highest goals – though they were complemented by an equally strong emphasis on personal relationships and stable family life. It was among young men in particular, the report argued, that these contemporary traits were most pronounced.[45] The following year Euromonitor produced an even more ambitious map of the culture and identities of the young. Its two-volume survey, *Young Britain*, projected seven ideal types, which aimed to capture the range and diversity of the contemporary youth scene. At one pole were 'the conformists', with lives dominated by a long-term search for personal and financial security. At the other end of the spectrum came the hedonists, or what Euromonitor dubbed the 'life's a party' crowd. This was a group with strong drives to enjoyment, low levels of social responsibility and a habitus predominantly in the Midlands and the south-east of England. In between was a plethora of types: 'alternatives' and 'intellectuals', as well as 'high achievers'.[46] What was significant about these projects was not their claims to statistical accuracy. The marketing industry was important because it assembled a range of typical or formulaic personalities which suggested solutions to the confusing debate over young people. The implicit conclusion was that, with the dramatic splintering of identities, retailers and manufacturers needed to rely more heavily than ever on professional research.

5 Bartle Bogle Hegarty:
An Agency With 'Attitude'

In the advertising business one agency in particular drew together these multiple trends within consumer theory. This was Bartle Bogle Hegarty (BBH). An intellectual voice within the industry, in the late 1980s the company acquired a powerful reputation for conceptual thinking. Founded by the breakaway group from TBWA Advertising in 1982, BBH rapidly established itself as an impressive newcomer, winning international corporate accounts from the German motor manufacturers Audi (with their famous 'Vorsprung durch Technik' campaign) and Pepsi Cola, as well as from the British grocery chain, ASDA. An 80 per cent increase in profits during 1985–6, together with even more impressive figures for the following year, fuelled rumours of an impending public flotation for the company on the London stock market. In 1986, when it scooped forty prizes for outstanding work, BBH added an in-house media department and design consultancy to its advertising portfolio.[47]

'A flair hard to beat,' proclaimed *Campaign* in its celebratory profile at the opening of 1987, after BBH became the magazine's agency of the year.[48] Notions of 'flair' condensed many of the tropes of creativity and marketing awareness characteristic of the newer agencies. The firm had an established reputation for robust independence, typical of the creative enterprise. BBH was what one commentator termed 'fussy' about prospective clients. In 1986 it terminated contracts with Bush Radio and Courvoisier Cognac, as a result of what the annual report termed 'growing incompatibility'.[49] The ill-fated, left-of-centre newspaper *News on Sunday* received the same treatment a year later. Professional and economic independence was also asserted in BBH's emphasis on the need for 'sympathy' between itself and prospective customers. It was a bold stance, but one which clearly commanded respect. Peter Cover, of Audi UK, admiringly summed up the BBH team: 'They are not sycophantic, they don't indulge us at all.'[50]

Many of the leading players joining the agency between 1985 and 1989 were recruited from creative backgrounds. A number of art directors and copywriters achieved rapid promotion to the status of company directors, breaking into the charmed boardroom circle of account managers and other executives. At the same time, younger members of the account management team were supportive of the company's approach to marketing.[51] BBH's role as an educational force in the drive towards a new advertising code was in large part due to the work of its creative director, John Hegarty. Hegarty himself was no newcomer to the industry. He had begun his career in 1965 at the age of 21, with a junior post at

the American-owned agency Benton and Bowles, alongside the young Charles Saatchi. Reviewing his early years, he recalled that he and others like him were part of a generation who actively chose to enter the expanding profession: 'we weren't just passing through.... We actually wanted to be in advertising.'[52] Hegarty's stubborn commitment to the principles of creative innovation were not always welcome in these early years. They had earned him the sack from Benton and Bowles in the late 1960s for being what he himself termed 'a pain in the arse'![53] Nevertheless, he continued with his idiosyncratic approach, working for a variety of agencies, including Saatchi & Saatchi.

The creative team which Hegarty drew together at BBH had a reputation for stylish and superbly executed work, with a heavily art-directed emphasis. It was seen by its critics as bordering on the precious, lacking a hard commercial edge.[54] But Hegarty argued repeatedly for the extension of the artistic formula, even to products usually understood to lie outside the creative pitch, including political advertising. Most significantly, the language of creativity endowed him with an evangelical sense of mission. He explained that the lifeblood of any agency lay in its continuing ability to take risks, both in the recruitment of staff and in the execution of a client's brief. As Hegarty himself saw it, companies needed to avoid getting stale by continually hiring 'new young people', who would do things in a different way. Whenever he was interviewing prospective employees he always posed two questions. They were: 'Is he our sort of person?' and 'Does this man have our standards?' Hegarty did not want a version of corporate man. Rather he sought out individuals who would share his experimental vision. Just as much as running a profitable company, he valued working with a group who had 'attitude' and 'point of view'.[55]

Bartle Bogle Hegarty's stance on consumption was polemical. The company projected a very particular reading of the role played by culture within contemporary advertising. Equally important was the agency's stress on gender. When Hegarty talked of recruiting *young men* with high artistic standards to his team, this was precisely what he meant. These issues return us to the question which has driven our account of the intellectual developments within agency culture in the 1980s; namely, the effect of the new philosophies on the commercial understanding of masculinity. We can begin to trace these influences in one of BBH's most celebrated campaigns.

In 1986 the American clothing company Levi Strauss opened the new year with a pan-European advertising burst. Their aim was to re-launch their 501, red-tab, button-fly jeans to the youth market.[56] Young men in the classic 16 to 24 age range were the main target of this offensive. Backed by a £4 million budget, the company engaged Bartle Bogle Hegarty for their assault on Britain and the rest of Europe. The centrepiece of the campaign involved two meticulously planned

television commercials. Both were exquisitely shot narratives, redolent with mood and atmosphere. What viewers saw on their screens ran as follows.

'Bath' began with a deliberate evocation of nostalgia in sounds and images. The arm of an original Dansette record player was lowered on to the vinyl, to a version of Sam Cook's 1960 soul classic, 'What a Wonderful World'. The accompanying visual background was deliberately vague, but the connotations were of a post-war apartment block in some vaguely American cityscape. The hero was also from that early moment of nascent youth culture – a James Dean-type loner who stood out from the crowd. Working out to the music, or glancing wistfully at his girlfriend's photo, the camera cut to a series of close-ups of the youth's body. Naked torso, thighs and crutch were momentarily freeze-framed as he slipped into his jeans, slowly buttoning the flies. The story ended with a still image of the individualist, clad in this toilette, personalising his Levi's product. Sliding into the bath, he narcissistically posed, while drinking Coke (plate 19). The second advert, 'Launderette', depicted a more public landscape of consumption. The image of a beefy, uniformed GI, along with other establishing shots, again of post-war America, panned to the entry of another youth, now in a Laundromat. The atmosphere of expectancy and authenticity was enhanced by the sound track, this time drawn from Marvin Gaye's 1968 Motown hit, 'I Heard It Through the Grapevine'. The young blood with Latinate good looks checked his image in the faces of a giggling female audience. Stripping to his boxer shorts, he slung his 501s into the machine for a customised wash. As he undressed, the camera again moved in close up, fixing the product with a rapid scan over the model's bum, waist and thighs (plate 20).

'Bath' and 'Launderette' ran for three months, strategically placed between contemporary youth viewing slots, such as Channel Four's soap opera, *Brookside*, and their music review programme, *The Tube*. They were backed by a year-long cinema screening and a substantial press campaign. The press work was carried primarily in *The Face*, with additional material appearing in the rest of the style press. They ran a variant of the themes announced in the television commercials, but with a different nuancing. Immaculate images of Levi's jeans were arranged alongside artefacts styled by international fashion leaders such as Gaultier and Paul Smith. Designer watches, loafers and leather jackets set off Levi's product in bleached wood or matt-black surroundings, to produce heavy signifiers of connoisseurial taste. They referenced an élite culture whose meanings were only recognisable to those 'in the know'.

Levi's choice of BBH as the agency best placed to handle their account caused a stir within the industry. Their preference for a company which was still seen as a relative newcomer, as opposed to one of the large established networks, was influenced by BBH's rising reputation for creativity. Negotiations with the firm in

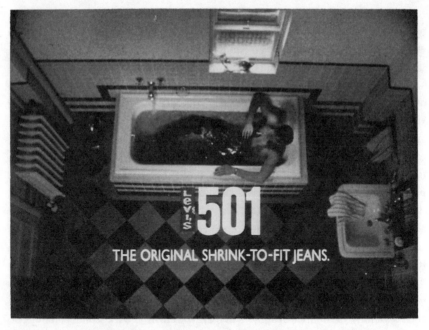

Plate 19 From 'Bath' television commercial, Bartle Bogle Hegarty for Levi's, 1985

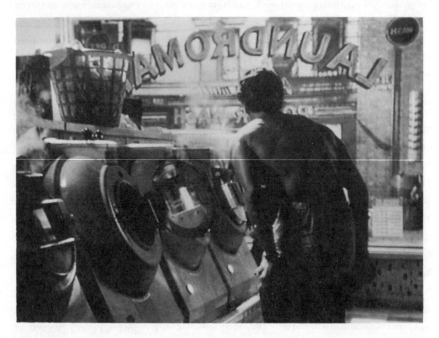

Plate 20 From 'Launderette' television commercial, Bartle Bogle Hegarty for Levi's, 1985

the summer of 1985 involved more than a routine overture at the beginning of a new campaign. They were driven by an element of panic. Levi's had a profound image problem. The company had first traded 501s to British youth in the early 1960s. The product had rapidly acquired a cult status, later featuring in the Victoria and Albert Museum's 'Boilerhouse' exhibition of the hundred best products.[57] Challenges from American competitors Lee and Wrangler in the 1970s had forced a marketing rethink. But Levi's decision to diversify into casual clothes had proved disastrous. In the early 1980s it was common knowledge among manufacturers that the firm's market share had slumped. The company was left with what Peter Shilland, their public relations manager in Britain, described as an 'unappealing £9.99 sweatshirt image'.[58]

The advertising brief was strategic; to reposition Levi's against its competitors by foregrounding the authentic value of the product. Tim Lindsay, BBH's account director at the time, put it succinctly. The approach was 'to convince people that 501s were the right look and the only label you should be wearing'.[59] 'People' here condensed the range of customer profiles which the agency aimed to speak to in their carefully crafted campaign. BBH drew heavily on the concept of niche-marketing, and on the theories of style leadership, to formulate the plan. Lindsay underlined the influence of the market segmentation debate when he spoke about three distinct groups targeted by his agency's advertising: 'stylists', 'early adopters' and 'young men in the street'.[60] In a heavyweight intervention in *Media Week* in 1988, marketing analyst John Preston gave his own exposition of this familiar theory. Evoking *Punch*'s famous cartoon of the nineteenth-century class system, Preston explained that much contemporary consumption was disseminated via osmosis, beginning at the top of the taste pyramid and slowly filtering down to the base. At the pinnacle were 'the innovators'. These were consumers who bought from the designer *haute couture* range and read the fashion press. Moving down the scale were the 'early adopters', those fashion-conscious but less individualistic consumers. At the bottom of the pile came the also-rans. Theirs was essentially the sphere of the mass market.[61] BBH's thinking behind the campaign for Levi's was to use different genres of the media to target these specific constituencies. If the ultimate aim was to prepare the product for a large market, then Preston was also emphatic about the importance of the *cognoscenti*. Like Sopp and Logan, he identified a small, but highly influential, coterie whose values needed to be reflected by promotional culture.

The alliance of creative advertising and marketing with the avant-garde discourse of style was evident at every level of BBH's influential campaign for Levi's. The synthesis of these two approaches to consumption was present as much in the intellectual planning as in the imagery, which was drawn on to represent young men to themselves. Hegarty himself had long been interested in

the concept of style leadership. Commenting in 1985 on the growing visibility of publications like *The Face* and its rivals, he noted: 'Much of what is in these mags is unreadable but the message is not in what you say but how you look.'[62] Advertisers needed to take careful note of the achievements of the new-wave magazines, he went on, because they were the most effective way of reaching fashion leaders. Hegarty's art-directed commercials raided the vocabulary of the taste élite. Retrospective imagery, drawing on the icons and artefacts of earlier moments of youth culture and reinforced by music, was integral to his overall aim: to achieve classic branding via *mise-en-scène*. The creative director's gloss on his use of this heritage montage was telling. As he put it, the past could be very acceptable, but it had to be 'relevant to what's going on now'.[63] Effectively packaged and 'air-conditioned', retro style could enhance the personal qualities of the brand, reinforcing the message that the jeans were *your* 501s.

At the heart of these efforts to establish cultural value was the representation of masculinity. Dramatic images of the male physique anchored Levi's product. The bodies of both television models were displayed clothed, encoded in and through the commodity. Close-up shots of face, skin and more private parts achieved a double effect. Surfaces were eroticised and dissected. Sexuality was evoked in the fragmentation of the body, via the fetishised display of the jeans. For these effects BBH drew heavily on the formula rehearsed by Ray Petri in his style narratives. It was no accident that the model used for the 'Launderette' commercial was Nick Kamen, already established as one of Petri's own favourites. The visual result was both intimate and showy. The looks and glances given off by the models invited two different kinds of spectatorship. Narcissistic self-dramatisation – the incitement to look self-consciously and to be looked at – was coupled with a more public ritual of commodity spectacle. Moreover, the look inscribed in these exchanges, between the actors and their imaginary viewers, suggested a knowingness about something more than a desired product. Like Petri's photo-shoots, the dialogue was redolent with the shared knowledge of a specific culture of masculinity.

Bartle Bogle Hegarty scored an impressive success with its campaign for Levi's. Sales for the product rose by 700 per cent in 1986. At Levi's factory in West Lothian, workers were put on eighteen-hour overtime shifts.[64] Almost immediately the advertising images spawned a set of 'me-too's', or copies, not only from major jeans competitors, but from other manufacturers, convinced that BBH's model could be raided for use in adjacent sectors. Hair-gels, shaving and toiletry products, as well as clothing and footwear, were all subjected to the new formula.[65] In the late 1980s a wide variety of commodities aimed at young men were marketed according to this personalised regime of representations. The significance of these campaigns was more than simply product-based. In

microcosm they testified to the rapid convergence of a number of quite different strands of business strategy. Creative advertising, placement marketing, the visual and aesthetic imperatives of style – the scrutiny of young men was not the result of 'consumption' *per se*, but rather a product of this complex tangle of alliances. Knowledge about masculinity was generated at the intersection of these forms of expertise. There was, however, one further twist to this commercial narrative of gender. It had less to do with marketing concepts themselves than with the more personal and intimate belief systems which sustained the consumer industries. As with the editorial team at *The Face*, the informal cultures of masculinity and femininity had significant effects on the ideas about gender aired in the marketplace. Unravelling the interconnections between professional practices and private philosophies involves some review of the sexual politics of advertising during the period.

6 Gender Trouble

Advertising has frequently been cited as one of the 'new professions' of the twentieth century, differentiated from established vocations such as the law or medicine by its career structure and its codes of social honour. With a relatively unrestricted recruitment policy and a youthful and predominantly meritocratic profile, agency culture in the 1980s presented a dynamic and flexible environment. The report, *Women in Advertising*, commissioned by the Institute of Practitioners in Advertising in 1990, believed that the profession was short on prejudice and tradition and long on risk-taking.[66] And yet, as the study puzzled, why was it that women had made so little progress over the previous thirty years, especially in the upper strata of management? And why was sexual discrimination – and in some cases more extreme forms of sexual harassment – still rife? Despite the fact that women accounted for almost half of all employees in advertising, they formed only 14 per cent of the membership of boards of directors. There were only twenty-two female managing directors and chief executives in the country. Of the thirty-one executives at BBH holding the post of company director between 1986 and 1990, as few as five were women. In contrast, the secretarial and cleaning staff of agencies were almost exclusively female.[67]

The *Women in Advertising* study was a sustained expression of professional anxiety about the gendered state of the industry. With evidence taken from both senior and junior men and women across more than twenty agencies, its recommendations called for an end to discrimination, both at the level of

recruitment and promotion and in its subtler manifestations as sexist working practices. The report was the culmination of more localised discontents which had erupted throughout the previous decade. These ranged from protests about the representation of women in advertising, and about the treatment of female consumers, to arguments about the industry's career structure. The 'sexism in advertising' debate, as it became known, was initially received by male professionals with a mixture of shock, outrage and amused contempt. But despite such resistance, it was undeniable that the question became more and more pressing during the 1980s. Undeniable, too, was the negotiated impact of feminism on the exposure of sexual inequality. Feminist campaigns were most visible in the struggles over sexist advertising. From the late 1970s more and more agencies had seen their work 'defaced', as Gail Kemp, associate editor of *Campaign*, put it in 1984, with those 'little stickers' making the point: 'This ad degrades women.' As Kemp pointed out to readers, political graffiti, together with sustained education by the women's movement, had certainly made 'people' think more seriously about the portrayal of gender and sexuality in advertising.[68] Growing institutional take-up of feminist readings of media power added further fuel to these exchanges. In January 1984 a TUC report on sexual stereotyping pointed the finger at the active connivance of advertisers in the restrictive portrayal of women. In May the Women's Committee of the Labour-led Greater London Council (GLC) gained press notoriety, when they succeeded in persuading London Transport advertising to tighten regulations governing the presentation of women in adverts at sites on buses and on the underground.[69]

Feminist interventions had the capacity to raise the temperature of debate and frequently the level of intellectual analysis. Yet such arguments could be kept at arm's length by advertising professionals. Feminism was cast as culturally distant by commercial practitioners, partly because 'feminists' did not represent an influential group of consumers – at least not in Britain. Advertisers' time-honoured riposte to the demands of sexual politics was to insist that their own role was heavily circumscribed. Advertising merely reflected the current state of society; it did not actively initiate social change. To do so, as senior management never tired of pointing out, would be to lose sight of the primary duty of salesmanship – to listen and *respond* to the consumer. But as the pace of argument quickened, well-known male figures became less balanced and more emotional. They hit out at the latent authoritarianism which, they claimed, lay beneath the surface of the feminist agenda. Tim Delaney, of the Legas Delaney agency, responded angrily to the GLC initiatives. They were, as he saw it, 'the worst element of left-wing politics' at work. 'Arrogant' and 'patronising', Delaney compared such policies ominously to what he termed the 'book burning syndrome'.[70] A.E. Pitcher, President of Ogilvy and Mather UK, expounded to the

Council of Europe's seminar on sexual equality in the media in 1983 that the industry needed to beware of trying to dictate social attitudes. It was not the function of the profession to influence cultural values.[71] Nor, he went on, were advertisers wise to listen to these 'superactive feminists', epitomised for Pitcher by women such as the journalist and writer Germaine Greer. This group was unrepresentative of women as a whole. They were, he pointed out, largely professional young women. A high proportion of them were single, separated or divorced – in other words, living 'independent of men'.[72]

If the demands of the women's movement could be dismissed, what was much more disconcerting for advertising professionals was the critique of sexual discrimination coming from within their own ranks. A series of internal studies reported that the industry was increasingly seen as conservative on gender issues, in ways which had significant implications for commercial ventures. This was an altogether more serious charge. It suggested that advertising was failing in its professional brief – to interpret current social trends successfully. Research compiled by Kitty O'Hagan, planning director at GGK London in 1986, pointed to a widening gulf between the world-view of a predominantly masculine profession and the consumer expectations of the majority of women. Advertisers were caught in a 'time-warp', O'Hagan suggested. They were on a par with the crustiest gentlemen's club in Pall Mall. Operating with the most conventional forms of gender stereotyping, they failed to recognise the rapid changes which were transforming women's lives and their self-image.[73] Television soap operas had kept pace with these shifts far more effectively than advertising. The commercial consequence of this mismatch was very worrying, O'Hagan concluded. Millions of pounds were being poured down the drain on campaigns which missed their target audience by miles!

Complaints of this sort called for a critical process of self-examination by the advertising industry. Not surprisingly, it was women members of agency teams who sustained the pressure for change. Their early efforts were generally mild-mannered; a fact which testified to the strength of masculine culture within the profession. The informal pressure group Adwomen, originally formed in the 1960s with the aim of gaining acceptance for women 'on a level footing with male colleagues', felt the need strenuously to deny accusations of a feminist agenda. Maria Kay, 'chairman' in 1987, insisted that members needed to retain their 'femininity and charm, without which an executive woman can become hard'.[74] Professionals were highly sensitive to the dangers of being branded feminists within their organisations, or even of raising women-only issues. This discreet balancing act, between the desire for equality and the need to maintain status credibility, confronted women across the professions as they struggled to negotiate the impact of feminism.[75] Within advertising, they were more likely to

be 'taken seriously' by male colleagues when they couched their criticisms in commercial terms. This approach avoided potential accusations of political militancy. By revealing business ineptitude and cultural stagnation in the way in which advertisers handled gender issues, such arguments suggested that the industry's much-vaunted claims to contemporaneity lacked substance.

One immediate consequence of this process of gendered critique was that the debate over women's issues gradually began to receive greater attention within agency culture. But the arguments about sexual politics went wider. Raising the profile of women also stimulated a flurry of speculation about men – and in particular about the nature of a business regime which excluded and marginalised women. As the *Women in Advertising* report concluded, equality would not simply materialise with the passing of time. The obstacles were structural. The rules of the industry were themselves implicitly masculine. As a result it was hardly surprising that men found it easy to occupy positions of power.[76] This growing scrutiny of masculinity, beginning in the early 1980s, occurred at precisely the moment when the more adventurous agencies were developing their new approach to young men. The timing was not coincidental. The commercial targeting of masculinity and the increasingly volatile nature of gender relations within the profession existed in a symbiotic relationship.

What were the specific codes of masculinity which were privileged within the agency teams? The *Women in Advertising* report reviewed the dominant character of this world. Contemporary advertising, it insisted, was a demanding business, full of 'awkward, unco-operative, unreasonable people with large egos who seem to respond better to bullying than to reasoned logical argument'. 'Jockeying for position', as the report termed it, was an integral part of the rhythms of both the office and the boardroom.[77] These codes of self-advancement were extended to the more informal networks of socialising and entertaining. Most companies placed a heavy emphasis on out-of-hours hospitality. From business breakfasts and late-night dinners, to social outings and sporting events – these were leisure activities where existing client relationships could be cemented and new customers secured. Attendance at functions of this sort was deemed essential for anyone hoping for promotion. Finally, the report admitted that contemporary advertising was no longer genteel. Since the 1960s, a more open policy of recruitment for men had displaced an older gentlemanly ethos by an altogether more irreverent style. As the Institute of Practitioners confessed, advertising was now a young, almost disrespectful business, in which self-conscious vulgarity, bad language and sexual innuendo were commonplace.[78] Such rituals were by no means unique to the profession. But they did encapsulate a very particular lifestyle which privileged a decidedly masculine world-view.

When women were admitted to this professional culture they were usually

depicted in one of two guises: either as honorary men, equipped with formidable clout, or as 'ladies', who had retained the trappings of femininity. *Campaign* profiled one example of the former type. Anita Davies, at the agency DDB Needham, was a force to be reckoned with, because, although 'very pleasant', she called 'a spade a shovel' and was 'as tough as old boots'.[79] The *Women in Advertising* study argued that, given the hegemony of male culture, it was hardly surprising that 'advertising woman' displayed rather more 'male characteristics' than women in general. Yet it went on to note that a younger cohort, joining firms in the 1980s, was more confident than women of previous generations.[80]

The rapid expansion of the advertising industry in the 1980s appeared to herald a major advance for women – especially in the sphere of creative production. This at least was the optimistic logic rehearsed by Fletcher and others in the halcyon years of growth.[81] It did not materialise. In the creative departments of art direction and copywriting women made least progress at all levels. Significantly, they were much more numerically visible in the management areas of account handling and planning, than in those fields designated as artistic and imaginative. The relatively meritocratic career structures of bookkeeping and administration presented fewer barriers to women. The creative sectors, on the other hand, appeared to operate as a male closed shop.[82] Women who had succeeded against the odds pondered the issue. Barbara Noakes, creative deputy at BBH under Hegarty in the late 1980s, believed that women's longstanding exclusion from creative teams had much to do with discriminatory recruitment policies, dating back at least twenty years. But she also speculated that the very nature of creative education displayed a masculine bias.[83] What Noakes was touching on was the way in which access to the fields of art and design education was itself historically structured along gendered lines. As we have already noted in our encounter with Neville Brody, notions of male creative genius (or more prosaically Hegarty's notion of 'attitude') continued to exert a powerful influence on teaching in fine art and graphic design courses well into the 1980s. It was these areas which provided the major recruitment pools for creative departments. New employees carried this version of male skill with them into the agencies, thereby reinforcing its power across the generations. This form of creative culture disadvantaged women, but its effect on contemporary philosophies of masculinity was altogether more productive.

Publicity profiles of creative sections usually depicted them as teams or duos. In the 1980s professional partners were photographed in their design studios, where young or 'youngish' men posed artfully against minimalist backgrounds. The award-winning team at Bartle Bogle Hegarty – art director Mark Denton and copywriter Chris Palmer – were one such combination.[84] Beneath these immaculate public images, however, lay a series of more contradictory messages about gender identity. Many women testified to the way in which creative networks

functioned as sites of male bonding, in which teamwork was secured through forms of homosociability. One anonymous woman member of a creative team complained that many departments openly boasted that they contained outright misogynists.[85] Kiki Kendrick, herself a successful creative artist, believed that it was the specific working conditions in these areas which told against women. As she expressed it: 'It's the only job in advertising where you work very closely with the same person. Given the choice, most men would rather work with another bloke.' Experience told her that men would 'never fully relax with a woman'.[86] And yet, among the men themselves, their public image was of precisely a 'relaxed', 'modern' stance on personal identity and social relationships. Indeed a 'cool' or 'laid-back' attitude was one of the hallmarks of this section of the profession, differentiating creatives from the more formal and upright personas displayed in other advertising departments. These personal philosophies of living paralleled similar formations which we have charted among the style entrepreneurs. It was this post-libertarian outlook which influenced creatives' attitudes to women colleagues and shaped their approach to the new advertising campaigns aimed at men.

✗ How did such personal beliefs inform advertisers' views about young men and consumption? Again there were strong similarities between this group of professionals and the style leaders. Both constituencies shared an optimistic belief in the power of commercial society. The market was seen as unstoppable in its inexorable movement to transform personal identities. The case for the beneficial impact of consumption on men's lives was reinforced by drawing parallels with the perceived effects of commodities on women's experience since the 1950s. As Barry Day, vice-chairman of McCann Worldwide summed up in 1985, just as in earlier decades 'female freedom and free enterprise went hand in hand', so now a similar process of liberation was under way for men.[87] The libertarian perspective was especially prominent when discussions turned to sex. Barry Brooks, creative director of Astral Advertising, recounted a familiar Whiggish history. He believed that the post-war years had witnessed a genuinely progressive unfolding of sexuality. This was exemplified, he claimed, in greater freedom, and more sexualised images of men and women in advertising.[88] The rhetoric of commercial dynamism made particular sense for creatives, as it did for the style leaders, because it reinforced a notion of themselves as professionals who were at the cutting edge of cultural as well as artistic change. A liberalised stance on masculinity – provided it was driven by consumer demand and not by the disruptive noises of feminism – fitted comfortably with their vision of a modern and vigorous entrepreneurial culture.

It was in this way that personal aspirations and professional knowledge were intertwined in the commercial debate about men. The negative effect of the

creative formula was that women continued to be marginalised from the advertising brief. At the same time the process precipitated a greater self-consciousness about masculinity. It was this double movement about gender which lay at the heart of advertising culture during the period. There were limit positions, however, to the liberal stance; boundaries which many within the industry believed it was unwise to transgress. Once more it was the figure of the male homosexual who policed the edges of discussions over the new forms of advertising. And again, personal anxieties frequently masqueraded as professional arguments.

Neil Saunders was the senior planner at Grey advertising, one of the agencies responsible for a number of the experimental commissions directed at young men. During the late 1980s Saunders became a focal point for opposition to this genre of commercials. Reviewing the various campaigns in the spring of 1990, he warned that the unequivocal championing of the new man carried with it 'all sorts of ambiguities'. The changed advertising scenario was presenting problems, especially for the less enlightened majority, whom Saunders championed as 'men's men' or 'conservative men'.[89] Voicing anxieties similar to those already sounded in the editorials of *Men's Wear* about contemporary fashion, Saunders and his colleague at Grey, vice-chairman Scott Sherrard, struck back. With growing irritation, Sherrard pointed the finger at a range of images which suggested the positive pleasures of a homosocial lifestyle for younger men.[90] Saunders also mounted an aggressive attack on the recent Halifax Building Society's advertising for instant card cash, which depicted bachelor-living in an urban apartment. He voiced his concerns obliquely in *Campaign*: 'Many men ask what is wrong with the guy in the Halifax ad because he lives on his own.'[91] As an account planner, he hinted that the difficulty was not simply the result of enigmatic imagery. The problem pointed back to the 'doubtful masculinity' evinced by some members of the creative teams themselves. It was these personal ambiguities, Saunders claimed, which were having adverse effects on the creative end-product. Ogilvy was more explicit about the issue. In the new preface to his *Confessions of an Advertising Man*, republished in 1987, he noted approvingly that one angry manufacturer referred to the current breed of art directors and copywriters as nothing more than a bunch of 'mincing pansies'![92]

Men like Saunders and Ogilvy hoped that their interventions would help to draw the line under what they felt to be the more 'hysterical' experiments of the 1980s. Grey's report, produced in 1990 (which clearly revealed the guiding hand of Saunders), called on advertisers to return to more conventional masculine iconography, in the interests of both good taste and profitability. Their research, conducted among 700 men aged between 16 and 64 across the social classes, revealed significant insights. Rapid cultural change among some groups, the

report insisted, had produced conflict and tension, both between different cohorts of men and at the level of individual psychology.[93] A larger study from Simon Sylvester, planning director at Burkitt Weinreich Bryant, advanced a different argument. Sylvester claimed that most of the excitement over the new man was misplaced. Such enthusiasm was largely a figment of the all too vivid imagination of advertising professionals, he made plain. His report marshalled a range of evidence, partly drawn from official statistics, to insist that there had been little discernible shift in men's roles. On issues such as participation in domestic labour, or sexual attitudes to women, change among men had been far slower than was currently believed. Sylvester's scepticism was intelligently argued. His research drew attention to the glaring gulf between advertising imagery and realities on the ground. But his intervention into sexual politics was heavy-handed and conservative. As he naively summed up, advertisers needed to forget the 'thin veneer' of contemporary culture, which had produced only superficial change among men. Creative strategies needed to be re-thought to target the basic instincts of the 'caveman' within![94] While such arguments were ostensibly made in the interests of marketing common sense or balance, they also touched on acute personal sensitivities. For many within the industry, creative advertising produced during the period was perceived as an affront to their own masculine sense of self.

7 Next for Men

We have established that the commercial scrutiny of masculinity in the 1980s was complexly driven. The forces which targeted young men were themselves wide-ranging and diverse. This alliance was driven not only by professional philosophies, but also by more intimate and personal perspectives on gender. Yet despite their much-trumpeted involvement in the marketplace, the stance of the advertisers and marketers at one level remained abstract and theoretical. They were the self-proclaimed savants of consumption. Principally concerned with the conceptual understanding of markets and symbolic communications, they were removed from the actual process of selling goods. The enhanced role awarded to these experts in our period was a testament both to the growth of their particular forms of knowledge and to a more explicit intellectualisation of the world of goods. But it would be misguided to read off processes of change from their discourse alone. It is here that we need to investigate a different moment in the consumer cycle. Moving from commercial ideas, generated in the agency or the design

studio, to retailing at the point-of-sale produces a more complex picture. At the level of salesmanship on the shop floor there was rarely any smooth implementation of a grand plan. What occurred was a process which was much more piecemeal and *ad hoc*. More often than not, retailers grafted elements of the new consumer theory onto established patterns of trading, juggling the latest ideas with much more traditional priorities. This was especially the case when they were working not with a model of the avant-garde consumer but with larger markets. One of the much-vaunted success stories of the decade, the Next retailing group, provides a significant example of these negotiated outcomes.

Reviewing the year in the Christmas edition of *Men's Wear*, Thom O'Dwyer pronounced that 1984 was set to go down as the moment when British men's fashion re-established its leadership role, after two decades of mediocrity. Evoking an earlier period of national pre-eminence, O'Dwyer argued that not since the 1960s had Britain been so closely watched by the international fashion world. A new, exciting generation of designers were giving menswear a big push. Echoing contemporary marketing debates, O'Dwyer claimed that men's clothes were no longer simply a matter of utility, or even of style. They now registered an aesthetic, even a moral sensibility. As he shouted, fashion today did not simply mean the clothing one wore, it was a state of mind, 'an attitude, a complete lifestyle'.[95] Sentiments such as these were echoed across the range of fashion journalists in the mid-1980s. *The Guardian*'s fashion editor, Brenda Polan, also claimed comparisons with the 'peacock revolution' of the 1960s, only this time, Polan insisted, the changes were supported by a thoroughgoing professionalism and a sound commercial base.[96] Fashion writer Belinda Morris believed that the 1980s were distinct from earlier periods of innovation. Today's dominant fashion concept was 'mixed', she enthused. There was a baroque synthesis of design styles and colour combinations, the blurring of hitherto rigid distinctions separating men's and women's wear and a growing cross-fertilisation between high fashion and the mass market.[97]

Rhetoric of this kind was of course the stock-in-trade language of fashion commentators. Their brief was to introduce periodic bouts of innovation into the clothing market, with a view to stimulating demand. However, the contemporary changes celebrated by O'Dwyer and his colleagues were specific. Sales of men's and women's clothes had fallen dramatically in the recession of 1979–81. What was noteworthy about the subsequent recovery was the strength of menswear sales. These findings were confirmed by more general statistics pointing to a modest rise in the amount of disposable income outlaid by men on clothes.[98] Equally significant was the fact that the *sites* of fashion influence were changing, as the sector itself was restructured. The design impresarios of *haute couture*, like Gaultier, now borrowed more obviously from street style and from the plethora of

creative talent which clustered in the field of popular culture. Many of the most innovative developments in fashion retailing were spearheaded by the mid-market chain stores. Paramount among these was Next for Men, created in 1984.[99]

Founded by the Liverpool retailing entrepreneur George Davies in 1982, as an offshoot of the former menswear multiple Hepworth's, Next began life retailing to 'smart, better-off women' in the 25 to 35 age band.[100] Davies himself explained that the company's original aim had been to exploit a glaring gap in the market between the non-fashion statements given off by Marks and Spencer on the one hand, and upmarket outlets such as Jaeger and the customised boutiques on the other. Next's emphasis was on good quality, classic styles in a co-ordinated range at the right price.[101] This winning combination remained central in all subsequent developments. Expansion over a six-year period at first sight read like a blueprint of the new consumer theories, as Next became synonymous with the so-called 'high street revolution' of the decade. Diversification was trumpeted as the key to growth. The firm's name suggested permanent change, mixed with impatience and vision; a compulsion to leap-frog the present into an ever-expanding future.[102] After Next for Men came a torrent of projects, all of which rang the changes of niche-marketing. There was Next Too and Next Collection in 1986, designed to segment women's wear sales into 'the working woman's wardrobe' and more individual fashion choices. The following year came Next for Boys and Girls, accompanied by a host of other shopping concepts: Next Interiors, 1985, Next the Jewellers in 1988, together with Next Directory, a revamped version of home-shopping. As Davies announced euphorically to the *Financial Times* in the middle of this expansionist push: 'there are no limits to segmenting the market into different approaches.'[103]

Advertised as centre-stage at Next for Men was a variant of the lifestyling formula. It was Davies' belief that successful change hinged on a total rethink of the men's clothing market – its retailing imagery and design solutions, but above all its address to the customer. As Davies always responded, when asked the question: 'Who is the Next Man?' this individual was not exclusively defined by age or social position but by his lifestyle.[104] It was the reason, explained the managing director, why the 'image factor' was so important in redefining menswear. Looking around the sector in the mid-1980s, Davies believed that consumer demand was running far ahead of the tired formulae perpetuated by the trade. British men had outgrown the 'conservatism' of the post-war years, he declared. They now had the freedom and confidence to experiment with fashion. The difficulty was that for those consumers unable to afford the price of designer clothes, options were limited. This was especially true outside London, where the industry was largely served by elderly gents, perpetuating 'years of stuffy and ill-fitting tradition'.[105] Davies' assessment of the current state of the market was

clichéd and over-general. But it provided him with the blueprint for his own retailing concept. The aim of Next was to float a series of icons of masculinity which reflected contemporary social mores.

Davies always maintained that the strength of successful retailing rested on the solid foundations of effective supply. (We should add that in the case of Next it was dependent on the founder's ability to charm the banks into advancing him almost limitless funds.) The company established supervision over the manufacturing process, emphasising the importance of consistent quality, flexibility and careful product development. Early computerisation of sales returns and stock controls opened the way for more precise merchandise planning.[106] In the mid-1980s Next's leading position was not only the result of these business systems, it was also underpinned by a coherent cultural strategy.

The company's efforts to develop a fashion statement for younger men rapidly became associated with an identifiable social type – the yuppie, or young urban professional. The *Investors Chronicle* believed that Next's success was largely due to the emergence of the new identity. The journal's reading of this much-discussed phenomenon was distinctive. The 'baby boom' generation of the 1950s and early 1960s were now in their mid-twenties. Despite continuing high levels of unemployment, it was pointed out that many of this youthful cohort were now in well-paid jobs in the expanding financial and service sectors. The 'fun clothes' of the 1970s were totally inappropriate for a new generation of the would-be affluent. The demand was for 'respectable' work wear, with a touch of fashion in the styling.[107] Next for Men offered a wide range of formal and casual clothes: trenchcoats and cashmere blazers, satin-revered tuxedos and patchwork sweaters. The chain was most strongly associated with the revival of the suit and its cultural symbolism. The 'double-breasted look' – slightly exaggerated shoulders, loose fitting, full jacket in shades of navy, grey or black – became Next's hallmark. After more than a decade of decline 'the suit has staged something of a recovery', observed the *Financial Times* in 1987. And, as the paper noted, the move back to formality registered a shift in social attitudes. Younger men were not only 'style conscious', they had also become more culturally 'conservative'.[108] Fashion designer Paul Smith, who himself worked with variants of the 'suited look', made an explicit connection between the revival of formal dressing and the sea-change in the political climate. The work ethic fostered by the Conservative government had instilled in the young a notion that they should not simply *be* successful, but that they should *be seen* to succeed. For young men, as well as for young women, appearance was no longer viewed as superficial, it had become a tangible demonstration of self-worth.[109]

This visual code for men was strongly present in much of Next's advertising in the later 1980s. The double-page spread placed in the August–September 1989

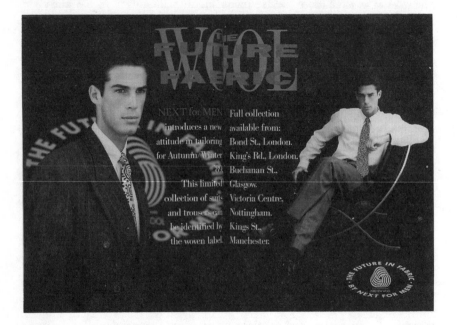

Plate 21 'The Future in Fabric', advertisement, Next plc and the International Wool Secretariat, *GQ*, August–September 1989

edition of *GQ* magazine (plate 21), in conjunction with the International Wool Secretariat, featured characteristic images to accompany articles on 'A Gentleman's Wardrobe' and on 'International Business Style'.[110] With its deliberate play on the financial markets, 'The Future in Fabric' projected two complementary snapshots. In the left-hand spread the half-length shot profiled a young man dressed for the city or the corporation. Poised and upright, his striped, double-breasted suit was buttoned – set off by a crisp white shirt and boldly patterned tie. With hair swept back, his determined face was brightly lit. But unlike the men in Petri's work or in the Levi's images, this model did not meet the viewer's gaze. Instead his eyes were fixed intently on a serious project in the middle distance. The other photograph suggested an interior setting. Seated in a boardroom-style chair of black leather and chrome, the young executive was intent on some business deal. With suit jacket off, his posture was tense and alert. He gripped the seat with one hand, while the other was lightly clenched. This time the model did confront his audience, but with authoritative eye-contact which demanded an answer. His clothes were generally sober – regulation white shirt, sharply creased grey-flecked trousers and black buckled brogues. What Davies termed 'the hint of style' was carried in the colour of the model's brightly patterned tie. The written copy played up the twin themes of poise and status: 'Next for Men introduces a new attitude in tailoring. ... This limited collection of suits and trousers can be identified by the woven label.'

Next's lifestyle formula for men was evident not only at the level of its advertising; it was also enacted in the design and fitting of its shop interiors. Space in the stores was coded to present a clearly defined environment. At the opening of the company's flagship premises, in London's Kensington High Street in 1984, it was announced that the new shops would be 'more sophisticated' than any previous venture. The aim was to recreate the 'leisurely atmosphere of a private dressing room'.[111] For the dominant motif in their retailing formula, Next drew on an older icon of the menswear trade; the image of the English gentleman, with his connotations of status and assurance. The new shop interiors were designed to 'reflect solid masculine virtues', which were reinforced by the use of traditional materials to promote a feeling of uncluttered space.[112] Flooring at Kensington High Street was in a combination of woodblock and terrazzo tiling, while fittings were in American cherry timber with marble facings. Merchandise was arranged so that customers were guided round the store in a 'natural and logical flow'.[113] The aim was to present a gentleman's wardrobe, with a complete collection of clothes. As the trade magazine *Retail* noted approvingly, changing rooms were spacious; gone were the 'poky, sweaty caverns', which 'alienated and degraded the customer'. The fitting area at Next was equipped with large mirrors, together with chairs, coffee tables and fashion magazines. Despite the borrowings from French

and American design concepts, the overall feel was pronounced to be 'very English'.[114] Next's approach to retailing deliberately evoked the atmosphere of a more leisured past, reviving an ambience of gentility. The visual style capitalised on the current nostalgia for things Edwardian, which was epitomised in the Merchant Ivory film revival of E.M. Forster's novels, such as *A Room With A View*, 1985 and *Maurice*, 1988.

And though the focus was on men, shopping at Next was also presented as a shared experience, a form of 'togetherness' for the modern couple, as the *Daily Express* gushed.[115] Advertising and store sitings promoted Next for Men as a mirror-image of Next women's wear. Shop openings in Romford and Reading in the spring of 1984 worked with this strategy, for as press statements announced: 'men and women (or at least their clothes) complemented each other beautifully.'[116] The aim was both practical and ideological. 'Twinned' stores would, as Davies explained, help to draw in the male partners of 'Next women'. The company was responding to contemporary market research, which pointed up women's continuing influence over the clothes shopping habits and the taste patterns of their male partners and relatives.[117] The overall retailing formula worked with a contemporary version of gendered complementarity, in which the pleasures of private life were secured via consumption.

Such was the grandiose blueprint for retailing projected by the company during its years of growth. The formula appeared seamlessly transparent. The new commercial philosophies promised limitless opportunities for enhanced profitability. The collapse of George Davies' proto-empire from 1988 – the result of a fatal combination of misplaced financial optimism and promiscuous spending – signalled an imminent downturn in the retailing sector. Next's difficulties were exacerbated by a much more unstable trading climate which heralded the onset of recession.[118] But it was not simply worsening economic conditions which revealed a more contradictory picture. Next was never quite the total manifestation of the new consumption which Davies and his management team proclaimed. Even during its expansionary period, company strategy was in reality a complex affair – a mixture of well-tried retailing policies and more innovatory techniques.

Davies' own biography illustrated this integration of the conventional with the new. Though hailed as a contemporary hero, receiving *The Guardian*'s accolade of Young Businessman of the Year in 1985, he had forged his career in the mass-market trading conditions of the 1960s and 1970s. Davies was a larger-than-life character who retained a buoyant outlook, regardless of the vagaries of the business cycle. Joining the department store chain Littlewoods in 1962, he made his name in children's wear. It was this knowledge which he carried to his own business, School Care, a mail order children's clothing company set up in 1972. When this institution folded three years later he was undaunted. He moved

on to Rosgill's Pippa Dee operation, which traded in home fashion to women. All Davies' early experience was at the bottom end of the market, working with bulk selling and tight profit margins. This business acumen was not jettisoned at Next. Reflecting on his early career, he remarked: 'It sounds boring, but it gave me a real taste for business.'[119] Davies' strategy at Next was guided as much by the intuitive knowledge gained in his early years as by more precise marketing information. He also displayed many of the characteristics of a traditional entrepreneur. As he put it in 1986:

> The priority is to keep building and never see a horizon. I am ambitious and have a lot to achieve. I am driven as hard today as I was four years ago. I want to keep doing things which are creative in retailing.[120]

Davies saw his company as a family team, with himself as the benign patriarchal head. He believed that the strength of his own expansive personality was the driving force behind Next's expansion.

For all the stress on segmented customer profiles and visionary retailing, Next continued to operate within a very traditional framework. The company was essentially a middle-market chain which prospered, as its director acknowledged, because management worked with the 'big picture'. The big picture involved selling to familiar consumer profiles, established long before the concept of market diversity. As Davies glossed it, Next's customer base was 'B, C1 ... and C2 customers'.[121] Company reports to shareholders also played up the company's image as a major clothing multiple with nationwide coverage. Ultimately, the organisation was in the business of creating more than a niche. It aimed for the largest share of the market.[122] This traditional emphasis on mainstream operations extended to the firm's message to its customers. Davies confided to the *Daily Express* in 1984 that part of the effectiveness of Next was that men of all ages and tastes were able to identify with its merchandise. A 40-year-old father was made to feel as comfortable in the store as his 18-year-old son.[123] Moreover, the touch of style which positioned the group upmarket from other clothing chains was never allowed to become exclusive. The company avoided any suggestion of avant-garde pretentiousness. Next spoke to young men with a conformist outlook. It was 'for those without the boldness to create their own look'.[124] There is little hard evidence of precisely who bought from Next during the period, but a reading of the company's marketing formula pointed to younger men in white-collar office work and service sector employment. Such customers looked for a mildly individualised fashion statement, balanced against an ethos of collective cultural conformity. As *Retail* magazine summed up: Next was the place to go for men where they couldn't 'get it wrong'.[125]

8 *Plus ça Change*? Commerce and Masculinity in the 1950s

Retailing at Next yoked together a dramatic formula for innovation with a very traditional approach to merchandising. The persistence of these established commercial strategies, amidst all the noise of cultural revolution, raises an important question over the claims made for the 1980s. To what extent was this discourse of consumption actually new? And how far did its address to younger men mark a significant break with earlier regimes of gender and commerce? Establishing the precise nature of the changes which were laid down during the decade demands a temporary break with our narrative. We need to situate these contemporary shifts within a broader historical understanding of the post-war consumer industries and their engagement with masculinity.

The commercial professions have themselves been notoriously uninterested in their own history. In the 1980s what dominated their concerns was an obsessive presentism, whereby transformations in consumption were understood to be driven only by the issues of the moment. When advertisers and marketers did examine their projects in the context of longer-term trends, their dominant idea was one of perpetual innovation. This account understood change as both cyclical and totalising. It was a variant of the more generalised image of the consumer revolution, which we have identified as a recurring motif in accounts of modern society. While such explanations made sense for many of those working in the consultancies and agencies, they militated against any developed historical sensibility. Repeated claims made for this state of permanent revolution prompted one elder statesman of the advertising industry, John Hobson, to question whether anything significant had changed at all. As Hobson put it in 1986, reviewing his own career, not constant change but perhaps *plus ça change*:

> Looking back on over fifty years in the agency business, I am constantly struck by the fact that, although so many peripheral factors have changed, the basic character of agency life is much the same as in 1930 when I first joined.... The same battles rage between the executive and the creative side; the media departments are still wheeling and dealing, though in different ways; the clients still seem to prefer the agencies with creative notability to those which concentrate on the marketing and selling theme; there is still no recognition that a brilliant presentation of the wrong selling story is much worse than a straightforward rendering of the right one.[126]

Conceived as a relaxed retrospective, Hobson remained agnostic about the

professional rhetoric of progress and modernisation which dominated his field. Yet the high point of Hobson's own career, in the mid-1950s and early 1960s, provides an incisive point of comparison with the 1980s. This earlier moment was also a time of significant change in the consumer industries. New forms of commercial expertise were proclaimed by a distinctive cadre of professionals. As in the 1980s, these shifts were concretised around an identifiable series of types or personalities. One of these was the male consumer.

The expansion of British advertising from the mid-1950s can be attributed to a number of interlocking factors. General conditions of post-war economic growth, especially in domestic markets, encouraged an upsurge of knowledge and information dedicated to the stimulation of demand. Freed from the general constraints of austerity, and the specific government controls placed on advertising expenditure throughout the late 1940s, agencies augmented their services, while a spate of mergers and acquisitions testified to a period of intense economic activity.[127] This atmosphere of buoyancy was complemented by an outpouring of professional writing about the theory and practice of advertising. Reviewing the late 1950s and early 1960s in their book *The Persuasion Industry*, 1965, journalists John Pearson and Graham Turner defined those years as a period of 'increased volatility' for those who sought to grasp the changing nature of commercial communications.[128] Such volatility has conventionally been ascribed to a double set of influences: the 'Americanisation' of British advertising culture and the impact of commercial television. Yet though the aggressive London takeovers by a number of American-owned multinational companies certainly reshaped the infrastructure of the domestic industry, their conceptual influence on British advertising was more mediated than has frequently been argued. There was no simple process of American hegemony at work in the developments underway among leading British agencies.[129] Furthermore, as Pearson and Turner themselves insisted, while television advertising after 1955 played an important part in professional reformulations, change was broader-based than the impact of any one new advertising medium.[130] Fundamentally, it involved a revision of established expertise, especially on the issue of how best to speak to the consumer.

An initial reading of advertising's intellectual developments in this mid-century period tends to confirm significant parallels with the later moment of the 1980s, though we should be cautious of exaggerating the similarities. Above all, it was the growth of a school of new agencies, with definite ideas about how the profession needed to respond to shifts in consumer demand, which evokes the most obvious comparisons with what occurred later. In familiar terms, these initiatives were grouped under the concept of creativity. In the late 1950s the connotations of this idea were predominantly stylistic and aesthetic. The notion

signalled a subtler approach to the representation of commodities. Media sociologist Jeremy Tunstall, writing in *The Advertising Man*, 1964, attempted to redefine the advertiser as a 'consumption engineer', who dealt in messages and symbols which were increasingly remote from the actual manufacture of goods.[131] Traditional arguments that consumers needed to be given a rational 'reason why' they ought to buy a product now looked increasingly irrelevant, he insisted. In contemporary advertising jargon, which prefigured later debates, 'hard sell' was to be replaced by 'soft sell'. As Tunstall pointed out, it was among a new breed of art-based professionals – notably copywriters and art directors – that the call for change was strongest.[132] Their argument was that contemporary advertising needed to work indirectly and tangentially, to establish connections between goods and key symbols of social prestige or individuality.

It was polemic of this type, about advertising's appeal to the emotive elements in human behaviour, which provoked the much-publicised contemporary attacks on the insidious nature of affluence from intellectuals on both sides of the Atlantic.[133] But the actual influence of commercial formulations on the direction of British advertising in the 1950s was far more prosaic. One of the leaders of the coterie of new agencies was John Hobson's own company, John Hobson and Partners. Founded in 1955 by John Metcalf and Hobson, the firm rapidly established itself as an intellectual presence within the industry. Pearson and Turner described the company in awed tones. It was composed of those 'dedicated men with the core of inner certainty, the men who really know'.[134] By the time the business had been renamed Hobson Bates and Partners, as a result of an American takeover in 1959, it was acknowledged as a conceptual leader in the field. Hobson's erudite approach to advertising theory in many ways prefigured Hegarty's own stance thirty years later. His highly influential text, *The Selection of Advertising Media*, 1955, commissioned by the Institute of Practitioners in Advertising, laid out his arguments in full. Acknowledging that the profession was 'still an inexact science', Hobson believed that, in addition to a battery of quantifiable data on markets and audiences, agencies also needed much 'more complete knowledge on the working of the mind and the emotions'.[135] As he went on to explain, this was necessary because advertising dealt with issues which were far more intangible than simple cost factors and levels of coverage. The critical element was what Hobson termed the 'atmosphere' of the message.[136] Atmosphere essentially involved subjective indicators; in particular the mood of consumers and their emotional response to products. While other features could be measured, 'atmosphere' demanded a more 'intuitive and perceptive' approach.

It would be wrong to overestimate the influence of this new form of advertising theory. It was by no means universally accepted. For David Ogilvy, reviewing recent trends in 1963, 'plain language' and sound informational content remained

far more critical to the professional's brief than what he dismissed as mere 'technique', or aesthetic intangibles.[137] Nevertheless, agencies such as Hobson Bates or Robert Sharpe and Partners were representative of a distinctive current within British advertising from the late 1950s, in which emotive and creative factors played an important role. A spate of celebrated television and press campaigns, for commodities as diverse as cars, cigarettes, food products and lager beers, testified to the impact of this formula. Advertisements designed by the London Press Exchange for cars and motor fuels were among the earliest British attempts to sell via the triple utopias of modernity, sex and status. Their 1963 account, 'Getaway People', for National Benzole, carried the message of 'petrol for the with-it people', the 'people who did good things'.[138] While the vision of the new Ford Anglia car, produced in the same year, was anchored by the caption 'Beauty with Long Legs', accompanied by an image of a veiled and aloof woman with bare midriff. A different language of modernisation was evident in J. Walter Thompson's long-running narrative about 'Katie and the Cube', for Oxo Ltd. Beginning in 1958, the agency told an ongoing tale about the domestic adventures of a young, modern housewife and her husband Philip – a family on the lower rungs of the executive ladder, who were decidedly 'semi-detached people'.[139]

Among Hobson Bates' contribution to these campaigns were two commercials addressed to younger men. Their acquisition of Ind Coope's Double Diamond pale ale account, from the London Press Exchange in 1963, involved an upgrading of the product. The traditional format of beer advertising (what was dubbed the masculinity of the saloon bar) was displaced by more modern codes of manliness. 'Double Diamond – the Beer the Men Drink' pictured men in a world of 'affluence and jet-age leisure': surfing, parachuting, water-skiing and mountaineering.[140] The emphasis was on virile, energised images. A contrasting stance was adopted in the agency's Strand cigarette advertising for W.D. and H.O. Wills which had appeared three years earlier. Here the individuality of the 'youth generation' was captured by an atmosphere of 'loneliness'. What John May, a member of Hobson's team, who coined the successful slogan 'You're never alone with a Strand', suggested was a 'hyperconsciousness', an 'entirely independent way of living' among the young.[141] Echoing the 'loner' theme pioneered by Hollywood cult figures such as Marlon Brando and James Dean, the actor in these cigarette commercials, Terence Brook, was shot in a variety of states of solitude. In one Strand advert he was filmed leaning against the wall of London's Chelsea Embankment, in another standing on a deserted Brighton beach. In both cases the settings reinforced what May termed a symbolic style of independence.

Atmospheric advertisements of this type reflected the soundings taken by market researchers on the social transformations which they believed had been set in train by the post-war upsurge of consumption. Central to these discussions

were the linked themes of status, gender and individuality. Much has been written about the cultural ramifications of affluence, but much less is known about the ways in which the commercial industries registered these changes at the level of their own systems of knowledge.[142] Like their counterparts in the 1980s, Hobson and his contemporaries were working to forge a different language of consumption, in response to what was perceived to be a changing cultural and business environment. Hobson's own musings on the marketing criteria used for the analysis of class were informative in this respect. Acknowledging that the conventional five status gradations, A to E, remained a touchstone for the industry, he nevertheless insisted that class categories were in urgent need of revision. Echoing the writings of New Left thinkers such as Raymond Williams and Edward Thompson, Hobson insisted that class now needed to be understood not simply as an economic indicator, but as a cultural variable, involving ways of life or 'lifestyles'.[143] Moreover, markets and consumer preferences were complicated by the emergence of what he termed 'special-interest groups', defined by age, or by leadership position within the community. Hobson's point was reinforced in a report issued by the Market Research Society working party in 1963, which concluded that growing professional confusion about the issue of class was in part the result of its ever-expanding reference points within the social sciences.[144] Professional debates on the questions of youth and gender complicated these speculations even further.

It was hypotheses such as these which stimulated a flurry of interest in young men as consumers. From the mid-1950s, advertisers and retailers produced a diverse range of information about the character and status of younger men. Histories of this period of commercial change in masculinity have usually been written from one dominant standpoint. They have been delivered as celebratory narratives about the arrival of style culture. The impact of avant-garde and subcultural influences has been seen as the major factor in generating a new range of personas for young men.[145] Yet as in the 1980s, closer inspection of this mid-century moment points up the ways in which mainstream advertising and marketing also played a pivotal role in the cultural refurbishment of masculinity. Menswear retailing again provides an illustrative case study of these consumer strategies in action.

The years 1953–4 were a key moment of change for the men's clothing industry. In a series of spectacular takeovers and mergers household names disappeared and new ones emerged, while fresh faces appeared in the boardrooms. Reviewing this frenetic activity, *The Times* noted that the reorganisation which followed involved something more than the familiar economies of scale. There was also a more modern approach to salesmanship. A surprising note of individuality was being sounded across the market. There seemed to be a flight

from uniformity; the whole aim was to get away from the atmosphere of regimentation which had dogged men's clothing in former times.[146] *Men's Wear* echoed the changes. Shop windows were getting livelier, colour touches were coming in, there was even the hint of a 'feminine angle'.[147] Since the end of the war men's attitudes had undergone a sea-change; the strait-jacket of dress formality was now pronounced dead.

Here, in embryo, was an early statement of the theme of cyclical innovation which was to dominate Next's own approach to retailing thirty years later. Fashion journalists, trade commentators and manufacturers joined forces to sing the praises of the British male, whose discerning taste demanded a constant round of fashion. The first serious salvos in the industry's campaign to reshape men's sartorial attitudes were launched by the newly established Publicity and Promotions Committee of the Wholesale Clothing Manufacturers' Federation after 1956.[148] This was no avant-garde grouping; it represented the influence of the large clothing multiples. The explicit brief was to stimulate demand. Despite a pronounced upturn in many sectors of the consumer economy in the mid-1950s, men's outlay on clothes had remained stubbornly static.[149] Seeking professional advice, the committee made its first foray into the world of marketing, with the appointment of a publicist, John Murphy, as their adviser. Murphy proposed an imaginative range of ideas to boost expenditure. Education was the key; men needed to be tutored into the desirability of being better dressed. This was a self-conscious attempt to encourage the idea of fashionability by manufacturers and retailers alike. It was a litany which went through endless permutations from the mid-1950s, across all sectors of the market. Later manifestations of the trend included the promotion of Italian styling in 1959, fashion designer Hardy Amies' slogan of the 'peacock revolution', coined in 1965, culminating with the quintessential image of sixties 'swinging London'.[150] At the heart of this commercial formula was a particular regime of retailing, advertising and marketing aimed at younger men. As in the 1980s, we can best observe the transformations at work in the policies of one of the most significant firms in the menswear market – the clothing retailer and manufacturer, Montague Burton.

9 Montague Burton, the 'Tailor of Taste'

Dear Sir

It is my pleasure to inform you that an event of great importance and personal interest to every gentleman ... takes place next Thursday. The event is the opening of our new branch.... Due to the growth of our trade ... which is a testimony not only to the excellent Montague Burton value but also to the discernment of our customers ... you are cordially invited to come and visit our elegant and up-to-date showroom, which is furnished in limed oak in the most modern manner. Here you can select from our wide range of Bespoke patterns ... or you may choose a ready tailored Suit ... at unbeatable value.

> (*Special letter of invitation on the opening of Burton's new premises in Devizes, 1953*)[151]

Market-day in Devizes, Wiltshire, in September 1953. The day, as it always should be on such occasions, was a memorable one. Montague Burton, the tailor of taste, was about to open a new branch in the town centre. The launch began at the historic Bear Hotel on the market square, where senior executives rubbed shoulders with local civic dignitaries. At eleven o'clock the clutch of notables processed on foot to the new premises. On the pavement a short speech of welcome was delivered by Mr W.J. Fryatt, the south-western area manager. Warming to his task, Fryatt's oration spoke of Burton's as a national institution, through which communities across the land were linked together by the flagship of British retailing. The new store, he enthused, formed 'yet one more link in the chain of sartorial palaces which extended throughout the British Isles'. Whereupon Captain C.H. Hargreaves, Burton's public relations officer, stepped smartly forward to invite 'a distinguished gentleman and resident of the area', Lord Long of Wraxhall, to cut the ribbon and declare the new premises open. The Viscount was one type of local dignitary whom Burton's preferred to front their opening events. Resident at Ashton Manor, Trowbridge, he had been the local Conservative MP between 1927 and 1931. With a distinguished military record in two world wars, his hobbies were listed as hunting, shooting and cricket. There is no record of Lord Long's sartorial style, but his social image was certainly that of the complete gentleman.

The ceremony over, the official party proceeded on a tour of inspection. Reports strategically placed in the local press recorded that the guests had been impressed

with the new shop design and its fittings.[152] Modernity and tradition had been skilfully blended together to produce an effect of elegance with up-to-date styling. Inside, an entrance hall of white marble was furnished with oak-finished armchairs. The ground floor was devoted to bespoke tailoring and visitors were 'immediately impressed with the atmosphere of freedom and beauty of setting'. There were magnificent displays of cloth 'in the piece', as well as a vast array of folded garments. But there was no air of clutter or fussiness. Clean masculine lines were the order of the day. Upstairs, in the fitting rooms, special mirrors had been installed to enable customers to gaze at themselves in an all-round view, 'in complete privacy'. Burton's staff went to strenuous efforts to cater not only for individual taste, but for the particularities of the male physique. As head office delicately put it: 'the tailor knows that many people have little peculiarities so slight, the individual has no notion of them, but they are all important to the fit of the garment.'

All this retailing finesse was now essential for any company which sought to address the male population. At this point Burton's management became particularly expansive. Of all the changes in manners and customs which had been brought about in recent years, none was more striking than the higher standards of dress displayed by the men of Britain. The company naturally claimed the credit for these sartorial changes. Burton's brought all the advantages of a great organisation to work for the individual customer. As the clutch of VIPs moved off for a special lunch at the Bear Hotel, the occasion was judged a 'first class opening'.

Viewed through the prism of cultural memory, Burton's has the power to evoke distinctive images of Britain in the 1950s. Positive reminiscences nostalgically recall the 'tailor of taste' as a stable landmark in town centres across the country. A focal point on the high street, Burton's window was always the most brightly lit spot. For the writer and broadcaster Ray Gosling, the atmosphere of a Burton's shop was unmistakable: 'Men talking to men. . . . This was the sound all over Britain on Saturdays as I remember. Customers standing on the silent, polished wooden floor. Legs akimbo, arms up. Keep it perfectly still.'[153] This reassuring image of collective cultural conformity – of a shared masculine culture fixed by retailing – was also reinforced by the size and scale of the Burton's empire. The company's precise market share is not recorded, but from the 1930s Burton's was the largest manufacturer and retailer of menswear in Britain.[154] Among its many contributions to the war effort, the firm made over a third of all demob clothes. Even as late as 1961, in the opinion of the Economist Intelligence Unit, Burton's remained the biggest brand name in men's suits.[155] In terms of market position, the tailor of taste lay almost in the dead centre of men's clothing retailers. Obviously distanced from the bespoke trade of Savile Row and upmarket

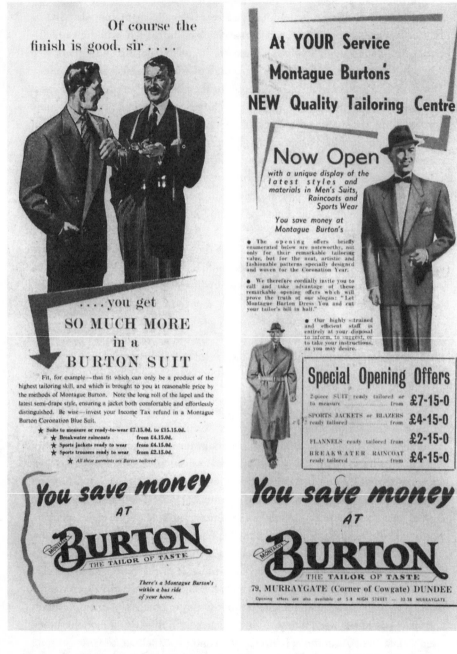

Plate 22 'Of course the finish is good, sir ...', Burton's national advertising, March 1953

Plate 23 Burton's local advertising, *Dundee Evening Telegraph*, 21 May 1953

competitors like Aquascutum or Simpson's, Burton's claims to taste and affordable elegance also differentiated it from firms such as the Fifty Shilling Tailor, where the emphasis was almost exclusively on price. It was the aim of the company's founder, Sir Montague Burton, to dress each and every man in well-made affordable clothes. Such an aspiration was not simply profit-driven. As a Jewish immigrant, self-made and self-educated, Sir Montague held out an inspirational vision for all men. When customers wore their Burton's suits, they could achieve the highest standards of personal taste.[156]

From the 1930s through to the mid-1950s Burton's techniques of salesman-ship centred on one clearly identifiable icon of masculinity. This was their image of the gentleman (plates 22 and 23). The emblem not only dominated the company's advertising, as the Devizes opening demonstrated, it also shaped the approach to customers at the level of the shop floor. Burton's gentlemanly codes of masculinity were formal and fixed. The firm's ideal type was of full adult manhood, indeterminate in age, but secure in position. Burton's gentleman might appear in different milieus – about town, as well as on the way to the office – but his standard pose was always upright, if not stiff. He was depicted either solo or in dialogue with other men, linked by the bonds of a shared masculine culture and its rules of etiquette. In manners and self-presentation this was a decidedly English world-view. It was taken as given that the gentleman always appeared correctly dressed, for clothes were a public sign of social honour.

Burton's gentlemanly ideal was in part the legacy of nineteenth-century languages of class. Clothes as expressive of status, manners as visible markers of distinction, these rituals were grounded in a vertical model of class relations. This ensemble was preserved by the company well into the post-war period. It was epitomised in Burton's bizarre image of their branch salesmen as the fount of community esteem. And yet neither Burton's salesmen nor the majority of their customers were persons of rank or status. The received wisdom about the firm's customer profile was that it was a composite of men from the lower middle class/respectable working class. There is little hard evidence about the exact position of those who bought from Burton's. But oral testimonies, together with the company's position in the menswear hierarchy, and its carefully judged pricing policy, all point to men in subaltern social groups.[157]

What was the appeal of this gentlemanly profile? Was the ordinary man simply being offered a latter-day fantasy of upper-class mores? Closer inspection of Burton's imagery points to a more complex negotiation of the aristocratic theme, assiduously adapted to the culture of their customers. Despite the continuing emphasis on status, there was a more democratic tinge to Burton's marketing after 1945. Pattern books and advertising copy tended to reread the gentleman as 'John Citizen'. Depicted serving in the armed forces, or against the municipal

landscape of the town hall, he was quite literally 'everyman', demanding clothes for his particular role in life. For many men who were dressed by Burton's in the early 1950s, initiation into the culture of the suit was part of a broader initiation rite into manhood. Grammar school boy Roy Hattersley, finishing his education in Sheffield in 1950, recalled that his first visit to Burton's marked one of the rites of passage into adulthoood:

> I bought my first Burton's suit when I was 17. It was part of a package of purchases – dressing gown, cabin trunk, brief case and single-breasted two-piece – in which I invested as a preparation for the great unknown – either university or National Service, according to the results of medical and Advanced Level examinations. I paid for the lot out of my own bank book. . . .
> I matriculated dressed as an undertaker's clerk.[158]

Along with those other milestones in the life-cycle of ordinary men during the period (such as matriculation, army service or the first job), purchase of the suit was a sign of male status. It was always approached with seriousness and forethought. The assumption of this adult persona conferred privileges as well as the burden of responsibility – a fact which becomes evident when the gentleman is viewed as a boundaried figure, with definite limits. Though Burton's ideal was indeed everyman, not everyone was welcome at Burton's.

It is a truism to state that the company projected a masculine image in the early 1950s, but it is an obviousness which needs unpacking. Burton's approach to retailing was premised on the exclusion of women and all associations of feminine culture. Selling was understood as a man's business. Women were kept away from customers. Though the branch cashier and the cleaners were women, they were never visible.[159] The ostensible reason for this marginalisation of women was the delicate issue of measuring the male body. It was deemed unsuitable for a 'lady' to measure a man. But there were also broader cultural assumptions at work. Until the mid-1950s, Burton's projected a rational and implicitly masculine understanding of the purchasing process. The customer was cast as a variant of economic man, calculating and in control. Significantly the term 'shopping', with its more feminine and potentially more chaotic connotations, was never used by the firm.[160]

A strong component of Burton's gentlemanly ideal was its affirmation of a collective male culture, which reproduced notions of separate spheres, even at the point of purchase. But Burton's gentleman also acquired status by being absolutely normal. Neither spectacular nor bizarre, not a 'clothes crank' or an eccentric, he was secure in his personality.[161] Ranged against this idea of the social conformist were all those dissidents and unconventional types who were marked out by improper dress. Prefiguring later debates, Burton's urged their salesmen

to avoid dangerous items such as loud colours, 'sporty or semi-négligé attire', even soft collars.[162] Contemporary anxieties over male homosexuality, brought to a head in the government's publication of the *Wolfenden Report* in 1957, frequently focused on the issue of whether homosexual men could be identified by their extravagant mannerisms and flamboyant clothing. But other nonconformists were also hinted at in Burton's moral code, for instance the 1940s image of the spiv and a more generalised notion of 'the exhibitionist', as well as the effeminate man. Burton's manly ideal was summed up in the company's famous memorandum to staff. All excess was to be avoided through restraint and quiet dignity: 'Avoid the severe style of the income-tax collector and the smooth tongue of the fortune teller. Cultivate the dignified style of the "Quaker tea blender" which is a happy medium.'[163]

By the late 1950s this company ideal had vanished. Yet it is misguided to read the change which took place during these years via the simple notion of a menswear revolution. As in the 1980s, detailed analysis of specific markets points to a complex account of the relationship between shifts in retailing and a new breed of consumer. How were the transformations played out at Burton's? The death of Sir Montague Burton, in September 1952, precipitated an immediate management crisis, which was compounded by the growing turbulence of the menswear market. The Burton's board recognised that survival rested on an influx of new managerial talent. Their takeover of the Newcastle firm Jackson the Tailor in July 1953 brought with it the company's sought-after managing director, Lionel Jacobson. Jacobson's style – dubbed by the industry as a 'very modern tycoon' – represented a new breed of senior manager.[164] There were strong similarities between Jacobson's approach to consumption and George Davies' later stance at Next. Jacobson was first and foremost a retailing entrepreneur.

Looking back on his early years with Burton's at the end of the decade, Jacobson recalled that he had been quick to read the signs of change among younger men.[165] By the mid-1950s there was a desperate yearning for more modern designs. But with a keen eye on his own market, he insisted that young men were not searching for complete informality, rather for casual elegance. As he put it: 'The wearer wants to project an image of himself of being slightly careless, but somehow just right.' On his arrival, Jacobson was seriously worried by Burton's notorious uniformity of style. He was also unimpressed by the company's means of speaking to the customer.[166]

The first sign of movement under Jacobson's regime was a comprehensive programme of branch refurbishment. By 1956 almost half of all Burton's stores had been refitted.[167] Many of the modernisation schemes were associated with the opening of sites in the shopping parades of new towns, such as those in Crawley and Hemel Hempstead. As significant as the process itself was the chairman's

grasp of the nature of retailing change. Constant innovation must now be regarded as an ever-present feature of our policy, Jacobson announced to shareholders.[168] Along with the modernisation programme, display was nationally organised.[169] 'The walls of Jericho are falling!' trumpeted the trade journal *Display* in 1954. 'Throughout Montague Burton's far-flung empire ... a new style is now feeling its way.'[170] Jacobson echoed the views of progressives in the industry when he declared that the traditional multiple tailor's window was both boring and vulgar. Prevailing display theory amounted to little more than a belief in advertising every inch of your stock. From now on windows would be opened up; they also needed to convey a specific theme or to tell a story. Branch managers could not be expected to dress their own windows. What the industry needed was a new breed of commercial expert – the display specialist. By 1964 Burton's display department had a staff of over four hundred, who were kept up to date via a central advisory bureau in Leeds.[171]

Burton's growing reliance on specialist expertise was further enhanced by the most extensive set of changes – the dramatic reorganisation of their advertising. The shift was not simply one of quantitative expansion; it marked a move away from a local emphasis towards a focus on national campaigns.[172] In early 1954 Burton's transferred their account to W.S. Crawford, the ninth largest advertising business in Britain. Crawford's had a reputation as a fashionable agency, with a strongly art-directed approach.[173] The results of Burton's move were immediately visible in a heavy burst of advertising in the national press. With a strong visual presence, Crawford's designs were hailed by the profession as revolutionary, marking a break away from traditional images of the tailoring industry. And as *The Outfitter* put it bluntly, with a sidelong glance at Burton's usual publicity: 'W.S. Crawford have given Montague Burton Ltd ... an injection of class.'[174] On the second night of commercial television, in September 1955, Burton's booked a full one-minute slot at peak viewing time for an advert designed by Crawford's. What viewers saw was a commercial which was atmospheric in mood, capturing an air of 'happiness and gaiety', that 'good to be alive feeling'.[175] Cruising down the road in a snappy sports car on a bright, sunny morning, a young man was about to call on his favourite girl. What was it that made him feel so good? The car? The sunshine? The girl? No, the Burton's suit he was wearing! Here was a new script from the tailor of taste, which spoke about leisure, affluence and a different version of masculinity.

This type of more casual and relaxed imagery began to dominate Burton's advertising from the middle of the decade (plate 24). It was not of course aimed at men in general, rather at a particular slice of the market – younger men. Yet the new persona was not a youth or a classic teenager; it pre-dated those identities and amounted to an image of a fashion-conscious, young adult man. Market

Fun at the fair?

Any man who thinks it doesn't matter a hoot what he wears when he's off the treadmill and "out for the day" had better try reading the thoughts of the girl he's with. She's probably too nice to mention these things, but that doesn't mean she actually *likes* her man to look like something pulled through a hedge backwards.

No; good tailoring — and you can trust women to know it — is as important for leisure clothes as for any others. More, in some ways, because these are essentially clothes for *action*.

Every man knows the kind of things that seem to fit when you stand to attention in front of a mirror but go haywire when you relax or swing into lively activity. Only tailors like Burton's, who really understand the difference between a tailor's dummy and a living man, can get comfort-in-movement into clothes as well as good looks.

But that's not all . . .

In leisure clothes a man has a chance to express himself a bit, to cut a little dash in pattern and colour. You'll find this, too, is well understood at Burton's. On our counters you can make your choice from as wide a range of materials as any in the country. Good stuff, too, all of it — as sound in wearing quality as it is correct in taste.

So if you're figuring on something new for "days off" this summer, whether you think first of "her" opinion, or your own comfort, or for that matter, your pocket, you'll do well to slip into Burton's for a chat. Wherever you happen to live, there's a Burton shop near by, and a friendly service waiting. Prices? They vary, of course, according to cloth. But to give you an idea, a two-piece suit specially made for you, or ready-to-wear, begins at 7 guineas.

You can't beat
BURTON
tailoring !

Plate 24 'Fun at the fair', Burton's national advertising, *Daily Mail*, 5 February 1954

research at the time was interested in an age range much broader than that immortalised by Mark Abrams in his *The Teenage Consumer*, 1959. The focus was on men in the 16 to 30 age band. As with Next's initiatives much later, Burton's address to what was principally a mainstream market meant that the more spectacular styles of contemporary youth culture were not written into their new approach to men. Teddy-boy suits were made in many branches, not least because their drape jackets and drainpipe trousers, however outlandish, were still tailored.[176] Nevertheless, Burton's new man was decidedly not a teenager.

In fact what was most significant about this new type was that he did not present a wholly coherent identity at all. While the gentleman was a unified personality, Burton's casual image resulted in a proliferation of styles and settings: the carefree motorist in his car, the country walker, the would-be executive with his attaché case. These multiple roles in part reflected retailers' efforts to introduce the much-needed cycle of innovation. As Sydney Jacobson, Lionel's brother, put it in his widely reported speech to the Clothing Institute in 1954, Burton's new advertisements were designed to 'raise doubts and questions in people's minds as to whether they are correctly dressed'.[177] Yet the restless quality of these images also reflected the industry's reading of broader cultural trends. It has been pointed out that masculinity in the 1950s displayed a variety of different and often contradictory facets: the domesticated husband of the sociological survey, the wartime hero, the sexually virile character of much contemporary fiction.[178] Lionel Jacobson himself glossed this changeability among men in sociological terms. Increased education, higher incomes and shifts in young men's relations with their fathers had combined to produce a customer who had new opportunities and demands.[179] Menswear retailers' notion of the fashion cycle was both a commercial response to these changes and itself an intervention into the culture of younger men.

And change was international as well as domestic. Burton's new look was less secure in its aura of Englishness than the gentleman had been, more cross-cut by international influences. Successive waves of foreign design styles reshaped the suit and its cultural symbolism. The arrival of the American drape in the mid-1950s was among the first of these imports. But it was the influence of 'continental' styling, in particular the impact of the Italian suit after 1959, which registered this internationalism most dramatically. With its lightweight materials, brighter colours and slimline jackets and trousers, the Italian style emphasised the contours of men's bodies, especially their legs and thighs, rather than camouflaging them under the weight of heavy fabrics. As the *Financial Times* remarked to its own readers in 1960, businessmen had been among the first to embrace the new outlook. It was their exposure to more stylish and less formal fashion, on trips to the continent or to America, which led the way.[180] On the eve of Britain's

hoped-for entry into the Common Market, European fashions gained an added significance.

The combined effect of these style-led innovations was to place men at the centre of attention; to subject men's personalities, as well as their physique, to greater scrutiny. As *The Outfitter* put it approvingly about Burton's first television commercials: 'it was important to the whole schema that the viewer's attention should be riveted on the male figure.'[181] Yet despite this celebratory stance, many within the industry continued to fret about the excesses of fashion. Their tone was familiar from the debates which we have charted thirty years later. For the *Advertiser's Weekly*, Burton's recent campaigns had been gaining a reputation for 'fantasy and extravagance' which bordered on the feminine. If men were treated in this way, the danger was that customers would see 'a whole series of precocious young men, dressed in anything save what ordinary mortals would ever dream of wearing – and displaying feet, legs and arms that were anything but typical'.[182] Here, as later, such anxieties hinted at the more eccentric versions of masculinity which were suggested by excessive dress consciousness. The key to avoiding these charges was to convey an air of 'naturalness' alongside the focus on style. And naturalness was anchored by a new emphasis on heterosexuality for men.

From the mid-1950s sequence after sequence of Burton's press and television advertisements pictured the young man with his girl. The first Crawford's commercials were cast as a light-hearted story of romance: opening with that 'special date' and then moving on to 'getting engaged' and 'meeting the family'.[183] Later adverts even went so far as to show the hero in a clinch, with his hair ruffled! Burton's use of what quickly became known in the trade as the 'boy–girl theme' was precisely the type of atmospheric campaign championed by John Hobson.[184] It was the inclusion of women which reinforced the mood of fun and carefree gaiety. Femininity could be used to suggest modernity, but also to provide an anchor of the normal, thus preventing accusations of eccentricity by conservatives within the industry. It was this double burden of the modern and the traditional which women carried within advertising throughout the 1950s. A 'feminine' angle was also evident on Burton's shop floor. From 1958 experiments as far apart as Aberdeen and Plymouth aimed to break the male atmosphere of the store. Every Saturday, while the husband was being fitted, a female employee served tea and biscuits to his wife, and sweets to the children.[185]

Burton's new approach to their market was not unique. As we have seen, during the later 1950s variations on the twin themes of individuality and status were visible across a wide variety of product ranges aimed at men. Burton's remained coy about the frame of reference of their advertisements. Yet their shift from the gentleman to the more fluid and ambiguous casual man involved a rereading of the changing social position of their customers. In the menswear

industry, as in other sectors, the 1950s were a key moment of transition. This was not simply a change in the presentation of commodities; it was taste understood as a key marker of social mobility.

10 Conclusion

In purely commercial terms Burton's project was a failure. Their efforts to read the signs of change in menswear miscarried. The company was quite literally overtaken by more dramatic changes in the market. It was the growth of genuinely casual clothes – and with it the casualisation of social mores – which presented the biggest headache for the tailoring trade in the 1960s. The tale of Burton's over the next decade was the story of a firm increasingly out of touch with contemporary trends.

To what extent can our detour into post-war commercial history shed further light on the consumer culture of the 1980s? Marked continuities across the two periods might prompt the conclusion that, far from being new, the processes at work were cyclical or even static. But such a reading flattens the complex dynamics of change. The 1950s and early 1960s need to be distinguished from later developments. Differences were marked in two important ways: in the operation of the consumer industries themselves, and in terms of the social field on which their projects were grounded. In the earlier moment the degree of self-consciousness about men, their personalities and their consumer choices was still restricted. Moreover, such discussions were overdetermined by class and status. What occurred in the 1980s was a massive expansion of commercial knowledge about masculinity, which was partly cut loose from its class-based referents. This is the key to understanding the debate about the aetiology of young men. These speculations were produced through multiple concepts, which varied according to the goods in question and their position in the marketplace. There was no one model of consumption which dominated, despite the evangelical claims of the creative innovators and the style *cognoscenti*. The dynamics of transformation were plural and diverse. Yet change in the later period was not simply professional. It was also driven by the eruption of arguments about gender – and about men in particular – from outside the business world. Commercial society in the 1980s was shot through with an awkwardness about sexual relations which registered the impact of feminism. Equally, the elaborate visual dramatisation of the male body, evident in so many advertising campaigns, pointed to the influence of a new and affirmative culture of homosexuality. Responses by

advertising professionals to these sea-changes were at times defensive or hostile. But the strength of their reactions testified to precisely what had shifted in the period between the 1950s and the 1980s.

Yet the appearance of an embryonic debate about younger men and their goods in the immediate post-war years does challenge accounts which celebrate the originality of consumer culture in the 1980s. There were undoubtedly antecedents for what was commercially set in place during that later decade, and in some cases clear continuities of knowledge and personnel. Situating both periods as part of longer-term transformations in patterns of gendered culture and identity can help to suggest broader perspectives on these moments of change. The commercial history of masculinity since the 1950s has displayed an increasing trend towards the intensified scrutiny of subjectivity. This strategy has centred on both the psychology of individuals and on the surfaces and workings of their bodies. Consumer culture, with its elaborate protocols of choice and discrimination, has played a major role in the process of self-dramatisation for men. However, the project has not been a universal cultural experience. The emphasis has been on particular groups of men, situated in specific milieus. Rendering this discourse of consumption more precise involves mapping a particular social geography of masculinity. It centres on a concrete topography of space, place and identity.

Topographies of Taste: Place, Space and Identity in 1980s London

1 London Metropolis:
The Spaces of Consumption

n the 1980s London acquired a spectacular role as the site of a new unfettered capitalism and its associated regimes of conspicuous consumption. Accelerated growth of the financial markets attendant on the deregulation of 'big bang' in 1986, the mushrooming of property values and rents, the transformation of the urban fabric of the City and Docklands into monuments of entrepreneurial puissance – all of these factors combined to re-centre the capital in national and international terms. Such developments were at once material and symbolic. They were enacted in the workings of policies and programmes and through systems of representation. As a result, the landscape of the metropolis was mapped in a number of distinct registers. From the dynamic movements of finance capital and commerce to the pageants of royal weddings and television soap operas, London was re-established as a premier setting for the 'national fantasy of everyday life'.[1] At an official level, the notion of the city as a utopia of the here and now was burnished by the Department of the Environment, in its *Strategic Guidance for London* document, published in 1989:

> London in the 1990s … a city where enterprise and local community life can flourish, where property and investment will continue to increase, where areas which had declined will find new rôles, where movement will become easier and where the environment will be protected and improved.[2]

The underside of these optimistic evocations – and linked to them as their mirror-image – was London as a city of crisis. For if the capital led the nation in the accumulation of wealth, it also headed the league tables for social deprivation. The metropolis was the site of riots and homelessness on the streets, of manufacturing collapse, poverty, insecurity, immobility and public squalor.[3]

These contradictory renderings of urban life formed part of the experience of many of the professionals who orchestrated the shifts in young men's consumer markets in the 1980s. We have already encountered the ways in which these experts exuded a general sense of metropolitan centredness in their public pronouncements about commercial society – a belief that geographically and socially they were at the centre of things. Yet for the doyens of contemporary consumption London was also important in rather more specific ways. For the leaders of style the capital was pivotal in two senses. First, the city was central to their employment prospects. London's historical position, as a focal point for

de-luxe markets and as a cultural entrepôt, provided these individuals with the economic rationale for living and working in the capital. But for the journalists, designers and other personalities who made up this loose alliance, the metropolis was also a focus of creative inspiration. The urban landscape provided a range of images and symbols which could be drawn on in their professional work. The careers of Brody, Burchill and Elms testified to the way in which this more intangible, but nevertheless important, metaphoric role of the city functioned in their lives. Encouraged by their own hyperbole, the taste leaders' claims about the capital frequently degenerated into national chauvinism. London, it was announced, had now displaced Paris or New York as the epicentre of fashion and style.[4]

A more pragmatic version of the metropolitan theme was evident in the language of the other grouping in this commercial coalition – the advertising profession. Historically the industry had been heavily concentrated in London since the inter-war period. Easy access to the adjacent sectors of publishing and the media, as well as to the centres of finance capital, influenced the siting of much of the advertising business in the West End. We have seen how the growing international prestige of a number of leading British agencies in the 1980s strengthened their sense of metropolitan belonging. The belief that London-based advertising was no longer simply a poor relation of New York, but was now a significant player in its own right, reinforced the geographical importance of the capital.[5]

There was then an identifiable discourse of metropolitanism projected by the intellectuals who have been at the centre of our story. At one level they traded in generalised images of the city, echoing the sentiments of urban *flâneurs* both old and new. Yet in another sense theirs was a particular spatial axis, grounded in the demands of workplace practices. This reading of social and symbolic geography – of the exigencies of space and place – introduces a further dimension to the narrative of gendered consumption during the period. Our emphasis on tracking not consumption in general, but on the dynamics of specific markets, is given a further twist. Place, setting and context were crucial to the enactment of commercial forms of masculinity.[6] A spatial matrix – of professional and business networks, of knowledges and representations – marked out a set of masculine personas which were associated with London as a consumer city. Yet it is here that the map needs rendering more precise. It was not London as a whole which was understood to be implicated in these spatial transformations. The urban geography was much more concrete. It was specific zones of the city, definite quarters, which became closely associated with these configurations of gendered commerce. Prominent among the areas was Soho, in the West End.

2 Soho: Archaeologies of Bohemia

'Redevelopment' was the anodyne term used to describe a wide variety of urban transformations occurring in both Europe and North America in the 1970s and 1980s. From Paris' Les Halles and London's own Docklands, to Baltimore's Harbor Place and San Francisco's Fisherman's Wharf, these schemes were driven by an alliance of public and private sector investment, targeting the regeneration and reordering of decayed urban space. Centre stage in such plans were usually a cluster of service sector industries: prestige shops and offices, hotels and leisure amenities. The changes taking place in Soho from the mid-1980s shared some common features with these initiatives. But Soho's renaissance was rather more specific. The area's renewal was on a much smaller scale and driven by different influences. It displayed much less of the impact of state-led planning and a stronger emphasis on local commerce. Soho's mutation at this time was symptomatic of a shifting balance of forces within the urban plan, characterised by what David Harvey has termed the replacement of corporate managerialism by entrepreneurialism.[7] In Soho, central and even local government were very much the junior partners in a loosely co-ordinated set of commercial projects. Unlike Docklands and many of the American blueprints, Soho was not a total redevelopment. Its infrastructure was not physically cleared, nor was it changed in such a way as to obliterate the existing topography. The process was piecemeal and *ad hoc*. New urban meanings were grafted on to an established landscape. Soho's transformation had more in common with other local and fragmented city schemes, such as those enacted in the Marais or Bastille quarters of central Paris, or in Madrid's Chueca zone, than with the larger undertakings. Most importantly, Soho shared a reputation with those other European inner city zones as a centre of avant-garde culture and artistic life. This was London's very own bohemia or *Quartier Latin*. The significance of the area's revival in the 1980s lay in the way in which a historically sedimented pattern of social space structured its contemporary development. It was this formation which shaped the appearance of a specific masculine discourse of consumption. Uncovering these layers of spatial culture is to trace a particular archaeology of bohemia.

From the late nineteenth century a plethora of guides and literary souvenirs emphasised that Soho did not possess an 'official' geography. Rather, its space could only be known by initiated tourists.[8] Nevertheless, in terms of physical mapping the name was usually taken to designate the square mile of densely packed streets crossed by four major thoroughfares: Oxford Street to the north, Coventry Street to the south, Charing Cross Road to the east and Regent Street to the west. These boundaries functioned not only as physical extremities; they also

carried strong symbolic resonances about the limits of Soho's cultural influence. Each of the main streets signalled a spatial resumption of more mainstream and normalising transactions. They were sites of mass entertainment, shopping or tourism which were marginalised in Soho itself. Within these spatial limits, the area has had its own internal subdivisions. The split between east and west Soho (following the original late seventeenth-century boundaries of the parishes of St Anne and St James) was a division not merely of residential and commercial function, but also of social expectation. There is still agreement among Soho devotees that the eastern half of the area constitutes the hub of the district. It is Old Compton Street, 'bang in the middle' and crossed by the main arteries – Dean Street, Frith Street and Greek Street – which has always been at 'the heart of Soho', exclaimed journalist Mark Edmonds in his *Inside Soho* guide for 1988.[9] What such affirmations referenced were the networks of cultural life concentrated in the district. It is within these historical accretions of metropolitanism that the changes of the 1980s need to be located.

> 'Where are they all? ... Where is the Quartier?' It is difficult to give an answer.... It is impossible to draw a map, and say, pointing with a finger, 'Here are artists, here romantic poets, here playwrights, here writers of polemical prose.' They are scattered over a dozen districts, and mingled all together.[10]

This was journalist and essayist Arthur Ransome, invoking the dispersed world of London's nomads and free spirits in his *Bohemia in London*, 1907. As Ransome admitted, bohemia was an abominable word. With its connotations of tinsel and sham, it conjured up images of 'suburban daughters' who reminded you twice in an afternoon that they were quite individual.[11] Yet he noted that the best dictionaries defined the term spatially as a 'certain small country'. Ransome's literary and artistic tour ranged across the whole of the capital. But he placed Soho centre stage in his account of unconventional London. It was here in the area's coffee houses and foreign restaurants, flourishing from the 1860s and 1870s, that the symbolist poets Paul Verlaine and Arthur Rimbaud gave readings and where painters and musicians moved among successive waves of French, Swiss and Jewish immigrants. Ransome recalled this period in his text:

> ... there were a few grand years in which we rivalled the Quartier [Latin Quarter] in costume, and outdid Montmartre in extravagant conversation.... All down our long table there were not two faces that did not seem to me then to bear the imprint of some particular genius. Some were assuredly painters, others journalists, some very obviously poets, and there

were several, too, of those amateur irregulars, who are always either exasperating or charming.[12]

His aim was to celebrate the 'strange, tense, joyful and despairing ... life' which was lived by young artists and writers.[13] In doing so Ransome evoked a Parisian model of bohemia. Genius was personified in the physignomies and the rituals of Soho's *habitués*. This English rendering of unconventionality was also taken up by the novelist John Galsworthy. 'Untidy, full of Greeks, Ishmaelites, cats, Italians, tomatoes, restaurants, organs, coloured stuffs, queer names, people looking out of upper windows', was how he evoked the turn-of-the-century atmosphere of the quarter to a middlebrow public in his Forsyte sequence of novels.[14]

In the years before 1914 Soho had become an established centre for sections of the cultural and artistic avant-garde.[15] The members of this circle frequently overlapped with similar coteries in Fitzrovia, to the north, and Bloomsbury, to the north-east. The Café Royale, on Soho's western borders in Regent Street, was the salon for an influential grouping. Its regulars included the artists Aubrey Beardsley and Walter Sickert, theatre critic and entrepreneur Max Beerbohm, and the intellectual generalist George Bernard Shaw. In the inter-war years Soho's population was augmented by the influx of new social actors, marked by sexual as well as cultural dissidence. Homosexual men began to patronise the Golden Lion pub in Dean Street in the 1920s, as the district became part of a network of homosexuality adjacent to the theatre world of Leicester Square. A decade later the arrival of the film industry, in Soho Square, added to the hybridity of Soho.[16]

By the 1940s and early 1950s Soho's reputation as a melting pot for a diverse range of cultures was attracting a fresh generation of immigrants. For Welsh and Irish writers, such as Dylan Thomas or Brendan Behan, the area functioned as a metropolitan haven, as it did for many English provincial and suburban exiles. Overwhelmingly, this was a masculine representation of bohemia which dealt in appropriate pleasures and sexual scripts. Soho chronicler and personality Jeffrey Bernard recalled his escape from the horrors of English public school life at 14 to discover Soho: 'Suddenly, I was surrounded by pretty girls, booze, nutcases, painters and writers. It was magic. . . . I've been drunk ever since.'[17] Jazz musician and critic George Melly testified to a similar range of attractions in the 1950s.[18] Excessive drinking bouts, public displays of bad behaviour and chance sexual encounters (whether heterosexual or between men) were the rules of the game. Colin MacInnes was one of the new generation of 'bad boys'. Surly, rude, awkward but not vicious, according to one contemporary observer, MacInnes used Soho as a public lounge for his literary career and for sexual liaisons with Caribbean men.[19] Italian restaurateur Elena Salvoni, who began work as a waitress at the Café Bleu in Old Compton Street in the 1940s, described the atmosphere as

'raffish', but it was a raffishness which was highly codified and only accessible to privileged initiates.[20]

The female counterparts to those masculine characters were represented by two types: the prostitute and, more exceptionally, a bohemian version of the society hostess. Soho's notoriety as a centre for female prostitution supposedly dated back to the seventeenth century. During the inter-war years the area's allure was enhanced in the eyes of many male punters. It reputedly supplied not only a market in English women, but also the de-luxe fantasy of French prostitutes.[21] Street girls often lived locally and on good terms with other residents. Their presence in public spaces and on the upper floors of Soho tenements was an accepted feature of the Soho scene.

Yet if prostitutes were a familiar part of bohemia, women who moved on equal terms with men were more unusual. In the immediate post-war period Birmingham and Jewish born Muriel Belcher was acclaimed as one such 'queen of Soho'. From 1948 she was hostess of the drinking club, the Colony Room, in Dean Street. Along with the more accessible pub, the York Minster, the Colony was a celebrated venue for the artistic *demi-monde*. Belcher's complex masquerade was highly successful. As a club owner she maintained an autocratic, off-hand posture, which mixed a form of 1930s 'high camp' with a more streetwise argot of stylised rudeness. Referring to her favourite customers as her 'daughters', she would hail them from the bar-stool with the greeting, 'Hello, dearie!' They would then be asked if they would like a 'drinkette'. Unsuspecting strangers who climbed the stairs to what was in effect her salon were greeted with the warning cry, 'Members only!' If they persisted, this was followed by an unanswerable 'Fuck off!'[22]

Muriel Belcher was cast as an unrepeatable original by her male contemporaries. This epithet testified not simply to the inventiveness of her image, but also to the way in which access to Soho's world was highly restricted for women. The other prominent female member of this group was the artist Nina Hamnett, friend of the painter Amadeo Modigliani and the magician and writer Aleister Crowley. During the inter-war period, Hamnett and her set divided their time between the drinking clubs of Soho and Fitzrovia and the Café Royale. Her talent was recognised in a series of individual shows mounted by the Great Marlborough Street art galleries in the 1930s. Yet by the 1950s she had become a chronic alcoholic. In her sixties she was penniless and incontinent and was often to be seen demanding drinks in Soho pubs.[23] Soho's few female bohemians charted a problematic route through what was essentially a male-defined habitus.

The world of Belcher, Hamnett and their male associates was essentially literary and artistic. By the early 1950s Soho was changing again, this time under the impact of the new music-based cultures, with their strong emphasis on youth. Among the most prominent of these arrivals were jazz musicians and their

audiences. Ronnie Scott opened his jazz venue, Club 11, as early as 1948. It was followed three years later by Studio 51 in Great Newport Street. Skiffle and blues clubs appeared at roughly the same time. The related phenomenon of the coffee bars – the Moka in Frith Street, the first with an *espresso* machine, started in 1953 – were centres for the recent wave of young immigrants. MacInnes documented these locations as 'the chicest thing to date among the juniors, the adolescent bum's delight', in *Absolute Beginners*, 1959.[24] Suburban youth escaped to all-night jazz sessions at clubs like the House of Sam Widges and to the Heaven and Hell, in Old Compton Street, or to the plusher surroundings of the Partisan, in Carlisle Street. The Partisan was architect-designed, featuring tubular steel chairs, glass tables and a cluster of post-1956 New Left intellectuals, who partly overlapped with the beat world.

Soho's post-war status as a centre of youth style was further enhanced in the early 1960s with the influx of the mods, drawn to the area by specialist fashion retailing. The reputation of Carnaby Street dated from the mid-1950s. It was at this time that 'Vince' (alias of the photographer Bill Green) set up a studio and began designing clothes for his male models and their boyfriends. At the outset Vince did not cater specifically for teenagers, because they were unable to meet the prices. Rather his market was a diverse mix of urban types: 'artists and theatricals, muscle boys, and celebrities of every kind'.[25] But by the end of the decade 'modernists', who had previously patronised the bespoke tailors of the East End, were frequenting his premises. Scottish salesman John Stephen expanded the trade. Boutiques with exotic names such as Donis or Domino Male opened. In the summer of 1962 there were five shops in west Soho, selling a mixture of made-to-measure suits, Levi's jeans and Ivy League shirts. Carnaby Street had become a 'menswear colony', noted the style historian Nik Cohn.[26] With the growing popularity of mod clubs such as the Flamingo and the Scene, the area also featured as a compulsory stopping-off point for suburban stylists arriving in the West End. Stimulated by drugs and subcultural fashion, such venues generated their own ambiguous sexual meanings. Young homosexual men often rubbed shoulders with the modernists, either in the same or in adjacent venues. The gay club La Douce, in D'Arblay Street, was a particular favourite. It genuflected to the modernist ethos by playing Tamla Motown and soul sounds.[27]

By the late 1960s Soho had been the recipient of heterogeneous accretions of bohemian and avant-garde culture over a hundred-year period. Much of this activity was broadly artistic, literary and latterly youth- and media-related. Most of it privileged a range of masculine personalities. This historical legacy was significant for the commercial developments which took place in the 1980s. Contemporary forms of consumer culture drew on the gendered representations of city life which had been laid down at various historical moments. This is the

key to understanding the importance of Soho's symbolic archaeology. The persistence of these earlier formations into the late twentieth century had much to do with the continuation of established milieus and personnel, alongside fresh waves of immigrants. But it also related to broad questions of language and culture, to the reproduction of a grammar for interpreting the urban landscape. This lexicon – what the cultural geographer Michel de Certeau collectively termed the micro-practices of the city – was constantly raided by the style professionals and other entrepreneurs who arrived in the 1980s.[28]

Though the long-term legacy of bohemian culture proved to be a positive factor in Soho's renewal, the immediate situation in the 1970s was not auspicious. The accelerated growth of the modern sex trade was the most pressing problem confronting local politicians and community groups, as well as potential developers, at this time. In 1973 the Royal Institute of British Architects warned of Soho's impending demise in the local press. A spiralling decline in the residential population was accompanied by the contraction of local amenities. As the *Westminster and Marylebone Chronicle* complained, this had been compounded by the near extinction of indigenous crafts and trades. The finger was pointed directly at the sex industry.[29] From the late 1960s the aggressive marketing of sexual commerce began to reshape the area yet again. Pornographic bookshops, striptease and peep-shows and so-called nude encounter bars proliferated. In part, this was one consequence of the 1959 Street Offences Act. The effect of this legislation was to drive prostitution off the streets and into the privatised spaces of massage parlours and bars. But more specific factors were also at work, notably the exodus of local prostitutes from Soho to the richer male sexual playground of Mayfair's Shepherd's Market, sited further west. Their departure left a vacuum which was quickly filled by the influx of organised cartels of sex businesses.[30]

Initially the municipal authority, Conservative-controlled Westminster City Council, adopted a *laissez-faire* approach. Largely content with the rising rateable value which the sex market produced, the administration at first remained deaf to environmental complaints from local residents. In the longer term the council aired plans for Soho's wholesale demolition and redevelopment, in line with the prevailing planning ethos of the day. But the formation of a vocal local lobby, the Soho Society, in 1972 forced a policy change on the area's future. The Society drew up comprehensive plans to counter the sex trade. Their careful use of predominantly environmental, rather than moral, arguments gained broad community support. The effect of this campaign, together with the defeat of Conservative candidates in the local elections of 1982, as a result of inaction on the sex trade, forced a dramatic rethink at the town hall. After 1982, Westminster Council's approach to Soho shifted in favour of the creative use of local government legislation to implement a staged reduction in the number of sex establishments.

The rubric of the Local Government Miscellaneous Provisions Act, 1982, empowered local authorities to control the sexual marketplace. Faced with mounting pressure, Westminster set targets of between ten and twenty sex premises for the district. By 1984 the actual number had shrunk from sixty-one to thirteen. As Councillor Young, chairman of the council's Environment Committee reaffirmed in 1987: 'There is no slackening for our support for the "Clean Up Soho" campaign.'[31]

3 Boulevards for the Fashionable and Famous

'The Soho sex shops ... of the last two decades will not be mourned,' insisted *The Times* in 1986, 'but what new Soho will emerge?'[32] Throughout the mid-1980s competing visions of the area's future vied for ascendancy. Many local residents rallied behind the arguments advanced by the Soho Society. The organisation maintained that the premises of former sex establishments should be reserved for small retail outlets, thus providing links with the original local craft and service industries.[33] But such aspirations looked increasingly utopian in the light of a different type of commercial development which was already making its mark. In all the contemporary debates over Soho's future one group more than any other was cast as the driving force for change. It was media professionals – dubbed by *The Times* as the affluent media men – who were seen to be in the vanguard of Soho's renaissance. Eccentrics and bohemians were being edged out, noted *The Daily Telegraph*'s columnist John Wyman in 1986; sleaze had given way to respectability.[34] The *Financial Times* flattered its own readers the following year when it told how 'people power' had saved Soho, tilting the balance back towards legitimate commerce. And the paper noted approvingly that media folk were encouraging further economic growth with their own specialist demands.[35] Theirs was a milieu of expense-account restaurants, personalised shopping and the thousand and one luxury commodities which were mushrooming in Soho. The discerning customers for these goods and services were identified as a familiar band – taste leaders in the world of fashion. *Midweek*, the weekly free paper for London's office workers, sang the praises of the new arrivals in Soho's square mile:

> Cosmopolitan, bohemian, wildly trendy – Soho is London's very own rive
> gauche. This square mile of style is a kingdom unto itself: the land of the
> brasserie lunch and the after-hours watering hole, the land of accessories

and attitude, where fashion relentlessly struggles to become style and image is simply everything; the glittering heart of media land where the worlds of art, journalism, film, advertising and theatre blend into one glamorous heady cocktail.... How does one become part of this bohemian world? How can you ... cut a dash as a get-ahead young turk effortlessly oozing that quintessential Soho style – style that you have only glimpsed at in the pages of *The Face?* ... There is a whole unspoken language to be learnt, a code of behaviour and dress, a long list of do's and don'ts.[36]

Here was a universe driven by dynamic but feverish consumption. Presented as a popular version of bohemia, it was peopled by a number of key characters. Young entrepreneurs and professionals were the personalities who moved so effortlessly across these landscapes. Like the disciples of *The Face*, their key to success was style. As we have seen, such coverage became the stock-in-trade language of consumer journalism in the late 1980s. Whether in the magazine sections of the Sunday newspapers, or through the gossip of television chat shows, media discourses began to represent a specific type of urban experience which focused on Soho.

This rhetoric of Soho as the centre of media style needs to be decoded with caution. A powerful metaphor, it appealed to metropolitan writers precisely because it testified to the energy of their own culture and the centrality of their terrain. Yet all this was not simply a journalistic fantasy. Under the generalised references to the media were subsumed a whole range of more concrete developments, for Soho was fast becoming the site of an expanding commercial infrastructure. It was the growth of advertising and public relations companies, as well as the publishing and film industries, which were most influential. Together they pointed to a professional network which laid claim to the area. They also hinted at a particular lifestyle shaped by the world of goods. Many of these changes have already featured in our history of *commerçants* in the 1980s. But their crystallisation in the social geography of London was distinctive. This is the key to unlocking Soho's significance at the time.

Such transformations had their own economic rationale. Market-based philosophies, already in the ascendant at Westminster Council by the middle of the decade, favoured an aggressively business-oriented approach to Soho's future. Centring on speculative property development, this involved the council encouraging ventures which promised higher rateable values and rents. In the summer of 1986 Conservative councillor Peter Hartley saw the choices facing his administration as increasingly stark:

If it's a choice between upgrading the area with a possibility that it would become a bit too upmarket or trendy, or leaving the place to become an

absolute junk-heap, the council has taken the view that the first was better.[37]

This emphasis on the positive aspects of commercial regeneration, as opposed to predictions of inevitable decline if the area were simply left to local residents, was underlined three years later by David Weeks, the council's deputy leader. Responding to accusations that Soho's growing popularity was producing an affluent but anodyne culture, Weeks affirmed his faith in a market-led approach to redevelopment. Sounding a note of mock resignation, he confided to *The Evening Standard Magazine*: 'One hopes a mixed character will remain, but all cities change and evolve.... We can only respond to market forces.'[38] The market forces identified by Weeks were generally media-related in character.

Viewed from the vantage point of the newly arrived professionals, Soho was an attractive proposition. A survey by local estate agents Allsop and Co., in 1987, noted that, while rents were rising, they were still minuscule when compared to the charges in neighbouring West End areas.[39] Many offices and studios migrated from adjacent locations in response to mounting fixed costs. Encouraged by growing media deregulation, a clutch of independent film companies and related services (such as dubbing, mixing and cutting) set up in Soho, on account of the area's established links with this sector.[40] Members of the style press also staked-out their interest in the same space. *The Face* was produced from basement offices in Broadwick Street, west Soho, in the early 1980s, before moving slightly further north. In 1987 Neville Brody set up his studios in Tottenham Court Road, on Soho's eastern limit. Most significantly, a number of the most prominent advertising agencies laid claim to prestige office developments in the district. Since the 1960s the industry's nerve centre had been sited on and around Charlotte Street, to the north of Oxford Street, together with sites in Mayfair and later in Covent Garden. But the continuing attraction of lower property costs drew advertisers and their clients towards the Soho net. Bartle Bogle Hegarty took up residence in Great Pultney Street in 1986, Ogilvy and Mather nestled in Soho Square, as did the design consultants Fitch and Co. Of the twenty top creative agencies named the following year, six had offices in or adjacent to Soho.[41] The glamorous reputations of these companies were embodied in the architectural facades and design styles of their offices. David Ogilvy had long preached the importance of the outward appearance of an advertising agency for attracting potential clients.[42] *Campaign* whispered that it had been granted a private view behind the exterior of Bartle Bogle Hegarty. Titillating their readers, journalists uncovered a characteristic mix of fashionable consumerism. Beautiful girls glided through contemporary but understated interiors, which were personally designed by Hegarty himself. Clients were offered tea from plain white Wedgwood in

uncluttered, minimalist surroundings. *Campaign* concluded that this was the perfect place to entertain German executives for an Audi car launch![43]

Prestige developments of this kind were skilfully managed by a number of recently formed property companies and estate agents, eager for further clients. Rumours of an impending rise in property values and rents intensified the atmosphere of feverish speculation. Paul Raymond, the acceptable face of the reformed sex industry (who continued to own a Soho portfolio larger than any other private landlord), celebrated this activity as a testament to the power of the open market.[44] Once established, the new businesses demanded a further range of services, especially leisure and entertainment facilities. A plethora of restaurants, cafés and bars opened in quick succession. All of these ventures were strategically marketed to the immigrants, while old established venues were remodelled. There was a brisk flow of commercial energy within a compressed urban space.

Alastair Little's celebrated restaurant in Frith Street appeared in 1985. Little had previously worked round the corner, as chef at L'Escargot in Greek Street.[45] Specialising in so-called 'new British cuisine', with a menu which was changed twice daily, his new venue quickly became a favourite with diners from the record and advertising industries. Less intimate, but more imposing, was Braganza's, sited further along Frith Street, which had started the previous year.[46] For this venture architects and interior designers had been specially commissioned to give each of the three floors a particular atmosphere. Opening its doors at the same time, the Soho Brasserie, in Old Compton Street, was one of Soho's first deliberate emulations of a Parisian café-bar.[47] Furnished with the ubiquitous chrome and stainless steel interior, marble-topped tables and authentic foreign waiters, the café offered a 'continental' ambience. Ordering a Kir, or perhaps a *salade de fruits de mer*, customers could seat themselves at window tables opening directly onto Soho's main thoroughfare. From this vantage point they could watch the boulevard like latter-day *flâneurs*.

Much of the new Soho raided Parisian models of urban behaviour. But the overall effect was not simply a continental pastiche. It was a distinctly English reading of Gallic culture. Metropolitan London was kaleidoscoped together with signifiers of French taste. Similar hybrid forms were produced in relation to Italy. Run by the Polledri family since the 1950s, the Bar Italia, in Frith Street, was hailed as the 'most authentic Italian café in Soho'.[48] During the soccer season, satellite broadcasts of Italian football matches beamed down from a huge television screen, while the walls of the bar were covered with posters of post-war Italian sporting heroes. Once again this was not simply the recreation of a Milanese or a Neapolitan environment. It translated an 'Italianate' experience into a London setting. These mimetic renderings of other European cultures pro-

liferated in Soho in the 1980s, as they did in London's other fashionable quarters, such as Camden or Hampstead in the north of the city.⁴⁹ But Soho's sedimented history of 'continentalism' gave its foreign atmosphere a more piquant and authentic flavour.

In all the flurry of leisure activity two particular venues symbolised the new Soho. These landmarks were The Groucho Club, opened in 1985, and the Limelight, which was launched a year later. The Groucho, in Dean Street, cemented an alliance between literary culture and the media industries. Carmen Callil and Liz Calder, of Virago feminist publishers, approached the leisure consultant and member of the chocolate manufacturing family, Tony Mackintosh, with a brief to create a new type of professional club. It was to be a venue which welcomed women and avoided the stuffiness of the traditional male bastion, the gentlemen's club. Mackintosh's choice of a Soho location was justified on the grounds of its rising status. As he put it: 'We chose Soho because it is enjoying a new lease of life.'⁵⁰ The Groucho serviced journalists, writers and their agents, as well as the media world. It aimed to provide a relaxed space, where commercial alliances and more informal social relations could be cemented. Opening membership was £200 a year, with a reduced fee for applicants under 28, reflecting the relatively youthful profile of many of the newcomers. In addition to its professional customers, the club rapidly acquired an influential position among members of the style community. *The Face* reported club gossip and the *bons mots* of celebrities in its lounges and dining rooms, especially after Madonna chose The Groucho for her birthday celebrations in 1987. Burchill also testified to the club's importance as a haunt of freelance writers and media intriguers. Such venues lay at the heart of her metropolitan fantasy, places where 'CVs and calling cards filled the ... sky'.⁵¹

While The Groucho Club provided an intimate setting for the *habitués* of Soho society, the Limelight, on Shaftesbury Avenue, was a much more public arena in which taste and fashionability could be asserted. We have already encountered the nightclub as the venue chosen by *The Face* to host its fashionable 'party of the year' in 1986. Launched by Peter Gatien, a 32-year-old Canadian multi-millionaire, its opening involved the dramatic conversion of a former Welsh Presbyterian chapel. The Limelight was designed to appeal precisely to the group christened by Gatien the new 'Sohoemians'. This was an untapped market of affluent 25- to 40-year-olds who, he observed, were missed by the contemporary London scene. Gatien's reading of his customer profile was based on experience gained in New York. There, he argued, a broad spectrum of older professionals took advantage of such nightspots, both to relax and to conduct business.⁵² Decorated with murals and with a strong general emphasis on art and architecture, the Limelight enshrined its own caste-like hierarchy within the spatial environment. The 'VIP suite'

restricted access to 'celebrities', or to those able to buy into celebrity status. From an elevated gallery the élite could either look out across London, or gaze down from a position of superiority on the dance-floor below.

The tropes of modishness and innovation were endlessly reproduced in surroundings of this type. But to what extent did Soho's earlier bohemian legacy inform the new urban vision? There was sharp disagreement between the older population and the newcomers about the value of the recent changes, which also condensed differences of age and status. Jeffrey Bernard was bitter in his complaint about the environmental and cultural pollution caused by the immigrants and their caravan of goods. Soho was now dead, he proclaimed, killed by a massive overdose of advertising executives with pocket bleepers and a taste for cheap wine![53] Bernard's polemic was unashamedly élitist. He was resolute in his insistence on the superiority of his own circle, as opposed to the superficiality of those he dubbed the new plebeians. Some of Bernard's contemporaries were less hostile in their appraisal of the changes. Melly, along with journalist Daniel Farson, was generally supportive of Soho's redevelopment. But both of them also worried about 'a cleaned up, hygienic Soho ... a fraud, a tourist attraction'.[54] Yet to the newcomers the situation appeared quite different. From their perspective, it was precisely the informal mixing of the area's established culture with more contemporary inputs which provided the allure. Estate agents and developers carefully wrote this repertoire into their advertising copy. 'Sohoemians like the idea of an area that is not too manicured', local estate agent Laurence Glynne confided to The Guardian in 1989.[55] Favourable comparisons were frequently made with neighbouring Covent Garden, where a sanitised environment had obliterated any traces of the original vegetable and flower market. Christopher New, whose first clothes shop opened in Dean Street in 1985, pointed out that many retailers moved to Soho not simply on account of lower rents, but because the district was 'considerably more interesting'.[56] New felt that the area had a genuine village feel. Fred Taylor, club manager of 'Freds' in Carlisle Street, believed that the secret of Soho's creative dynamism lay with its bohemian atmosphere: 'From the word go' he had found it full of 'incredible diversity' and an 'intangible ambience'. Talent thrived and, as a result, coming into Soho was always a voyage of discovery. Soho was 'like a club'; anyone with style could apply for membership.[57]

Let us briefly trace the circuit of these new bohemians as they wove their way through the network of Soho's spaces. Emerging from the design studio or the media conference with colleagues or prospective clients, professional life might continue in the more informal setting of one of the area's media pubs. For a special occasion, or a more prestigious client, the choice might be the Champagne Bar of Kettners restaurant, in Romilly Street. If there was no after-hours business

then shopping, for personal accessories or for gifts, could be the alternative. There were the eye-catching items displayed in American Retro in Old Compton Street, where owner Sue Tahran brought together an abundance of classic design items: from Braun alarm clocks and Zippo lighters to more esoteric commodities, such as a 'matt black hand-held photocopier'. Or for personal organisers there might be a visit to Just Facts, in Broadwick Street, reputedly the only shop in the world to stock the entire Filofax range. Distinctive 'eye-wear' could be bought at Eye Tech in Brewer Street, designer clothes picked up at Workers For Freedom or the Academy, both showcases for young fashion talent. Later in the evening the party might wind up with an authentic *espresso* at the Bar Italia, or take in a jazz set at nearby Ronnie Scott's.

Such vignettes of contemporary life were among the standard narratives circulated about Soho's renaissance during the 1980s. According to their register, they were either stories offered up to Soho initiates, with the accompanying pleasure of self-recognition, or accounts produced for a more distant tourist gaze. Like nineteenth-century *feuilleton* literature or the early guides to Paris, Soho journalism taught readers how to find their bearings – to locate a position within these representations of social space. Forms of reportage might stimulate the desire for actual metropolitan experience, but they could also supply the mental furniture for a more imaginary participation in the city.[58] If Soho could not actually be concretely apprehended, it could be visited in fantasy, via the structures of journalism and literary leisure.

Yet a historical reading of these urban myths reveals the extent to which they were selective and partial. They were in fact carefully edited tales of Soho's redevelopment during these years. Written into their formula were a number of important silences and concealments. Selecting a series of emblematic artefacts and personality types, these accounts evoked a landscape of consumer desire which was instantly recognisable and glamorous, and at the same time seamless and coherent. They were discreetly regulatory in two related senses. First, they worked with a system of topographical closure. Under their rubric the urban map was homogenised and unified. What were marginalised, or deliberately ignored, were a number of more heterotopic forms of city life; a series of other worlds and spaces which jostled for attention on the boulevards. Further, these narratives remained silent about gender. Following standard patterns of urban story-telling, the inhabitants of London's West End were generally assumed to be men, but there was little exploration of these masculine identities. Yet Soho in the 1980s did not display such an unproblematic syntax. Rather it presented the geography of not one but several different taste communities. They were linked by their gendered hold on public space.

4 Significant Others

By February 1993 Old Compton Street had become the venue for a different type of spectacle – Soho's 'Queer Valentine Carnival'.[59] In festive atmosphere nearly two thousand 'lesbians, gay men and their friends' gathered for an afternoon party. The high point of the day was a street parade to commemorate the homosexual takeover of the area. Earlier, partygoers had thronged Soho Square, marshalling behind a carnival float which supported the 'gods' and 'goddesses' of gay love and their choir – a Brazilian samba band. Dressed in gold robes, the chief 'deity', film-maker and gay celebrity Derek Jarman, declared the proceedings open. Moving off through Soho, revellers proceeded to 'bless' every venue with showers of confetti. As the parade turned into Old Compton Street, activist Peter Tatchell conducted a renaming ceremony. Henceforward, he proclaimed, the thoroughfare was to be known as 'Queer Street'. To commemorate the event a painted sign was unveiled from the window of Comptons pub, while its landlord sprayed the crowd with champagne.

Such manifestations of the carnivalesque were not exactly spontaneous. They marked the deliberate attempt to fuse together a new upsurge of radical sexual politics with the celebratory style of the street festival. Organised by the activist alliance Outrage, which had spearheaded radical campaigning work around AIDS and other political issues, London's carnival borrowed heavily from similar events which had been staged across the gay diaspora in the 1970s and 1980s. The well-established street parties in New York and San Francisco, or Sydney's annual Mardi Gras festivities, were partly the model. In Soho the reclaiming of the gay city was also linked to a new stance on homosexuality. 'Queer politics', as it came to be termed in the early 1990s, was characterised by a renewed stress on militant action, as well as on the power of transgressive sexuality.[60]

Yet Soho's carnival involved something more than an exercise in sexual politics. It was also a testament to the growing commercialisation of homosexuality. Every time the Valentine parade stopped on its way through the area, it drew attention to the diverse network of consumer culture which was now established. Bars and clubs, cafés and shops held out the promise of a homosexual life, shaped by the market. In these spaces the carnival promised a 'mixed' utopia – a commingling of lesbians, gay men and their friends. However, it was one particular constituency – young homosexual men – who laid particular claim to the streets of Soho. Despite the visibility of lesbians on the February parade, it was a masculine perspective on public space which predominated, even though this was masculinity defined as irregular and sexually disruptive.

'With the opening of its own gay shop, Old Compton Street is fast becoming the high street of a Soho gay village. Other traders please copy,' reported London's gay paper, *Capital Gay*, about the launch of the new emporium, Clone Zone, in November 1992.[61] The store had a ground floor devoted to sportswear, books and gifts. In the 'cellar' below customers were invited to explore a range of sexual toys and body jewellery. The following year saw the appearance of Balans restaurant next door, modelled on the brasserie venues which had been pioneered elsewhere in the district. The aptly named Village Group, a chain of local gay businesses, strove hard to portray Soho as London's very own homosexual quarter, through carefully targeted advertising. Specially commissioned market research pointed to the growing demand for a distinctly gay milieu in the centre of London, especially among younger men. Taste preferences were believed to be specific; the choice was for a 'continental-style' café-bar culture.[62] The free weekly youth paper *Boyz* promoted an aggressive mixture of Soho-based consumer pleasures for the gay hedonist. Whether dining, shopping, clubbing or looking for a boyfriend, the understanding was that every attraction could be found there. This notion of a geographically concentrated site of gay consumption was welcomed by the majority of entrepreneurs. For them it made effective marketing sense, because it sited goods and services in an easily identifiable location. The absence of an accompanying residential population in Soho made it unlikely that the area would foster the type of ethnically centred gay communities which had emerged in San Francisco's Castro district, or in New York's Greenwich Village. Nevertheless, in the context of metropolitan London, this growing concentration of a commercial infrastructure for male homosexuality marked an important development.

The stance adopted by the gay media towards Soho's new consumer culture was upbeat and positive. The ties binding London-based papers and magazines such as *Capital Gay* and *Boyz* to their advertising revenue meant that any more critical stance on the phenomenon was extremely subdued. Yet there were disclaimers to the accelerating commercialisation of homosexuality. More often than not these dissident voices were backed by an anti-capitalist critique. Paud Hegarty, writing in the monthly gay socialist magazine *Rouge* in 1992 was particularly outspoken. Gay businessmen were merely promoting the metropolis as an urban playground – 'an alienating and individualised pleasuredrome' – in which style and a sexualised ethic of the body were now the only markers of community.[63] This sense of disquiet was also partly shared by journalist Keith Alcorn. In a spate of articles in *Capital Gay*, Alcorn worried about the implications of gay consumerism.[64] At one level, he argued, Soho's homosexual culture simply reflected wider social and political trends. The contemporary obsession with niche-retailing, coupled with the market-led chaos which had descended on London in the wake of the abolition of the Greater London Council in 1986, made

it inevitable that gay culture would be shaped predominantly by commercial forces, Alcorn concluded. And yet, as he puzzled, gay consumption was double-edged. If the growth of shopping and other services seemed to shift the community away from activism and politics, it also stimulated a self-confidence in urban, public space.[65] The consumerist ethos was encouraging homosexual men to stake a greater claim to ownership of the city.

Contemporary commentators took up these questions in the early 1990s, at the moment when Soho became clearly identifiable as a gay centre. Yet underpinning this debate were a series of longer-term historical changes taking place over more than a decade. For what lay behind the carnivals and business ventures was the gradual renaissance of the area as a focus for homosexual culture. Broadly coinciding with the arrival of the media industries, this development produced its own ethos of consumption and an associated social geography. From the mid-1980s Soho became redefined, not only as a site for a buoyant cadre of new professionals, but also as the centre for a revitalised network of homosexuality. Both formations were predominantly masculine, though they evoked competing interpretations of identity and space. It was the particular arrangement of Soho's commercial infrastructure which drew these different communities into adjacent locations.

We have already noted how the pubs and clubs in Soho during the inter-war and immediate post-war years functioned as points of social and sexual exchange for homosexual men. Many testified to the magnetic attraction of the district, producing its own sense of symbolic 'home-coming' or belonging. John Alcock, born in 1927 and frequently on army leave in London during the late 1940s and early 1950s, recounted Soho's allure:

> It was about this time that I went to London for the first time, for a weekend.
> I found myself in Leicester Square and it was fascinating for me to see young airforce men in uniform with make-up on! I went back ... and told my boyfriend that I wanted to go to London and he said that he always knew that would happen, that once I saw London I'd never be able to keep away from it. So we packed up and went.[66]

This image of the metropolis as a secular utopia has exercised a powerful hold on the homosexual imagination over the last hundred years. The American historian John D'Emilio has identified its centrality for migrants to San Francisco and New York in the 1940s, often stimulated by the 'freedom' of military service.[67] In Alcock's London testimony the city's attraction was double-edged. It represented a world of magic and fascination, but like a total addiction it threatened the stability of his own domestic arrangements in the provinces. Soho and its environs occupied a central place in the world-view of a generation of homosexual men in

the mid-twentieth century. The biographies and personal testimonies of those who yearned for a culture of sexual belonging repeatedly focused on the excitement of London's West End.[68]

Yet the crystallisation of Soho's gay culture in the 1980s and early 1990s cannot be understood as an evolutionary history from this earlier moment. By the mid-1960s the nodal points of homosexual sociability were shifting. Sited further west, Chelsea, Kensington and Bayswater emerged as new centres of a burgeoning gay community.[69] In part this move pointed to the expansion and diversification of London's 'scene', but it also testified to the growing importance of a different group of consumers. Affluent professional men, resident in west London, partly distanced themselves from the theatre world of Leicester Square and Soho's *demi-monde* on the grounds of taste and social status. Commanding higher disposable incomes, they demanded a different type of ambience. This was provided in nightclub venues such as By Appointment, in Bayswater, or Yours or Mine at the Sombrero, in Kensington High Street. These locations, with names often suggestive of a pseudo-exotic or knowing intimacy, were essentially sites of conspicuous display, where late-night alcohol consumption was tied to supper licences.[70] Many of the clubs on Chelsea's King's Road were equally up-market, though some catered for a more diverse range of customers. Sited underneath a fashionable restaurant, the Gigolo served only soft drinks. Here students and other acceptable *déclassés* mingled with artists and gay celebrities in a sexualised space. Despite heavy policing by the management, customers did manage to kiss and cuddle. Jarman recalled the club, where sexual availability was twinned with cultured repartee: 'At the back of the Gigolo everyone had their flies undone. It was jam-packed. The management turned a blind eye to this. At the bar people would be balancing their glass cups of Nescafé, chatting about art!'[71] Venues like the Gigolo registered a shift towards more explicit forms of sexuality, with an emphasis on casual sex for gay men. It was a change which was encouraged by the partial decriminalisation of male homosexuality, with the passing of the 1967 Sexual Offences Act. Legal liberalisation also stimulated other fledgling forms of modern gay consumerism. The spate of magazines appearing in the late 1960s covered the world from a gay perspective, mixing gossip, the arts, fashion and pop music.[72]

These facilities serviced a culturally and financially privileged sector of the embryonic market. Outlets of this sort continued to expand in west London throughout the 1970s. But the gradual drift of the gay scene back eastwards into central London once again marked a qualitative shift in cultural emphasis, which was simultaneously a spatial migration. The most important feature of this movement was the creation of a gay mass market. From the mid-1970s gay male culture underwent a process of democratisation. It involved a loosening of the

class and status hierarchies which had anchored many of the venues further west. Soho was central to these developments, though the appearance of pubs and clubs in the working-class districts of the East End and in south London (with evocative proletarian names such as the London Apprentice and the Two Brewers) also consolidated a new homosexual map of the metropolis.

The coming of a mainstream gay market to Soho can be conveniently symbolised by the appearance of two large-scale nightclub venues: Bang in Charing Cross Road, which opened in 1976, and Heaven, situated to the south of Soho, off Villiers Street, which started four years later. Bang was a deliberate attempt by its deejay and co-founder, Jerry Collins, to follow an American club model – specifically the Studio One club in Los Angeles. Multiple bars, an extensive dance-floor and effective sound systems were the hallmarks of this venture.[73] Characteristic musical styles were a focal point for the new gay culture and these became inseparable from the overall atmosphere. In the 1970s it was Disco and later HiNRG – music with emotionally charged dance rhythms, coupled with an unvarying beat – which provided further means of identification for the gay clientele. Heaven, launched as London's 'ultradisco', consolidated this trend towards dynamic cultural conformity. Originally the club pitched for an élite image, but as the managing director, David Inches, recalled, the organisers quickly realised their mistake. Reading the signs of a changing customer base, the whole concept was transformed 'to give Heaven as wide an appeal as possible to the broadest cross-section of the gay market'.[74] As at Bang, the emphasis was on size and scale, symbolising the increased visibility of gay culture.

It was the appearance of these major projects which provided commercial anchor points for the return of homosexuality to Soho in the 1980s. Their visible success began to encourage smaller, more locally based businesses to target goods and services to gay customers. 1986 was a significant year for this process of commercial expansion. In June London's first explicitly gay café, appropriately called First Out, opened in St Giles High Street, on Soho's eastern fringes. Along with its co-operative ethos went an emphasis on the importance of consumption in shaping the subculture. 'For most people being gay is ... a private leisure activity, separate from the rest of their existence,' explained the business plan.[75] Together with the recently opened London Lesbian and Gay Centre in Islington to the east, First Out aimed to combine leisure facilities with the advantages of a community resource. Organised yet again on 'continental' lines, the café exploited the area's potential at the crossroads of a number of major thoroughfares used for shopping and night-life. Reviewing this and other openings, *Capital Gay* noted that 'the pulling power of Soho' was also forcing many established venues to move up-market in response to the influx of a new type of customer.[76] The Swiss Tavern in Old Compton Street had been a regular haunt of Soho's 'low-life' since the

1950s. It was renamed Comptons in the autumn of 1986 after an expensive refit. Madame Jo Jo's exotic cabaret, on the site of the former Piano Bar in Brewer Street, opened at the same time. Its curtains went up on a 'scarlet and gold shrine to camp'![77] Even the Golden Lion pub, in Dean Street, launched a 'clean-up' campaign in an attempt to shed its 'rent boy' image. The new managers aimed to turn the bar into a 'relaxed, comfortable place to go'.[78]

Two related philosophies of culture and money underpinned these initiatives. Looking to New York and San Francisco, American perceptions of the urban consolidation of gay communities informed the vision of many London entrepreneurs. But they also looked to contemporary debates over the growing power of gay money, or what was christened the 'pink pound'. Marketing surveys encouraged speculation about the purchasing power of gay men, identifying them as the capital's most affluent and discriminating minority. 'An organised gay business community is the sign of a strong community', argued the Gay Business Association, established in 1984, as an institution dedicated to the commercial expansion of homosexuality.[79] Yet despite the emphasis on size and scale, by the mid-1980s companies also detected some important signs of change in the gay scene. These shifts paralleled the broader reassessments of consumption patterns taking place among advertisers and marketers. Echoing such professional reformulations, gay businesses declared that the era of mass consumption was giving way to a period of greater segmentation. As First Out co-op members put it, gay people were not a homogeneous unit, any more than the rest of society.[80] In the West End there was increasing customer demand for prestige services, especially high quality clubs, restaurants and coffee-shops. Covent Garden's own redevelopment in the early 1980s had set the pace of change, and other districts needed to follow. The argument was that gay men were at the forefront of this transformation in demand, because of their comparatively high levels of disposable income and their greater demand for non-home-based entertainment. Soho's growing visibility on the homosexual map of the metropolis was the direct result of these changes. A weekend Bank Holiday promotion in the spring of 1986 symbolised the spatial realignment. Promising customers a grand tour of gay London, it covered most of the established sites of homosexuality – from Earls Court and Chelsea to Brixton in the south. Significantly the trip began and ended in Soho.[81]

The expansion of gay venues in Soho in the 1980s adds a further twist to our understanding of the area's historical geography. By the end of the decade the district had experienced not one but a number of commercial redevelopments, which were broadly linked by their emphasis on retailing, the media and other service sector industries. However, this was not a unified culture, despite the rhetoric of contemporary journalism. Just as The Face held together diverse and

often competing images under its banner of style, so Soho in the period condensed a range of taste communities in a tightly bounded environment. Such spatial transformations were not only linked to the appearance of particular forms of culture. As marketers were only too aware, they were associated with a series of clearly identifiable personalities. Media professionals, gay urbanites and style experts were among the characters who laid claim to this segment of city space. Decoding these identities returns us to the issue which has been central to our story of consumer culture: the relationship between the world of goods and masculine presentations of the self.

5 The Yuppie

Let us return to the scenario which opened our account: the debate over the budget in the spring of 1988. Listen to Labour MP Brian Sedgemoor, evoking a fantasy world of conspicuous consumption in his denunciation of free-market economics which he delivered to Parliament:

> ... yesterday I went to a celebration party for the Budget at the Dorchester in Mayfair. It was organised by a merchant bank for the hundred richest people in England. Everyone who was anyone was there. I felt privileged to be a fly on the wall. . . . It was straight out of 'The Great Gatsby'. . . . 'Men and girls came and went like moths among the whisperings, and the champagne and the stars. . . .' The bar was in full swing. Floating rounds of cocktails were picked out by the glittering diamonds in the chandeliers. Laughter – at first light, then raucous – spiralled out with prodigality. . . . The first supper of the evening for the magnificent Budget was a sumptuous affair – with oysters, black and red caviar, smoked salmon, escargots and lobster. At one table was . . . Maurice from Saatchi . . . who takes home . . . £500,000 per year. . . . Then came the final supper at midnight – the most fabulous that I have ever witnessed. It had hardly begun when 'He' appeared . . . there was a wave of sentiment, as if a war had been won and a new civilisation was about to dawn. . . . Some of the guests then passed out, others were sick into their bibs and a few made it home, their thingumajigs unable to rise to the occasion. Who was left but the Chancellor of the Exchequer standing alone.[82]

In familiar terms, Sedgemoor's exotic critique depicted the metropolis as a city of consumer spectacle, a panorama of glossy surfaces and showy pleasures. A skilled

satirist, he deliberately evoked Scott Fitzgerald's modernist world to conjure up an image of the capital as a new Sodom. London was the centre for a national orgy of material excess. As a member of Labour's left-wing Campaign group, with an inner-city constituency in Hackney, Sedgemoor spoke up for that other Britain, which, he claimed, had been dispossessed. The cultures of the City and of advertising had combined to produce a new and ugly set of personalities.

Versions of Sedgemoor's story were rehearsed endless times during the late 1980s. Framed either as moral diatribes or as hymns to the market, most of them associated the contemporary worlds of business and commerce with an identifiable set of social actors. The figure of the yuppie was the most publicly visible form of this imagery and the one around which the most expansive loathings and aspirations were hung. The icon of the young urban professional was originally an import from New York's Manhattan. His translation to a London setting produced a particular reading of the persona. Pre-eminently the yuppie was the personification of Britain's unstable economy and commercial culture during the 1980s. Part hero, part victim, he was a creation of the short-lived boom.

What were the characteristic features of the yuppie's identity? Did he embody a particular aetiology? We have already encountered one facet of his presentation in the advertising campaigns of the clothing industry. The most significant feature of this type was that he did not present a coherent identity at all. The yuppie was a hybrid, the focal point for a wide variety of economic and cultural obsessions. The particular inflection of his character depended on the world-view of the speaker or writer. In the financial columns of the press he was closely identified with the City of London, especially after the deregulation of the markets. As city editors never tired of pointing out, the financial sector was in the throes of a revolution. The relaxed, urbane stance of the city gent had been nudged aside by a new type of player on the Stock Exchange and in the dealing rooms.[83] In this context the stress was on the yuppie as the representative of an aggressive personality, whose single-minded dedication to work had displaced the older forms of gentlemanly amateurism. As the Deputy Governor of the Bank of England explained to the world's financial community in 1985: 'There is no point in playing by the rules of cricket when … the rest of the world are playing baseball.'[84] Anthony Hilton, city editor of the The London Standard, lauded the fact that the new men were in the office by 7.30 a.m., quitting their desks more than twelve hours later. Leisurely business dining was a thing of the past. More often than not lunch was now nothing more than a high-fibre sandwich and a glass of mineral water. Not confined to reports of the changing face of the financial sector, these tales of a reinvigorated puritan work ethic also featured in coverage of the comings and goings of media professionals and other service sector workers. Nick Dubrule was a 29-year-old film writer in 1986, who decided that he could treble

his production rate by locking himself away from his family at the London Writing Rooms.[85] This was a converted warehouse in Farringdon where workaholics concentrated single-mindedly on their output. The emphasis on intensely individualised, even heroic labour was recurrent across different sites of commercial activity.

The work rhythms of an egoistical business culture were also understood to have ushered in a more egalitarian approach to status. As Paul Neild, head of equities at the finance house Phillips and Drew, put it, the new professional was also a democrat.[86] Translated into the populist language of tabloid journalism such images became closely associated with a celebration of the Conservative government's economic credo, especially the values of competitive individualism. *The Sun*, in particular, repeatedly profiled the careers of the country's 'new tycoons'. The paper announced that Britain now boasted more than 20,000 millionaires. Despite their often humble origins, these 'real go-getters' had realised their ambitions through hard work and the policies of a 'go-ahead Government'.[87] Popular dramatisations carried with them a traditional moral homily. Wealth was the reward for individual effort and hard work. Yet the soft underside of this tale of self-reliance was much more ambiguous. For the new generators of wealth did not conserve their riches. They were driven by an excessive desire to spend money. Whether it was property, cars, clothes or personal artefacts, consumption was a dominant feature of the yuppie lifestyle.

To what extent did these personifications of affluence shape the presentation of masculinity in Soho and its environs? We can begin by returning to the culture of advertising. In 1988, at the height of agency expansion, *Campaign* reviewed the calibre of the rising young professionals. The identities of these 'young turks' reflected the characteristic virtues which we identified in our survey of the industry. There was the archetypal image of the corporate executive: 'ambitious, aggressive and determined to reach the heights', whose greatest asset was 'his steeliness and determination'.[88] These qualities described William Eccleshare, a Cambridge graduate and 'a good modern account man', who at 32 had grabbed a seat on the board at J. Walter Thompson, in Berkeley Square. But there was also the silent man of strength and character, like Nick Hough, the latest recruit to Yellowhammer as board director, who exuded 'a quiet but menacing presence'.[89] At Bartle Bogle Hegarty, Tim Lindsay was different again. After Cambridge, Lindsay joined Grey advertising as a graduate trainee. Passed over for promotion to account director, he resigned from the company in a fit of arrogance. Arriving at BBH, Lindsay demonstrated what his boss, Nigel Bogle, praised as 'an enormous creative sensibility', together with skills as a lucid strategist.[90] At the age of 29 he too was admitted to the charmed circle of the boardroom.

This gallery of talent again privileged traditional masculine qualities. Ambi-

tion, dynamism and ruthlessness were the attributes which were most highly prized. But the reverse side of the young executive's character was more hedonistic. Depicted as part of a world of lavish entertaining and partying, the image was frequently of young men with too much money going out of control. Getting 'thoroughly plastered' at celebration launches, 'high jinx' involving 'naughty' sexual pranks, these were the types of narratives which appeared in *Campaign*'s gossip columns.[91] As *maître d'hôtel* at Soho's L'Escargot, Salvoni witnessed many displays of these advertising and media professionals 'at play' – and she was frequently left to clean up the mess! Drunken riots with soda siphons, or bunfights with restaurant food, were not uncommon. One media stag night was billed as an 'officers and tarts' party, where the men sporting turn-of-the-century uniforms marched in mock formation through the dining room. They were followed by the arrival of 'the tarts' – all girls from local advertising agencies – clad in little more than sequins and feather boas.[92]

Such displays echoed many of the traditional structures of male excess which had their origins in the nineteenth-century aristocratic culture of London's West End. They also introduced the female counterpart to the male reveller. Within Soho's expanding professional culture the companion for these young men at play was usually a subordinate, rarely an equal. It was principally the female secretary who also participated in these revels. Employment consultants, recruiting secretarial staff for Soho's advertising and media agencies, talked up a world of glamour and excitement which awaited prospective employees. 'The people are dynamic – offices are glitzy – so you can't say no if you are under twenty-one,' enthused the advert from one agency, with their headquarters just north of Oxford Street. The successful applicant would be 'mixing with famous clients (names on TV)' and giving 'tons of secretarial and admin back-up to a team at Director level'. All for £11,000 a year![93] Copy of this sort referenced the feminine culture of central London's office staff and clerical workers. The ups and downs and the gossip of these young women was standard coverage in the capital's free magazines, *Midweek* and *Nine to Five*. Short articles and interviews depicted work as an adjunct to socialising, shopping and above all having fun. At the heart of this journalism was the figure of the single girl about town. She circulated at office parties, set up 'blind dates' for her friends and arranged for 'kissograms' to be delivered on staff birthdays. This unattached female hedonist was invariably cast in a servicing role to her male boss. Yet she was also awarded a degree of social and sexual independence, which was made possible by her participation in the city's urban pleasures. Sal Paradise, editor of *Nine to Five*, told readers of her own weekly scrapes, which usually ended with a weekend of partying and sexual encounters:

> To finish off the week's excitement there was Ro's party. Wall to wall young
> men in designer outfits; I don't know where she finds them. Ro's parties are
> the only parties where you can guarantee there'll be no shortage of single men.
> With all that choice I couldn't decide where to concentrate my efforts.[94]

This fantasy vision of fun and flirtation was offered to young women as their reward for labour at work. Invariably it was portrayed via a liberationist account of sexuality. For as one *Nine to Five* reviewer philosophised: 'when you get down to the nitty gritty' sex was 'the dominant emotion'.[95] Winston Fletcher echoed these sentiments in his novel, *The Manipulators*, where the principal players in the advertising business, women as well as men, were seen to be driven by the Faustian appetites of power, wealth and, above all, sex. His witty observations on the state of the industry also talked up the importance of the informal networks of heterosexual culture. 'Gender difference', he argued, was important at work, 'for flattering flirtation' was 'the first and only worthwhile rule of heterosexual meeting manipulation'. Sex would out, Fletcher insisted, despite the worthy efforts of the apostles of sexual equality![96] Fletcher's viewpoint was, of course, a masculine perspective on the sexual dynamics of the office, which at one level complemented the exuberance of the girl about town. But it was an unequal exchange of pleasures. As one *Campaign* editorial put it in 1988 about fickle clients: 'just as the wife is supposed to be the last to know about an unfaithful husband's bed-hopping activities, so advertising agencies are too often kept in blissful ignorance about a client who is on the point of straying.'[97] Or as Zed Zawada voiced it more personally, when asked about his future career prospects, in 1988: 'As long as it's got young women, motorbikes or rock and roll in it, I'm absolutely ready.'[98] Metaphorically, and at the level of actual encounters, men's attitude to office fun continued to view women as objects of sexual conquest, or through the duplicitous rituals of the extramarital affair.

Such transactions placed young professional men securely inside the normative structures of heterosexuality. Yet other practices were more unstable. At this point we return to the uncertainties surrounding masculinity which surfaced in the contemporary culture of the advertising industry. We have observed how, within the agencies, these ambiguities frequently centred on the creative teams. In the autumn of 1988 *Campaign* gossiped about the 'perennial exhibitionism' of one such duo. Graham Fink and Jeremy Clarke, who had recently moved to Saatchi & Saatchi, celebrated Fink's 29th birthday in great style.[99] The 'birthday boy' was woken by his creative partner, accompanied by a hired butler, who ironed and folded Fink's clothes and ran his bath. The party then processed to a gentleman's barber's in Brook Street, for a shave and other toiletry preparations. Breakfast was at the Inn on the Park 'with a few mateys', and then on to Saatchi's.

At this point a helicopter was waiting, to whisk the pair off to Raymond Blanc's prestige restaurant, Le Manoir aux Quat' Saisons, in Oxfordshire, for lunch. When they returned several hours later, a string quartet was waiting in Fink's office to entertain them both for the rest of the afternoon. Rituals of this type secured particular forms of male bonding in and through an exchange of gifts. Commodities cemented personal contact between young men, who were cognisant of a shared knowledge of élite consumption. Magazines like *Arena* instructed its readers in this mode of consumer competence, urgently striving to invest it with social honour and divest it of shame. But in Soho in the 1980s these were not the only masculine scripts in circulation. They coexisted with more explicitly dissident styles of behaviour. Homosexual actors rubbed shoulders with the new professional types in many of the area's public spaces.

6 Homosexual *Flâneurs* and their Hybrids

For many of Soho's older *habitués*, fine distinctions between the new arrivals were hardly worth making. Bernard's attack on each and every newcomer as hastening Soho's demise was characteristic. Similarly, in Fletcher's novel, Wally, the fictional landlord of the pub in Fitzrovia, The Quills, poured scorn on all of the immigrants. They were collectively classed as 'the tight-arsed little nancy brigade' who turned 'countless decent pubs into wine bars'.[100] Critical accounts ran together the themes of effeminacy and cultural sophistication in order to condemn men who were attracted to the new forms of consumption. But this was a simplified reading of Soho in the 1980s. The growth of gay male culture in the area produced its own distinctive forms of identity. These social personalities partly broke with established subcultural codes and crystallised a new homosexual type.

The male homosexual, since his appearance in the urban centres of Europe and North America in the latter part of the nineteenth century, was formed out of the complex intersection of official discourses and resistant cultures. There was no linear development of one dominant sense of self; rather, what occurred was the growing proliferation of ways of living a homosexual life.[101] The expansion of the marketplace from the mid-1970s, in London as elsewhere, encouraged a number of specific images among gay men, which were closely linked to commerce. One of the most significant of these was the gay clone.

The clone was an international phenomenon whose personality celebrated

both the growth of urban gay culture and an optimistic, pre-AIDS sexual philosophy. Sporting an exaggerated masculine wardrobe – short hair, moustache, check flannel shirt, Levi's jeans and bumpers or workboots – he was a gay everyman, whose identity was assembled out of the signifiers of mainstream fashion. Though there were subtle variations in style, the clone image was essentially a uniform which any man could acquire. The presentation was democratic and relatively ageless. No expensive items of clothing were necessary, nor was there an overriding concern with youth. The clone's lifestyle was emphatically pro-sex. A late twentieth-century *flâneur*, he cruised the streets with a clear agenda. Casual sex between men, desacrilised and uncoupled from the context of romantic love or long-term relationships, was a high priority. It was a sexual perspective which paralleled other liberationist ideologies of the 1960s and 1970s, especially those of the counter-cultural movements. But the clone was not a theorist; he was primarily a sexual practitioner. Personal accessories – such as coloured handkerchiefs, keys and earrings – were used to convey precise sexual preferences. The surfaces of his body were used to display a range of erotic signifiers.[102] By no means all gay men aspired to the clone ethos. Many resisted it – and some criticised its consumerist stance on personal relations. Nor at the level of subjective experience was this image as neatly packaged as it appeared in the pubs and clubs. Nevertheless, the clone was an attractive icon for many gay men. It exuded a confidence which drew strength from the growth of the homosexual city.

The spatial recentring of Soho on the sexual map of London in the 1980s coincided with a partial recomposition of this coherent image. It was not a total shift. What occurred was a subtle blurring of some of the sharpness of the gay identity, together with a greater emphasis on diversity and heterogeneity. The stance was largely promoted by a particular grouping of younger gay men. Benefiting from a decade of sexual politics, this was the generation who were comfortable enough with their sexual sense of self to begin to push at its boundaries. Many of the leaders of this culture, such as the activist Mark Ashton and singer Jimmy Somerville, again worked with self-conscious positions of marginality.[103] Many were also members of London's latter-day democratised bohemia, which included film-makers, freelance journalists, painters, booksellers and students. In their discourse at this time one idea more than any other encapsulated the changing stance on sexual identity. This was the notion of 'mixed' cultures. The concept encompassed an understanding of the plurality of personalities and spaces, as well as their related forms of experience. It was a language of hybridity which projected an optimistic vision of the future. We have already encountered variants of this emphasis as a recurrent motif in the style press. In a more concrete form it featured in the wide variety of leisure

venues which sprang up in and around Soho.

Nightclubs, with their particular musical vocabularies, were a key ingredient in this more heterogeneous culture. Heaven promoted its Thursday nights at the Sanctuary in 1986 as a refuge for all 'mixed/gay straightbodies'. In its mock dungeon deejays scrambled '70s trash ... funk, house, go go and bits and pieces'.[104] This jumbling of musical genres deliberately brought together different sexual constituencies. Stallions' 'Roadblock' nights at Falconberg Court were presented as: 'a wicked funky stew for a mixed funky crew'.[105] The Jungle club at Busby's, on Charing Cross Road, was the most deliberate attempt to promote sexual diversity. Its advertising flyers spoke to 'gay men and women and their friends'. Inside the club visual motifs suggested the commingling of bodies and personalities in the undergrowth of the jungle. 'Jungle – lose yourself in the jungle', proclaimed club banners which were hung across the dance-floor.[106] Visual culture featured strongly in this attempt to obscure meaning. On the walls of the club's main space slide projection blow-ups of Titian and Veronese paintings, portraying the high Renaissance passions of Venus and Adonis, jostled for attention with more contemporary images. Club promoters guaranteed a 'journey into the unknown', a crossing from one plane to another. In a similar way Go Global at the Astoria Theatre, again on Charing Cross Road, promised a multi-media exploration of all barriers through 'film, video and body contact'.[107] Advertising for the club came in the form of mock passports and travel documents.

The creation of these atmospheric environments was the work of particular architects of ambience. Banners, sculptures, painted floorboards, together with individually designed promotional flyers and membership cards, gave each venue an identifiable character. Prominent among the nightclub designers was George Georgiou. An ex-student from Hornsey College of Art and Leicester Polytechnic, Georgiou was recruited to the club scene by entrepreneur Oliver Peyton, a contemporary from Leicester. Peyton's first club, publicised by Georgiou's flyers, was called BB Crop. It was run from Soho's Tisbury Court in 1985. In the autumn of that year Peyton opened RAW, at the Tottenham Court Road YMCA, and once again Georgiou handled the publicity and customised the dance-floor. By this time Georgiou had formed his own partnership, General Practice, which specialised in nightclub design.[108]

Projects of this sort were notable for more than their sexual pluralism. The emphasis on mixed cultures tentatively began to open up London's homosexual spaces to more ethnically diverse audiences. Once again the impact of a different ensemble of music was crucial. The 'funky stew', billed by deejays like Vaughan Toulouse and Fat Tony, involved the spinning of contemporary black–white crossover sounds, including soul, funk, hip-hop, ska and fast reggae. These forms

were themselves the product of a dialogue between Afro-Caribbean and white youth taking place in London, New York and elsewhere from the early 1980s onwards.[109] In Soho such cultural conversations were not confined to the dance-floor. By the spring of 1988 the area had generated a number of specialist record outlets, where retailing brought together customers from different ethnic constituencies via the common denominator of music. The new shops included Black Market Records, in D'Arblay Street, specialising in garage sounds, Groove Records, in Greek Street, known for rare hip-hop imports, and Hitman Records, in Lexington Street, selling lover's rock. Adjacent to the large music stores of Virgin and HMV on nearby Oxford Street, these sites functioned as a loose community resource, especially for young black youth, who might otherwise never have set foot in Soho. As Steve Jerviere, co-founder of Black Market, noted in the autumn of 1989, his shop had become 'a place where people hang out, people talk to each other, people get work and make deals with each other'.[110]

Musical cultures of this kind were already well established in the heterosocial nightclub spaces of Soho. But their impact on gay clubs marked a significant departure. They resulted in the partial displacement of the dominant styles of disco music and HiNRG. Simultaneously, the new sounds established different styles of self-presentation. The emphasis might be variously on displays of 'cool' (as in funk, or in jazz and Latin rhythms), or on the acrobatic routines turned out by hip-hop dancers. In the majority of cases the effect of these cultural imports was to pluralise gay culture. Deejay Steve Swindells promoted his weekly venue for men of colour at the Lift in 1987 by pushing reggae and deliberately marginalising what he termed 'gay music'. Along with Asylum at Heaven and The Bell at King's Cross, the Lift was one of the first venues to recognise the existence of an ethnically mixed clientele.[111]

If music carried one strand of this move towards cultural diversity, clothes and the presentation of the body encapsulated another element. In its review of 1986, *The Face* noted how street fashion that year had thrown up a new image. This was the style of the 'matt black street urchin', wearing 501 jeans and a black or green bomber jacket.[112] It was precisely the look which Petri raided countless times in his buffalo sequences. Among his resources were Soho's new homosexual spaces. The style appeared in the window displays of local shops with a strong gay customer base, such as American Retro, or Flex, at the Trocadero Centre in Piccadilly. As a form of visual coding it eroticised the surfaces of the gay body. Jeans, haircuts, shoes and boots were not simply used to signify homosexuality, or to indicate sexual preference, as they had done in the heyday of the clone. These forms of representation were now assembled as part of a visual culture which revolved around the objects and artefacts of consumer style. Like the Levi's adverts, it was the commodities themselves and their symbolic arrangement

which evoked sexual meanings. Such images also produced a subtle shift in forms of gay spectatorship on the street. 'Cruising' – whereby gay men visually took stock of each other as a prelude to sex – became partly redefined. Looks of recognition were now also fixed on mutual displays of admiration, coded through the discourse of style. Soho's developing gay infrastructure, together with its extensive legacy of bohemianism, made the area an important site for these encounters.

It would be wrong to overestimate the extent of these cultural transformations. In Soho, as elsewhere, more plural representations of homosexuality coexisted with images which reaffirmed the importance of sexual separateness. Yet a number of broadly based changes encouraged the move towards diversity. In part, the type of sexual recomposition visible within gay culture was one result of the long-term impact of AIDS. The threat of HIV infection, together with safer sex injunctions, led to a re-evaluation of sexual practice, especially in relation to penetration. The result was a greater level of self-awareness among a generation of younger gay men who had never known sex without the anxiety of the HIV virus. This involved some pluralisation of the circuits of homosexual desire, together with an inventive recasting of erotic meanings.[113] The men's personal columns of the gay press testified to this process of experimentation. Again it was the surfaces of the body, linked to particular styles or looks, which began to be privileged as sites of sexuality, rather than an exclusive focus on one dominant sexual act:

> Rockabilly seeks Rockabilly guys into boxer shorts, Y-fronts and anything 1950s for fun, friendship and hopefully more.[114]

> Flat top seeks safe teddy bear for Xmas. Good looks, blond. Likes clubbing, dance music. Rockabilly, skins.[115]

The search for sex was run together with music, dancing and all the paraphernalia of style which had been forged in the culture of the marketplace.

These youth-oriented forms of identity registered the impact of a contemporary aesthetic which foregrounded a playful and, at times, an ironic account of sexual orientation. Earlier types of gay imagery, such as 'camp' or 'drag', were also revived, alongside more up-to-date signifiers. The overall effect of this language of pastiche and bricolage was deliberately to disrupt sexual meanings. A spate of gay 'trash' magazines, or fanzines, appeared in the late 1980s, with tongue-in-cheek titles such as *FF* or *Vada Magascene*.[116] Their trademark was a version of camp burlesque, together with a strategic use of obscenity. Thom O'Dwyer, in an article entitled 'Jocks in Frocks', argued that this desire to experiment with language and identity was a sign of growing self-confidence among younger

homosexual men. After the rigidities of the 1970s, which had pushed gays into adopting the pseudo-masculine clone image, O'Dwyer claimed that the community was 'starting to loosen up', becoming 'less nervous about accepting Yin and Yang'.[117]

The sense of cultural diffusion was also encouraged by a renewed alliance between lesbians and gay men. This dialogue was visible not only at the level of political campaigning – such as AIDS activism and other struggles over discrimination – but also in some of the new leisure venues appearing in the West End. The First Out café marked a break with the prevailing ethos of masculine consumption, by catering for the needs of lesbians as well as gay men. As the founders of First Out noted, women's requirements were very poorly catered for, especially in central London, on account of perceptions of their low spending power. The café's aim was to create a truly mixed space, in which women as well as men could feel comfortable.[118] Though masculine personas predominated in Soho's version of the homosexual city, the emphasis on plurality did encourage the appearance of more visible forms of lesbianism.

Such experiments involved some subtle modifications to an established culture of homosexuality in Soho. Yet what was equally important was the extent to which elements of this repertoire bled outwards, to be taken up and reworked by other constituencies. Young men, who by no means embraced a gay identity, but who mingled in the same or adjacent spaces with their gay contemporaries, also negotiated a number of these codes of self-presentation. At this point we return to the homosocial networks which have punctuated our account. To what extent was there evidence of any mixing of sexual cultures in the area? Here the evidence is thinner, but spatial and linguistic discourses point to some significant exchanges. Once again Soho's night-life played a critical role. A number of prominent club venues did attempt to integrate heterosocial and homosocial patterns of leisure. The most significant of these was the Wag Club, in Wardour Street. Billed as one of Soho's 'hippest nightspots', it regularly attracted a mixture of 'languid young blades and ... existentialists'.[119] The key to getting past the tight door policy, operated by the notorious bouncer Winston, was to 'look cool, distant and interesting'. For most of the week the Wag was decidedly straight, but on Saturday night the atmosphere changed. A different mix of music – mainly 'light-hearted soul and disco' – encouraged an ambience which was, in the words of *City Limits*: 'More camp than gay, but not too camp to become unbearable'.[120] The notion of camp – as opposed to the more obvious signifier, gay – once again referenced a culture in which identities were temporarily blurred, via the rituals of the city at night. Other clubs, such as the Academy at the Astoria (favoured by Petri for one of his style narratives), or Sunday nights at the Reptile House on Charing Cross Road, experimented with similar types of hybridity.

One effect of this tentative crossing of sexual boundaries was registered at the level of language. Comments from the young heterosexual men who participated in Soho's style culture during the period displayed an increasingly ironic tone in speaking about themselves and their world. At times this vocabulary raided gay argot. Letters in *The Face* repeatedly used a grammar which was redolent with ambiguity and *double entendre* in commenting on men's involvement in style and fashion culture. One correspondent, signing himself 'the Vagabond of Sheffield', poked fun at what he implied were the camp antics of London lads: 'Why is it that London boys think they are so bitch? Why do they credit themselves with everything that happens on the streets of Britain?'[121] The joke played on the familiar masculine rivalry between north and south. In doing so 'the Vagabond' deployed gay slang to depict London men as sexually passive, or 'bitch'.

The contemporary fanzine *Boy's Own*, founded by deejays Terry Farley and Paul Oakenfold, worked with a different version of homosociability. On sale in clothes shops and clubs in the Soho area in the late 1980s, its editor hyped the magazine as 'dangerously trendy and read by thugs'.[122] In fact its coverage produced a running parody of conventional forms of masculinity. The title mimicked the name of a traditional boy's paper, while the editor spoke to readers in words of mock intimacy, signing himself 'Love and Loveably, the Outsider'.[123] Articles ranged from pieces on football violence to accounts of cut-throat razor shaves at the barbers, and stories about 'being true to your mates'. But their style was not conventionally masculine; it was disingenuous and knowingly *faux-naïf*. Irony, mixed with a waggish repartee, were strategies used to render young men self-conscious and to disrupt their dominant scripts. Soho's heterosexual population danced a version of this urban pirouette quite as much as their homosexual contemporaries. It was the rituals of consumption, backed by the area's highly specific social geography, which provided the infrastructure for these experiments in masculinity.

What can be deduced from this archaeology of Soho? How does our mapping of the spaces of London's West End complexify the narrative of gender and commerce in the 1980s? The move to Soho formed part of an argument about the specific dynamics of consumption, as opposed to its generalities. In the working out of young men's consumer markets at this time, place and context were crucial. Definite zones of the metropolis were privileged sites at which a number of important cultural rituals were played out. In this respect de Certeau's insights into the mechanics of modern consumption are instructive. Commercial regimes, he has insisted, are dispersed and devious. Operating not only from the most obvious social vantage points – such as in products and their imagery – they also

write themselves into the fabric of everyday life.[124] A significant part of these micro-practices are spatial in their organisation. In Soho, young men who occupied its streets and public places negotiated their routes with the aid of a grammar for reading the consumer city. This was a contemporary system of knowledge, but it was also historically sedimented. Our account of Soho's past was not simply an antiquarian ramble through the quarter. It was concerned to demonstrate how a particular map of bohemia continued to inform the area's commercial development well into the 1980s. Latter-day *flâneurs* staked out their claim to city space armed with the authority of much earlier guides. But such languages of urban culture were far from simply existing as disembodied texts. They were representations which were grounded in definite institutional pro-grammes and intellectual alliances. In Soho, as elsewhere, it was a loose but effective team of advertising and media professionals, together with more avant-garde taste leaders, who assembled this urban vision. As the style *cognoscenti* put it: city life always needs an editor.

Soho's topography provided one important landscape for the enactment of particular modes of self-presentation among young men. Yet space was not simply a passive backdrop, to be occupied by pre-formed personalities. Soho's geography was active in the construction of the public and private personas of its consumers. Such masculine identities were plural rather than singular, diverse rather than unified. The area's redevelopment produced a heterotopic world in which separate taste-communities coexisted uneasily. Young men from different constituencies opened up the quarter to specific and at times competing uses and symbolic interpretations. For the most part these were organised along an axis separating heterosexual from homosexual behaviours. However, at moments more hybrid forms of identity were generated, as ways of being and acting mutated from one group to another. Our story of Soho has begun to trace some of the codes through which these forms of selfhood were imagined and played out. There is, however, a further level to the exploration of masculinity which brings into play the interior dynamics of subjectivity and more intimate biographies. For these we remain in Soho, but turn to different types of testimony and to different types of texts.

7 Some Conversations

It is worth reviewing for a moment how the question of identity has featured in our history. *Cultures of Consumption* has charted a number of interlinked narratives of economy and culture. It has traced the ways in which a specific

regime of commerce generated a number of personas offered to young men in the 1980s. The figure of the 'new man' which opened our account was a composite icon, assembled out of a diverse alliance of knowledges and forms of business expertise. He was most immediately visible as a set of images which circulated in the marketplace. Identity in this sense was a symbolic form of representation, crystallised in texts which were associated with promotional culture. But identity also punctuated the analysis in a different way. It appeared in an exploration of the authorial consciousness of a number of leading advocates of the new approach to consumption. A powerful sense of centred individuality – a belief that the world did indeed revolve around the actions of a few prestigious actors – figured prominently in the tactics employed by the leaders of style and advertising. Gender was a key distinguishing motif in these public projections of the self. Finally, identity surfaced as a central part of the urban question; in the topographical mapping of those zones of city life most closely identified with fashionable consumer society. The spatial organisation of Soho generated a diversity of masculine scripts which were dominant in the area's thoroughfares and leisure spaces in the 1980s. Identities as textual projections, as devices for centring the ego, or as positions within space and place – these are the ways in which the issue has informed our analysis.

However, it might be argued that there is an obvious lacuna in this project. Identity has been theorised as an effect of a range of social programmes – a discursive space marked out within the commercial field. To adopt such a framework is to remain silent about subjectivity as it is enacted at the level of self-understanding or self-dramatisation. Our exploration of gender and consumer culture demanded some engagement with the personal testimonies of the young men who participated in city life. This autobiographical dimension was important, not because it guaranteed a more authentic account of consumption, against which the various entrepreneurial strategies might be judged. The area of personal affirmation was significant because it introduced a different level of analysis. It provided a way into exploring the interiority of male subjectivity, its tensions and fragilities, as well as its more coherent satisfactions. The various commercial undertakings which we have documented were essentially reflexive endeavours, encouraging young men to turn their attention on themselves. It was therefore important to chart the extent to which such strategies of self-scrutiny informed the autobiographical narratives which young men presented. Was there any continuity between these different levels of social practice? It was the possible relationship between an internal landscape of identity and more public networks and institutions which concerned us in the final stage of work on Soho.

We begin with a long fragment of a conversation which took place between the author and Andrew, the chef at the First Out café, early in 1987:

ANDREW: I'm 21. I've lived in London for two years. I come from Aylesbury in Buckinghamshire in the Home Counties.... My parents, er my Dad, originates from London, my Mum from India. My Dad comes from a working-class background, but he's pulled himself out of it. He's a manager in a department store and mum works in an office. I think we've been brought up with sort of middle-class attitudes.

AUTHOR: What attracted you to working in catering?

ANDREW: Oh, er [pause] well, I was at school, I was in the sixth form. And I sort of realised that I wasn't very academic and one of the things I enjoyed at the time was cooking. I say at the time, 'cos now I'm not really very interested in it apart from socially. [pause] Entertaining people – I like to make them food. I enjoy cooking on a small scale and making spreads.... Well, I went to London and worked in a hall of residence. I couldn't stay at home anymore, 'cos my parents – er, I'm not out to my parents. I discovered fashion, clothes – well not fashion, style, and the look. After I moved to London I stopped buying corduroys and shirts and started having my hair cut the way you're supposed to. Which was quite good, it gave me a sense of freedom and I could live in the West End in my own flat. That was good and the money was good.

AUTHOR: Are you interested in clothes and style?

ANDREW: [emphatically] Yes I am. I am quite interested. I usually go in phases of spending all my money, when I find a new shop that I feel like I can afford at the time. Do you want the names? Dexter Wong, off St Martin's Lane. I mean I don't think many people know about it. I go to De Mob, like everybody else, but they're good quality and they're different.[125] I don't go into the high street stores.

AUTHOR: Why not?

ANDREW: I find in Next and Top Man they have so much stuff which is such bad quality and it's all the same thing and I find it quite boring. I've had arguments with friends about 'Who do I dress for?' I think in the end for other people.

AUTHOR: For other men?

ANDREW: [emphatically] For other men. I like to be looked at.

AUTHOR: In a sexual way, or in a sort of visual way?

ANDREW: I think one thing leads to another. I do think of an identity in the way I dress. There is a certain image that is sort of my image, a very sort of Soho look. When I walk around I find it very difficult to tell who's gay and who's not. I usually think I can tell when I'm walking down Oxford Street or somewhere. But when somebody comes along with that look – the flat-top, the black jacket and the DM shoes, or whatever – I think they might

be gay, but not necessarily.... You do sort of look at each other quite a lot and if somebody's dressed quite similar to you and just had their hair cut and it looks quite neat and, erm, you do catch people looking, don't you?

AUTHOR: Is it a sexual look?

ANDREW: I think that depends. They may be looking at your clothes, especially if you're wearing something different, er, I don't really know. I know it's quite fashionable for young straight men to go to gay clubs. I know my flatmate's boyfriend finds it quite exciting – he's straight – to go to gay clubs during the summer. And I, er, flirted with him quite a lot. He was very interested in me and I was very interested in him. Especially the dress, with the black jacket and the jeans and the DMs.

Andrew's conversation ranged across many of the themes which have been central to our story. There was a familiar account of the allure of contemporary metropolitan life and its impact on young men's sense of their place in the world. Here were the day and night-time venues which have appeared on the map of 1980s London. Andrew felt his way through the new environment with the aid of a particular cartography of taste. As so often, this was a select, rather than a popular travel guide, which divulged sought-after information about the significant sites of style. Within these locations it was visual culture which predominated as the common currency of communication. Positioning himself within this universe involved negotiating one of the major fault lines regulating masculinity: the line dividing normal from dissident sexualities. And yet Andrew's disclosures gestured towards the partial blurring of such distinctions. He testified to the fact that within privileged urban milieus, more hybrid scripts were becoming available to young men. The dynamics of commercial society had apparently opened up the space for different forms of homosociability, which were manifested in the culture of the city.

This autobiographical sketch was one of over twenty collected throughout 1987, in Soho and adjacent areas of London. These were loosely structured, taped interviews with young men, aged between 16 and 25. The chosen age range followed one of the most significant consumer segments identified by contemporary market research. Visual appearance was an important criterion for interview selection. This was not a superficial starting point, given the centrality of self-image in the contemporary debates about masculinity. There was also an attempt to nominate a sexually and ethnically mixed constituency of young men. These groups were recruited by the deliberate selection of particular urban locations. The choice was for those work environments and leisure settings which were associated with Soho's new consumer culture. Shops, bars, restaurants, cafés, nightclubs, as well as the street, were the principal sites for the research.

Subjects were usually interviewed *in situ*, in order to preserve the spatial dimensions of the transactions. The project marked a limited excursion into the field. But what could it deliver? This was not a rigorous ethnography, with tightly defined objectives, sample quotas and control group corollaries. It that sense it did not systematically follow either the procedures of academic sociology or those of qualitative market research. Nor was the project conceived as a limited piece of contemporary oral history, designed to map the experience of young men in any simple sense. The difficulties involved in adhering to these research protocols were not only practical, relating to issues of time and resources, they also centred on two important and unresolved theoretical problems. The first of these concerned the model of cultural transmission which informed the approach to fieldwork, in particular the conceptualisation of the relationship between the production and reception of cultural forms. The second dilemma involved an even larger question, namely: the understanding of subjectivity itself.

Qualitative market research which has drawn on ethnographic traditions has usually understood consumers as part of a narrowly bounded producer–receiver circuit, positioned in relation to a single or isolated series of consumption goods. Within this framework, audiences have been of interest to the fieldworker insofar as they have provided evidence for the impact or diffusion of products and services. The result has often been an artificially restricted view of the consumer process. Such accounts have made it extremely difficult to follow the more dispersed and extended networks through which commodities are circulated. In particular, what have been marginalised in this type of analysis are all the cultural rituals within which goods are constituted as part of the fabric of everyday life.[126] Consumption practices in the minds of consumers are extremely porous; they are not usually perceived as narrowly circumscribed. It was precisely these broad-based practices and social landscapes which figured prominently in the testimonies of our respondents. Many of those interviewed defined their identities, their sexuality and their sense of place and environment with the aid of commercial signposts. But markers of this kind did not produce a wholly unified account of subjectivity. The personal testimonies of these young men displayed a contradictory movement. They were at once self-centred and fragmented. Frequently the accounts which they presented of themselves and their relation to commercial society exhibited a nomadic quality. Their autobiographies appeared to wander through a range of social and spatial terrains, rather than projecting wholly coherent identities.[127] A decentred understanding of subjectivity has rarely been grasped in conventional market research, nor has it predominated within more academic practices of ethnography. What continue to inform both sets of accounts are psychological or rationalist assumptions about the unity of the subject.

In what follows, subjectivity was understood as the negotiation of practices

which shaped the individual into a diversity of positions, rather than any one single stance. Such apparatuses included, of course, the narrative act of interviewing itself, together with the spatial environments within which these dialogues took place. The result was not, however, total incoherence. If there was discontinuity at the level of self-presentation it was partial rather than totalising. The young men we encountered did position themselves in relation to a set of institutions and structures which figured repeatedly in their conversations, and which were perceived by them to exert a major influence on the organisation of their lives. Our excursion into the field was an attempt to map some of these habits of everyday life, or day-to-day existence. With these issues in mind, we return to Andrew's account.

Andrew's testimony opened with a familiar trope of spatial migration. A confined early life spent in the provinces was suddenly transformed by escape to the metropolis. We have encountered a number of these journeys to the centre: from Julie Burchill's dramatisation of her own story to the forms of symbolic home-coming celebrated by generations of homosexual men on reaching London. Andrew's flight from home was both specific and generic. It was a response to the particular demands of home life, with its pressures to conform to traditional patterns of sexuality. But his solution drew on a range of well-established cultural resources. He rehearsed a familiar sense of excitement associated with the process of metropolitan discovery. His arrival in the capital involved the take-up of a new and what was for him a more positive form of subjectivity. Like a convert or a novice, the process was recounted as an initiation rite. It involved the symbolic donning of a new costume and a break with habitual routines. Andrew's hair was cut 'in the way you're supposed to have it cut', while his visual appearance showed all the signs of conforming to the demands of fashionability – what he aptly termed 'the look'. Many of the young men interviewed testified to having been affected by this type of metropolitan transformation. It was especially strong among those who identified with the homosexual culture of the city.

Neil was a final-year psychology student in Portsmouth, who came up to London almost every weekend. The allure of London's gay scene was such that as soon as he returned to his home town every Monday, he was planning the next trip to the capital. London's magnetic attraction had confirmed in his own mind that the only place to live was in the city. As he explained: 'as soon as I leave Portsmouth, I'm going straight back to London. I'm going back to London this weekend.' For these young gay men, urban migration was not only accepted as an inevitable fact of life; it was embraced positively because it was seen to lead to an expansion of their sense of self and their sexual identity. In their imagination, Andrew and Neil both pictured London as the site of a future utopia, which revolved around the world of goods. They referred to this as 'the good life'. As Neil saw it:

I know the ideal I'm aiming for.... Having a rather plush flat somewhere. Just being able to afford to live in London. I like to be able to feel I can go off on holidays at least twice a year. [laughs] When you're able to think, I've got some money, now I can play around with it. Not in the sense that I want to be a great capitalist and amass a fortune. Just enough to be happy.

Or as Andrew explained:

I want to live comfortably, have somewhere of my own. At the moment I'm worried so much about where I live. I lived on my own previously and had my own flat in Tichfield Street for two years. And now I'm having to live with two other students.... I find it really difficult.... I think that is the one thing; to have control over your own life and conditions.

At one level their version of the secular sublime focused on a common enough desire for material advancement in status and social position via a familiar range of goods and services, such as housing and holidays. But as young homosexual men, the personal advantages to be gained from the acquisition of these effects was driven by more than material calculation. For Neil and Andrew, possession of a number of key commodities carried with it strong assumptions about the correct modes of inhabiting the city and living a homosexual life. Consumption goods guaranteed effective participation in a new society. They also provided the conditions of freedom to 'be oneself'. Their vision was projected via the dual perspectives of sexual dissidence and commercial culture. Consumer rituals and a contemporary sexual lifestyle were understood to be inextricably linked.

This was not the only migrants' story. Other accounts bore witness to quite different types of social experience and projected different versions of the self. Many of these stories have been rehearsed much more frequently. One dominant motif involved variants of the Dick Whittington fable, or in reality more modest versions of the metropolitan tale, in which the capital provided the space for self-advancement for men from subordinate social groups. Such narratives were frequently organised around an image of London not so much as the city of glamour, but as the city of gold. Chris had worked on stalls in Birmingham's rag market before moving to the capital. He was now a sales assistant in a smart men's clothes shop in Wardour Street, selling a range of suits and casual wear. It was 'the money and a bit more scope for expansion' which brought him to the metropolis: 'because there's more business and more of everything down in the south. In Birmingham it's limited, dreadfully limited.' Echoing the dominant commercial and business rhetoric of the period, in Chris's discourse London featured as the focal point for all entrepreneurial activity. Once established, he believed he could not only accrue wealth, but quite literally expand his personality. Future prospects

hinged on opening his own business, selling 'smart clothes, done at competitive prices'. But London was also 'brilliant' for other reasons, especially on account of the limitless potential for leisure and night-life. As he saw it: 'It's another good reason for moving down here. I mean in Brum we've got a total of like two clubs. It's like good to get down, to be able to go out somewhere different every Friday or Saturday.' For Chris the pleasures of the urban scene were linked to the self-evident superiority of the metropolis: the size, scale and the brilliance of its facilities, against which Birmingham could never compete.

Ranged against these enthusiastic commitments to metropolitan living were a number of much more resistant readings of the city. The disturbed migrant – the young man who lamented the loss of a settled existence in the provinces after moving to London – was one such character. Darren was a carpenter in his early twenties. Originally from Fratton, a working-class district of Portsmouth, he had moved to London to find work:

> I've lived in London for four years. I'm not a racialist, but there's so many foreigners up here. You can't make friends, you can't trust nobody. When you've grown up with your mates and that, you know who you can trust and who you can't. I've found it very lonely, a very lonely city. But they're all clones up here; they all stick to their own type. It's over-rated.... It's expensive, isn't it? It's different from down in Portsmouth. You're always [pause] you're always looking over your shoulder in a place like this, aren't you? You don't know who's who.

Darren's complaint about the disturbed nature of city life was a traditionalist masculine elegy for a lost world. The past and present were defined in predominantly spatial terms. Portsmouth was remembered as the site of positive networks of organic solidarity between men. Subsequently these patterns of existence had been broken up by the move to London. Darren's vocabulary was shot through with distinctions between community and anomie. In the secure world of Portsmouth it was easy to establish who was on the inside, or on the outside, of any group. London had disrupted those structures of recognition. The alienation felt by the migrant was exacerbated by the presence of a familiar type of stranger – the foreigner – carrying overtones of racial difference and incompatibility. Darren's negative stance on London was reinforced by the segmented patterns of identity which characterised life in the capital. This he believed to be the root cause of his loneliness. Individuals clustered around their own types – a process which significantly he referred to as cloning. Darren's use of the term was ambiguous, but it implied a range of unnatural or artificial personalities. The result was a lack of safe territory and an absence of familiar

structures of feeling. Traditional masculine signifiers of social class had dis-
appeared. As he concluded: 'You don't know who's who.'

A different critique of metropolitan space was mounted from the position of
racial difference. Paul was a young black, the assistant manager of a clothes shop
in Tottenham in north London. He came into the West End regularly to 'check
out' the sounds in the specialist record shops, but he remained massively
unimpressed with Soho's claims to culture. His critique of the area was bound up
with the restricted nature of the space. Soho, he believed, was a white ghetto:

> To me the people here are irrelevant. 'Cos they're people who are not on the
> street level, who have little contact. Just people who are working from past
> memories, or people who, as far as I'm concerned, don't know what's
> happening.... To be quite honest, this is an ethnic issue. Guys from
> Tottenham aren't going to buy *I-D* or *The Face* or anything like that.

Paul's attack on Soho involved an exposure of the lack of credibility of its
population. This was conceived in terms of a cultural politics of race, which was
dramatised through competing notions of fashion. The guys from his own area
were closer to the pressure points of 'real style', because they were closer to the
street. The 'majority of blacks dressed well,' Paul asserted, in contrast to 'the
English', who were the 'worst dressed people around'. In his exposure of Soho,
Paul also celebrated a different metropolitan geography, which refused the
centrality of the West End. What came into visibility were the sites of established
black communities: Stratford, in east London, Brixton, in south, as well as his own
home territory of Tottenham. Yet this different spatial axis presented its own
problems for Paul as a budding entrepreneur:

> There's only one direction – to start my own business. But the clothing
> industry is white, middle-class dominated you know. There's no direction,
> you know, unless I can go for ethnic companies.... You've got to be local
> and have a relationship with your customers. But in doing that they [the
> shops] have always got to be in the worst areas. They can't be in central
> London. They've always got to be like a small family business.

Paul registered the obstacles confronting retailers who wanted to promote their
styles and products beyond the confines of specific black communities. He also
drew attention to the ways in which black business was differently organised,
often constructing its markets via strong local links. And he underlined the fact
that, for the majority of the young black Britons, London's West End was far from
being at the centre of their world. Though they might temporarily inhabit its
spaces, their urban plan presented a challenge to the dominant map. These points
were echoed by David, an actor who worked mainly in commercials from a small

modelling agency in Soho. His basic problem was the sporadic nature of employment, particularly for black artists: 'Everything's laid on in this game when you're working.... But jobs are few and far between for blacks. If you ever want a black Nubian slave, just give me a ring, OK!' The solution as he saw it was ultimately to escape from Britain to a different and more compatible world of business and leisure: 'What exists for me is getting together five grand. Buy a little flat in Jamaica – make America my base. I just want to go out there. I don't feel happy here. Silly little things I don't like.' For these respondents, Soho was by no means the focal point of their utopia.

Complex and conflicting patterns of material and symbolic migration were a characteristic feature of many young men's lives. But it was the stories which respondents told of London as a consumer city which produced the most extended reflections about the self. In this respect consumption featured quite literally as both a labour and a pleasure. A number of young men were interviewed in their workplace environments, which formed the infrastructure of Soho's buoyant consumer culture. Their experience frequently involved some reflection on the relationship between time spent at work in the service sector and the identities they held as men. For those individuals who had taken on a gay persona, this issue was relatively unproblematic, though there were often difficulties of a different sort. Andrew's own job as a chef had originally attracted him because it seemed glamorous and because he enjoyed entertaining and serving food. These were traditional servicing roles, which, as employment opportunities, were relatively accessible to homosexual men. Andrew complained that the glamour attached to First Out had rapidly disappeared. For him the café was now more often than not simply the site of hard work.

However, despite such dissatisfactions, the assumption of a homosexual lifestyle and employment in the service industries did not jar. Two shop assistants, who performed as a double-act behind the counter in Astrohome (a store specialising in de-luxe items of interior decor, in Neal Street to the east of Soho), presented an ironic commentary on the homosexualisation of shopping. Jokingly referring to themselves as 'shop-girls', they recounted that their routine for getting through the working day was to gossip endlessly, adopting a pose of 'not actually being there'. Like the female assistants in Emile Zola's nineteenth-century novel, *Au Bonheur des dames*, daydreaming was a significant part of these young men's existence. As one of them put it: 'Yeah, half the time when I'm in the shop I'm in a world of my own, anyway. I kind of say, "Well I'm not here, I'm on another planet".' Resistance to the tedium of shopwork involved absenting oneself, in an attempt to deny the realities of place. These forms of avoidance also involved elaborate jokes and repartee, such as 'taking the piss out of the customers', as well as insulting the manager, whom they referred to as an 'old queen'. These gay men

lacked any pretensions to status; their overwhelming experience of work was boredom. They insisted that there was nothing glamorous about this aspect of their lives: 'it's like any shop, if you work in there eight hours a day, by five o'clock in the evening you just want to get out. I think everybody feels like that, and people are lying if they say they love working in a shop.' But it was a world which was made acceptable by the space it provided for them to live out a gay identity relatively easily.

Yet for other respondents, especially those who did not inhabit Soho's homosexual culture, the perceived feminisation of work, as a result of their participation in the service sector, provoked a good deal of reflection. Listen to Jonathan, a graduate in film studies from the London College of Printing, who earned money as a barman at the Soho Brasserie, in order to finance his scriptwriting and film projects. Being 'front-of-house', as he termed it, was very much about performance:

> JONATHAN: There's a certain campness, if you like. I like camp. In the sense that Susan Sontag said of camp, er [pause, he trails off]. All or most of the men who work in the restaurant – the two or three – they're gay. And they're camp in a nice way. But there's slightly more generally something camp about the place. And you find yourself playing up to that. It's a bit like being on the stage. As soon as you walk behind a bar, you're acting the barman. You don't act yourself.
> AUTHOR: So what sort of role do you adopt?
> JONATHAN: I love playing the role, I love acting; it gives me a stage if you like. It's the hub of a wheel. Everything around you is buzzing very fast and you're actually doing a lot and not being seen to move too fast. [laughs] That's the secret. I'm trying to think about this gender thing. . . . I mean I'm there for my physical presence. I got a bollocking for not shaving this morning, I tell you, 'cos people come in and see me. I'm front-of-house, if you like, and what I look like reflects on the establishment. Which is why I have to perform this role.
> AUTHOR: Which is quite a traditionally female sort of thing?
> JONATHAN: That's why I say camp, that's what it is. It's that front – sort of flirtatious. You're always flirting with the customers.

Jonathan was clearly a very self-possessed barman. He had acquired a sophisticated range of competencies from his college education. These concepts equipped him to analyse his own role. Well-versed in cultural theory, concepts of camp and performativity fed into the understanding of his work routines. Such a process of intellectualisation also provided him with a means of distancing himself from the more mundane features of the tasks he carried out. Whereas the shop assistants

at Astrohome resorted to daydreaming, Jonathan was able to draw on a tighter framework. He was not simply acting out a role behind the bar, he was self-reflexively observing another self performing this part, from the detached vantage point of the cultural analyst.

In their very different ways Jonathan and the assistants at Astrohome reflected on the relation between their respective workplace environments and their gendered identities. But equally, it was young men's sense of themselves as *consumers* of goods and services which shaped their subjectivity. In this respect again the differences between heterosexual and homosexual cultures, each with their distinctive stance on the role of commodities for men, were marked. Young men who declared themselves to be 'style conscious', but identified with sexual normality, were often hesitant about committing themselves to a process of extended reflection about their personalities and their bodies.

Chris was a final-year graphic design student in the West Midlands, currently working on a placement scheme with a small video company in Soho. He experienced constant anxiety about the clothes choices facing him in his new environment. He admitted to continual feelings of inadequacy, which surfaced every time he thought about his appearance. A particular source of worry was a potential invitation from his boss to socialise in the evening: 'I dread to think what I would throw on if they invited me out at night. I haven't anything to reach for.' Being a student, much of this pressure was financial, the result of a lack of money needed to buy into Soho's work and leisure culture. But Chris's difficulties also touched on more personal insecurities, which stemmed from traditional moral fears about an over-cultivation of the self through fashion. Replying to a question asking him to define his image, he voiced a quasi-ethical critique of the contemporary obsession with style:

> I think I have problems in answering questions like that ... because I don't think too much about it, which at one level is a good thing. I'm quite pleased with myself, because to an extent it means I don't spend that long thinking about it.

Chris felt that this relative lack of interest in his public presentation was 'right for himself'. But his subsequent remarks revealed a more fractured position. 'Dress', he believed, was 'all very calculated, but calculated to make it look that you haven't thought twice about it. Although you care what you look like, you don't necessarily want to give the game away.' For Chris, as for many of the other young heterosexual men who were interviewed, the notion of 'giving the game away' condensed multiple social and sexual tensions. At one level it referenced a belief that the physical cultivation of the body (of the sort encouraged by the new

regimes of consumption) should remain a relatively clandestine affair – performed in the privacy of the bathroom or bedroom. Chris admitted to feeling dissatisfied with the shape of his teeth and experiencing difficulties with his hair. But he believed that it was not 'credible' for men to be 'caught out' in the act of narcissism. This notion of discovery, or forced disclosure, suggested the loss of an appropriate identity and with it some forfeiting of masculine status.

In Chris's case, an over-attention to his personal appearance was also associated with the problem of being unattached. He looked back nostalgically to the years when he had been in a long-term relationship. This was a period when he had been able to relax from the pressures of aspiring to some ideal physical type:

> ... from when I was 17 to when I was 22 I had the same girlfriend ... over
> that period I came to be less fussy about what I looked like because it was
> less important to attract [he trails off, pause]. In my relationship it became
> less and less important what we wore. It happened not just to me but to her
> ... I don't know, I had no qualms then, no dissatisfactions if you like, with
> what was happening to me, and I wasn't being too fussy about what I looked
> like. I suppose to an extent I think it shouldn't make any difference now.

For Chris, part of the security of being in a relationship involved the satisfaction of knowing that the presentation of himself to others no longer assumed an exaggerated importance. In his understanding of heterosexuality, once the courtship rituals were over, the need to present a sexually attractive profile was not a major concern.

Ultimately, for this young man, the issue of subjectivity was about placing himself on the correct side of a number of social and sexual boundaries. These demarcations were implicit in his discourse rather than overtly stated, but they clearly related to the fear of being marked out as abnormal. For many of those interviewed commercial pressures were blamed for such troubling feelings. As Chris voiced it, advertising was pushing men to move 'too quickly'. 'The guy' who was always changing his presentation, in response to consumer demands, was most in danger of 'losing credibility'. This was because he would be seen by his peers to have been 'pushed into it'. A proper sense of decorum was all-important for men. Yet this adherence to accepted codes of masculine conduct did not appear to guarantee stability. In some unspecified sense Chris felt that he was operating in an ill-defined territory as a man:

> The grey area. I can normally find myself sympathising with a bit of this,
> a bit of that and a bit of the other. The same in sort of dress and politics and
> all the rest of it. How I fit in? I'm not sure whether I fit in all round.

The feeling of displacement was worrying, but Chris believed it was part of 'the contemporary situation' for many men. Other respondents, such as Paul, the shop manager from Tottenham, were stronger and more outspoken in their justification of existing boundaries, especially for Afro-Caribbean men within his own community in Tottenham. Echoing contemporary advertisers and marketers, who were worried by the excesses of commercial experiments with masculinity, Paul affirmed a traditional set of gender commitments. He appealed to the established ground rules, and to the familiar fear of homosexuality: 'I don't think guys can identify with each other in the same way as women. I think there's still the old stereotype of being a pansy. I don't think that will change in my lifetime. No way.'

These defensive and hesitant reflections, made from inside heterosexuality, contrasted sharply with the positive stance taken by many young homosexual men towards their sense of identity. It would, of course, be wrong to celebrate such a position too strongly. The extended codes used by gay men to define their subjectivity in part registered modern strategies directed at regulating the homosexual self; in particular the construction of the homosexual as wholly other in his individuality. But on the ground, these affirmatory tactics related to the generally higher levels of competence displayed by gay men about their own self-appraisal. Visual as well as verbal languages played a significant part in these disclosures. Neil, the student from Portsmouth, was especially articulate about the way he conceived his public personality as an act of performance. He believed that it was important to cultivate an air of elegance at all times: 'I try ... to have this air of dignity. And that comes out, or I try to make it come out, in my clothes and elegance.' Neil's notion of 'coming out' was the reverse of Chris's fear about 'getting caught in the act'. It involved declaring a commitment to homosexuality through visual presentation. Many of the resources which these young men drew on were clearly part of a shared knowledge of gay cultural history. Neil's reference to 'elegance' condensed successive waves of homosexual dandyism. His latest find had been the 'sailor-look'. Reading Jean Genet's novel, *Querelle de Brest*, had provided him with a fashion image for that summer: 'You can wear baggy jeans, with a striped T-shirt and they look OK, sailorish, like Querelle.' Body art and jewellery were other components of this repertoire. Fred was a trainee in a graphic design studio in Golden Lion Square. He was heavily into tattoos, but not as a form of public display, rather as a private act of narcissism:

It's a private thing. It's about me. I mean I don't show them [the tattoos] off very often. I generally wear long-sleeved shirts or whatever. . . . I was always fascinated by tattoos, when I was like very young, 'cos my dad had them. I always wanted one done. When I was 18 I had one done and sort of got carried away.

Such acts of disclosure were neither hesitant nor embarrassed; they were part of the way in which the world of the everyday was understood and made meaningful. Fred went on to talk about how a sophisticated sense of visual and verbal role-play was important to his enjoyment of sex:

> To some people the idea seems perverted. But to me it [sex] is about power play. It's about chopping and changing during one scene ... like it's not a rigid set of rules from start to finish.... I might change round during the scene.

Sex was seen as part of individual identity, but in ways which were fluid rather than fixed. Taken together, narratives of this kind testified to the way in which an expanded language of the self was central to the lives of these young gay men.

A number of those interviewed were expansive about these forms of subjectivity, pushing the argument beyond the conventional boundaries of homosexuality. Many respondents confirmed that the exchange of looks and glances in metropolitan sites was indeed throwing up new cultures of homosociability, in which the lines demarcating normal and dissident forms of masculinity were increasingly blurred. Neil asserted that it was visual culture which was stimulating developments of this kind. He described the phenomenon as a code of pictorial aesthetics:

> ... men are more willing to look at each other and see that there's a man who's attractive, not in any sexual sense, perhaps just like a picture. You look at a picture and you think, 'That's a nice picture.' I think men are more willing to look at each other and say, 'That's a nice look.' They can appreciate it from an aesthetic point, rather than from any sexual undertone.

It is this issue about the emergence of more hybrid forms of male culture which has been at the heart of our argument about men and consumption in the 1980s. From the visual lexicon of Ray Petri's fashion imagery, through the expansion of commercial knowledges generated by advertisers and marketers, to Soho's urban spectacle, we have emphasised that a growing dialogue across one of the most important frontiers of masculinity has become a marked feature of contemporary urban life. Yet evidence for this sea-change has been partial. Much of it has come from the dissident side of the masculine divide. Was it, therefore, simply a vision of a future utopia generated by homosexual men? Had my own arguments over-privileged this reading, in the interests of a more plural interpretation of masculinity? It is time, by way of conclusion, to introduce one final element into the conversations – the issue of my own subjective involvement in these narratives of self and identity.

Much recent debate on the methodologies of ethnographic research has

revolved around the two-way nature of the interview transaction. Far from being an exercise in sociological neutrality, with the researcher invisible in the process, what has repeatedly been affirmed is the reciprocal nature of such dialogues. The interaction, or the collision, of personalities resulting from these encounters has been seen as a significant part of the research outcome in its own right. The most sustained insistences in this area have come from feminist practitioners interviewing women.[128] But the issue of fieldwork as a conversation between subjectivities is also thrown up when men meet men. Here the dynamics of what we might term the research contract are very specific indeed.

In my own experience, the interviews in Soho were organised around a version of what might be termed a gentlemen's agreement. In the brief period prior to the opening question, a number of unwritten rules were laid down by both parties about the boundaries of what was to follow. They were usually implicit, established by such signifiers as body posture, look and gesture, or verbal style. They related crucially to what could and could not be spoken about and the room for manoeuvre within this domain. For my own part, as interlocutor, I was keen to establish these protocols as the means to generate the raw material of my research. Gentlemanly codes of this type frequently rested on the fiction of a shared form of masculine culture, which could lead to a productive outcome in the form of talk. The levels of assent I gained for this reciprocity were extremely variable. They ranged from quite expansive assumptions about the bonds between men to much more restricted forms of contact. The nature of this dialogue also varied within the course of the interview itself. An encounter which at the outset seemed extremely promising, ultimately went nowhere. On other days, a respondent who initially appeared non-committal, bored and uninterested in me and my project, mid-way through the conversation warmed to the issues and to me. The identities of both myself and the respondents were often unstable in relation to each other, as we slipped across the transactions of language and culture. It would be inappropriate to attribute all these variations to the type and degree of masculine contact which suffused the interview situation. Other much more prosaic variables impinged on the event. Many young men clearly disliked being approached at all and were keen to move on; others simply read the encounter as an insignificant, or esoteric, piece of market research. Nevertheless, it was also apparent that the larger structures shaping masculinity impinged on the conversation between me and my interviewees.

There was one particular incident when these issues surfaced in an acute form. They involved my dialogue with David, the black actor/model, whom we met earlier. The interview was going well; David's manner was confident and mildly flirtatious. Asking a standard question about Soho and the opportunities for employment, I pressed him about the types of work he did. His response, full of

ambiguity and innuendo, led both of us into dangerous territory. Egging the two of us on, he bragged that he would do anything for a sufficient reward: 'I'd do anything for money, strip naked, so long as there's cash involved. Anything, and I have done.' Excited by a fruitful research lead, I tried to push him further, in order to render his tantalising remarks more discursively precise. His response became hostile. Abruptly, he terminated the interview with an aggressive rejoinder. David's parting remark deftly overturned the balance of power. He exploded: 'Do you think I'm queer or something?' With these words the contract between us was broken. The reasons for the collapse in communication were complex. In microcosm they condensed a number of issues about the contemporary organisation of masculinity. For my part, I had pressed David too hard. I had disrupted one of the most important elements in our agreement; the pledge to tread carefully on the personal dimensions of sexuality. I also felt awkward about race, in particular about reproducing a pathologising gaze in relation to this young black man as a sexual object. The sense of guilt made me hesitant about questioning him again. David's response was to reaffirm the fixity of his own position within heterosexuality, after a conversation which had been much more fluid. This reinstatement of sexual boundaries was designed to force me to take up a stance on one side or other of the divide. His interrogative question, 'Do you think I'm queer?' demanded a double reply. It asked me to state my views about his identity, but it also probed my own. Henceforward any conversation between us would take place across this fault line. Our dialogue was at an end.

Paul Willis has suggested that such small moments in the interview transaction are actually quite momentous in terms of their significance. They are essentially incidents when the researcher is taken by surprise and the subject temporarily highjacks the project.[129] In my work in Soho, most of these experiences occurred when the dialogue touched on a number of cultural flashpoints. Most of them also forced some explicit reflection, from both myself and my respondents, about our identities as men. One way of interpreting these tense encounters would be to rehearse a familiar argument about the limits of masculinity. In other words, to insist that the reason for my restricted conversation with men such as David was a consequence of the deep structures separating men; in this case the binary line dividing heterosexual from homosexual behaviours and the divisions of race. While this argument is tempting, it tends to simplify what such episodes revealed about current forms of masculine identity. *Cultures of Consumption* has uncovered more than the established boundaries organising and regulating men. It has pointed up the ways in which the languages of homosociability constitute an important and developing ingredient in the social relations of masculinity. This category is unstable; the discourse of the homosocial is continually slipping among and between more established practices. Nor is it

wholly new. Yet the consumer spaces of Soho pointed to its visibility and its effects. David's final rejoinder was indeed a reinstatement of traditional markers of sexual discourse. However, it did not encompass the whole story about what had taken place in the commercial orchestration of masculinity in the 1980s. It is time to move to some conclusions.

CONCLUSION

Maurice Saatchi was ousted from the flagship company he had co-founded with his brother in a protracted boardroom struggle, which erupted in the weeks before Christmas of 1994 and ran on into the New Year. The battle between the rival factions was fought out in the full glare of the media. The outcome was Maurice Saatchi's departure. This was his very public letter of resignation:

To everyone at Saatchi and Saatchi

For twenty-five years I have had the privilege of working with you to create and build Saatchi & Saatchi.

Throughout those years, your loyalty to the company in both good and hard times made me feel uniquely blessed.

The letters so many of you have sent me during the past week, urging me to stay as chairman of Saatchi & Saatchi Advertising, have been inspiring. I will always treasure them.

So, it is with sadness that I must tell you that I cannot accept the offer of that position, and instead must sever my links with the company which we have built together.

You deserve to know the reasons:

Saatchi & Saatchi has been taken over. No bid for the company has been announced. No offer has been made. No premium has been paid. No shareholder vote has been taken. But, make no mistake, Saatchi and Saatchi is under new control.

The new 'owners' – a group of shareholders owning around 30 per cent of the shares – have found a simple, if crude, method of controlling the company.

By threatening the directors with an extraordinary general meeting – at which they could outvote others – they have given the directors their orders: 'Take your chairman into a corner and shoot him quickly – we don't want the fuss of a public trial.'

I have watched in dismay as some of our longest client relationships have been jeopardised, the wishes of key clients ignored, and the loss of their business assessed as 'a price worth paying'.

I have listened in despair as the views of leading executives of this company were dismissed as 'irritating' and 'irrelevant'. And, for the first time in 25 years, found myself in an advertising company where the term

'advertising man' was being used as an insult.

I have observed how, after seeing the value of their shares rise by 17 per cent since spring against a 2 per cent fall for the FTSE 100 index, this shareholder group nevertheless went ahead and plunged the company into a period of uncertainty and instability.... How could I help to strengthen our relationships with our clients when, in the perverse logic of our new 'owners', loyal client relationships are not understood to be the company's greatest asset?

How could I reassure you of your critical importance to the company, when the views of so many of the most respected among you have been ruthlessly brushed aside?

This enforced parting grieves me deeply. Yet I look forward to 1995 with great anticipation. Because, as we have always believed at Saatchi & Saatchi ... Nothing is Impossible.

With every good wish,

Maurice Saatchi,

3rd January, 1995.

The narrative of Maurice Saatchi's fall mixed the classic motifs of financial high drama with the clash of male egos which were such a recurrent feature of the advertising industry in the 1980s. As *Campaign* saw it, 'Money, power, revenge and egomania' were the ingredients which made the story compelling.[1] Long-standing dissatisfaction with the company's management organisation and financial performance among a group of influential shareholders came to a head at an eight-hour meeting on 16 December. Flexing their collective muscle, the dissident faction was led by David Scott, Saatchi's chief executive, and David Herro of Harris Associates, the Chicago-based investment group. Claiming to speak for as many as one-third of disgruntled investors, the duo forced Maurice Saatchi's climbdown as company chairman. Adding insult to injury, Saatchi was given until the New Year to decide whether to remain as honorary president of a Saatchi subsidiary. Despite an emotional campaign mounted by employees to persuade him to stay, Maurice dismissed the offer. He returned from Christmas holidays spent in Thailand, to his spiritual home in London's Charlotte Street, spoiling for a fight. Closeting himself in his former office, on the top floor of the company's headquarters, he faxed his valedictory letter to all staff throughout Europe and America.[2]

The final act of the Saatchi affair was played out as a story of vengeance and personal rivalry. In microcosm it condensed broader discourses of personality and power which have punctuated our history. When Maurice protested about the insults which he had been forced to endure as an 'advertising man' at the hands

of his usurpers, he drew attention to a familiar power struggle between the competing forces within the advertising world. Herro, Saatchi's challenger, was above all a corporate executive, trained in the American tradition, with an earlier career in stockbroking. Reputedly referring to Maurice as a 'toffee-nosed Brit', he attacked the former chairman for his amateurish displays in the boardroom. Herro's obituary on Maurice's career announced a new note of business realism. He praised Saatchi's brilliance, but lamented the fact that he was wayward, irresponsible and had 'no dollar sense'.[3] Herro saw the clash of personalities as a necessary fight to the finish between serious financial managers like himself and capricious individualists like Maurice. The former chairman responded by asserting his own personal commitment to advertising in the language of romantic individualism. As he enthused in a rare interview for *The Times*, the profession was still a 'uniquely thrilling and meritocratic world for any young person' – a romance, quite as much as a business.[4] The Saatchi story dramatised a conflict of social meanings – between promotional culture defined purely commercially and a different understanding of advertising as a creative vocation – which had resonated in the industry throughout the previous decade.[5]

Outside the Saatchi boardroom, London's agency culture gossiped endlessly about events. For Chris Powell, the outgoing president of the Institute of Practitioners in Advertising, the Saatchi affair was potentially damaging because it reinforced public perceptions of the profession as 'ego-ridden and un-business-like', especially among City analysts.[6] John Hegarty championed a different view. Reaffirming his own personal beliefs, and echoing those of John Hobson nearly forty years earlier, Hegarty insisted that despite all the recent changes, advertising continued to be as much about the emotions as about the intellect. Maurice's sense of passionate commitment was needed more than ever, Hegarty claimed.[7] The forced departure of Saatchi's chairman had removed the company's spiritual leadership. As Maurice Saatchi regrouped to form a new enterprise, friends and colleagues spurred him on. Urging his hero forward, one correspondent, writing to *Campaign*, extolled the virtues of what he termed 'Saatchiness'. His language celebrated the masculine culture which had formed the cement of much of the agency world in the 1980s. As he put it: 'One more time lads ... for all of us.'[8]

Beyond the heated claims and counter-claims, the Saatchi incident was significant in a wider symbolic sense. Despite their different interpretations, commentators were generally agreed that the fall of one of the doyens of commercial society drew a line under the dynamic entrepreneurialism which for so many had characterised the 1980s. What was significant was that the majority of players in the affair now spoke of that decade in the *past* tense. Though his enthusiasm for new projects remained undiminished, Maurice himself echoed this prevailing tone. Paraphrasing the opening lines of L.P. Hartley's novel, *The*

Go-Between, he reminisced: 'The past is another country. They do things differently there.'[9] The deputy advertising director of the *Financial Times*, Peter Highland, was more prosaic and less sentimental. Summing up the 1980s, Highland remarked that a decade which began on a high note of business optimism had fizzled out as a jaded soap opera.[10]

This dominant reading of the fall of Saatchi & Saatchi paralleled broader interpretations of commercial and consumer activity emerging in the early 1990s. With variations, most commentators sought to mark out a historical distance between the present and the immediate past. The reasons for this interpretative shift were not difficult to unravel. The severity of the current recession had damaged all areas of business confidence, but the consumer industries had been especially hard hit. As late as 1995, economic forecasts which looked towards the medium-term horizon were extremely sober. A combination of tight supply-side government policies, aimed at curbing inflation, high levels of personal debt and a marked degree of caution on the part of borrowers and lenders, meant that consumer spending was set to remain unspectacular in the near future.[11] And as always, these economic manifestations of shifting patterns of demand were associated with a distinctive cultural symbolism. True to its original manifesto, *The Face* was one of the first to sound the new note. Its 'Futures Issue', the last of 1989, listed nineteen ways to spend the forthcoming decade. It was new age mysticism, ecology, alternative technology and science fiction which were heralded as the coming thing, in contrast to what was now cast as the old dogma of consumption.[12] More concretely, but no less grandly, The Henley Centre for Forecasting put down its own marker for the end of the 1980s in its first *Planning Consumer Markets* report for 1991. Running together the spheres of politics and commerce, Henley proclaimed the 1980s dead with the fall from power of Margaret Thatcher in November 1990. Although The Centre insisted that the future remained uncertain, there was growing evidence to believe that politics, business and culture had shifted away from the type of hard individualistic values which had dominated the previous ten years. The movement, Henley claimed, was towards more consensus and more collectivism.[13]

Such pronouncements marked an attempt by a number of the influential players in our story to forge a response to a changing set of commercial and cultural circumstances. Their discourse was characteristically prophetic. It was also tinged with a hint of millenarianism, a belief that *fin-de-siècle* conditions would inevitably produce their own sea-change in business activity. Their ideas were matched by political interventions which sought to map out a new future. Economic and social analyst Stewart Lansley, surveying the burdens of contemporary affluence in his book *After the Gold Rush*, 1994, took the broad post-war period across the advanced industrial countries as his focus. He identified British

developments in the 1980s as exemplifying the problems of competitive individualism, which beset all the mature economies. The spiralling of unsustainable demand, fostered by private-sector consumption, Lansley argued, was in large part responsible for the tattered fabric of western societies, producing economic instability, deepening public disaffection and widening social divisions. A co-ordinated response, which was cultural as much as formally political, the author claimed, needed to forge a 'post-consumerist' ethos which defined a range of alternative rewards and values to those found in the consumer marketplace.[14] Critiques of the paucity of consumer culture were not of course new. They had been rehearsed in the various versions of the 'limits to growth' thesis by figures such as J.K. Galbraith, Herbert Marcuse and Fred Hirsch from the 1950s onwards.[15] But the early 1990s did see a revival of these themes in a changed economic and environmental climate. Economic journalist Will Hutton, analysing the current decay of Britain's public institutions in *The State We're In*, 1995, placed the national preference for inveterate consumption in the context of a long-standing debate about the decline of Britain. His attack was directed specifically at the effects of recent Conservative hegemony. It sought to mount a broad-based challenge to free-market economics and to project a renewed version of social consensus.[16]

While such arguments sought to convince by political persuasion, their theses enshrined precisely the problems surrounding consumption with which we opened the book. Taken together, they projected an over-grandiose definition of consumer society, which ranged across the terrains of economic, political and cultural life. Furthermore, the notion of a seismic shift in consumption patterns ushered in by recession reproduced a simplified chronology of commercial change, with one era seen to supersede another. Periodisations of this type have punctuated the history of modern consumption. Our account has produced a more complex and differentiated picture. At the risk of repetition, general pronouncements about the consumer characteristics of the 1980s, or about the future, fail to identify what is meant in precise terms by the concept of consumption and its historical usage. The issue returns us to our initial argument; the attempt to identify the transformations set in train during these years, not in overarching terms, but in relation to the themes which have been at the centre of our study: commerce and masculinity.

Judged by their own standards of entrepreneurship the efforts to forge a new market for young men and their goods in the 1980s were an undisputed success. In the face of the later economic downturn, the commodities which sought to speak to men through their gender expanded rather than contracted. Consumer journalism, clothing, toiletries, together with a plethora of other personal objects, continued to display the characteristic imprint of the new formula. Likewise, those

zones of the city which provided the settings for the associated consumption rituals proliferated. London, along with most of the other western metropolitan centres, has a burgeoning homosexual quarter, where commerce, community and sexual politics coexist alongside more mainstream practices of city life. There has been no closing down of these projects. The commercial experiments in masculinity appear to have been long-term, not merely transient.

Our history of the ways in which this market was put together has delivered a number of significant insights into the workings of late twentieth-century commercial society. Prominent among them has been the importance of non-economic factors in shaping the appearance of this masculine world of goods. The range of influences which were at work here were enormously diverse. Professional knowledges, personal hunches, the logistics of space and place, the gendered obsessions of artists and experts were just as important as the profit motive. Economists and economic historians ignore these dimensions of entrepreneurship at their peril. Even in the men's market, the world is not reducible to *homo economicus*. We need a new synthesis of business and cultural history, which is able to grasp the complexity of such interrelationships, and which abandons cautious and compartmentalised narratives in favour of genuine interdisciplinarity.

What occurred in the 1980s was a partial reordering of the map of consumption, not for all consumers, but for specific populations. This shift in business practices, and their associated forms of promotional imagery, generated intensified representations of individualism. One result of this process was the expanding number of social identities offered to young men. Far from existing only as advertising texts, consumption scripts shaped the interiority of experience of those who participated in the drama of contemporary city life. Commercial signposts have come to occupy a prominent place in young men's narratives about themselves and their place in the world. However, here a word of caution is necessary. Not all of the developments were as new as the experts proclaimed at the time. Comparisons with earlier moments of market turbulence, notably the 1950s, point to longer-term narratives of change. What this reveals is not that consumer revolutions simply repeat themselves. It brings into focus a broader history of commercial activity and its place within the structures of twentieth-century British society.

The sociologist Anthony Giddens, addressing the characteristics of late modernity, has offered some extremely suggestive ways of framing the interrelationships between consumption and identity which we have charted. Within contemporary western societies, Giddens has argued, identity has not only been linked to movements of self-affirmation, but has also become integrated into lifestyle decisions made about the self. The net effect has been to produce social

selfhood as a reflexively organised endeavour, which extends deep into the individual.[17] Giddens' concept of lifestyles is more broadly conceived than its understanding by the consumer industries. It embraces all those spheres of everyday life in which individual appraisal has displaced more external rules of authority. Nevertheless, the commercial history of masculinity in Britain since the Second World War has displayed an increasing trend towards this type of self-dramatisation.

Yet such an endeavour has not been the result of some smooth meta-logic of the late modern epoch. It has depended on much more specific strategies and programmes, and has addressed very particular groups of social actors, dominant in concrete environments and locations. These milieus have produced a plurality of masculinities, many of which have rubbed against each other in tension or antagonism. Differences of economic power and status, of generation, regional positioning, sexuality and ethnicity, have all contributed to this contested pluralism. Moreover, the move towards greater self-consciousness among men has had contradictory implications for women. As our encounter with business culture has shown, liberalisation for men has not of itself guaranteed a more progressive stance on relations with women. At times the discourse of the homosocial has worked to exclude femininity. The movement towards men's cultivation of themselves has involved contradictory forms of social experience.

It has recently become fashionable, even in some circles compulsory, to conclude such accounts on a note of political prescription; to suggest the ways in which historical and social analysis might aid movements and programmes in the present. I am hesitant about that type of ending, not because I disclaim the relationship between historical work and practical initiatives. Rather, because of the difficulties of formulating an effective politics of consumption which is neither sentimental nor simply instrumentalist. I propose a quieter, though no less ambitious conclusion. It is an agenda for new research. Our study is part of a much broader story: the history of the commercial sphere. Cultural and economic life in the twentieth century is significantly about the centrality of this commercial world. Its narrative remains substantially underwritten. The task remains to map its multiple histories.

NOTES

Introduction: Narratives of Consumption

1 See N. Lawson, *The View from No. 11: Memoirs of a Tory Radical*, London, Bantam Books, 1992, chapter 66. Lawson also referred to his 1988 statement in more measured terms as 'a balanced budget'. For retrospective criticisms of the Chancellor's strategy, partly coloured by later events, see the comments of Margaret Thatcher, *The Downing Street Years, 1979–90: First Volume of the Memoirs of Margaret Thatcher*, London, HarperCollins, 1993, pp. 672–6.

2 Speech of the Chancellor of the Exchequer, *Parliamentary Debates (Hansard)*, House of Commons, 6th series, session 1987–8, vol. 129, cols 993–1013.

3 Lawson, *The View from No. 11*, p. 818.

4 'Lots A Lovely Lolly', *The Sun*, 16 March 1988, p. 1; 'We're *All* In The Money', *Daily Express*, 16 March 1988, p. 1.

5 Cartoon, *The Sun*, 16 March 1988, pp. 16–17.

6 See for example: 'Top 10 Earners' and 'Jon's the Winner', *The Sun*, 16 March 1988, p. 2.

7 Speech of A. Salmond, *Parliamentary Debates*, Commons, 1987–8, vol. 129, col. 1008. Salmond was 'named' by the Deputy Speaker as a result of his interruption to the Chancellor's budget speech and was subsequently suspended from the service of the House.

8 Speech of B. Gould, *Parliamentary Debates*, Commons, 1987–8, vol. 130, col. 53.

9 Speech of R. Hughes, *Parliamentary Debates*, Commons, 1987–8, vol. 129, col. 1036.

10 C. Lévi-Strauss, *The Savage Mind*, quoted in M. Douglas and B. Isherwood, *The World of Goods: Towards an Anthropology of Consumption*, London, Allen Lane, 1979, p. 87.

11 For quantitative analysis of the shifts in consumption patterns during the 1980s see C. Gardner and J. Sheppard, *Consuming Passion: The Rise of Retail Culture*, London, Unwin Hyman, 1989, pp. 1–7. Gardner and Sheppard make a number of important points about the relationship between wages, consumer expenditure, retail sales and savings in the period 1981–8. They note that the percentage increase in both retail sales and disposable income between 1984 and 1988 was at roughly the same rate – around 8 per cent. Moreover, the percentage increase in the *value* of retail sales between 1981 and 1988 remained fairly constant, at an annual growth rate of between 8 and 8.5 per cent. What in fact grew enormously was the percentage increase in the *volume* sales of retail goods: from 0.2 per cent in 1981 to just under

5 per cent in 1988. In other words, retail outlets sold an increasing number of goods, but they became relatively cheaper, compared with overall prices. Sectorally there were also marked differences. It was clothing and footwear which experienced exceptionally rapid growth, while the proportion of household income spent on food actually decreased during the decade, following a trend begun in the 1960s. Judged against such figures, Gardner and Sheppard conclude that the characterisation of the 1980s as a period of large-scale consumer or retail boom, needs qualification.

12 D. Cannadine, 'The Present and the Past in the English Industrial Revolution 1880–1980', *Past and Present*, 1984, no. 103, pp. 131–72. Maxine Berg makes the same point in *The Age of Manufactures: Industry, Innovation and Work in Britain, 1700–1820*, London, Fontana, 1985, pp. 15–20.

13 For characteristic analysis of this sort see: W. Kay, *Battle for the High Street*, revised edition, London, Corgi, 1989; Gardner and Sheppard, *Consuming Passion*.

14 T. Conran, quoted in Kay, *Battle for the High Street*, p. 33. See also the arguments advanced by Ian MacLaurin of Tesco, p. 220, and by Sir Ralph Halpern in V. Grove, 'A Knight in Shining Flannel', *The Sunday Times Magazine*, 7 July 1984, p. 34.

15 For some of the most significant contributions to the debate over industrial restructuring see: A. Gorz, *Farewell to the Working Class: An Essay on Post-Industrial Socialism*, trans. M. Sonenscher, London, Pluto, 1982, and *Paths to Paradise: On the Liberation from Work*, trans. M. Imrie, London, Pluto Press, 1985; N. Abercrombie and J. Urry, *Capital, Labour and the Middle Classes*, London, Allen & Unwin, 1983; M. Piore and C. Sabel, *The Second Industrial Divide: Possibilities for Prosperity*, New York, Basic Books, 1984; C. Offe, *Disorganized Capitalism*, Cambridge, Polity Press, 1985; S. Lash and J. Urry, *The End of Organized Capitalism*, Cambridge, Polity Press, 1987; K. Williams, T. Cutler, J. Williams, C. Haslam, 'The End of Mass Production?' *Economy and Society*, August 1987, vol. 16, no. 3, pp. 405–39; P. Hirst and J. Zeitlin (eds), *Reversing Industrial Decline? Industrial Structure and Policy in Britain and Her Competitors*, Oxford, Berg, 1989; R. Murray, 'Fordism and Post-Fordism' and 'Benetton Britain: The New Economic Order', in S. Hall and M. Jacques (eds), *New Times: The Changing Face of Politics in the 1990s*, London, Lawrence & Wishart, 1989, pp. 38–64.

16 Murray, 'Fordism and Post-Fordism', p. 43.

17 See especially the analysis of Thatcherism and consumption pioneered by Stuart Hall in 'The Great Moving Right Show' and 'The Culture Gap', in *The Hard Road to Renewal: Thatcherism and the Crisis of the Left*, London, Verso, 1988, pp. 39–56 and 211–19. For other related forms of analysis which attempted to pose the economic and cultural ramifications of consumption and consumer markets as a problem for socialist politics see: R. Plant, *Equality, Markets and the State*, Fabian Tract no. 494, London, Fabian Society, 1984; C. Leadbeater, *The Politics of Prosperity*, Fabian Tract no. 523, London, Fabian Society, 1987; J. Le Grand and S. Estrin (eds), *Market*

Socialism, Oxford, Clarendon Press, 1989; F. Mort, 'The Politics of Consumption', in Hall and Jacques (eds), *New Times*, pp. 160–72. For analyses which disputed this reading of the success of Thatcherism see: B. Jessop, K. Bonnett, T. Ling, S. Bromley, 'Authoritarian Populism, Two Nations and Thatcherism', *New Left Review*, September–October 1984, no. 147, pp. 32–60; P. Hirst, *After Thatcher*, London, Collins, 1989, especially chapter 1.

18 See P. Hirst and J. Zeitlin, 'Introduction', and Hirst, 'The Politics of Industrial Policy', in P. Hirst and J. Zeitlin (eds), *Reversing Industrial Decline?* pp. 1–16 and 269–87. Also P. Hirst and J. Zeitlin, 'Crisis, What Crisis?' *New Statesman*, 18 March 1988, vol. 115, no. 2973, pp. 10–12.

19 Z. Bauman, 'Britain's Exit from Politics', *New Statesman and Society*, 29 July 1988, vol. 1, no. 8, pp. 34–8.

20 See especially: M. Mauss, *The Gift: Forms and Functions of Exchange in Archaic Societies*, trans. I. Cunnison, London, Cohen & West, 1970; Douglas and Isherwood, *The World of Goods*. The work of the French sociologist, Pierre Bourdieu, on contemporary forms of consumption involves a critical engagement with structuralist anthropology; see P. Bourdieu, *Distinction: A Social Critique of the Judgement of Taste*, trans. R. Nice, London, Routledge & Kegan Paul, 1984. For an overview of these traditions see D. Miller, *Material Culture and Mass Consumption*, Oxford, Basil Blackwell, 1987.

21 For some of the most significant examples of this cultural agenda see: S. Hall and T. Jefferson (eds), *Resistance through Rituals: Youth Subcultures in Post-War Britain*, London, Hutchinson, 1976; D. Hebdige, *Subculture: The Meaning of Style*, London, Methuen, 1979; T. Modleski, *Loving with a Vengeance: Mass-Produced Fantasies for Women*, Hamden, CT, Archon Books, 1982; J. Radway, *Reading the Romance: Women, Patriarchy and Popular Literature*, Chapel Hill, NC, University of North Carolina Press, 1984; R. Coward, *Female Desire*, London, Paladin, 1984; E. Wilson, *Adorned in Dreams: Fashion and Modernity*, London, Virago, 1985; D. Morley, *Family Television: Cultural Power and Domestic Leisure*, London, Comedia, 1986; K. Myers, *Understains: The Sense and Seduction of Advertising*, London, Comedia, 1986; C. Steedman, *Landscape for a Good Woman: A Story of Two Lives*, London, Virago, 1986; J. Williamson, *Consuming Passions: The Dynamics of Popular Culture*, London, Marion Boyars, 1986; J. Winship, *Inside Women's Magazines*, London, Pandora, 1987; A. McRobbie (ed.), *Zoot Suits and Second-Hand Dresses: An Anthrology of Fashion and Music*, Basingstoke, Macmillan, 1989; P. Willis, *Common Culture: Symbolic Work and Play in the Everyday Cultures of the Young*, Milton Keynes, Open University Press, 1990; A. Tomlinson (ed.), *Consumption, Identity and Style: Marketing, Meanings and the Packaging of Pleasure*, London, Routledge, 1990; M. Nava, *Changing Cultures: Feminism, Youth and Consumerism*, London, Sage, 1992. Much of the work had its origins in a particular reading of Antonio Gramsci's analysis of populism. For a critical review of this tradition see J. McGuigan, *Cultural Populism*, London, Routledge, 1992.

22 For readings of postmodernism from this perspective see: J. Baudrillard, *Le miroir de la production; ou l'illusion critique du matérialisme historique*, 2nd edition, Tournai, Castermann, 1977; *A l'ombre des majorités silencieuses, ou la fin du social; suivi de, l'extase du socialism*, Paris, Denoël, 1982; *Seduction*, trans. B. Singer, Basingstoke, Macmillan, 1990; M. Poster (ed.), *Selected Writings, Jean Baudrillard*, Cambridge, Polity Press, 1988; J.F. Lyotard, *The Postmodern Condition: A Report on Knowledge*, trans. G. Bennington and B. Massumi, Manchester, Manchester University Press, 1984, and *Moralités postmodernes*, Paris, Galilée, 1993; F. Jameson, 'Postmodernism or the Cultural Logic of Late Capitalism', *New Left Review*, July–August 1984, no. 146, pp. 53–92; H. Foster (ed.), *Postmodern Culture*, London, Pluto, 1985; L. Appignanesi (ed.), *Postmodernism: ICA Documents 4 and 5*, London, Institute of Contemporary Arts, 1986; D. Hebdige, *Hiding in the Light: On Images and Things*, London, Comedia, 1988. For the application of post-modernist theory to specific areas of culture see C. Jencks, *The Language of Post-Modern Architecture*, London, Academy, 1977.

23 Z. Bauman, *Intimations of Postmodernity*, London, Routledge, 1992, p. 49. For similar arguments see Gorz, *Farewell to the Working Class*.

24 See for example: Z. Bauman, 'Industrialism, Consumerism and Power', *Theory Culture and Society*, 1983, vol. 1, no. 3, pp. 32–43; *Intimations of Postmodernity*, pp. 48–52, 97–110, 182–200; *Legislators and Interpreters: On Modernity, Post-Modernity and Intellectuals*, Cambridge, Polity Press, 1987, pp. 163–91; W. Leiss, 'The Icons of the Marketplace', *Theory Culture and Society*, 1983, vol. 1, no. 3, pp. 10–21; S. Lash, *Sociology of Postmodernism*, London, Routledge, 1990; M. Featherstone, *Consumer Culture and Post-modernism*, London, Sage, 1991. For earlier versions of this debate see: D. Bell, *The Coming of Post-Industrial Society: A Venture in Social Forecasting*, Harmondsworth, Penguin, 1976, and *The Cultural Contradictions of Capitalism*, London, Heinemann, 1976.

25 For the spatial implications of economic restructuring in the 1980s in Britain and elsewhere see: D. Massey, *Spatial Divisons of Labour: Social Structures and the Geography of Production*, Basingstoke, Macmillan, 1984; D. Harvey, *The Limits to Capital*, Oxford, Basil Blackwell, 1982, and *The Urbanization of Capital*, Oxford, Basil Blackwell, 1985.

26 For specific studies of the spatial dimensions of contemporary consumption systems see: S. Zukin, *Loft Living: Culture and Capital in Urban Change*, Baltimore, Johns Hopkins University Press, 1982; F. Fitzgerald, *Cities on a Hill: A Journey through Contemporary American Cultures*, New York, Simon & Schuster, 1986; R. Shields, 'Social Spatialization and the Built Environment: The West Edmonton Mall', *Society and Space*, 1989, vol. 7, pp. 147–64, and *Places on the Margin: Alternative Geographies of Modernity*, London, Routledge, 1991; A. Warde, 'Gentrification as Consumption: Issues of Class and Gender', *Society and Space*, 1991, vol. 9, pp. 223–32; P. Jackson, 'Towards a Cultural Politics of Consumption', in J. Bird, B. Curtis, T. Putnam, G. Robertson, L. Tickner (eds), *Mapping the Futures: Local Cultures,*

Global Change, London, Routledge, 1993, pp. 207–28. For more general debates about the cultural and symbolic dimensions of space see: M. Heidegger, *On Time and Being*, trans. J. Stanbaugh, London, Harper & Row, 1977; M. de Certeau, *The Practice of Everyday Life*, trans. S. Rendall, Berkeley, University of California Press, 1988; D. Harvey, *The Condition of Post-modernity: An Enquiry into the Origins of Cultural Change*, Oxford, Basil Blackwell, 1989; H. Lefebvre, *The Production of Space*, trans. D. Nicholson--Smith, Oxford, Basil Blackwell, 1991.

27 The classic account of the consumer revolution of the late eighteenth century is that outlined by N. McKendrick, J. Plumb, J. Brewer, *The Birth of a Consumer Society: The Commercialization of Eighteenth-Century England*, London, Europa, 1982. For earlier arguments on the same theme see: N. McKendrick, 'Josiah Wedgwood: An Eighteenth Century Entrepreneur in Salesmanship and Marketing Techniques', *Economic History Review*, 1959–60, vol. 12, no. 3, pp. 408–33; 'Josiah Wedgwood and Thomas Bentley: An Inventor–Entrepreneur Partnership in the Industrial Revolution', *Transactions of the Royal Historical Society*, 1964, vol. 14, pp. 1–33; 'Home Demand and Economic Growth: A New View of the Role of Women and Children in the Industrial Revolution', in N. McKendrick (ed.), *Historical Perspectives: Studies in English Thought and Society in Honour of J.H. Plumb*, London, Europa, 1974, pp. 152–210. For different interpretations see: J. Brewer and R. Porter (eds), *Consumption and the World of Goods*, London, Routledge, 1993.

28 B. Fine, 'Modernity, Urbanism and Modern Consumption', *Society and Space*, 1993, vol. 11, p. 600. For an extended exposition of this approach see B. Fine and E. Leopold, *The World of Consumption*, London, Routledge, 1993.

29 For analysis of these interactions and a reply to Fine's approach see: P. Glennie and N. Thrift, 'Modern Consumption: Theorising Commodities and Consumers', *Society and Space*, 1993, vol. 11, pp. 603–6. Also P. Glennie and N. Thrift, 'Modernity, Urbanism and Modern Consumption', *Society and Space*, 1992, vol. 10, pp. 423–43.

30 The earliest statement of the trickle-down theory has been attributed to George Simmel in 'Fashion', *The International Quarterly*, October 1904, vol. X, no. 1, pp. 130–55. See also McKendrick *et al.*, *The Birth of a Consumer Society*. For a critical summary see B. Fine and E. Leopold, 'Consumerism and the Industrial Revolution', *Social History*, May 1990, vol. 15, no. 2, pp. 151–79.

31 F. Mort, *Dangerous Sexualities: Medico-Moral Politics in England since 1830*, London, Routledge & Kegan Paul, 1987.

32 For accounts of the history of advertising which have been drawn on here see: B. Elliott, *A History of English Advertising*, London, Business Publications Ltd, 1962; J. Tunstall, *The Advertising Man in London Advertising Agencies*, London, Chapman & Hall, 1964; J. Pearson and G. Turner, *The Persuasion Industry*, London, Eyre & Spottiswoode, 1965; T.

Nevett, *Advertising in Britain: A History*, London, Heinemann, 1982; D. West, 'Multinational Competition in the British Advertising Agency Business, 1936–1987', *Business History Review*, Autumn 1988, vol. 62, no. 3, pp. 467–501. The archives of The History of Advertising Trust also contain a wealth of unresearched material.

33 L. Segal, *Slow Motion: Changing Masculinities, Changing Men*, London, Virago, 1990, p. ix.

34 For the idea of a crisis of masculinity in the 1980s see: B. Ehrenreich, *The Hearts of Men: American Dreams and the Flight from Commitment*, New York, Anchor-Doubleday, 1983; M. Humphries and A. Metcalf (eds), *The Sexuality of Men*, London, Pluto Press, 1985; H. Brod (ed.), *The Making of Masculinities: The New Men's Studies*, London, Allen & Unwin, 1987; A. Jardine and P. Smith (eds), *Men in Feminism*, London, Methuen, 1987; J. Rutherford, 'Who's that Man?' in R. Chapman and J. Rutherford (eds), *Male Order: Unwrapping Masculinity*, London, Lawrence & Wishart, 1988, pp. 21–67; J. Hearn and D. Morgan, *Men, Masculinities and Social Theory*, London, Unwin Hyman, 1990; V. Seidler (ed.), *The Achilles Heel Reader: Men, Sexual Politics and Socialism*, London, Routledge, 1991, and *Recreating Sexual Politics: Men, Feminism and Politics*, London, Routledge, 1991. For critical appraisals of this notion of crisis see: F. Mort, 'Crisis Points: Masculinities in History and Social Theory', *Gender and History*, April 1994, vol. 6, no. 1, pp. 124–30; J. Tosh, 'What should Historians do with Masculinity? Reflections on Nineteenth-Century Britain', *History Workshop*, Autumn 1994, no. 38, pp. 179–202.

35 See for example: J. Scott, *Gender and the Politics of History*, New York, Columbia University Press, 1988; D. Riley, *'Am I That Name?': Feminism and the Category of Women in History*, Basingstoke, Macmillan, 1988; J. Butler, *Gender Trouble: Feminism and the Subversion of Identity*, New York, Routledge, 1990; J. Butler and J. Scott (eds), *Feminists Theorize the Political*, London, Routledge, 1992.

36 For analysis of the instability of masculine identities see for example: D. Morgan, *Unmasking Masculinity: A Critical Autobiography*, London, Unwin Hyman, 1990; N. Clarke, 'Strenuous Idleness: Thomas Carlyle and the Man of Letters as Hero', and J. Tosh, 'Domesticity and Manliness in the Victorian Middle Class: The Family of Edward White Benson', in M. Roper and J. Tosh (eds), *Manful Assertions: Masculinities in Britain since 1800*, London, Routledge, 1992, pp. 25–43 and 44–73; G. Dawson, *Soldier Heroes: British Adventure, Empire, and the Imagining of Masculinities*, London, Routledge, 1994; M. Roper, *Masculinity and the British Organization Man since 1945*, Oxford, Oxford University Press, 1994.

37 M. Foucault, *The History of Sexuality*, vol. 1: *An Introduction*, trans. R. Hurley, New York, Pantheon Books, 1979, p. 94. For an interesting attempt to utilise Foucault for consumption studies see M. Nava, 'Consumerism and its Contradictions', *Cultural Studies*, May 1987, vol. 1, no. 2, pp. 204–10.

38 For theoretical and historical analyses of the relationship between commercial culture and the public sphere of formal politics in Europe and North America in the twentieth century see: V. de Grazia, *The Culture of Consent: Mass Organisation of Leisure in Fascist Italy*, Cambridge, Cambridge University Press, 1981, and *How Fascism Ruled Women: Italy, 1922–1945*, Berkeley, University of California Press, 1992; G. Stedman Jones, 'Working-Class Culture and Working-Class Politics in London, 1870–1900: Notes on the Remaking of a Working Class', in G. Stedman Jones, *Languages of Class: Studies in English Working Class History 1832–1982*, Cambridge, Cambridge University Press, 1983, pp. 179–238; K. Peiss, *Cheap Amusements: Working Women and Leisure in Turn- -of-the-Century New York*, Philadelphia, Temple University Press, 1986; L. Boltanski, *The Making of a Class: Cadres in French Society*, trans. A. Goldhammer, Cambridge, Cambridge University Press, 1987; H. Gruber, *Red Vienna: Experiments in Working-Class Culture, 1919–1934*, Oxford, Oxford University Press, 1991; L. Paggi, 'The Shaping of Post-Bourgeois Politics in Europe, 1945–68', unpublished paper delivered to the Conference on 'Paths to Mass Consumption', Columbia University, New York, May 1994.

PART ONE The Cultural Authority of Style

1 P. Bourdieu, *Homo Academicus*, trans. P. Collier, Cambridge, Polity Press, in association with Basil Blackwell, 1988, pp. 174–81.

2 J. Williamson, 'Male Order', *New Statesman*, 31 October 1986, vol. 112, no. 2901, p. 25. See also Williamson's review, 'Above the World', *New Statesman*, 10 October 1986, vol. 112, no. 2898, p. 25.

3 P. Hodson, 'New Man', *She*, July 1984, p. 126.

4 S. Taylor, 'Magazines for Men: On the Trail of the Typically British Male', *Campaign*, 29 August 1986, p. 44. For similar arguments see R. Mayes, 'Jumping on the Bands Wagon', *Media Week*, 6 September 1985, pp. 20–1.

5 McCann Erickson, *Manstudy Report*, 1984, quoted in S. Marquis, 'The Publishing Conundrum: How to Reach the "New Man"', *Campaign*, 26 July 1985, p. 39.

6 B. Isaacs, quoted in C. Davis, 'Brasserie Man – Open All Hours', *The Evening Standard*, 24 November 1987, p. 33.

7 P. York, quoted in C. Bowen-Jones, 'Adman Finds a New Woman', *The Times*, 16 March 1988, p. 26.

8 T. O'Dwyer, 'Are You Gauguin, New Colonial, or Savile Row?' *The Guardian*, 28 August 1986, p. 11.

9 T. O'Dwyer, 'Liberated Man Power Arrives', *Men's Wear*, 23 August 1984, p. 8. For similar comments by O'Dwyer see: 'Public Image', *Men's Wear*, 5 July 1984, p. 16; 'Style Counsel '85 ... New Blood', *Men's Wear*, 20 December 1984, p. 17.

10 B. Kennedy and J. Lyttle, 'Wolf in Chic Clothing', *City Limits*, 4–11 December 1986, pp. 14–17.

11 See for example: 'Girls! Is Your Guy a Page Seven Fella?', *The Sun*, 27 March 1987, pp. 16–17; 'Sheer Joy with My Sexy Toyboy', *The Sun*, 15 February 1987, p. 9.

12 See for example: F. Mort, 'Images Change: High Street Style and the New Man', *New Socialist*, November 1986, no. 43, pp. 6–8; A. Metcalf and M. Humphries, 'Introduction', in A. Metcalf and M. Humphries (eds), *The Sexuality of Men*, London, Pluto Press, 1985, pp. 1–14; J. Rutherford, 'Who's That Man?' in R. Chapman and J. Rutherford (eds), *Male Order: Unwrapping Masculinity*, London, Lawrence & Wishart, 1988, pp. 21–67; A. Jardine and P. Smith (eds), *Men in Feminism*, London, Methuen, 1987.

13 L. Segal, *Slow Motion: Changing Masculinities, Changing Men*, London, Virago, 1990. For other sceptical commentaries see: R. Chapman, 'The Great Pretender: Variations on the New Man Theme', in Chapman and Rutherford (eds), *Male Order*, pp. 225–48; S. Moore, 'Target Man', *New Socialist*, January 1987, no. 45, pp. 4–5.

14 P. Toynbee, 'The Incredible, Shrinking New Man', *The Guardian*, 6 April 1987, p. 10.

15 Z. Zawada, quoted in Taylor, 'Magazines for Men', p. 41. For other similar comments see, among very many: S. Ludgate, 'The Magazines for the Young Generation', *Campaign*, 16 March 1984, pp. 54–8; N. van Zanten, 'In Search of Elusive Youth', *Campaign*, 16 March 1984, pp. 63–4; Marquis, 'The Publishing Conundrum', pp. 37–41; S. Oriel, 'The Ideal Homme Magazine', *Media Week*, 12 February 1988, pp. 43–5; S. Buckley, 'How to Talk to More Men', *Media Week*, 12 February 1988, p. 46.

16 For details of *Man About Town* and *About Town* see D. Cook, 'From Pillar to "Post"', MA thesis submitted to the Royal College of Art, London, May 1993.

17 For details of these magazines see P. Burton, *Parallel Lives*, London, Gay Men's Press, 1985, pp. 48–9.

18 B. Braithwaite, 'The Eagle Has Landed', *Media Week*, 8 December 1989, pp. 28–9.

19 For analysis of *Smash Hits* and *Just Seventeen*, in the context of both shifts in magazine publishing and changes to the culture of young women in the 1980s, see: J. Winship, 'A Girl Needs to Get Street-Wise: Magazines for the 1980s', *Feminist Review*, 1987, no. 21, pp. 25–46, and *Inside Women's Magazines*, London, Pandora, 1987, pp. 148–62; A. McRobbie, *Feminism and Youth Culture: From 'Jackie' to 'Just Seventeen'*, Basingstoke, Macmillan, 1991, pp. 135–88. The total circulation figures for teenage magazines in 1984 showed an 11 per cent increase on the previous year, at a time when magazine circulation as a whole dropped by 2 per cent. See: *Media Week*, 6 September 1985, p. 20; S. Nixon, 'Looking for the Holy Grail: Publishing and Advertising Strategies for Contemporary Men's Magazines', *Cultural Studies*, 1993, vol. 7, no. 3, pp. 467–92.

20 Advertisement for *The Hit, Campaign*, 6 September 1985, pp. 26–7.

21 'The Hit Hits the Stands', *Media Week*, 17 May 1985, p. 2.

22 P. McNeill, quoted in Mayes, 'Jumping on the Bands Wagon', p. 20.

23 D. Porter, quoted in A. Rawsthorn, 'The Hit: Why It Failed so Miserably to Reach Its Male Target', *Campaign*, 15 November 1985, p. 15.

24 J. Reid, quoted in S. d'Arcy, 'Next for Men?' *Media Week*, 16 August 1985, p. 10.

25 Porter, quoted in Rawsthorn, 'The Hit'. The magazine closed early in November 1985, after sales had dropped to 80,000.

26 M. Ellen, quoted in Rawsthorn, 'The Hit'.

27 Marquis, 'The Publishing Conundrum'. Italian and French men's magazine titles included *L'Uomo Vogue* and *L'Homme Vogue* respectively. The United States had seen a dramatic rise in men's magazines. *Esquire* was the most established title, with a circulation in 1986 of 700,000. *GQ*, or *Gentlemen's Quarterly*, was started as a trade magazine by *Esquire* in 1957, but underwent a transformation on its sale to Condé Nast in 1979. Circulation figures were 660,000 in 1986. Other titles with smaller circulations included *M* magazine and *MGF* (Men's Guide to Fashion). In the mid-1980s America's largest black-owned business, the Johnson's publishing company, launched *Ebony Man*. There was at this stage a second magazine aimed at black men entitled *MBM* (Modern Black Men). See R. Bailey, 'Men's Writes', *Media Week*, 2 May 1986, pp. 14–17.

28 M. Revelle, Letters, 'The Specialist Press: An Ideal Youth Target', *Campaign*, 29 November 1985, p. 28.

29 Advertisement for *Mayfair* magazine, *Campaign*, 15 February 1985, p. 32.

30 B. Ritchie, 'Tête-à-tête with The Face', *The Sunday Times*, 7 March 1982, p. 54.

31 For the most expansive discussion of the discourse of *The Face* as a manifestation of postmodernism see: D. Hebdige, *Hiding in the Light: On Images and Things*, London, Comedia, 1988, pp. 155–76; S. Frith and H. Horne, *Art into Pop*, London, Methuen, 1987, pp. 123–61. For a more specific analysis of the style press in the context of the developments in consumer journalism in the 1980s see: Nixon, 'Looking for the Holy Grail'; Winship, *Inside Women's Magazines*, pp. 148–62.

32 Ludgate, 'The Magazines for the Young Generation', p. 54.

33 See M. Brown, 'A Teenage Trendsetter, Aged 36', *The Sunday Times*, 8 May 1983, p. 14.

34 Ritchie, 'Tête-à-tête'. See also 'The Face', *The Face*, May 1985, no. 61, pp. 110–12.

35 For details of *Blitz* see Ludgate, 'The Magazines for the Young Generation', p. 55.

36 *Media Week*, 3 May 1985, p. 2. Sales of *The Face* rose from 66,520 to 80,032 in the second half of 1984. Sales of *Blitz* doubled early in 1984 from 10,000 to 20,000, Ludgate, 'The Magazines for the Young Generation'. For further discussion of the circulation figures for the style press in the 1980s see Cook, 'From Pillar to "Post"'.

37 Comag created a retail availability measurement survey, which provided up-to-date statistical information about distribution and sales. Harris claimed that this information also fed into subsequent product development. See Ritchie, 'Tête-à-tête'.

38 For details of *The Face's* readership see D. O'Donaghue, 'The Dedicated Followers of Fashion', *Campaign*, 20 November 1987, p. 64.

39 J. Reid, quoted in Marquis, 'The Publishing Conundrum', p. 41.

40 R. Elms, '1984: Style', *The Face*, January 1985, no. 57, p. 51.

41 'New England', *The Face*, August 1986, no. 76, p. 41.

42 Ibid., pp. 41–9.

43 Elms, 'Reflections on the Ascent of Teenage Tribes', *Campaign*, 8 August 1986, p. 50.

44 J. Savage, 'Golden Oldies of '85', *The Observer Magazine*, 10 February 1985, p. 23. For similar comments see: A. Edmondson, 'Cult Fever!' *The Observer Magazine*, 10 February 1985, pp. 14–17; J. Cummins, 'Self-Expression', *The Observer Magazine*, 17 February 1985, p. 9.

45 Cummins, 'Self-Expression'.

46 N. Brody, quoted in B. Hipkin, 'Designs for the Visual', *Marxism Today*, November 1985, vol. 29, no. 11, p. 41.

47 N. Logan, quoted in J. Wozencroft, *The Graphic Language of Neville Brody*, London, Thames & Hudson, 1988, p. 99.

48 Logan, quoted in Brown, 'A Teenage Trendsetter'.

49 Logan, quoted in J. Davies, 'On the Spot Nick Logan', *Direction*, September 1988, pp. 22–5. See also 'Men's Fashion is Logan's Latest Run', *Campaign*, 15 August 1986, p. 18.

50 R. Sopp, quoted in Nixon, 'Looking for the Holy Grail', p. 477. Nixon argues that Sopp was influenced by Abram Manslow's developmental schema of motivational consumer categories.

51 C. Labovitch, quoted in A. Jivani, 'Blitz: Continuing the Search for Style', *Campaign*, 22 August 1986, p. 6. For similar comments see Ludgate, 'The Magazines for the Young Generation'.

52 Logan, quoted in Wozencroft, *The Graphic Language*, p. 113. Also Davies, 'On the Spot Nick Logan'.

53 See for example: 'Fashion', *The Face*, May 1985, no. 61, p. 92; P. Zerbib, 'The Six Inventions of Jean-Paul Gaultier', *The Face*, February 1984, no. 46, pp. 22–7; M. Ackerman, 'Spell it G-a-u-l-t-i-e-r Le Style Anglais', 'Face Fashion Extra', *The Face*, April 1986, no. 72, no page.

54 'Who's Shooting Who? In Beirut It Pays to Know Your Terrorist', *The Face*, July 1986, no. 75, pp. 81–5.

55 See for example Burchill's essays from the period, republished in *Damaged Goods: Cults and Heroes Reappraised*, London, Century, 1986, pp. 1–15.

56 See for example: D. Rimmer, *Like Punk Never Happened: Culture Club and the New Pop*, London, Faber & Faber, 1985; D. Laing, *One Chord Wonders: Power and Meaning in Punk Rock*, Milton Keynes, Open University Press, 1985.

57 This is the argument advanced by a number of participants in punk. See: J. Burchill and T. Parsons, 'The Boy Looked at Johnny': The Obituary of Rock and Roll, London, Pluto, 1978; J. Savage, England's Dreaming: Sex Pistols and Punk Rock, London, Faber & Faber, 1991.

58 Frith and Horne, Art into Pop, pp. 74–161. For similar debates about the relationship between modern art and commercial culture see: J. Walker, Cross-Overs: Art into Pop, Pop into Art, London, Comedia, 1986; T. Crow, 'Modernism and Mass Culture in the Visual Arts', in F. Frascina (ed.), Pollock and After: The Critical Debate, New York, Harper & Row, 1985, pp. 233–66.

59 Wozencroft, The Graphic Language, p. 94.

60 Brody, quoted in ibid., p. 5.

61 For details of Hornsey College of Art and its place within post-war art and design education see: C. Ashwin, A Century of Art Education 1882–1982, London, Middlesex Polytechnic, 1982; Students and Staff of Hornsey College of Art, The Hornsey Affair, Harmondsworth, Penguin, 1969.

62 Brody, quoted in Wozencroft, The Graphic Language, p. 5.

63 For analysis of this tension see: Frith and Horne, Art Into Pop; Walker, Cross-Overs and Art in the Age of the Mass Media, revised edition, London, Pluto, 1994.

64 Brody, quoted in Wozencroft, The Graphic Language, p. 5.

65 Ibid., p. 9.

66 Ibid., p. 5.

67 Ibid., p. 6. For Brody's reflections on the position of the artist within contemporary culture see Hipkin, 'Designs for the Visual'.

68 Brody, quoted in Wozencroft, The Graphic Language, p. 15.

69 R. Kinross, 'Commercial Cred', The Times Literary Supplement, 20–26 May 1988, p. 556.

70 Brody, quoted in Wozencroft, The Graphic Language, p. 56.

71 Logan, quoted in Wozencroft, The Graphic Language, p. 96.

72 Wozencroft, The Graphic Language, p. 96.

73 Ibid., p. 102.

74 J. Wozencroft, The Graphic Language of Neville Brody 2, London, Thames & Hudson, 1994, pp. 7–8.

75 Wozencroft, The Graphic Language, p. 12.

76 Brody, quoted in Hipkin, 'Designs for the Visual', p. 40.

77 See for example: V. Packard, The Hidden Persuaders, London, Longmans, Green & Co., 1957; M. McLuhan, The Medium is the Massage, Harmondsworth, Penguin, 1967; J. Baudrillard, Le miroir de la production; ou l'illusion critique du matérialisme historique, 2nd edition, Tournai, Castermann, 1977; P. Virilio, The Aesthetics of Disappearance, trans. P. Beitman, New York, Semiotext(e), 1991.

78 Brody, quoted in Wozencroft, The Graphic Language, p. 99.

79 Ibid., p. 24.

80 Wozencroft, The Graphic Language, pp. 24, 35. For histories and analyses of

typography see: R. McLean, *From Moxon to Morrison: The Growth of Typography as a Profession*, Cambridge, Cambridge University Press, 1983; R. Carter, B. Day, P. Meggs, *Typographic Designs: Form and Communication*, Wokingham, New York, Van Nostrand Reinhold, 1985; A. Lawson, *Anatomy of Typeface*, London, Hamish Hamilton, 1990.

81 For details of the new wave of British graphic designers in the 1980s see: J. Withers, *New British Graphic Designers*, Kyoto, Japan, Kyoto Shoin, 1991; H. Rees (ed.), *The Graphic Beat: London/Tokyo*, vol. 1, Tokyo, P.I.E. Books, 1992.

82 Victoria and Albert Museum, *Catalogue of the W.H. Smith Illustration Awards 1987*, London, Victoria and Albert Museum, 1987, no page.

83 Quoted in 'The Face', p. 111.

84 'Trivia', *The Face*, September 1986, no. 77, p. 26.

85 Hebdige, 'The Bottom Line on Planet One', p. 159.

86 For biographical details of Logan see: Ritchie, 'Tête-à-tête'; Brown, 'A Teenage Trendsetter'; D. Campbell, 'Pressing on the Style', *The Observer Magazine*, 10 February 1985, pp. 30–5.

87 Elms, quoted in Davies, 'On the Spot Nick Logan', p. 23.

88 Logan, quoted in Davies, 'On the Spot Nick Logan', p. 25. For details of Logan's sale of 40 per cent of his company to Condé Nast see J. Slade, 'Face Lift for Logan', *The Times*, 30 November 1988, p. 35.

89 R. Poggioli, *The Theory of the Avant-Garde*, trans. G. Fitzgerald, Cambridge, MA, Harvard University Press, 1968, p. 3; R. Krauss, *The Originality of the Avant-Garde and Other Modernist Myths*, Cambridge, MA, MIT Press, 1985, p. 157. For other contributions to the debate over the definition of the avant-garde see: P. Burger, *Theory of the Avant-Garde*, trans. M. Shaw, Manchester, Manchester University Press, 1984; S. Suleiman, *Subversive Intent: Gender, Politics, and the Avant-Garde*, Cambridge, MA, Harvard University Press, 1990; D. Kuspit, *The Cult of the Avant-Garde*, Cambridge, Cambridge University Press, 1993.

90 R. Scruton, 'In Inverted Commas', *The Times Literary Supplement*, 18 December 1992, p. 4. For a more complex reading of Burchill's career see S. Frith, 'Julie and Camille', *The Times Higher Education Supplement*, 4 June 1993, p. 21.

91 Burchill, quoted in T. Willis, 'Housewife Superstar', *The Sunday Times*, 24 January 1993, 5, p. 1.

92 Burchill, *Damaged Goods*, p. 51.

93 Burchill, 'Nature, Nurture or Nietzsche? Excerpts from the Julie Burchill Story', in *Sex and Sensibility*, London, Grafton, 1992, pp. 245–52. Burchill also rehearsed her own life story in the portrait of the heroine, Susan Street, in her novel *Ambition*, 1989.

94 Burchill, *Sex and Sensibility*, pp. 94–6.

95 Burchill, *Love It or Shove It: The Best of Julie Burchill*, London, Century, 1985, pp. 1–2.

96 K. Saunders, 'Birds of a Feather', *The Sunday Times*, 8 September 1991, 3, p. 1.

97 Burchill, quoted in E. Dickson, 'Words to the Wise', *The Times Saturday Review*, 5 October 1991, p. 22. For Burchill's views on homosexuality see 'Fags Ain't What They Used to Be', in *Sex and Sensibility*, pp. 188–96. For her position on romantic love see 'The Dead Zone: The Rise of the Relationship and the Death of Romance', *Arena*, July–August 1988, no. 10, pp. 43–4.

98 Burchill, 'Born Again Cows', in *Damaged Goods*, p. 3.

99 Ibid., p. 10.

100 For details of Burchill's feud with Paglia see: S. Frith, 'Julie and Camille'; S. Wavell, 'Feminist Insults Fly in the Battle of the Bitches', *The Sunday Times*, 28 March 1993, 1, p. 3. Hostilities began over Burchill's critical review of Paglia's book, *Sex, Art and American Culture: Essays*, London, Viking, 1993, in *The Spectator* in January of that year.

101 Burchill, 'Lad Overboard', *The Face*, February 1986, no. 70, pp. 28–31.

102 Quoted in the biographical information in Elms' book, *In Search of the Crack*, Harmondsworth, Penguin, 1989.

103 Ibid., p. 41.

104 Ibid., p. 64.

105 R. Elms, 'Ditching the Drabbies: A Style for Socialists', *New Socialist*, May 1986, no. 38, pp. 12–14. For a reply to Elms in the same issue, defending 1960s' progressivism, see D. Edgar, 'Never Too Old: Learning from the Sixties', pp. 16–20.

106 For debates over cultural politics on the British left during the period see: G. Mulgan and K. Worpole, *Saturday Night or Sunday Morning? From Arts to Industry, New Forms of Cultural Politics*, London, Comedia, 1986; S. Weir, 'Ringing the Changes', *New Socialist*, May 1986, no. 38, p. 2, and *Marxism Today* throughout the 1980s. For analysis of the cultural stance of *Marxism Today* in the context of the history of the British Communist Party see R. Samuel, 'The Lost World of British Communism', *New Left Review*, November/December 1985, no. 154, pp. 3–53.

107 C. Petit, 'Love among the Literati', *The Times*, 8 September 1988, p. 21. For other examples of Elms' journalism in this genre see: 'Culture Junction', *The Face*, February 1985, no. 58, pp. 24–7; 'The Mode in Jazz', *The Face*, April 1986, no. 72, pp. 44–7.

108 Quoted in R. Elms, 'Pogue in the Eye', *The Face*, March 1985, no. 59, pp. 30–5.

109 Bailey, 'Men's Writes'.

110 L. Eisenberg and A. Cooper, quoted in Bailey, 'Men's Writes', p. 14.

111 For more complex feminist analyses of women's relationship to modern forms of consumption see: R. Coward, *Female Desire*, London, Paladin, 1984; E. Carter, 'Alice in the Consumer Wonderland', in A. McRobbie and M. Nava (eds), *Gender and Generation*, London, Macmillan, 1984, pp. 185–214; E. Wilson, *Adorned in Dreams: Fashion and Modernity*, London, Virago, 1985; C. Steedman, *Landscape for a Good Woman: A Story of Two Lives*, London, Virago, 1986; J. Williamson, *Consuming Passions: The Dynamics of Popular Culture*, London, Marion Boyars, 1986. For the

anti-consumerist tendencies within the British women's movement in the 1960s and 1970s see M. Nava, 'Consumerism Reconsidered: Buying and Power', *Cultural Studies*, May 1991, vol. 5, no. 2, pp. 157–73.

112 In 1987 the gender, class and age readership profiles of a sample of consumer monthlies was as follows:

Readership gender profile

	Male	*Female*
The Face	62	38
Blitz	49	51
Vogue	20	80
Elle	17	83
Tatler	33	67

Readership class profile

	A	*B*	*C1*	*C2*	*D*	*E*
The Face	6	22	38	17	10	7
Blitz	4	21	33	21	15	6
Vogue	7	24	31	21	11	6
Elle	7	27	37	16	8	5
Tatler	13	29	40	9	6	4

Readership age profile

	15–24	*25–34*	*35–44*	*45–54*	*55–64*	*65+*
The Face	74	20	3	3	–	–
Blitz	68	20	8	3	1	–
Vogue	36	21	16	11	8	8
Elle	50	20	12	11	5	2
Tatler	25	22	19	11	10	13

Source: O'Donaghue, 'The Dedicated Followers of Fashion', p. 64.

113 Nixon, 'Have You Got the Look? Masculinities and Shopping Spectacle', in R. Shields, *Lifestyle Shopping: The Subject of Consumption*, London, Routledge, 1992, pp. 149–69.

114 Logan, quoted in 'Men's Fashion is Logan's Latest Run'.
115 Cover page, *The Face*, March 1985, no. 59.
116 'The Harder They Come', styling R. Petri, photography J. Morgan, *The Face*, no. 59, pp. 85–91.
117 Ibid., p. 84.
118 Wozencroft, *The Graphic Language*, p. 117.
119 For the part played by photography within the British fashion renaissance of the 1980s see: Photographer's Gallery, *Out of Fashion: Photographs by Nick Knight and Cindy Palmano*, London, Photographer's Gallery, 1989; M. Harrison, *Appearances: Fashion Photography since 1945*, London, Jonathan Cape, 1991.
120 R. Barthes, *The Fashion System*, trans. M. Ward and R. Howard, London, Jonathan Cape, 1985. For commentary on the role of the various professionals who contribute to the fashion photograph see: Harrison, *Appearances*; M. Helvin, *Catwalk: The Art of Model Style*, London, Pavilion, 1985; A. Elgart, *Arthur Elgart's Models Manual*, New York, Grand Street Press, 1993.
121 N. Chapman, *Careers in Fashion*, 3rd edition, London, Kogan Page, 1994, pp. 46–7. See also E. Jabenis, *The Fashion Director: What She Does and How to Be One*, London, John Wiley & Sons, 1972, pp. 35, 347–9. For the concept of styling as understood within product design see Design Museum, *Study Notes Styling*, London, Design Museum, 1989.
122 N. Logan and D. Jones, 'Ray Petri', *The Face*, October 1989, no. 13, p. 10.
123 For biographical details of Petri, on which the following account is based see: Logan and Jones, 'Ray Petri', *The Independent*, 18 August 1989, p. 17; A. Sharkey, 'Ray Petri', *Time Out*, 23–30 August 1989, no. 992, p. 11; 'Nature Boy', *The Face*, November 1989, no. 14, pp. 56–67; 'The Long Goodbye', *Arena*, November 1989, no. 18, pp. 130–7.
124 See 'Summer Strip', photography Morgan, *The Face*, August 1983, no. 49, pp. 52–3.
125 J. Blame, quoted in C. Rose, *Design After Dark: The Story of Dancefloor Style*, London, Thames & Hudson, 1991, p. 31.
126 Logan and Jones, 'Ray Petri', *The Face*.
127 Morgan, quoted in 'Nature Boy', p. 60.
128 'ragamuffin hand me down my walking cane', styling Petri, photography M. Brading, *Arena*, March–April 1987, no. 2, pp. 71–5.
129 N. Kamen, quoted in 'Nature Boy', p. 62.
130 See 'ragamuffin', in P. Babcock Gove (ed.), *Webster's Third New International Dictionary*, London, G. Bell & Son, 1961, p. 1874.
131 Petri, quoted in L. White, 'Talent', *The Face*, May 1985, no. 61, p. 44.
132 For examples of Bruce Weber's characteristic fashion imagery see: C. Hix, photographs by B. Weber, *Looking Good: A Guide for Men*, London, Angus & Robertson, 1979; B. Weber, *Hotel Room with a View: Photographs by Bruce Weber*, Washington, Smithsonian Press in association with Constance Sullivan Editions, 1992. In the 1970s and 1980s Weber undertook commissions for a variety of fashion magazines, including the American

edition of *GQ* and the Italian titles *Per Lui* and *L'Uomo Vogue*. Weber's characteristic iconography portrayed archetypal images of athletic American youth, including tennis players, swimmers and gymnasts. For analysis of Weber's fashion imagery in the context of a longer visual tradition of Anglo-American male eroticism see A. Ellenzweig, *The Homoerotic Photograph: Male Images from Durieu/Delacroix to Mapplethorpe*, New York, Columbia University Press, 1992, pp. 163–7.

133 See J. Ayto and J. Simpson, *The Oxford Dictionary of Modern Slang*, Oxford, Oxford University Press, 1992, p. 294.

134 'the boys in the band', styling Petri, photography M. Lebon, *Arena*, no. 2, pp. 80–3, 85.

135 For analysis of the handling of ethnicity in Mapplethorpe's photography see: K. Mercer, 'Just Looking for Trouble: Robert Mapplethorpe and Fantasies of Race', in L. Segal and M. McIntosh (eds), *Sex Exposed: Sexuality and the Pornography Debate*, London, Virago, 1992, pp. 92–110, and 'Imaging the Black Man's Sex', in P. Holland, J. Spence, S. Watney (eds), *Photography/Politics: Two*, London, Comedia, 1986, pp. 61–9. For a commentary on Petri's visualisation of ethnicity see Rose, *Design After Dark*, p. 31.

136 'Float Like a Butterfly Sting Like a Bee ... Check Out the Beef!' photography Morgan, Petri, *The Face*, June 1985, no. 62, pp. 34–41; 'The Cowboy, the Indian and Other Stories', photography R. Charity and Morgan, styling Petri, *The Face*, October 1985, no. 66, pp. 62–71; 'Buffalo: A More Serious Pose', photography Morgan, Petri, *The Face*, September 1986, no. 77, pp. 90–4.

137 For analysis of the cultural resources deployed by Petri see: Logan and Jones, 'Ray Petri', *The Independent*; Sharkey, 'Ray Petri', *Time Out*.

138 Petri, quoted in White, 'Talent'.

139 For discussion of the relationship between concepts of the male homosexual identity and visual art in the nineteenth and twentieth centuries see: E. Cooper, *The Sexual Perspective: Homosexuality and Art in the Last 100 Years in the West*, London, Routledge & Kegan Paul, 1986; Ellenzweig, *The Homoerotic Photograph*. For similar arguments about the cinema see R. Dyer, *Now You See It: Studies on Lesbian and Gay Film*, London, Routledge, 1990.

140 For discussion of the 'buffalo' look see: D. Jones, *Haircuts: Fifty Years of Styles and Cults*, London, Thames & Hudson, 1990, pp. 75, 106; 'Bombers Away', *The Face*, June 1986, no. 74, p. 33; 'Review of 1986', *The Face*, January 1987, no. 81, p. 68.

141 J. Cocteau, 'Le Livre Blanc: Notes on Homosexuality', in Cocteau, *Professional Secrets: An Autobiography of Jean Cocteau; Drawn from his Lifetime Writings by Robert Phelps*, trans. R. Howard, New York, Farrar, Straus & Giroux, 1970, p. 117. For other accounts of the importance of visual discourses within twentieth-century homosexual culture see: J. Gardiner, *A Class Apart: The Private Pictures of Montague Glover*, London, Serpent's Tail, 1992; C. Evans and L. Gamman, 'The Gaze Revisited, or Reviewing Queer

Viewing', in P. Burston and C. Richardson (eds), *A Queer Romance: Lesbians, Gay Men and Popular Culture*, London, Routledge, 1995, pp. 13–56.

142 S. Sontag, 'Notes on Camp', in S. Sontag, *Against Interpretation and Other Essays*, New York, Dell, 1979, p. 279.

143 J.P. Gaultier, quoted in S. Mower, 'Gaultier', *Arena*, July–August 1987, no. 4, p. 64.

144 Brody, quoted in Wozencroft, *The Graphic Language*, p. 140.

145 Editorial, *Men's Wear*, 14 August 1986, p. 2. The analysis called for a reinstatement of more elegant styling in men's clothes. For similar comments see T. O'Dwyer and B. Morris, 'Ruling Class', *Men's Wear*, 7 August 1986, p. 13.

146 Editorial, *Men's Wear*, 27 March 1986, p. 2.

147 J. Taylor, 'Meanwhile Back at the Camp', *Men's Wear*, 7 August 1986, p. 7. For other examples see Taylor, 'John Taylor's Commentary', *Men's Wear*, 10 April 1986, p. 12.

148 Taylor, 'The Freaks Had a Word for It', *Men's Wear*, 8 May 1986, p. 7.

149 See Davies, 'On the Spot Nick Logan', p. 25. *Arena*'s first audited circulation was 65,000 at the end of 1986. For further details of *Arena*'s launch see: 'News Hotline', *Campaign*, 8 August 1986, p. 3; 'Men's Fashion Is Logan's Latest Run', p. 18; S. Taylor, 'Magazines for Men'.

150 Brody, quoted in Wozencroft, *The Graphic Language*, p. 140.

151 For *Arena*'s élite conception see: Davies, 'On the Spot Nick Logan', p. 24; Nixon, 'Looking for the Holy Grail', p. 485.

152 A. Jivani, 'Can LM and Q Survive in a Field Littered with Corpses?', *Campaign*, 19 September 1986, p. 57. For further analysis of Q see: 'EMAP Makes Bid to Launch Glossy Men's Magazine', *Campaign*, 23 May 1986, p. 7; Jivani, 'British Males Give Yet Another Hopeful Suitor the Cold-Shoulder', *Campaign*, 5 June 1987, p. 19; S. Richmond, 'As Soft Porn Stagnates, Are Men Really Ready for the Mass-Market Style?', *Campaign*, 7 July 1989, p. 27.

153 R. Hill, quoted in 'Vogue Men Gets Set to Stand on its Own', *Campaign*, 26 September 1986, p. 7.

154 I. Birch, quoted in P. Nathanson, 'Can Murdoch's Sky Survive the Jinx That Plagues Teenage Titles?' *Campaign*, 27 March 1987, p. 20. *Sky* was billed as part of Rupert Murdoch's media strategy for the next decade, launched at a cost of £500,000. Murdoch was reported to have claimed that he wanted one-third of future company profits to come from magazine publishing.

155 J. Durden, 'A Title for the Upscale Male', *The Daily Telegraph*, 27 July 1988, p. 10.

156 P. Keers, quoted in R. McKay, 'GQ – for the 40 Per Cent Well-Fed Man', *Campaign*, 13 May 1988, p. 33.

157 S. Quinn, quoted in Bailey, 'Men's Writes', p. 17.

158 M. Boxer, quoted in T. Douglas, 'Magazines That Could Explode the Male Myth', *The Observer*, 26 April 1987, p. 29.

159 For details of the GQ survey see: 'Market Research Helps Define GQ',

Campaign, 1 April 1988, p. 19; Durden, 'A Title for the Upscale Male'.

160 Keers, quoted in Durden, 'A Title for the Upscale Male'.

161 A. Carter, 'Skin Care', *Arena*, July–August 1987, no. 4, p. 101. For similar articles see: R. Ryan, 'Dyeing Young', *Arena*, March–April 1988, no. 8, pp. 130–1 and 'Going Balmy', *Arena*, September–October 1989, no. 17, p. 172.

162 S. Taylor, '"Slave to the Shave": Fighting Shaving's Cut-Throat Wars', *Arena*, December–January, 1986–7, no. 1, p. 17. For analysis of cosmetic advice to women see: Coward, *Female Desire*, pp. 35–46; K. Myers, *Understains: The Sense and Seduction of Advertising*, London, Comedia, 1986, pp. 69–80.

163 'Shopping for Clothes', *Arena*, September–October 1987, no. 5, p. 130.

164 J. Savage, 'What's So New about the New Man?' *Arena*, no. 8, pp. 33–9.

165 S. Beard and J. McClellan, 'Transports of Desire', *Arena*, May–June 1988, no. 9, pp. 76–80.

166 S. Beard and J. McClellan, 'You're in the Army Now', *Arena*, May–June 1989, no. 15, pp. 66–72.

167 L. Buckley, 'Despatches', *Arena*, May–June 1987, no. 3, p. 7.

168 P. Ward, 'Despatches', *Arena*, January–February 1988, no. 7, p. 10. In the same issue see also Id Croft, 'Despatches', p. 10.

169 K. Sampson, 'Masturbation: One from the Wrist', *Arena*, no. 3, p. 109.

170 'Whatever Comes to Hand', 'Despatches', *Arena*, no. 4, p. 7.

171 J. Berens, 'Rourke', *Arena*, no. 1, p. 25.

172 J. Truman, 'Mike Tyson Baptism for a Heavyweight', *Arena*, no. 1, p. 90.

173 M. Tyson, quoted in Truman, 'Mike Tyson', pp. 90–4.

174 For similar articles in this genre see: T. Parsons, 'Harrison Ford: No Gun No Bullwhip', *Arena*, no. 2, pp. 24–9; Parsons, 'Hoddle', *Arena*, no. 4, pp. 86–9; J. Truman, 'The Devil in James Woods', *Arena*, July–August 1988, no. 10, pp. 28–32. For analysis of aspects of the male romance genre see: T. Bennett and J. Woollacott, *Bond and Beyond: The Political Career of a Popular Hero*, Basingstoke, Macmillan, 1987; J. Bristow, *Empire Boys: Adventures in a Man's World*, London, Unwin Hyman, 1991.

175 R. Ryan, 'Solitary Refinement', *Arena*, November–December 1988, no. 12, pp. 92–6.

176 J. Ferry, 'Charlotte Lewis Lovestruck', *Arena*, no. 2, p. 122.

177 For similar treatment of women in this genre see: L. O'Brien, 'Dianne Reeves', *Arena*, September–October 1988, no. 11, p. 189.

178 G. Burn, 'This Way Mandy . . .', *Arena*, no. 2, p. 47.

179 T. Baker, 'Rossellini and Lynch: Shocking Blue', *Arena*, no. 2, p. 18.

180 'Urban Cowboys', fashion Petri, photography N. Watson, *Arena*, no. 5, pp. 46–55; 'South of the Border', styling Petri, photography Watson, *Arena*, November–December 1987, no. 6, pp. 104–11.

181 J. Burchill, 'Where's the Beef?' *Arena*, no. 11, pp. 51–2.

182 E. von Unwerth, 'tender is the night', *Arena*, no. 3, p. 114.

183 E. Byrne, Letters, *The Face*, February 1986, no. 70, p. 81.

184 T. Fairbanks, Letters, *The Face*, April 1987, no. 84, p. 95.

185 'Men's Fashion Is Logan's Latest Run'.
186 S. Taylor, 'The Message in a Bottle', *Campaign*, 6 March 1987, pp. 37–42.
187 G. Deane, 'Uncommon Scents', *Arena*, no. 1, p. 67.
188 For comments on Logan's lack of mainstream commercial ambition see Ludgate, 'The Magazines for the Young Generation', p. 58.
189 Labovitch, quoted in Ludgate, 'The Magazines for the Young Generation', p. 58.
190 Labovitch, quoted in Jivani, 'Blitz: Continuing the Search for Style', p. 6.
191 Burchill, 'Nature, Nurture or Nietzsche?' pp. 255–6.
192 Brody, quoted in Hipkin, 'Designs for the Visual', p. 40.

PART TWO Commercial Epistemologies: Advertising, Marketing and Retailing since the 1950s

1 Comment, 'Looking Back on a Tough Year', *Campaign*, 20 December 1985, p. 19.
2 Expenditure on television advertising rose by 48 per cent in real terms between 1975 and 1986, while press advertising increased by over 60 per cent, poster advertising nearly doubled and radio advertising grew by over 200 per cent. In 1986 alone the growth figures were: television 17.7 per cent, posters 15.5 per cent and radio 7.7 per cent. The Advertising Association's 1987 forecast for expenditure projected further years of expansion ahead. See M. Waterson, 'Ad Spending Looks Set for at Least Another Two-Year-Run of Dynamic Growth', *Campaign*, 29 May 1987, pp. 14–15.
3 J. Claridge, 'Agency of 1986. BBH: A Flair Hard to Beat', *Campaign*, 9 January 1987, p. 32.
4 M. Forrester, *Everything You Always Suspected Was True about Advertising: But Were Too Legal, Decent and Honest to Ask*, Glasgow, Fontana, 1987, p. 11. Saatchi and Saatchi led British advertisers' assault on the USA, with their takeover of Compton Communications in 1982, and Dancer Fitzgerald Sample and Ted Bates in 1986. Other similar signs of British aggrandisement included the acquisition of the American agencies Della Femina Travisano, HBM/Creamer, Heller Breene and R.A. Becker by Wright Collins Rutherford Scott in 1986. See: D. West, 'Multinational Competition in the British Advertising Agency Business, 1936–1987', *Business History Review*, Autumn 1988, vol. 62, no. 3, pp. 467–501; I. Fallon, *The Brothers: The Rise and Rise of Saatchi and Saatchi*, London, Hutchinson, 1988, pp. 220–32; Saatchi and Saatchi Company plc, *Annual Report for the Year Ending September 30 1985*, London, Saatchi & Saatchi, 1985, p. 2; F. McEwan, 'Advertising: Financial Times Survey', *Financial Times*, 22 October 1986, p. 1.
5 M. Saatchi, quoted in Saatchi and Saatchi, *Annual Report*, 1987, p. 9.
6 In the financial year 1986–7 Saatchi and Saatchi's pre-tax profits were

£124.1 million, an increase of 77 per cent compared with 1986. Earnings per share rose by 20.2 per cent. Over the previous ten-year period the agency's client base had grown to over 10,000 and average annual pre-tax profits had risen by 59 per cent. In 1987 the group had over 14,000 employees and claimed to work with 250 of the world's top 500 corporations. See Saatchi and Saatchi, *Annual Report*, 1987, p. 3.

7 T. Levitt, 'The Globalization of Markets', *Harvard Business Review*, May–June 1983, no. 3, pp. 92–102. See also his *The Marketing Imagination*, 2nd edition, London, Collier MacMillan, 1986. For the influence of Levitt on the Saatchi brothers see Fallon, *The Brothers*, pp. 201–4.

8 'The Global Approach', Saatchi and Saatchi, *Annual Report*, 1987, p. 1.

9 A. Simonds-Gooding, 'Review of Communications Services', Saatchi and Saatchi, *Annual Report*, 1985, p. 18.

10 For forecasts of Saatchi and Saatchi's impending difficulties see N. Blackley, 'Saatchi's, Omnicom: What Cost the Mega-Mergers?', *Campaign*, 26 September 1986, p. 41. Perceptions of Saatchi's waning creative commitment, as the company expanded, were fictionally depicted in Winston Fletcher's novel, *The Manipulators*, London, Macmillan, 1988, in which the agency, Isaacs and Isaacs, stood as a thinly veiled parody of Saatchi's.

11 T. Lloyd, quoted in Saatchi and Saatchi, *Annual Report*, 1987, p. 1.

12 W. Fletcher, *Creative People: How to Manage Them and Maximize Their Creativity*, London, Hutchinson, 1990, p. 6.

13 J. Hegarty, quoted in Fallon, *The Brothers*, p. 51. See also G. Kemp, 'Fragile Balance That Can Make or Break a Creative Marriage', *Campaign*, 15 May 1987, pp. 41, 44, 49.

14 R. Halpern, quoted in Fletcher, *Creative People*, p. 12.

15 L. Butterfield, 'Third Wave: Or Merely a Ripple on the Water?', *Campaign*, 13 May 1988, pp. 48–9. Third-wave agencies created in 1987 were seen to include: Butterfield Day Devito Hockney; Legas Shafron Davies; Woolams Moira Gaskin O'Malley; Howell Henry Chaldecott Lury; Elgie Stuart Smith. See D. Midgley, 'Third Wave First Report', *Campaign*, 21 October 1988, pp. 55–6. For a broader based historical analysis of creative agencies see: J. Hobson, 'The Agency Viewpoint 2', and T. Bell, 'The Agency Viewpoint 3', in B. Henry (ed.), *British Television Advertising: The First 30 Years*, London, Century Benham, 1986, pp. 423–53.

16 Butterfield, 'Third Wave', p. 49.

17 S. Bull, 'Communications Irony That Is Killing Off the Copywriter', *Campaign*, 24 April 1987, pp. 48–9. For analysis of the shift towards a more 'emotive' approach to the consumer during the period see: F. Mort, 'The Politics of Consumption', in S. Hall and M. Jacques (eds), *New Times: The Changing Face of Politics in the 1990s*, London, Lawrence & Wishart, 1989, pp. 160–72; A. Tomlinson, 'Introduction: Consumer Culture and the Aura of the Commodity', in A. Tomlinson (ed.), *Consumption, Identity and Style: Marketing, Meanings and the Packaging of Pleasure*, London, Routledge, 1990, pp. 1–38; R. Shields (ed.), *Lifestyle Shopping: The Subject of*

Consumption, London, Routledge, 1992.

18 Bull, 'Communications Irony', p. 49.

19 Ibid. See also L. Hagen, 'Global Ads: Fashion, Fact or Fantasy?' *Campaign*, 28 November 1986, p. 65.

20 R. Auton, quoted in C. Edwards, 'Blueprint for a New Consumer', *Campaign*, 11 September 1987, p. 55.

21 See Bull, 'Communications Irony', pp. 48–9.

22 P. Sampson, 'Inside the Mind of a Consumer', *Campaign*, 5 September 1986, p. 59. See also B. Salmon, T. Dale and Partners, *Psychographics and Lifestyles*, London, Institute of Practitioners in Advertising, 1989.

23 R. Fitch, quoted in 'Design on the New Consumer', *Marketing*, 24 October 1985, p. 20.

24 Forrester, *Everything You Always Suspected*, pp. 59–64. Forrester's account was anecdotal but was clearly written from the inside. He was a copywriter at J. Walter Thompson between 1981 and 1984. For other contemporary accounts of creatives see D. Ogilvy, *Confessions of an Advertising Man: The All-Time Best Seller about Advertising*, revised edition, London, Pan, 1987.

25 Fletcher, *The Manipulators*. The heroes of Fletcher's novel were the creative team of Tom Nathan and Paul O'Reilly at 'Pendleton's'.

26 Hegarty, quoted in L. Ludwick, 'The Chemistry behind Agency–Client Harmony', *Campaign*, 13 February 1987, p. 33.

27 D. McLaren, quoted in Ludwick, 'The Chemistry', p. 33.

28 P. Nowlan, 'A Visual Vogue for Today's Design Age', *Campaign*, 16 January 1987, p. 42.

29 T. Brignull, quoted in A. Chatburn, 'Friend or Foe? How Creatives See Their Account Comrades', *Campaign*, 26 June 1987, p. 34.

30 P. Arden, quoted in R. Olins, 'How Flexible is Advertising's Top Creative Talent?' *Campaign*, 30 January 1987, p. 46.

31 D. Bailey, quoted in T. Delaney, 'The Commercial Inspiration for Non-Commercial Artists', *Campaign*, 5 September 1986, p. 52.

32 W. Olins, quoted in Fletcher, *Creative People*, p. 134.

33 Ogilvy, *Confessions*, pp. 15–16.

34 M. Grade, quoted in Fletcher, *Creative People*, p. 34.

35 Fletcher, *Creative People*, p. 120.

36 R. Howell, 'Lessons in Cultural Studies', *Campaign*, 24 June 1988, p. 41.

37 The Henley Centre for Forecasting, *Planning for Social Change*, vol. 1, London, The Henley Centre for Forecasting, 1986, p. 117. For similar arguments from Henley see *Leisure Futures*, London, The Henley Centre for Forecasting, Spring 1988, p. 18. Henley's analysis of the decline of production-led solidarities and the crystallisation of new forms of individualism shaped by consumption had most in common with sociological debates about post-industrialisation and postmodernity. See especially: D. Bell, *The Coming of Post-Industrial Society: A Venture in Social Forecasting*, Harmondsworth, Penguin, 1976, and *The Cultural Contradictions of*

Capitalism, London, Heinemann, 1976; A. Gorz, *Farewell to the Working Class: An Essay on Post-Industrial Socialism*, trans. M. Sonenscher, London, Pluto, 1982, and *Paths to Paradise: On the Liberation from Work*, trans. M. Imrie, London, Pluto Press, 1985; Z. Bauman, *Legislators and Interpreters: On Modernity, Post-Modernity and Intellectuals*, Cambridge, Polity Press, 1987, and *Intimations of Postmodernity*, London, Routledge, 1992.

38 D. Bradbury, 'Social Class', in Henley, *Planning Consumer Markets*, Analysis Volume, London, The Henley Centre for Forecasting, Summer 1988, pp. 9–12. For similar commentaries see: A. Heath and G. Evans, 'Working-Class Conservatives and Middle-Class Socialists', in R. Jowell, S. Witherspoon, L. Brook (eds), *British Social Attitudes: The 5th Report*, Aldershot, Gower, 1988, pp. 53–69; J. Rentoul, 'Individualism', in R. Jowell, S. Witherspoon, L. Brook (eds), *British Social Attitudes: The 7th Report*, Aldershot, Gower, 1990, pp. 167–82.

39 'Classifying People – Are Lifestyles Threatening Demographics?' *Campaign*, 3 April 1987, p. 42.

40 P. York, *Style Wars*, London, Sidgwick & Jackson, 1990; A. Barr and P. York, *The Official Sloane Ranger Handbook: The First Guide to What Really Matters in Life*, London, Ebury, 1982.

41 R. Elms, 'Splinter Groups That Make up the New Music Press', *Campaign*, 20 March 1987, pp. 48–50. See also his 'Reflections on the Ascent of Teenage Tribes', *Campaign*, 8 August 1986, pp. 50–1.

42 Advertisement for Holder and Scorah, *Campaign*, 16 March 1984, p. 54.

43 N. van Zanten, 'In Search of Elusive Youth', *Campaign*, 16 March 1984, pp. 63–4.

44 S. Holder, *Media Week*, 19 April 1985, pp. 22–3. See also S. Fisher and S. Holder, *Too Much Too Young?* London, Pan, 1981.

45 Mintel, *Youth Lifestyles: Mintel Special Report*, London, Mintel, 1988, pp. 149–52.

46 Euromonitor, *Young Britain: Stage II Report*, London, Euromonitor, 1989. For similar debates see: Marketing Direction Ltd, *Youth Facts '88*, London, Marketing Direction, 1988; Salmon, Dale and Partners, *Psychographics and Lifestyles*; Information Group Services, *Teenagers: An In-Depth Study of Consumer Attitudes and Behaviour*, London, Information Group Services, October 1992.

47 For details see Bartle Bogle Hegarty, 'Bartle Bogle Hegarty and Subsidiary Company: Report and Accounts for the Year Ended 30th June 1986', unpublished, Companies House, London; 'Report and Accounts', 1987.

48 Claridge, 'Agency of 1986'.

49 Bartle Bogle Hegarty, 'Report and Accounts', 1986, p. 3.

50 P. Cover, quoted in F. McEwan, 'A Stringent Set of Rules', *Financial Times*, 15 January 1987.

51 In 1987 six copywriters and art directors joined the directorship of Bartle Bogle Hegarty; see Bartle Bogle Hegarty, 'Notice of Change of Directors or Secretaries and Their Particulars', form no. 288, Companies House, 10

January 1986. Also: 'Notice of Change of Directors', 22 September 1987; 'Notice of Change of Directors', July 1988; 'Notice of Change of Directors', 15 December 1989.

52 Hegarty, quoted in Fallon, *The Brothers*, p. 18.

53 Ibid., p. 24.

54 See McEwan, 'A Stringent Set of Rules'.

55 Hegarty, quoted in Kemp, 'Fragile Balance', p. 49.

56 For advertising commentaries on this much-discussed campaign see, among many, 'Levis Opts for Bartle Bogle to Relaunch 501s in Europe', *Campaign*, 22 November 1985, p. 1; 'How Heritage Will Be Used to Relaunch a Levis Classic', *Campaign*, 29 November 1985, pp. 39–44; M. Prangnall, 'Mining the Red Seam', *The Sunday Times*, 15 June 1986, p. 44. For more academic analysis see: F. Mort, 'Boy's Own? Masculinity, Style and Popular Culture', in R. Chapman and J. Rutherford (eds), *Male Order: Unwrapping Masculinity*, London, Lawrence & Wishart, 1988, pp. 193–224; J. Fiske, *Understanding Popular Culture*, London, Unwin Hyman, 1989, pp. 1–21.

57 See 'How Heritage Will Be Used', p. 43.

58 P. Shilland, quoted in Prangnall, 'Mining the Red Seam'.

59 T. Lindsay, quoted in T. Mason, 'The Dangers of Standing Still in the Volatile UK Jeans Race', *Campaign*, 15 May 1987, p. 33.

60 Lindsay, quoted in H. Sebag-Montefiore, 'The Bottom Line', *The Sunday Times Magazine*, 1 February 1987, p. 62.

61 J. Preston, 'Selling Style', *Media Week*, 29 April 1988, pp. 23–30.

62 Hegarty, quoted in H. Thompson, 'The Great Style Steal', *The Guardian*, 2 December 1985, p. 13. See also S. Oriel, 'The Ideal Homme Magazine', *Media Week*, 12 February 1988, p. 45.

63 Hegarty, quoted in 'How Heritage Will Be Used', p. 39.

64 Sales of Levi's jeans reportedly increased by 700 per cent in the six months after Bartle Bogle Hegarty's campaign. See Prangnall, 'Mining the Red Seam'.

65 For details of these campaigns see: G. Kemp, 'How Brylcream Plans to Cash In on Men's New Style Awareness', *Campaign*, 4 October 1985, p. 15; 'Fred Perry Plays the Cult Angle', *Campaign*, 20 February 1987, p. 12; S. Taylor, 'The Message in a Bottle', *Campaign*, 6 March 1987, pp. 37–42; J. Tylee, 'Scholl Cashes In on Rock 'n' Roll Revival', *Campaign*, 3 April 1987, p. 11; R. Johnson, 'Bone Fide Desert Boot That Enjoys a New Cult Status', *Campaign*, 15 May 1987, pp. 51–2.

66 M. Baxter, *Women in Advertising: Findings and Recommendations of a Study Commissioned by the Institute of Practitioners in Advertising*, London, Institute of Practitioners in Advertising, 1990, p. 10. The report took evidence from twenty-three British agencies, including many of the newer creative firms, in addition to in-depth interviews with women employees.

67 In 1989 a census of employment of member agencies of the Institute of Practitioners in Advertising recorded that 47 per cent of all employees in advertising were women, an increase from 38 per cent when records began

in 1960. A more detailed breakdown of the distribution of women's employment revealed the following profile:

Women as percentage of employees in each job function (1989)

	%
Executive/account handling	33
Account planning/research	52
Media	42
Copywriting/artists	20
Print production	31
Audio visual production	61
Finance/data processing	64
Secretarial	99
Others	57

Source: *Women in Advertising*, p. 15. For more general discussion of women in professional careers in the 1980s see: M. Fogerty, I. Ashton, P. Walters, *Women in Top Jobs 1968–1979*, London, Heinemann, 1981; J. Martin and C. Roberts, *Women and Employment: The Report of the 1980 DE/OPES Women and Employment Survey, a Lifetime Perspective*, London, HMSO, 1984; J. Marshall, *Women Managers: Travellers in a Male World*, Chichester, John Wiley & Sons, 1984; A. Kakabase and C. Margerison, 'The Female Chief Executive: An Analysis of Career Progress and Development Needs', *Journal of Managerial Psychology*, vol. 2, no. 2, 1987, pp. 17–25; F. Schwartz, 'Management Women and the New Facts of Life', *Harvard Business Review*, January 1989, no. 1, pp. 65–76.

68 G. Kemp, 'The Sexist Ad Debate: Are Women Really the Victims?', *Campaign*, 25 May 1984, p. 30. For other examples see: Institute of Practitioners in Advertising, *Women in Advertisements: A Selection of IPA Marketing Appraisals and Bibliography*, London, Institute of Practitioners in Advertising, 1981; R. Hamilton, B. Halworth, N. Sardar, *Adman and Eve: An Empirical Study of the Relative Marketing Effectiveness of Traditional and Modern Portrayals of Women in Certain Mass-Media Advertisements, Carried Out in June–October 1981 for the Equal Opportunities Commission by the Marketing Consultancy and Research Services of the University of Lancaster*, Manchester, Equal Opportunities Commission, April 1982; J. Reed, 'Is Adman Being Awful to Eve?', *Campaign*, 29 April 1982, p. 24; F. McEwan, 'The Image and Reality Begin to Get Closer', *Financial Times*, 18 October 1984, p. 20.

69 For details see: Kemp, 'The Sexist Ad Debate'; Opinion, 'The Changes in Sexual Imagery', *Campaign*, 20 January 1984, p. 23.

70 T. Delaney, quoted in Kemp, 'The Sexist Ad Debate', pp. 30–1.

71 A. Pitcher, 'Advertising and Equality of the Sexes', in Council of Europe,

Proceedings of the Seminar on the Contribution of the Media to the Promotion of Equality between Women and Men, Strasbourg, Council of Europe, 1984, pp. 121, 123. See also Opinion, 'The Changes in Sexual Imagery'.

72 Pitcher, 'Advertising and Equality of the Sexes', p. 122.

73 K. O'Hagan, quoted in J. Tylee, 'Agency Structures That Time-Warp Women in Advertising', *Campaign*, 12 December 1986, p. 16. For similar arguments see: V. Hodson, 'The "Lost" Women of Advertising', *Campaign*, 22 March 1985, pp. 77–9; F. Fletcher, 'Power of the Female Pound', *What's New in Marketing*, June 1991, pp. 30–1.

74 M. Kay, quoted in 'The Secret Life of an Adwoman', *Campaign*, 10 April 1987, p. 30.

75 For discussion of this dilemma for professional women, see Baxter, *Women in Advertising*, p. 37.

76 Ibid., p. 8.

77 Ibid., p. 26.

78 Ibid., p. 26.

79 'Face Values for 1988', *Campaign*, 15 January 1988, p. 40.

80 Baxter, *Women in Advertising*, p. 27.

81 Fletcher, *Creative People*, p. 4.

82 In 1990 only 20 per cent of agency creatives were women, the figures being the same for both copywriters and art directors. Not surprisingly, therefore, there were very few women creative directors – only two among the top fifty agencies. See Baxter, *Women in Advertising*, p. 32.

83 B. Noakes, quoted in S. Richmond, 'Sex: The Creative Barrier', *Campaign*, 11 September 1992, p. 26.

84 See T. Mason, 'Going Solo: Is There Any Life Outside the Agency Walls?' *Campaign*, 20 March 1987, pp. 44–5. Denton and Palmer moved to Lowe Howard-Spink Marschalk in 1987.

85 See Baxter, *Women in Advertising*, p. 33.

86 K. Kendrick, quoted in Richmond, 'Sex: The Creative Barrier', p. 27.

87 B. Day, 'Adman Open the Closet Door and Give Sex Updated Appeal', *Campaign*, 1 March 1985, p. 33. For similar evidence of commercial optimism in relation to masculinity see F. McEwan, 'Treading the Knife Edge of Sensuality', *Financial Times*, 5 June 1986, p. 16.

88 B. Brooks, 'How to Read Sex', *Nine to Five*, 8 March 1982, pp. 4–5.

89 N. Saunders, quoted in R. Ashton, 'The Truth of Man about the House', *Campaign*, 15 June 1990, p. 39. Saunders was the author of Grey's report *About Men*, 1990.

90 S. Sherrard, quoted in 'The Eighties' New Man Goes Grey', *Campaign*, 16 March 1990, p. 35.

91 Saunders, quoted in Ashton, 'The Truth of Man about the House'.

92 Ogilvy, *Confessions*, pp. 15–16.

93 For details of Grey's report see Ashton, 'The Truth of Man about the House'.

94 S. Silvester, *Man or Caveman? Bad News for the Women of the Caring, Sharing*

Nineties: The Other Half of Society Isn't Playing, London, Burkitt Weinreich Bryant Clients & Co. Ltd, undated (1991–2?), p. 5. The latter part of the 1980s witnessed a spate of campaigns projecting excessively masculinist imagery, especially for lager beers, which seemed to signal a partial return to the type of advertising called for by Silvester and his colleagues. For discussion of these campaigns see, among very many: A. Watson, 'Selling Bud to the Pepsi Generation', *Business*, May 1986, pp. 106–11; J. Daley, 'Advertising Men Carry the Can When Lager Louts Follow the Beer', *The Sunday Times*, 30 October 1988, H5.

95 T. O'Dwyer, 'Style Counsel '85 … New Blood', *Men's Wear*, 20 December 1984, p. 17. See also: 'Public Image', *Men's Wear*, 5 July 1984, p. 16; 'The Leaders of the Pack', *Men's Wear*, 19 July 1984, pp. 18–19. For more academic analyses of the changes in men's fashion in the 1980s see: N. Spencer, 'Menswear in the 1980s', in J. Ash and E. Wilson (eds), *Chic Thrills: A Fashion Reader*, London, Pandora, 1992, pp. 40–8; C. Breward, *The Culture of Fashion*, Manchester, Manchester University Press, 1995; C. Evans and M. Thornton, *Women and Fashion: A New Look*, London, Quartet, 1989, pp. 50–74.

96 B. Polan, 'Making Off with the Girls' Clothes', *The Guardian*, 27 September 1984, p. 23.

97 B. Morris, 'Going Baroque', *Men's Wear*, 15 November 1986, p. 13.

98 The volume of menswear sales rose appreciably in the first half of 1984, encouraging predictions of further growth. See: Opinion, *Men's Wear*, 12 July 1984, p. 4; 'Clothing Closes the RPI Gap', *Men's Wear*, 2 August 1984, p. 7.

99 In addition to the opening of Next for Men, a number of the major menswear retailers underwent refits in 1984. In August Littlewood's was given a face-lift, involving revamped stores, upgraded merchandise and the introduction of branded lines. The following month saw similar plans from the John Collier group, while over the Christmas period Foster's Menswear announced its own lifestyle concept. See: D. Ramage, 'Littlewood's – the New Men's Wear Challenger in the Battling 80's', *Men's Wear*, 2 August 1984, p. 18; 'New Chain Planned by Collier Group', *Men's Wear*, 13 September 1984, p. 1; 'Foster's Launches "Lifestyle" Store', *Men's Wear*, 29 November 1984, p. 1.

100 'J. Hepworth', *The Times*, 2 May 1984, p. 16. For a personal history of Next see G. Davies with J. Davies, *What Next?* London, Century Hutchinson, 1987. Also C. Gardner and J. Sheppard, *Consuming Passion: The Rise of Retail Culture*, London, Unwin Hyman, 1989, pp. 28–31.

101 Davies, *What Next?* p. 47.

102 See: *The Sunday Times*, 10 January 1988, quoted in McCarthy Information Ltd, *Next Plc*, Warminster, McCarthy Information Ltd, 4 July 1987 to 24 March 1988; N. Britton, 'Next on the List', *Marketing*, 27 August 1987, pp. 23–5.

103 G. Davies, quoted in D. Churchill, 'The Next Collection of Developments', *Financial Times*, 21 August 1986, p. 9.

104 G. Davies, quoted in J. Modlinger, 'What's Next Mister?' *Daily Express*, 22 August 1984, pp. 18–19.

105 Davies, *What Next?* p. 74.

106 For details of Next's innovations in production and merchandising see: Davies, *What Next?* pp. 19, 55–6, 74; Next plc, *Report and Accounts 1988*, Enderby, Next Design Group, 1988, p. 21.

107 See R. Preston, 'Cashing in on Today's Woman', *Investors Chronicle*, 9 November 1984, pp. 14–15. For similar statements associating Next with the yuppie phenomenon see: I. Williams, 'Next Please, a Shopping Revolution', *The Sunday Times*, 6 July 1986, p. 63; A. Rawsthorn, 'Catering for the Next Generation of Yuppies', *Financial Times*, 14 September 1987, p. 7.

108 A. Rawsthorn, 'Fashion Trend Suits Menswear Industry', *Financial Times*, 24 August 1987, p. 5.

109 P. Smith, quoted in Rawsthorn, 'Fashion Trend Suits Menswear Industry'. Suits sales by volume had declined over a ten-year period to 1984, but in the later 1980s there was a marked recovery. Research by the International Wool Secretariat suggested that a new generation of younger consumers were inclined to buy more expensive and stylish suits than their predecessors.

110 Next/Pure New Wool Advertisement, 'The Future in Fabric', *GQ*, August–September 1989, pp. 56–7. For accompanying articles see: P. Keers, 'A Gentleman's Wardrobe', pp. 59–61; 'International Business Style', pp. 127–37.

111 See 'Hepworth Man's Next Venture', *Financial Weekly*, 10 August 1984, p. 2.

112 See A. Brew, 'Hepworth's Hunt for the Elusive Male', *Financial Times*, 10 August 1984, p. 8. Also Davies, *What Next?* p. 122.

113 See Davies, *What Next?* pp. 95, 122. Also S. Nixon, 'Have You Got the Look? Masculinities and Shopping Spectacle', in Shields, *Lifestyle Shopping: The Subject of Consumption*, pp. 157–9.

114 *Retail*, Autumn 1984, quoted in McCarthy Information Ltd, *Next Plc*, 16 February 1982 to 6 April 1986.

115 Modlinger, 'What's Next Mister?'

116 See *The Standard*, 30 May 1984, quoted in McCarthy Information Ltd, *Next Plc*, 16 February 1982 to 6 April 1986.

117 See: M. Waiters, 'What Is Next in Store for the Hepworth Man?' *Daily Mail*, 28 July 1984, p. 24; Brew, 'Hepworth's Hunt'.

118 For analysis of Next's difficulties in the late 1980s see: Gardner and Sheppard, *Consuming Passion*, pp. 28–31; M. Urry, 'Profits Growth Slows at Next', *Financial Times*, 28 September 1988, p. 27; D. Brewerton, 'Next's Eroding Margins Leave Credibility Gap', *The Times*, 28 September 1988, p. 27. For a more personal view see: Davies, *What Next?* Davies was forced to resign from the company in December 1988.

119 Davies, quoted in A. Litham, 'Next – It's Saturday Night Fervour', *Daily Express*, 17 April 1986, p. 41.

120 Ibid.

121 Davies, *What Next?* p. 47.

122 Next plc, *Report and Accounts*, 1989.

123 Modlinger, 'What's Next Mister?' See also Brew, 'Hepworth's Hunt'.

124 *Market Place*, Autumn 1985, quoted in McCarthy Information Ltd, *Next Plc*, 16 February 1982 to 6 April 1986.

125 *Retail*, Autumn 1984, quoted in McCarthy Information Ltd, *Next Plc*, 16 February 1982 to 6 April 1986.

126 Hobson, 'The Agency Viewpoint 2', p. 433.

127 For general accounts of the expansion of British advertising in the post-war period see: B. Elliott, *A History of English Advertising*, London, Business Publications Ltd, 1962; J. Tunstall, *The Advertising Man in London Advertising Agencies*, London, Chapman & Hall, 1964; J. Pearson and G. Turner, *The Persuasion Industry*, London, Eyre & Spottiswoode, 1965; T. Nevett, *Advertising in Britain: A History*, London, Heinemann, 1982. For the specific effects of austerity see H. Henry, 'Some Observations on the Effects of Newsprint Rationing (1935–1959) on the Advertising Media', *Journal of Advertising History*, December 1977, no. 1, pp. 18–22. Despite post-war expansion, advertising expenditure calculated as a proportion of national income did not reach the pre-war figure of 2 per cent until 1958. See Tunstall, *The Advertising Man*, p. 267.

128 Pearson and Turner, *The Persuasion Industry*, p. 9.

129 For analysis of the impact of American companies on British agency culture in the 1940s and 1950s see: West, 'Multinational Competition in the British Advertising Agency Business, 1936–1987', and 'From T-Square to T-Plan: The London Office of the J. Walter Thompson Advertising Agency, 1919–1970', *Business History*, 1987, no. 29, pp. 199–217. In 1960 there were twelve American-based agencies in London, controlling some 30 per cent of aggregate billings. In the post-war years, acquisition was the major form of the process of Americanisation. US agencies purchased thirty-two British agencies between 1957 and 1967. However, during these years top British firms began to amass the types of knowledge and skill previously accruing only to the Americans. Contemporary commentators also noted the reluctance of many British agencies to adopt American-style advertising philosophies, on account of their inappropriateness for British audiences. See: Hobson, 'The Agency Viewpoint 2', p. 432; Pearson and Turner, *The Persuasion Industry*, p. 134.

130 Pearson and Turner, *The Persuasion Industry*, p. 197.

131 Tunstall, *The Advertising Man*, p. 20.

132 Ibid., pp. 58–9. For a more substantial account of the professional shifts within agency culture during the period I am grateful to Tony Bagnall Smith for allowing me access to his unpublished history of Dorland's Advertising.

133 The most substantial attacks were launched on the type of American-based motivational research pioneered by Ernest Dichter. See for example: V. Packard, *The Hidden Persuaders*, London, Longmans, Green & Co., 1957;

J. Galbraith, *The Affluent Society*, Boston, Houghton Mifflin Co., 1958; B. Friedan, *The Feminine Mystique*, London, Victor Gollancz, 1963.

134 Pearson and Turner, *The Persuasion Industry*, p. 134.

135 Hobson, *The Selection of Advertising Media*, 4th edition, London Business Publications Ltd, 1961, p. 32.

136 Ibid., p. 18.

137 Ogilvy, *Confessions*, pp. 126, 134.

138 For details of the National Benzole campaign see Pearson and Turner, *The Persuasion Industry*, p. 42.

139 Ibid., p. 79.

140 Ibid., p. 149.

141 J. May, quoted in ibid., p. 163.

142 For debates about the impact of affluence in the 1950s and 1960s see: M. Abrams, *The Teenage Consumer*, London, London Press Exchange, 1959; P. Willmott and M. Young, *Family and Class in a London Suburb*, London, Institute of Community Studies, 1960; J. Goldthorpe, F. Bechhofer, D. Lockwood, J. Platt, *The Affluent Worker: Industrial Attitudes and Behaviour*, Cambridge, Cambridge University Press, 1968, *The Affluent Worker: Political Attitudes and Behaviour*, Cambridge, Cambridge University Press, 1968, and *The Affluent Worker in the Class Structure*, Cambridge, Cambridge University Press, 1969; V. Bogdanor and R. Skidelsky (eds), *The Age of Affluence, 1951–64*, London, Macmillan, 1970.

143 Hobson, *The Selection*, p. 21. The similarities between Hobson's definition and Raymond Williams' analysis of class-based cultures as 'ways of life', in *Culture and Society*, 1958, are striking.

144 Market Research Society, *Social Class Definition in Market Research*, 1963, quoted in Tunstall, *The Advertising Man*, pp. 139–40.

145 For classic avant-gardist accounts see: N. Cohn, 'Today There Are No Gentlemen', in *Ball the Wall: Nik Cohn in the Age of Rock*, London, Picador, 1989, pp. 261–4, 270–5; D. Hebdige, *Subculture: The Meaning of Style*, London, Methuen, 1979.

146 A Correspondent, 'Men's Clothiers in Merger Deals', *The Times Review of Industry*, new series, December 1954, vol. 8, no. 95, p. 65. For analysis of this moment of change see F. Mort and P. Thompson, 'Retailing, Commercial Culture and Masculinity in 1950s Britain: The Case of Montague Burton, the "Tailor of Taste"', *History Workshop*, Autumn 1994, no. 38, pp. 106–27.

147 Editorial, *Men's Wear*, 13 February 1954, p. 24.

148 For the publicity work of the Wholesale Clothing Manufacturers' Federation see Modern Records Centre, University of Warwick, MSS. 222/CM/1/6. I am grateful to Peter Thompson for this information.

149 In the later 1950s the figure remained at just under 3 per cent of total consumers' expenditure, in spite of the increase in real wages. See Central Statistical Office, *National Income and Expenditure 1958*, London, HMSO, 1958, pp. 24–5. For analysis of the clothing industry's prospects in the light

of these figures see M. Abrams, 'More Money, Less Clothes?' *Financial Times*, 1 October 1955, p. 4.

150 For examples of this move towards fashionable innovation see, among very many: 'Fashion Comes to the Market', *Financial Times*, 20 May 1960, p. 10; 'Peacock Revolution', *Daily Mail*, 4 September 1965, p. 11.

151 'Special letter of invitation', in file marked 'Opening of new premises', 1953, Burton's Archives, Box 122, West Yorkshire Archive Service, Leeds. The account of the Devizes opening is taken from the 'Editorial to be used in connection with the opening of the new branch' in this file.

152 See: *Wiltshire News*, 10 September 1953; *Wiltshire Gazette*, 11 September 1953.

153 R. Gosling, 'Gosling on the High Street', Radio 4, 10 July 1992. For more negative views of men's fashion and masculinity in the 1950s see Cohn, *Ball the Wall*, pp. 258–9.

154 For Burton's position in the menswear market see: The Monopolies Commission, *United Draperies Stores Ltd and Montague Burton: A Report on the Proposed Merger*, Cmnd. 3397, London, HMSO, 1967; K. Honeyman, 'Montague Burton Ltd: The Creators of Well-Dressed Men', in K. Honeyman and J. Chartres (eds), *Leeds City Business 1893–1993: Essays Marking the Centenary of the Incorporation*, Leeds, privately printed, 1993, pp. 186–217.

155 Economist Intelligence Unit, 'Men's Suits', *Retail Business*, December 1961, 4, 46, p. 26.

156 For Sir Montague Burton's entrepreneurial philosophy see his *Globe Girdling: Being the Impressions of an Amateur Observer*, vol. 1, Leeds, Petty & Son, 1935. Also 'Burton, Sir Montague Maurice', in D. Jeremy (ed.), *Dictionary of Business Biography*, vol. 1, London, Butterworths, 1984, pp. 526–31.

157 For contemporary debates about the class specificities of Burton's market see 'Ten Provincial Shares for 1956', *Stock Exchange Gazette*, 30 December 1955, p. 101.

158 R. Hattersley, 'Gone for a Burton', *The Independent*, 8 April 1994, p. 19.

159 Liz Marsden, cashier at Burton's St-Anne's-on-Sea branch during the period, testified to the way in which she existed in a kind of purdah. Enclosed in a wooden booth, she was unable to look out into the shop at all. See Gosling, 'Gosling on the High Street'.

160 For contemporary views of the female shopper as irrational and susceptible to manipulation see Galbraith, *The Affluent Society*.

161 See Montague Burton, *Manager's Guide*, January 1953, p. 55, in Burton's Archives, Box 5.

162 Ibid., p. 64.

163 Quoted in E. Sigsworth, *Montague Burton: The Tailor of Taste*, Manchester, Manchester University Press, 1990, p. 51.

164 Among many biographical sketches of Jacobson see 'Top Tailor', *The North East Industrialist*, August 1962.

165 L. Jacobson, quoted in H. Thompson, '"Revolutionary" behind the Ever-

Open Door', *The Sunday Sun* (Newcastle), 29 May 1960, p. 4.

166 This had clearly worried Jacobson to the extent of demanding complete control of company policy in these areas before accepting Burton's takeover of Jackson's. See file marked 'Jackson's merger', Burton's Archives, Box 135.

167 See Chairman's Statement, Montague Burton Ltd, *Annual Report*, 1956, p. 12, Burton's Archives, Box 185.

168 See Chairman's Statement, Montague Burton Ltd, *Annual Report*, 1955, p. 12, Burton's Archives, Box 185.

169 See Chairman's Statement, Montague Burton Ltd, *Annual Report*, 1954, p. 12, Burton's Archives, Box 185.

170 *Display*, April 1954, in Newscuttings, 1953–5, Burton's Archives, Box 183/2, p. 38.

171 See 'Address by Mr L. Jacobson to National Display Convention, 21 and 22. 9. 1954', in file marked 'Jackson's', Burton's Archives, Box 124. For details of Burton's display centre see 'Limiting Space – to Create a More Intimate Atmosphere', *Style for Men Weekly*, 2 April 1964, p. 14.

172 Burton's advertising budget increased sixfold between 1952 and 1955, from 7 to 25 per cent of the total press advertising expenditure of all men's tailors. See *The Statistical Review of Press Advertising*, 1952, vol. xx; 1955, vol. xxiii.

173 For information on W.S. Crawford I refer to T. Bagnall Smith's unpublished history of Dorland's Advertising.

174 *The Outfitter*, 3 April 1954, in Newscuttings, 1953–4, Burton's Archives, Box 183/2, p. 38. For comment on Burton's new approach to advertising see: 'Crawford's Now Handle Burton's', *Advertiser's Weekly*, 11 February 1954, p. 310; 'Advertising Accounts', *World's Press News*, 12 February 1954, p. 30; 'Ad Clinic: A Slip in Emphasis', *World's Press News*, 4 June 1954, pp. 18–19.

175 For details of Burton's first television commercials see *Commercial Television News*, 7 October 1955, in Newscuttings, 1955–6, Burton's Archives, Box 183/3, p. 66.

176 For Burton's address to youth see L. Rosen, 'The Tailor of "Taste"', paper delivered to Leeds Jewish Historical Society, undated, p. 5, Burton's Archives, Box 204.

177 S. Jacobson, quoted in 'Clothes Advertising Campaigns Are Educating Public', *Men's Wear*, 16 October 1954, p. 17. See also 'Talking Points', *Advertiser's Weekly*, 28 October 1954, p. 226.

178 See for example L. Segal, *Slow Motion: Changing Masculinities, Changing Men*, London, Virago, 1990, pp. 20–1.

179 L. Jacobson, quoted in Factfinder, 'Montague Burton Suits Me', *Stock Exchange Gazette*, 8 March 1957, p. 753.

180 'Lighter and Brighter Clothes for Men', *Financial Times*, 24 May 1960, p. 9.

181 'TV Clothes Circuit', *The Outfitter*, 22 December 1956, p. 8.

182 See 'Photography in Advertising', *Advertiser's Weekly*, 1 June 1956, in Newscuttings, 1955–6, Burton's Archives, Box 183/3, p. 158.

183 For details of these campaigns see *The Outfitter*, 3 April 1954.

184 For discussion of this theme see 'Tailor-Made for Burton', *World's Press News*, 23 February 1962, p. 26.

185 See *Aberdeen Press and Journal*, 23 May 1959. Also *Style for Men*, March 1958.

PART THREE Topographies of Taste: Place, Space and Identity in 1980s London

1 See G. Stedman Jones and D. Feldman, 'Introduction', in G. Stedman Jones and D. Feldman (eds), *Metropolis London: Histories and Representations since 1800*, London, Routledge, 1989, p. 1. See also R. Porter, *London: A Social History*, London, Hamish Hamilton, 1994, pp. 364–84.

2 Department of the Environment, *Strategic Guidance for London*, 1989, quoted in M. Edwards, K. MacDonald, P. Newman, A. Thornley, 'A Vision for London', in A. Thornley (ed.), *The Crisis of London*, London, Routledge, 1992, p. 196.

3 For accounts of this 'other' London see: Greater London Council, *Draft Greater London Development Plan*, London, GLC, 1985; P. Hall, *London 2001*, London, Unwin Hyman, 1989; Cambridge Economics/NIERC, *Employment Forecasts*, Cambridge, Cambridge Econometrics, 1990; The Henley Centre for Forecasting, *London 2000: Report Produced for the Association of Local Authorities by The Henley Centre*, London, The Henley Centre for Forecasting, 1990; Thornley (ed.), *The Crisis of London*. For more optimistic forecasts see: Confederation of British Industry, *A London Development Agency: Optimizing the Capital's Assets*, London, CBI, 1991; Coopers and Lybrand Deloitte, *London World City: Stage II Report*, London, Coopers & Lybrand Deloitte, 1991.

4 See for example: L. White, 'Talent', *The Face*, May 1985, no. 61, pp. 28–44; M. Ackerman, 'Spell it G-a-u-l-t-i-e-r Le Style Anglais', 'Face Fashion Extra', *The Face*, April 1986, no. 72, no page.

5 For analysis of the growing geographical centrality of London for world advertising in the 1980s see D. West, 'Multinational Competition in the British Advertising Agency Business, 1936–1987', *Business History Review*, Autumn 1988, no. 62, pp. 467–501.

6 For analysis of the differential registers of space and place see: D. Harvey, *The Condition of Postmodernity: An Enquiry into the Origins of Cultural Change*, Oxford, Basil Blackwell, 1989, and 'Between Space and Time: Reflections on the Geographic Imagination', *Annals, Association of American Geographers*, 1990, no. 80, pp. 418–34; M. de Certeau, *The Practice of Everyday Life*, trans. S. Rendall, Berkeley, University of California Press, 1988; H. Lefebvre, *The Production of Space*, trans. D. Nicholson-Smith, Oxford, Basil Blackwell, 1991.

7 D. Harvey, *The Urban Experience*, Oxford, Basil Blackwell, 1989.

8 For guides and histories of Soho see: Clergy of St Anne's, *Two Centuries of*

Soho: Its Institutions, Firms and Amusements, London, Truslove & Hanson, 1898; Rev. J. Cardwell *et al.*, *Men and Women of Soho Famous and Infamous*, London, Truslove & Hanson, 1904; E. Chancellor, *The Romance of Soho: Being an Account of Its Past Distinguished Inhabitants, Its Historic Houses, and Its Place in the Social Annals of London*, London, Country Life, 1931; S. Jackson, *An Indiscreet Guide to Soho*, London, Muse Arts, 1946; M. Goldsmith, *Soho Square*, London, Sampson Low, 1947; S. Dewes, *Soho*, London, Rich & Cowan, 1952; F. Sheppard (general editor), *Survey of London: The Parish of Saint James, Westminster*, vols xxxi–xxxii, London, Athlone Press, 1963 and *The Parish of St. Anne, Soho*, vols xxxiii–xxxiv, London, Athlone Press, 1966; J. Norman and J. Bernard, *Soho Night and Day*, London, Secker & Warburg, 1966; I. McCalman, *Radical Underworld*, Oxford, Oxford University Press, 1988; R. Thames, *Soho Past*, London, Historical Publications, 1994.

9 M. Edmonds, *Inside Soho*, London, Robert Nicolson, 1988, p. 6.

10 A. Ransome, *Bohemia in London*, London, Chapman Hall, 1907, pp. 10–11.

11 Ibid., p. 7.

12 Ibid., p. 112. Ransome was describing an evening at Roches restaurant in Old Compton Street.

13 Ibid., p. 3.

14 J. Galsworthy, quoted in Edmonds, *Inside Soho*, p. 9.

15 For discussion of Soho's avant-garde cultures see J. Summers, *Soho: A History of London's Most Colourful Neighbourhood*, London, Bloomsbury, 1989.

16 For details of homosexual culture in the area around Leicester Square see J. Gardiner, *A Class Apart: The Private Pictures of Montague Glover*, London, Serpent's Tail, 1992, pp. 17–19.

17 J. Bernard, quoted in D. Farson, *Soho in the Fifties*, London, Michael Joseph, 1987, p. 83. See also Taki and J. Bernard, *High Life, Low Life*, London, Unwin, 1982, p. 15.

18 See G. Melly in his introduction to Farson, *Soho in the Fifties*, p. xiii.

19 The comment was made by MacInnes' contemporary, Henrietta Law. See Farson, *Soho*, pp. 48–9. For MacInnes' fictional depiction of the area see *Absolute Beginners*, London, MacGibbon & Kee, 1959.

20 E. Salvoni, with S. Fawkes, *Elena: A Life in Soho*, London, Quartet, 1990, pp. 100, 117.

21 For details of the history of prostitution in the area see: Jackson, *An Indiscreet Guide to Soho*; M. Tomkinson, *The Pornbrokers: The Rise and Fall of the Soho Sex Barons*, London, Virgin, 1982.

22 M. Belcher, quoted in Summers, *Soho: A History*, p. 192. For other accounts of Belcher see: Farson, *Soho in the Fifties*, pp. 40–7; Taki and Bernard, *High Life*, p. 72.

23 For details of Hamnett see D. Hooker, *Nina Hamnett: Queen of Bohemia*, London, Constable, 1986. See also Hamnett's own autobiographies: *Laughing Torso: Reminiscences etc.*, London, Constable & Co., 1932 and *Is She a*

Lady? A Problem in Autobiography, London, Allan Wingate, 1955.

24 MacInnes, *Absolute Beginners*, p. 65. For an account of Soho's music culture in the immediate post-war period see J. Platt, *London's Rock Routes*, London, Fourth Estate, 1985, pp. 2–37.

25 N. Cohn, *Ball the Wall: Nik Cohn in the Age of Rock*, London, Picador, 1989, p. 281. For further details of the growth of Carnaby Street see Platt, *London's Rock Routes*, pp. 131–2.

26 Cohn, *Ball the Wall*, p. 286.

27 For the growth of male homosexual culture in Soho and its environs in the 1960s see: P. Burton, *Parallel Lives*, London, Gay Men's Press, 1985, pp. 14–45; D. Jarman, *At Your Own Risk: A Saint's Testament*, London, Hutchinson, 1992, pp. 47–9.

28 de Certeau, *The Practice of Everyday Life*, p. 96. A similar point is made by Harvey in *The Condition of Postmodernity*, p. 48.

29 '300 Year-Old Soho in Danger of Extinction', *Westminster and Marylebone Chronicle*, 14 September 1973, p. 1. For similar warnings about Soho's future see: 'Must Soho Die?' *Soho Clarion*, December 1973, no. 1, p. 1; R. Insall, 'Sex Shops Drive Out the Soho "Villagers"', *Evening News*, 17 December 1975, p. 8.

30 For details of the shifts in sexual commerce in the 1960s see Tomkinson, *The Pornbrokers*. Also Salvoni, *Elena*, pp. 141, 156.

31 Councillor Young, reply to Councillor Peltz, City of Westminster, Council Meeting, 28 October 1987, in City of Westminster, *Minutes and Proceedings of the Lord Mayor and Councillors with Index*, 1987, p. 318. For changing council attitudes to sexual commerce in Soho see City of Westminster, *Report (No. 2) of General Purposes Committee*, 16 November 1982, in *Minutes and Proceedings*, 1982, pp. 401–5. Subsequent controls were introduced under Section 12 of the Greater London Council (General Powers) Act, 1986, c.iv, to act against Soho premises which had evaded the 1982 legislation, such as peep shows, male revues and nude encounter premises. See City of Westminster, *Report (No. 2) of Environment Committee*, 3 April 1986, in *Minutes and Proceedings*, 1986, p. 83. For press coverage see: 'Clean Up or Else, Porn Kings Told', *Holborn and City Guardian*, 7 November 1980, p. 3; 'Tory War on Soho Porn', *The Daily Telegraph*, 30 December 1980, p. 11; M. Berlins, 'Taking Sex out of Soho', *The Times*, 11 June 1986, p. 14.

32 Berlins, 'Taking Sex out of Soho'.

33 For local aspirations on Soho's future see the views of the Soho Society in the *Soho Clarion* throughout the early 1980s. Also D. Laurie, Letters, *The Times*, 28 August 1984, p. 11. Laurie was editor of the *Soho Clarion*.

34 J. Wyman, 'Soho: Goodbye Sleaze, Hello Respectability', *The Daily Telegraph*, 16 June 1986, p. 19.

35 A. Thorncroft, 'How People Power Saved Sleazy Soho', *Financial Times, Weekend FT*, 1 August 1987, p. 1.

36 M. Noble, 'Square Mile of Style', *Midweek*, 20 February 1992, p. 10.

37 P. Hartley, quoted in Berlins, 'Taking Sex out of Soho'.

38 D. Weeks, quoted in L. Bredin, 'The Council's Plans', in 'Save Our Soho', *The Evening Standard Magazine*, January 1989, p. 12, in Papers of the Parish of St Anne, Soho, City of Westminster Archive Centre, London.

39 See 'Cut-Price Soho Lures from Convent Garden', *The Daily Telegraph*, 10 November 1987. For details of aggressive property developments and impending rises in rents see: J. Glancey, 'Property Focus: After the Sin – the Price Rise', *London Daily News*, 27 March 1987, p. 35; J. Westwell, 'Imperial Carves Soho Empire', *The Sunday Times*, 25 October 1987, p. 85.

40 By 1988 the following independent film companies were based in Soho: Comic Strip, Goldcrest, Limelight and Palace Pictures. See M. Edmonds and M. Jaffé, 'Meals on Reels', *The Observer Magazine*, 8 May 1988, p. 42; A. Morris, 'The Growth of a New Cottage Industry on the Streets of Soho', *The Independent*, 20 January 1988, p. 15.

41 For details of the advertising agencies in Soho and their leading position within the industry see B. McAlhone, 'Top 30 Award Winners', *Campaign*, 24 June 1988, pp. 47–8.

42 See I. Fallon, *The Brothers: The Rise and Rise of Saatchi and Saatchi*, London, Hutchinson, 1988, p. 91.

43 See J. Glancey, 'Rooms at the Top', *Campaign*, 2 December 1988, p. 52; also Glancey's profile of the design consultants Fitch and Co. in the same article.

44 See: Edmonds, 'The Tycoon Paul Raymond' in 'Save Our Soho', p. 13; T. Barlass, 'Raymond's Rent Review', *The Evening Standard*, 15 May 1990, p. 15. Raymond owned around sixty individual freeholds in the Soho area, including L'Escargot restaurant and the buildings which housed Ronnie Scott's club in Frith Street.

45 For details of Alastair Little see Edmonds, *Inside Soho*, p. 46.

46 Ibid., p. 54.

47 Ibid., p. 97.

48 Ibid., p. 91.

49 See Harvey's comments on what he terms these 'pot-pourri' forms of internationalism in *The Condition of Postmodernity*, p. 87.

50 A. Mackintosh, quoted in Farson, *Soho in the Fifties*, p. 171. For details of The Groucho Club see: *The Face*, December 1985, no. 68, p. 17; Edmonds, *Inside Soho*, p. 200.

51 J. Burchill, *Sex and Sensibility*, London, Grafton, 1992, p. 94.

52 See R. Bailey, 'Grooving in the Aisles', *The Sunday Times*, 6 April 1986, p. 44. For other coverage of the Limelight see: Observer, 'A New Ace of Clubs', *Financial Times*, 8 July 1985, p. 20; P. Weatherhead, 'Limelight', *Building*, 8 August 1986, p. 27.

53 Taki and Bernard, *High Life*, p. 16.

54 D. Farson, 'Soho Revisited', *The London Evening Standard*, 9 November 1987, p. 30. See also George Melly in his introduction to Farson, *Soho in the Fifties*, p. xv.

55 L. Glynne, quoted in D. Lawson, 'Soho without the Sleaze', *The Weekend*

Guardian, 25–26 February 1989, p. 27.

56 C. New, quoted in A. Dannatt, 'Soho What?' *The Sunday Times*, 14 June 1987, p. 45.

57 F. Taylor, 'The Clubowner', in 'Save Our Soho', *The Evening Standard Magazine*, p. 12. See also 'News', *The Architect's Journal*, 9 December 1987, p. 11.

58 For imaginary participation in the culture of the city via literary tourism see, among others: J. Urry, *The Tourist Gaze: Leisure and Travel in Contemporary Societies*, London, Sage, 1990. In the specific context of nineteenth- and early twentieth-century Paris see N. Green, *The Spectacle of Nature: Landscape and Bourgeois Culture in Nineteenth-Century France*, Manchester, Manchester University Press, 1990, pp. 54–61; A. Rifkin, *Street Noises: Parisian Pleasure, 1900–40*, Manchester, Manchester University Press, 1993, pp. 88–136.

59 The following account is taken from A. Saxton, 'Poofters on Parade Make Business Boom', *Capital Gay*, 19 February 1993, p. 4. For other comments on the carnival see 'A Grave Mistake', Letters, *Capital Gay*, 26 February 1993.

60 For debates over queer politics and theory see: A. Sinfield, 'What Is in a Name?' *Gay Times*, May 1992, p. 25; M. Phillips, 'Politics of the New Queer', *The Guardian*, 23 June 1992, p. 19; P. Tatchell, 'Do Us a Favour – Call Us Queer', *The Independent on Sunday*, 26 July 1992, p. 22; P. Parmar and I. Julien, 'Queer Questions', *Sight and Sound*, September 1992, p. 35; C. Smyth, *Lesbians Talk Queer Notions*, London, Scarlet Press, 1992; F. Mort, 'Essentialism Revisited? Identity Politics and Late Twentieth-Century Discourses of Homosexuality', in J. Weeks (ed.), *The Lesser Evil and the Greater Good: The Theory and Politics of Social Diversity*, London, Rivers Oram Press, 1994, pp. 201–21. For related perspectives see: E. Kosofsky Sedgwick, *The Epistemology of the Closet*, Berkeley, University of California Press, 1990; J. Dollimore, *Sexual Dissidence: Augustine to Wilde, Freud to Foucault*, Oxford, Oxford University Press, 1992; A. Sinfield, *The Wilde Century: Effeminacy, Oscar Wilde and the Queer Moment*, London, Cassell, 1994.

61 'Champagne Opening for Soho Shop', *Capital Gay*, 20 November 1992, p. 1.

62 For details of market research on the gay economy in London see: M. Simpson, 'Purchasing Power of the Pink Pound Makes Gays an Attractive Market', *The Guardian*, 21 November 1992, p. 37; 'Village Soho: Cruising with Spy', *Capital Gay*, 15 December 1993, p. 9.

63 P. Hegarty, 'I Consume, Therefore I Am Queer', *Rouge*, no. 11, 1992, p. 12. See also Smyth, *Lesbians Talk Queer Notions*, p. 34.

64 See K. Alcorn, 'Communities of the Night', *Capital Gay*, 18 September 1992, p. 14. Also his 'Niches for All', *Capital Gay*, 18 December 1992, and 'Ghetto Heaven', *Capital Gay*, 12 February 1993, p. 14.

65 Alcorn, 'Communities of the Night'.

66 J. Alcock, in Hall Carpenter Archives and Gay Men's Oral History Group, *Walking After Midnight: Gay Men's Life Stories*, London, Routledge, 1989, p. 44.

67 J. D'Emilio, *Sexual Politics, Sexual Communities: The Making of a Homosexual Minority in the United States, 1940–70*, Chicago, University of Chicago Press, 1983. See also: A. Bérubé, *Coming Out Under Fire: The History of Gay Men and Women in World War Two*, New York, Free Press, 1990; G. Chauncey, *Gay New York: Gender, Urban Culture and the Making of the Gay Male World 1890–1940*, New York, Basic Books, 1994. In a British context see J. Weeks, *Coming Out: Homosexual Politics in Britain from the Nineteenth Century to the Present*, London, Quartet, 1977, pp. 207–30.

68 See for example the many testimonies in Hall Carpenter Archives, *Walking after Midnight*, especially those of Philip Barker and Bernard Dobson. Also Jarman, *At Your Own Risk*, pp. 47–9; Burton, *Parallel Lives*, pp. 14–45.

69 For the spatial movement of the gay scene westwards in the later 1960s see: Burton, *Parallel Lives*, p. 46; Jarman, *At Your Own Risk*, pp. 47–9.

70 See Burton, *Parallel Lives*, p. 46.

71 For recollections of the Gigolo see: Jarman, *At Your Own Risk*, p. 47. See also the testimony of Todd Butler in Hall Carpenter Archives, *Walking After Midnight*, p. 88.

72 For details of these early forms of gay consumerism see Burton, *Parallel Lives*, pp. 48–9.

73 For details of Bang see ibid., pp. 48–50.

74 D. Inches, quoted in Burton, *Parallel Lives*, p. 48.

75 First Out Co-operative, 'Business Plan', unpublished, 1985, p. 4. I am grateful to Bruce Wood for giving me access to this document. See also 'Coffee and Cakes Courtesy of Persil', *Capital Gay*, 27 June 1986, p. 12.

76 'Soho's Pulling Power', *Capital Gay*, 3 October 1986, p. 9.

77 'First Glimpse of Madame Jo Jo's', *Capital Gay*, 12 September 1986, pp. 9–10, and 'Soho's Pulling Power'.

78 'Soho Pub's Spring Clean-Up', *Capital Gay*, 30 May 1986, p. 13.

79 *Capital Gay*, 26 April 1986, p. 8.

80 First Out, 'Business Plan', p. 4.

81 'Coach Cruises', *Capital Gay*, 2 May 1986, p. 4.

82 Speech of B. Sedgemoor, *Parliamentary Debates (Hansard)*, House of Commons, 6th series, session 1987–8, vol. 130, cols 84–5.

83 See A. Hilton, 'The Cloth Cap Professionals Are Taking Over in the City', *The London Standard*, 20 October 1986, p. 21. Also: D. McCrystal, 'All Greek to Me', *The London Standard*, 28 October 1986, p. 44; A. McGill, 'How to Sell a Chap a Desk – Kick Him in the Ear!' *The London Standard*, 16 July 1986, p. 25.

84 See 'Changes in the Structure of the Financial Markets: A View from London', *Bank of England Quarterly Bulletin*, March 1985, vol. 25, no. 1, p. 77. See also S. Whimster, 'Yuppies: A Keyword of the 1980s', in L. Budd and S. Whimster (eds), *Global Finance and Urban Living: A Study of Metropolitan Change*, London, Routledge, 1992, pp. 312–32.

85 See J. Hughes-Onslow, 'A Place to Write That Masterpiece', *The London Standard*, 8 July 1986, p. 5.

86 P. Neild, quoted in Hilton, 'The Cloth Cap Professionals'.

87 M. Ridley, 'I Made a Mi££ion at 22, Thanks to Maggie', *The Sun*, 20 June 1988, p. 9. For other examples of the same genre see: N. Wallis and M. Ridley, 'We're Blacks Who Made It Big', *The Sun*, 16 May 1988, pp. 14–15; 'Buying a Home Is Child's Play', *The Sun*, 12 March 1988, p. 21; 'How Maggie Made My Dreams Come True', *The Sun*, 3 May 1989, p. 9.

88 'Face Values for 1988', *Campaign*, 15 January 1988, p. 40. For similar profiles see 'Top 18 from the under Thirty Club', *Campaign*, 22 July 1988, p. 46.

89 'Face Values for 1988', p. 41.

90 N. Bogle, quoted in K. McMillan, 'Twenty Faces to Watch in 1987's Next Generation of High Fliers', *Campaign*, 30 January 1987, p. 29.

91 See for example: Insider, *Campaign*, 15 January 1988, p. 33; 'Cover-up for the Naughty Knickers', *Campaign*, 5 February 1988, p. 32.

92 Salvoni, *Elena*, p. 9. For Salvoni's tolerant comments on this bad behaviour see p. 117.

93 Advertisement for Personality Plus, Career Moves Recruitment Consultants, *Nine to Five*, 5 October 1987. For similar adverts see Radcliffe Accountancy, 'Bookeeper Film Studio!' *Nine to Five*, 28 September 1987, p. 75.

94 S. Paradise, 'Tipsy Hangers and Floggers', *Nine to Five*, 21 September 1987, p. 15. See also: 'On the Town', *Nine to Five*, 28 September 1987, p. 26; 'It's Party Time with Nine to Five', *Nine to Five*, 14 September 1987; J. Delingpole, 'A Dreadful Night Out at the Hippodrome', *The Illustrated London News*, July 1988, p. 20.

95 'Sex Is Everything. So Say All of Us!' *Nine to Five*, 21 September 1987, p. 20.

96 W. Fletcher, *Meetings, Meetings: How to Manipulate Them and Make Them More Fun*, London, Michael Joseph, 1983, p. 45. See also Fletcher's view of human nature as portrayed in his novel *The Manipulators*, London, Macmillan, 1988.

97 'Professional Discourtesies', *Campaign*, 5 February 1988, p. 39.

98 Z. Zawada, quoted in 'Zed Refuses to Bend the Knee', *Campaign*, 8 July 1988, p. 30.

99 See: Insider, *Campaign*, 23 September 1988, p. 61; Insider, *Campaign*, 8 July 1988, p. 33.

100 Fletcher, *The Manipulators*, p. 55.

101 For accounts of the emergence of forms of gay male identity see: M. McIntosh, 'The Homosexual Role', *Social Problems*, 1968, vol. 16, no. 2, pp. 182–92; Weeks, *Coming Out*; K. Plummer (ed.), *The Making of the Modern Homosexual*, London, Hutchinson, 1981; D'Emilio, *Sexual Politics*.

102 For an early study of this form of sexual coding see H. Fischer, *Gay Semiotics: A Photographic Study of Visual Coding among Homosexual Men*, San Francisco, NFS Press, 1977.

103 See 'Mark Ashton: Five Friends Remember', in Hall Carpenter Archives, *Walking After Midnight*, pp. 206–8.

104 'BPM Sanctuary', *City Limits*, 11–18 December 1986, p. 52. For similar entries see: 'Two Perverts Balls in One Heaven' and 'Propaganda',

City Limits, 5–12 March 1987, p. 55.

105 'Roadblock, Stallions', *City Limits*, 13–20 November 1986, p. 52.

106 See 'Jungle', *City Limits*, 13–20 November 1986, p. 56. The account is also based on notes taken by the author, 10 February 1987.

107 'Go Global', Astoria Theatre, Charing Cross Road, 20 February 1987, flyer in the author's collection.

108 For details of Georgiou see C. Rose, *Design after Dark: The Story of Dancefloor Style*, London, Thames & Hudson, 1991, p. 97.

109 For analysis of these forms of cultural crossover between Afro-Caribbean and white youth see: D. Hebdige, *Cut 'n' Mix: Culture, Identity and Caribbean Music*, London, Comedia, 1987, chapter 17; S. Jones, *Black Culture, White Youth: The Reggae Tradition from JA to UK*, Basingstoke, Macmillan, 1988.

110 S. Jerviere, quoted in Rose, *Design after Dark*, p. 50.

111 See Burton, *Parallel Lives*, p. 51. For analysis of the role of music within gay male culture since the 1970s and especially of disco and HiNRG see: S. Frith, *Sound Effects: Youth, Leisure and the Politics of Rock*, revised edition, London, Constable, 1983; J. Savage, 'Tainted Love: The Influence of Male Homosexuality and Sexual Divergence on Pop Music and Culture since the War', in A. Tomlinson (ed.), *Consumption, Identity and Style: Marketing, Meanings and the Packaging of Pleasure*, London, Comedia, 1990, pp. 153–71.

112 'Review of 1986', *The Face*, January 1987, no. 81, p. 68. Also 'Bombers Away', *The Face*, June 1986, no. 74, p. 33.

113 The take-up of safer-sex practices was also accompanied by a contradictory movement, a rise in unsafe sex among younger gay men, especially in central London. After a drop in the number of reported cases of sexually transmitted diseases in the late 1980s, government monitoring of infection rates at the Communicable Diseases Surveillance Centre noted a rise in cases of gonorrhoea from 1990 among men, as a result of same-sex contact. See: Department of Health, *On the State of the Public Health: The Annual Report of the Chief Medical Officer of the Department of Health for the Year 1990*, London, HMSO, 1991, pp. 121–8, and *On the State of the Public Health ...for 1991*, London, HMSO, 1992, pp. 83–97.

114 'Men's Personal', *Capital Gay*, 27 March 1987, p. 18.

115 Ibid., 18 December 1987, p. 41.

116 *Vada Magascene* drew on the homosexual slang, polari (varda: to look at).

117 T. O'Dwyer, 'Jocks in Frocks', *Vada Magascene*, 1990, no. 2, p. 14.

118 See First Out, 'Business Plan', pp. 4–5.

119 Edmonds, *Inside Soho*, p. 207.

120 'Cash, Wag Club', *City Limits*, 5–12 March 1987, p. 56.

121 Letters, *The Face*, July 1985, no. 63, p. 74. For similar comments see Letters, *The Face*, June 1986, no. 74, p. 96.

122 Editorial, *Boy's Own*, undated, no page.

123 Ibid., p. 2.

124 de Certeau, *The Practice of Everyday Life*, p. xii.

125 Dexter Wong and De Mob, fashionable clothes shops in the Soho area at that time.

126 For extended as opposed to restricted accounts of consumption processes see: de Certeau, *The Practice of Everyday Life*; S. Willis, *A Primer for Daily Life*, London, Routledge, 1991; R. Cowan, 'The Consumption Junction: A Proposal for Research Studies in the Sociology of Technology', in W. Bijker, T. Hughes, T. Pinch (eds), *The Social Construction of Technological Systems*, Cambridge, MA, MIT Press, 1992, pp. 261–80; P. Glennie and N. Thrift, 'Modern Consumption: Theorising Commodities and Consumers', *Society and Space*, 1993, vol. 11, pp. 603–6.

127 For discussion of the concept of nomadic subjectivity in relation to ethnographic studies see: J. Radway, 'Reception Study: Ethnography and the Problems of Dispersed Audiences and Nomadic Subjects', and L. Grossberg, 'Wandering Audiences, Nomadic Critics', *Cultural Studies*, October 1988, vol. 2, no. 3, pp. 359–91; M. Morris, 'At Henry Parkes Motel', *Cultural Studies*, January 1988, vol. 2, no. 1, pp. 1–16, 29–47. For related debates about autobiography see: L. Marcus, ' "Enough about You, Let's Talk about Me": Recent Autobiographical Writing', *New Formations*, Spring 1987, no. 1, pp. 77–94; C. Steedman, *Childhood, Culture and Class in Britain: Margaret McMillan, 1860–1931*, London, Virago, 1990, part 3.

128 See for example A. McRobbie, 'The Politics of Feminist Research: Between Talk, Text and Action', *Feminist Review*, 1982, no. 12, pp. 46–57. For attempts to think through the ethnographic dialogue from a post-structuralist perspective on subjectivity see: J. Clifford and G. Marcus (eds), *Writing Culture: The Poetics and Politics of Ethnography*, Berkeley, University of California Press, 1986; P. Smith, *Discovering the Subject*, Minneapolis, University of Minnesota Press, 1988.

129 P. Willis, 'Notes on Method', in S. Hall, D. Hobson, A. Lowe, P. Willis (eds), *Culture, Media, Language: Working Papers in Cultural Studies, 1972–9*, London, Hutchinson, 1980, p. 93. See also McRobbie, 'The Politics of Feminist Research', p. 54.

Conclusion

1 J. Tylee, 'Maurice's Silence and Saatchi Ego Stoke Speculation', *Campaign*, 20 January 1995, p. 14.

2 See: M. Marckus, 'Saatchi Anger at "Takeover"', *The Times*, 4 January 1995, p. 1; 'Maurice Saatchi Severs Links with Agency', *The Times*, 3 January 1995, p. 32. Also: 'Adman Overcome by Creative Tensions', *Financial Times*, 4 January 1995, p. 1; T. May and R. Smithers, 'Furore as Saatchi "the Suit" Exits', *The Guardian*, 4 January 1995, p. 13.

3 D. Herro, quoted in L. Buckingham, 'Saatchi to Sue over Poaching Clients', *The Guardian*, 12 January 1995, p. 14. For details of Herro see 'Pass Notes David Herro', *The Guardian*, 12 January 1995, G2, p. 3.

4 M. Saatchi, quoted in V. Grove, '"Why Aren't You Wearing Lipstick?"' *The Times*, 6 January 1995, p. 15.

5 At one level this perceived clash of ideologies was peculiar, since Maurice Saatchi had always been the financial and business figure in the Saatchi partnership, while Charles had been the advertising theorist. Yet in the battle between Maurice Saatchi and Herro, it was Maurice who assumed the creative persona.

6 C. Powell, quoted in G. Kemp, 'Has the Saatchi Wrangle Damaged the Industry?' *Campaign*, 27 January 1995, p. 13.

7 J. Hegarty, quoted in M. Hood, 'Industry Reels at Saatchi's Ousting', *Campaign*, 23 December 1994, p. 2. See also the comment of Mike Walsh, chairman of Ogilvy and Mather, in the same article.

8 P. Newman, Letters, *Campaign*, 6 January 1995, p. 10. See also D. Mills and S. Hatfield, 'What Difference Does It Make If Maurice Leaves?' *Campaign*, 23 December 1995, p. 7.

9 Saatchi, quoted in Grove, '"Why Aren't You Wearing Lipstick?"' The exact quotation from L.P. Hartley's novel, *The Go-Between*, 1953, runs: 'The past is a foreign country: they do things differently there.'

10 P. Highland, quoted in Kemp, 'Has the Saatchi Wrangle Damaged the Industry?'

11 See for example The Henley Centre for Forecasting, *UK Economic Forecasts*, London, The Henley Centre for Forecasting, January 1995, p. 3.

12 *The Face*, December 1989, no. 15.

13 Henley, *Planning Consumer Markets*, Analysis Volume, London, The Henley Centre for Forecasting, January 1991, p. 2. For other commercial commentaries about the end of the 1980s see C. Gardner and J. Sheppard, *Consuming Passion: The Rise of Retail Culture*, London, Unwin Hyman, 1989, pp. 208–44.

14 S. Lansley, *After the Gold Rush: The Trouble with Affluence: 'Consumer Capitalism' and the Way Forward*, London, Century, 1994.

15 See for example: J. Galbraith, *The Affluent Society*, Boston, Houghton Mifflin Co., 1958, and *The Culture of Contentment*, London, Sinclair-Stevenson, 1992; H. Marcuse, *Eros and Civilization: A Philosophical Inquiry into Freud*, London, Routledge & Kegan Paul, 1956, and *One-Dimensional Man: Studies in the Ideology of Advanced Industrial Societies*, London, Routledge & Kegan Paul, 1964; F. Hirsch, *The Social Limits to Growth*, London, Routledge & Kegan Paul, 1977.

16 W. Hutton, *The State We're In*, London, Jonathan Cape, 1995. For related arguments see: P. Hirst, *After Thatcher*, London, Collins, 1989, and *Associative Democracy: New Forms of Economic and Social Governance*, Cambridge, Polity Press, 1994.

17 A. Giddens, *Modernity and Self-Identity: Self and Society in the Late Modern Age*, Cambridge, Polity Press, 1991, p. 32, and *The Transformation of Intimacy: Sexuality, Love and Eroticism in Modern Societies*, Cambridge, Polity Press, 1992.

SELECT BIBLIOGRAPHY

I Unpublished manuscripts and collections

Bartle Bogle Hegarty, Annual Reports, Papers and Accounts, Companies House, London.

Burton's Archives, West Yorkshire Archive Service, Leeds.

First Out Co-operative, London, 'Business Plan', 1985.

The History of Advertising Trust, Norfolk, papers relating to Dorland's Advertising.

Papers of the Parish of St Anne, Soho, City of Westminster Archive Centre, London.

Papers of the Wholesale Clothing Manufacturers' Federation, Modern Records Centre, University of Warwick.

II Unpublished works

Bagnall Smith, T., 'History of Dorland's Advertising', 1993.

Cook, D., 'From Pillar to "Post"', MA thesis submitted to the Royal College of Art, London, May 1993.

Nixon, S., 'Hard Looks: Masculinities, the Visual and Practices of Consumption in the 1980s', dissertation for the Ph.D. degree, The Open University, 1994.

Paggi, L., 'The Shaping of Post-Bourgeois Politics in Europe, 1945–68', paper delivered to the Conference on 'Paths to Mass Consumption', Columbia University, New York, May 1994.

III Official publications

Central Statistical Office, *National Income and Expenditure 1958*, London, HMSO, 1958.

Department of Health, *On the State of The Public Health: The Annual Report of the Chief Medical Officer of the Department of Health*, 1989–93, London, HMSO.

Martin, J. and Roberts, C., *Women and Employment: The Report of the 1980 DE/OPES Women and Employment Survey, a Lifetime Perspective*, London, HMSO, 1984.

The Monopolies Commission, *United Draperies Stores Ltd and Montague Burton: A Report on the Proposed Merger*, Cmnd. 3397, London, HMSO, 1967.

IV Rules, reports and proceedings

Baxter, M., *Women in Advertising: Findings and Recommendations of a Study Commissioned by the Institute of Practitioners in Advertising*, London, Institute of Practitioners in Advertising, 1990.

Cambridge Economics/NIERC, *Employment Forecasts*, Cambridge, Cambridge Econometrics, 1990.

City of Westminster, *Report (No. 2) of General Purposes Committee*, 16 November 1982, in *Minutes and Proceedings of the Lord Mayor and Councillors with Index*, 1982, pp. 401–5.

——*Report (No. 2) of Environment Committee*, 3 April 1986, in *Minutes and Proceedings of the Lord Mayor and Councillors with Index*, 1986, p. 83.

——*Minutes and Proceedings of the Lord Mayor and Councillors with Index*, 1987.

Confederation of British Industry, *A London Development Agency: Optimizing the Capital's Assets*, London, CBI, 1991.

Coopers and Lybrand Deloitte, *London World City: Stage II Report*, London, Coopers & Lybrand Deloitte, 1991.

Euromonitor, *Young Britain: Stage II Report*, London, Euromonitor, 1989.

Greater London Council, *Draft Greater London Development Plan*, London, GLC, 1985.

Hamilton, R., Halworth, B., Sardar, N., *Adman and Eve: An Empirical Study of the Relative Marketing Effectiveness of Traditional and Modern Portrayals of Women in Certain Mass-Media Advertisements, Carried out in June–October 1981 for the Equal Opportunities Commission by the Marketing Consultancy and Research Services of the University of Lancaster*, Manchester, Equal Opportunities Commission, April 1982.

The Henley Centre for Forecasting, *Leisure Futures*, 1985–94, London, The Henley Centre for Forecasting.

——*Planning Consumer Markets*, 1986-94, London, The Henley Centre for Forecasting.

——*Planning for Social Change*, vol. 1, London, The Henley Centre for Forecasting, 1986.

——*UK Economic Forecasts*, 1990–5, London, The Henley Centre for Forecasting.

——*London 2000: Report Produced for the Association of Local Authorities by The Henley Centre*, London, The Henley Centre for Forecasting, 1990.

Information Group Services, *Teenagers: An In-depth Study of Consumer Attitudes and Behaviour*, London, Information Group Services, October 1992.

Institute of Practitioners in Advertising, *Women in Advertisements: A Selection of IPA Marketing Appraisals and Bibliography*, London, Institute of Practitioners in Advertising, 1981.

McCarthy Information Ltd, *Next Plc* [microfiche holdings], Warminster, McCarthy Information Ltd, 1982–90.

Marketing Direction Ltd, *Youth Facts '88*, London, Marketing Direction, 1988.

Mintel, *Youth Lifestyles: Mintel Special Report*, London, Mintel, 1988.

Montague Burton Ltd, *Annual Reports*, 1945–65.

Next plc, *Report and Accounts*, 1987–89, Enderby, Next Design Group.

Parliamentary Debates (Hansard).

Pitcher, A., 'Advertising and Equality of the Sexes', in Council of Europe, *Proceedings of the Seminar on the Contribution of the Media to the Promotion of Equality between Women and Men*, Strasbourg, Council of Europe, 1984, pp. 118–24.

Saatchi and Saatchi Company plc, *Annual Reports*, 1985–8, London, Saatchi & Saatchi.

Salmon, B., Dale, T. and Partners, *Psychographics and Lifestyles*, London, Institute of Practitioners in Advertising, 1989.

Silvester, S., *Man or Caveman? Bad News for the Women of the Caring, Sharing Nineties: The Other Half of Society Isn't Playing*, London, Burkitt Weinreich Bryant Clients & Co. Ltd, undated (1991–2?).

The Statistical Review of Press Advertising, 1952, 1955.

The Times Review of Industry, 1954.

V Newspapers, periodicals and dictionaries

Aberdeen Press and Journal
Advertiser's Weekly
The Architect's Journal
Arena
Bank of England Quarterly Bulletin
Blitz
Boy's Own
Building
Business
Campaign
Capital Gay
City Limits
Commercial Televison News
Daily Express
Daily Mail
The Daily Telegraph
Dictionary of Business Biography
Direction

Display
Evening News
The Face
Financial Times
Financial Weekly
Gay Times
GQ
The Guardian
Holborn and City Guardian
I-D
The Illustrated London News
The Independent
Investors Chronicle
London Daily News
Marketing
Media Week
Men's Wear
Midweek
New Statesman, New Statesman and Society
Nine to Five
The North East Industrialist
The Observer
The Observer Magazine
The Outfitter
The Oxford Dictionary of Modern Slang
Retail Business
Rouge
She
Soho Clarion
The Standard, The Evening Standard, The London Standard
Stock Exchange Gazette
Style for Men
Style for Men Weekly
The Sun
The Sunday Sun (Newcastle)
The Sunday Times
The Sunday Times Magazine
Time Out
The Times
The Times Higher Education Supplement
The Times Literary Supplement
Vada Magascene
Webster's Third New International Dictionary
Westminster and Marylebone Chronicle
What's New in Marketing

Wiltshire Gazette
Wiltshire News
World's Press News

VI Published books and articles

Abercrombie, N. and Urry, J., *Capital, Labour and the Midddle Classes*, London, Allen & Unwin, 1983.

Abrams, M., *The Teenage Consumer*, London, London Press Exchange, 1959.

Appignanesi, L. (ed.), *Postmodernism: ICA Documents 4 and 5*, London, Institute of Contemporary Arts, 1986.

Ashwin, C., *A Century of Art Education 1882–1982*, London, Middlesex Polytechnic, 1982.

Barr, A. and York, P., *The Official Sloane Ranger Handbook: The First Guide to What Really Matters in Life*, London, Ebury, 1982.

Barthes, R., *The Fashion System*, trans. M. Ward and R. Howard, London, Jonathan Cape, 1985.

Baudrillard, J., *Le miroir de la production; ou l'illusion critique du matérialisme historique*, 2nd edition, Tournai, Castermann, 1977.

———*A l'ombre des majorités silencieuses, ou la fin du social; suivi de, l'extase du socialism*, Paris, Denoël, 1982.

———*Seduction*, trans. B. Singer, Basingstoke, Macmillan, 1990.

Bauman, Z., 'Industrialism, Consumerism and Power', *Theory Culture and Society*, 1983, vol. 1, no. 3, pp. 32–43.

———*Legislators and Interpreters: On Modernity, Post-modernity and Intellectuals*, Cambridge, Polity Press, 1987.

———*Intimations of Postmodernity*, London, Routledge, 1992.

Bell, D., *The Coming of Post-Industrial Society: A Venture in Social Forecasting*, Harmondsworth, Penguin, 1976.

———*The Cultural Contradictions of Capitalism*, London, Heinemann, 1976.

Bell, T., 'The Agency Viewpoint 3', in B. Henry (ed.), *British Television Advertising: The First 30 Years*, London, Century Benham, 1986, pp. 435–53.

Bennett, T. and Woollacott, J., *Bond and Beyond: The Political Career of a Popular Hero*, Basingstoke, Macmillan, 1987.

Berg, M., *The Age of Manufactures: Industry, Innovation and Work in Britain, 1700–1820*, London, Fontana, 1985.

Bérubé, A., *Coming Out Under Fire: The History of Gay Men and Women in World War Two*, New York, Free Press, 1990.

Bogdanor, V. and Skidelsky, R. (eds), *The Age of Affluence, 1951–64*, London, Macmillan, 1970.

Boltanski, L., *The Making of a Class: Cadres in French Society*, trans. A. Goldhammer, Cambridge, Cambridge University Press, 1987.

Bourdieu, P., *Distinction: A Social Critique of the Judgement of Taste*, trans. R. Nice, London, Routledge & Kegan Paul, 1984.

————*Homo Academicus*, trans. P. Collier, Cambridge, Polity Press, in association with Basil Blackwell, 1988.

Breward, C., *The Culture of Fashion*, Manchester, Manchester University Press, 1995.

Brewer, J. and Porter, R. (eds), *Consumption and the World of Goods*, London, Routledge, 1993.

Bristow, J., *Empire Boys: Adventures in a Man's World*, London, Unwin Hyman, 1991.

Brod, H. (ed.), *The Making of Masculinities: The New Men's Studies*, London, Allen & Unwin, 1987.

Burchill, J., *Love It or Shove It: The Best of Julie Burchill*, London, Century, 1985.

————*Damaged Goods: Cults and Heroes Reappraised*, London, Century, 1986.

————*Ambition*, London, Bodley Head, 1989.

————*Sex and Sensibility*, London, Grafton, 1992.

Burchill, J. and Parsons, T., *'The Boy Looked at Johnny': The Obituary of Rock and Roll*, London, Pluto, 1978.

Burger, P., *Theory of the Avant-Garde*, trans. M. Shaw, Manchester, Manchester University Press, 1984.

Burton, Sir M., *Globe Girdling: Being the Impressions of an Amateur Observer*, 2 vols, Leeds, Petty & Son, 1935, 1937.

Burton, P., *Parallel Lives*, London, Gay Men's Press, 1985.

Butler, J., *Gender Trouble: Feminism and the Subversion of Identity*, New York, Routledge, 1990.

Butler, J. and Scott, J. (eds), *Feminists Theorize the Political*, London, Routledge, 1992.

Cannadine, D., 'The Present and the Past in the English Industrial Revolution 1880–1980', *Past and Present*, 1984, no. 103, pp. 131–72.

Cardwell, Rev. J. et al., *Men and Women of Soho Famous and Infamous*, London, Truslove & Hanson, 1904.

Carter, E., 'Alice in the Consumer Wonderland', in A. McRobbie and M. Nava (eds), *Gender and Generation*, London, Macmillan, 1984, pp. 185–214.

Carter, R., Day, B., Meggs, P., *Typographic Designs: Form and Communication*, Wokingham, New York, Van Nostrand Reinhold, 1985.

Chancellor, E., *The Romance of Soho: Being an Account of Its Past Distinguished Inhabitants, Its Historic Houses, and Its Place in the Social Annals of London*, London, Country Life, 1931.

Chapman, N., *Careers in Fashion*, 3rd edition, London, Kogan Page, 1994.

Chapman, R., 'The Great Pretender: Variations on the New Man Theme', in R. Chapman and J. Rutherford (eds), *Male Order: Unwrapping Masculinity*, London, Lawrence & Wishart, 1988, pp. 225–48.

Chauncey, G., *Gay New York: Gender, Urban Culture and the Making of the Gay Male World 1890–1940*, New York, Basic Books, 1994.

Clarke, N., 'Strenuous Idleness: Thomas Carlyle and the Man of Letters as Hero', in M. Roper and J. Tosh (eds), *Manful Assertions: Masculinities in Britain since 1800*, London, Routledge, 1992, pp. 25–43.

Clergy of St Anne's, *Two Centuries of Soho: Its Institutions, Firms and Amusements*, London, Truslove & Hanson, 1898.

Clifford, J. and Marcus, G. (eds), *Writing Culture: The Poetics and Politics of Ethnography*, Berkeley, University of California Press, 1986.

Cocteau, J., 'Le Livre Blanc: Notes on Homosexuality', in J. Cocteau, *Professional Secrets: An Autobiography of Jean Cocteau; Drawn from his Lifetime Writings by Robert Phelps*, trans. R. Howard, New York, Farrar, Straus & Giroux, 1970.

Cohn, N., *Ball the Wall: Nik Cohn in the Age of Rock*, London, Picador, 1989.

Cooper, E., *The Sexual Perspective: Homosexuality and Art in the Last 100 Years in the West*, London, Routledge & Kegan Paul, 1986.

Cowan, R., 'The Consumption Junction: A Proposal for Research Studies in the Sociology of Technology', in W. Bijker, T. Hughes, T. Pinch (eds), *The Social Construction of Technological Systems*, Cambridge, MA, MIT Press, 1992, pp. 261–80.

Coward, R., *Female Desire*, London, Paladin, 1984.

Crow, T., 'Modernism and Mass Culture in the Visual Arts', in F. Frascina (ed.), *Pollock and After: The Critical Debate*, New York, Harper & Row, 1985, pp. 233–66.

Davies, G. with Davies, J., *What Next?* London, Century Hutchinson, 1987.

Dawson, G., *Soldier Heroes: British Adventure, Empire, and the Imagining of Masculinities*, London, Routledge, 1994.

de Certeau, M., *The Practice of Everyday Life*, trans. S. Rendall, Berkeley, University of California Press, 1988.

de Grazia, V., *The Culture of Consent: Mass Organisation of Leisure in Fascist Italy*, Cambridge, Cambridge University Press, 1981.

——*How Fascism Ruled Women: Italy, 1922–1945*, Berkeley, University of California Press, 1992.

D'Emilio, J., *Sexual Politics, Sexual Communities: The Making of a Homosexual Minority in the United States, 1940–70*, Chicago, University of Chicago Press, 1983.

Design Museum, *Study Notes Styling*, London, Design Museum, 1989.

Dewes, S., *Soho*, London, Rich & Cowan, 1952.

Dollimore, J., *Sexual Dissidence: Augustine to Wilde, Freud to Foucault*, Oxford, Oxford University Press, 1992.

Douglas, M. and Isherwood, B., *The World of Goods: Towards an Anthropology of Consumption*, London, Allen Lane, 1979.

Dyer, R., *Now You See It: Studies on Lesbian and Gay Film*, London, Routledge, 1990.

Edgar, D., 'Never Too Old: Learning from the Sixties', *New Socialist*, May 1986, no. 38, pp. 16–20.

Edmonds, M., *Inside Soho*, London, Robert Nicolson, 1988.

Edwards, M., MacDonald, K., Newman, P., Thornley, A., 'A Vision for London', in A. Thornley (ed.), *The Crisis of London*, London, Routledge, 1992, pp. 185–201.

Ehrenreich, B., *The Hearts of Men: American Dreams and the Flight from*

Commitment, New York, Anchor-Doubleday, 1983.

Elgart, A., *Arthur Elgart's Models Manual*, New York, Grand Street Press, 1993.

Ellenzweig, A., *The Homoerotic Photograph: Male Images from Durieu/Delacroix to Mapplethorpe*, New York, Columbia University Press, 1992.

Elliott, B., *A History of English Advertising*, London, Business Publications Ltd, 1962.

Elms, R., 'Ditching the Drabbies: A Style for Socialists', *New Socialist*, May 1986, no. 38, pp. 12–14.

——*In Search of the Crack*, Harmondsworth, Penguin, 1989.

——*Spain: A Portrait After the General*, London, Heinemann, 1992.

Evans, C. and Gamman, L., 'The Gaze Revisited, or Reviewing Queer Viewing', in P. Burston and C. Richardson (eds), *A Queer Romance: Lesbians, Gay Men and Popular Culture*, London, Routledge, 1995, pp. 13–56.

Evans, C. and Thornton, M., *Women and Fashion: A New Look*, London, Quartet, 1989.

Fallon, I., *The Brothers: The Rise and Rise of Saatchi and Saatchi*, London, Hutchinson, 1988.

Farson, D., *Soho in the Fifties*, London, Michael Joseph, 1987.

Featherstone, M., *Consumer Culture and Postmodernism*, London, Sage, 1991.

Fine, B., 'Modernity, Urbanism and Modern Consumption', *Society and Space*, 1993, vol. 11, pp. 599–601.

Fine, B. and Leopold, E., 'Consumerism and the Industrial Revolution', *Social History*, May 1990, vol. 15, no. 2, pp. 151–79.

——*The World of Consumption*, London, Routledge, 1993.

Fischer, H., *Gay Semiotics: A Photographic Study of Visual Coding among Homosexual Men*, San Francisco, NFS Press, 1977.

Fisher, S. and Holder, S., *Too Much Too Young?* London, Pan, 1981.

Fiske, J., *Understanding Popular Culture*, London, Unwin Hyman, 1989.

Fitzgerald, F., *Cities on a Hill: A Journey through Contemporary American Cultures*, New York, Simon & Schuster, 1986.

Fletcher, W., *Meetings, Meetings: How to Manipulate Them and Make Them More Fun*, London, Michael Joseph, 1983.

——*The Manipulators*, London, Macmillan, 1988.

——*Creative People: How to Manage Them and Maximize Their Creativity*, London, Hutchinson, 1990.

Fogerty, M., Ashton, I., Walters, P., *Women in Top Jobs 1968–1979*, London, Heinemann, 1981.

Forrester, M., *Everything You Always Suspected Was True about Advertising: But Were Too Legal, Decent and Honest to Ask*, Glasgow, Fontana, 1987.

Foster, H. (ed.), *Postmodern Culture*, London, Pluto, 1985.

Foucault, M., *The History of Sexuality*, vol. 1: *An Introduction*, trans. R. Hurley, New York, Pantheon Books, 1979.

Friedan, B., *The Feminine Mystique*, London, Victor Gollancz, 1963.

Frith, S., *Sound Effects: Youth, Leisure and the Politics of Rock*, revised edition, London, Constable, 1983.

Frith, S. and Horne, H., *Art into Pop*, London, Methuen, 1987.

Galbraith, J., *The Affluent Society*, Boston, Houghton Mifflin Co., 1958.

――*The Culture of Contentment*, London, Sinclair-Stevenson, 1992.

Gardiner, J., *A Class Apart: The Private Pictures of Montague Glover*, London, Serpent's Tail, 1992.

Gardner, C. and Sheppard, J., *Consuming Passion: The Rise of Retail Culture*, London, Unwin Hyman, 1989.

Giddens, A., *Modernity and Self-Identity: Self and Society in the Late Modern Age*, Cambridge, Polity Press, 1991.

――*The Transformation of Intimacy: Sexuality, Love and Eroticism in Modern Societies*, Cambridge, Polity Press, 1992.

Glennie, P. and Thrift, N., 'Modernity, Urbanism and Modern Consumption', *Society and Space*, 1992, vol. 10, pp. 423–43.

――'Modern Consumption: Theorising Commodities and Consumers', *Society and Space*, 1993, vol. 11, pp. 603–6.

Goldsmith, M., *Soho Square*, London, Sampson Low, 1947.

Goldthorpe, J., Bechhofer, F., Lockwood, D., Platt, J., *The Affluent Worker: Industrial Attitudes and Behaviour*, Cambridge, Cambridge University Press, 1968.

――*The Affluent Worker: Political Attitudes and Behaviour*, Cambridge, Cambridge University Press, 1968.

――*The Affluent Worker in the Class Structure*, Cambridge, Cambridge University Press, 1969.

Gorz, A., *Farewell to the Working Class: An Essay on Post-Industrial Socialism*, trans. M. Sonenscher, London, Pluto, 1982.

――*Paths to Paradise: On the Liberation from Work*, trans. M. Imrie, London, Pluto Press, 1985.

Green, N., *The Spectacle of Nature: Landscape and Bourgeois Culture in Nineteenth-Century France*, Manchester, Manchester University Press, 1990.

Grossberg, L., 'Wandering Audiences, Nomadic Critics', *Cultural Studies*, October 1988, vol. 2, no. 3, pp. 377–91.

Gruber, H., *Red Vienna: Experiments in Working-Class Culture, 1919–1934*, Oxford, Oxford University Press, 1991.

Hall, P., *London 2001*, London, Unwin Hyman, 1989.

Hall, S., *The Hard Road to Renewal: Thatcherism and the Crisis of the Left*, London, Verso, 1988.

Hall, S. and Jacques, M. (eds), *New Times: The Changing Face of Politics in the 1990s*, London, Lawrence & Wishart, 1989.

Hall, S. and Jefferson, T. (eds), *Resistance through Rituals: Youth Subcultures in Post-war Britain*, London, Hutchinson, 1976.

Hall Carpenter Archives and Gay Men's Oral History Group, *Walking After Midnight: Gay Men's Life Stories*, London, Routledge, 1989.

Hamnett, N., *Laughing Torso: Reminiscences etc.*, London, Constable & Co., 1932.

――*Is She a Lady? A Problem in Autobiography*, London, Allan Wingate, 1955.

Harrison, M., *Appearances: Fashion Photography since 1945*, London, Jonathan Cape, 1991.

Harvey, D., *The Limits to Capital*, Oxford, Basil Blackwell, 1982.

——*The Urbanization of Capital*, Oxford, Basil Blackwell, 1985.

——*The Condition of Postmodernity: An Enquiry into the Origins* *Change*, Oxford, Basil Blackwell, 1989.

——*The Urban Experience*, Oxford, Basil Blackwell, 1989.

——'Between Space and Time: Reflections on the Geographic Imagination', *Annals, Association of American Geographers*, 1990, no. 80, pp. 418–34.

Hearn, J. and Morgan, D., *Men, Masculinities and Social Theory*, London, Unwin Hyman, 1990.

Heath, A. and Evans, G., 'Working-Class Conservatives and Middle-Class Socialists', in R. Jowell, S. Witherspoon, L. Brook (eds), *British Social Attitudes: The 5th Report*, Aldershot, Gower, 1988, pp. 53–69.

Hebdige, D., *Subculture: The Meaning of Style*, London, Methuen, 1979.

——*Cut 'n' Mix: Culture, Identity and Caribbean Music*, London, Comedia, 1987.

——*Hiding in the Light: On Images and Things*, London, Comedia, 1988.

Heidegger, M., *On Time and Being*, trans. J. Stanbaugh, London, Harper & Row, 1977.

Helvin, M., *Catwalk: The Art of Model Style*, London, Pavilion, 1985.

Henry, H., 'Some Observations on the Effects of Newsprint Rationing (1935–1959) on the Advertising Media', *Journal of Advertising History*, December 1977, no. 1, pp. 18–22.

Hipkin, B., 'Designs for the Visual', *Marxism Today*, November 1985, vol. 29, no. 11, pp. 40–1.

Hirsch, F., *The Social Limits to Growth*, London, Routledge & Kegan Paul, 1977.

Hirst, P., *After Thatcher*, London, Collins, 1989.

——*Associative Democracy: New Forms of Economic and Social Governance*, Cambridge, Polity Press, 1994.

Hirst, P. and Zeitlin, J. (eds), *Reversing Industrial Decline? Industrial Structure and Policy in Britain and Her Competitors*, Oxford, Berg, 1989.

Hobson, J., *The Selection of Advertising Media*, 4th edition, London, Business Publications Ltd, 1961.

——'The Agency Viewpoint 2', in B. Henry (ed.), *British Television Advertising: The First 30 Years*, London, Century Benham, 1986, pp. 423–33.

Honeyman, K., 'Montague Burton Ltd: The Creators of Well-Dressed Men', in K. Honeyman and J. Chartres (eds), *Leeds City Business 1893–1993: Essays Marking the Centenary of the Incorporation*, Leeds, privately printed, 1993, pp. 186–217.

Hooker, D., *Nina Hamnett: Queen of Bohemia*, London, Constable, 1986.

Humphries, M. and Metcalf, A. (eds), *The Sexuality of Men*, London, Pluto Press, 1985.

Hutton, W., *The State We're In*, London, Jonathan Cape, 1995.

Jabenis, E., *The Fashion Director: What She Does and How to Be One*, London, John Wiley & Sons, 1972.

Jackson, P., 'Towards a Cultural Politics of Consumption', in J. Bird, B. Curtis, T. Putnam, G. Robertson, L. Tickner (eds), *Mapping the Futures: Local Cultures, Global Change*, London, Routledge, 1993, pp. 207–28.

Jackson, S., *An Indiscreet Guide to Soho*, London, Muse Arts, 1946.

Jameson, F., 'Postmodernism or the Cultural Logic of Late Capitalism', *New Left Review*, July–August 1984, no. 146, pp. 53–92.

Jardine, A. and Smith, P. (eds), *Men in Feminism*, London, Methuen, 1987.

Jarman, D., *Modern Nature: The Journals of Derek Jarman*, London, Century, 1991.

——At Your Own Risk: A Saint's Testament, London, Hutchinson, 1992.

Jencks, C., *The Language of Post-Modern Architecture*, London, Academy, 1977.

Jessop, B., Bonnett, K., Ling, T., Bromley, S., 'Authoritarian Populism, Two Nations, and Thatcherism', *New Left Review*, September–October 1984, no. 147, pp. 32–60.

Jones, D., *Haircuts: Fifty Years of Styles and Cults*, London, Thames & Hudson, 1990.

Jones, S., *Black Culture, White Youth: The Reggae Tradition from JA to UK*, Basingstoke, Macmillan, 1988.

Julien, I., 'Queer Questions', *Sight and Sound*, September 1992, p. 35.

Kakabase, A. and Margerison, C., 'The Female Chief Executive: An Analysis of Career Progress and Development Needs', *Journal of Managerial Psychology*, vol. 2, no. 2, 1987, pp. 17–25.

Kay, W., *Battle for the High Street*, revised edition, London, Corgi, 1989.

Kosofsky Sedgwick, E., *The Epistemology of the Closet*, Berkeley, University of California Press, 1990.

Krauss, R., *The Originality of the Avant-Garde and Other Modernist Myths*, Cambridge, MA, MIT Press, 1985.

Kuspit, D., *The Cult of the Avant-Garde*, Cambridge, Cambridge University Press, 1993.

Laing, D., *One Chord Wonders: Power and Meaning in Punk Rock*, Milton Keynes, Open University Press, 1985.

Lansley, S., *After the Gold Rush: The Trouble with Affluence: 'Consumer Capitalism' and the Way Forward*, London, Century, 1994.

Lash, S., *Sociology of Postmodernism*, London, Routledge, 1990.

Lash, S. and Urry, J., *The End of Organized Capitalism*, Cambridge, Polity Press, 1987.

Lawson, A., *Anatomy of Typeface*, London, Hamish Hamilton, 1990.

Lawson, N., *The View from No. 11: Memoirs of a Tory Radical*, London, Bantam Books, 1992.

Leadbeater, C., *The Politics of Prosperity*, Fabian Tract no. 523, London, Fabian Society, 1987.

Lefebvre, H., *The Production of Space*, trans. D. Nicholson-Smith, Oxford, Basil Blackwell, 1991.

Le Grand, J. and Estrin, S. (eds), *Market Socialism*, Oxford, Clarendon Press, 1989.

Leiss, W., 'The Icons of the Marketplace', *Theory Culture and Society*, 1983, vol. 1, no. 3, pp. 10–21.

Levitt, T., 'The Globalization of Markets', *Harvard Business Review*, May–June 1983, no. 3, pp. 92–102.

———*The Marketing Imagination*, 2nd edition, London, Collier MacMillan, 1986.

Lyotard, J.F., *The Postmodern Condition: A Report on Knowledge*, trans. G. Bennington and B. Massumi, Manchester, Manchester University Press, 1984.

———*Moralités postmodernes*, Paris, Galilée, 1993.

McCalman, I., *Radical Underworld*, Oxford, Oxford University Press, 1988.

McGuigan, J., *Cultural Populism*, London, Routledge, 1992.

MacInnes, C., *Absolute Beginners*, London, MacGibbon & Kee, 1959.

McIntosh, M., 'The Homosexual Role', *Social Problems*, 1968, vol. 16, no. 2, pp. 182–92.

McKendrick, N., 'Josiah Wedgwood: An Eighteenth Century Entrepreneur in Salesmanship and Marketing Techniques', *Economic History Review*, 1959–60, vol. 12, no. 3, pp. 408–33.

———'Josiah Wedgwood and Thomas Bentley: An Inventor–Entrepreneur Partnership in the Industrial Revolution', *Transactions of the Royal Historical Society*, 1964, vol. 14, pp. 1–33.

———'Home Demand and Economic Growth: A New View of the Role of Women and Children in the Industrial Revolution', in N. McKendrick (ed.), *Historical Perspectives: Studies in English Thought and Society in Honour of J.H. Plumb*, London, Europa, 1974, pp. 152–210.

McKendrick, N., Plumb, J., Brewer, J., *The Birth of a Consumer Society: The Commercialization of Eighteenth-Century England*, London, Europa, 1982.

McLean, R., *From Moxon to Morrison: The Growth of Typography as a Profession*, Cambridge, Cambridge University Press, 1983.

McLuhan, M., *The Medium is the Massage*, Harmondsworth, Penguin, 1967.

McRobbie, A., 'The Politics of Feminist Research: Between Talk, Text and Action', *Feminist Review*, 1982, no. 12, pp. 46–57.

———(ed.), *Zoot Suits and Second-Hand Dresses: An Anthology of Fashion and Music*, Basingstoke, Macmillan, 1989.

———*Feminism and Youth Culture: From 'Jackie' to 'Just Seventeen'*, Basingstoke, Macmillan, 1991.

Marcus, L., '"Enough about You, Let's Talk about Me": Recent Autobiographical Writing', *New Formations*, Spring 1987, no. 1, pp. 77–94.

Marcuse, H., *Eros and Civilization: A Philosophical Inquiry into Freud*, London, Routledge & Kegan Paul, 1956.

———*One-Dimensional Man: Studies in the Ideology of Advanced Industrial Societies*, London, Routledge & Kegan Paul, 1964.

Marshall, J., *Women Managers: Travellers in a Male World*, Chichester, John Wiley & Sons, 1984.

Massey, D., *Spatial Divisions of Labour: Social Structures and the Geography of Production*, Basingstoke, Macmillan, 1984.

Mauss, M., *The Gift: Forms and Functions of Exchange in Archaic Societies*, trans. I. Cunnison, London, Cohen & West, 1970.

Mercer, K., 'Imaging the Black Man's Sex', in P. Holland, J. Spence, S. Watney (eds), *Photography/Politics: Two*, London, Comedia, 1986, pp. 61–9.

————'Just Looking for Trouble: Robert Mapplethorpe and Fantasies of Race', in L. Segal and M. McIntosh (eds), *Sex Exposed: Sexuality and the Pornography Debate*, London, Virago, 1992, pp. 92–110.

Metcalf, A. and Humphries, M. (eds), *The Sexuality of Men*, London, Pluto Press, 1985.

Miller, D., *Material Culture and Mass Consumption*, Oxford, Basil Blackwell, 1987.

Modleski, T., *Loving with a Vengeance: Mass-Produced Fantasies for Women*, Hamden, CT, Archon Books, 1982.

Moore, S., 'Target Man', *New Socialist*, January 1987, no. 45, pp. 4–5.

Morgan, D., *Unmasking Masculinity: A Critical Autobiography*, London, Unwin Hyman, 1990.

Morley, D., *Family Television: Cultural Power and Domestic Leisure*, London, Comedia, 1986.

Morris, M., 'At Henry Parkes Motel', *Cultural Studies*, January 1988, vol. 2, no. 1, pp. 1–16, 29–47.

Mort, F., 'Images Change: High Street Style and the New Man', *New Socialist*, November 1986, no. 43, pp. 6–8.

————*Dangerous Sexualities: Medico-Moral Politics in England since 1830*, London, Routledge & Kegan Paul, 1987.

————'Boy's Own? Masculinity, Style and Popular Culture', in R. Chapman and J. Rutherford (eds), *Male Order: Unwrapping Masculinity*, London, Lawrence & Wishart, 1988, pp. 193–224.

————'The Politics of Consumption', in S. Hall and M. Jacques (eds), *New Times: The Changing Face of Politics in the 1990s*, London, Lawrence & Wishart, 1989, pp. 160–72.

————'Crisis Points: Masculinities in History and Social Theory', *Gender and History*, April 1994, vol. 6, no. 1, pp. 124–30.

————'Essentialism Revisited? Identity Politics and Late Twentieth-Century Discourses of Homosexuality', in J. Weeks (ed.), *The Lesser Evil and the Greater Good: The Theory and Politics of Social Diversity*, London, Rivers Oram Press, 1994, pp. 201–21.

Mort, F. and Thompson, P., 'Retailing, Commercial Culture and Masculinity in 1950s Britain: The Case of Montague Burton, the "Tailor of Taste"', *History Workshop*, Autumn 1994, no. 38, pp. 106–27.

Mulgan, G. and Worpole, K., *Saturday Night or Sunday Morning? From Arts to Industry, New Forms of Cultural Politics*, London, Comedia, 1986.

Murray, R., 'Benetton Britain: The New Economic Order', in S. Hall and M. Jacques (eds), *New Times: The Changing Face of Politics in the 1990s*, London, Lawrence & Wishart, 1989, pp. 38–53.

————'Fordism and Post-Fordism', in S. Hall and M. Jacques (eds), *New Times: The Changing Face of Politics in the 1990s*, London, Lawrence & Wishart, 1989, pp. 54–64.

Myers, K., *Understains: The Sense and Seduction of Advertising*, London, Comedia, 1986.

Nava, M., 'Consumerism and its Contradictions', *Cultural Studies*, May 1987, vol. 1, no. 2, pp. 204–10.

——'Consumerism Reconsidered: Buying and Power', *Cultural Studies*, May 1991, vol. 5, no. 2, pp. 157–73.

——*Changing Cultures: Feminism, Youth and Consumerism*, London, Sage, 1992.

Nevett, T., *Advertising in Britain: A History*, London, Heinemann, 1982.

Nixon, S., 'Have You Got the Look? Masculinities and Shopping Spectacle', in R. Shields, *Lifestyle Shopping: The Subject of Consumption*, London, Routledge, 1992, pp. 149–69.

——'Looking for the Holy Grail: Publishing and Advertising Strategies for Contemporary Men's Magazines', *Cultural Studies*, 1993, vol. 7, no. 3, pp. 467–92.

Norman, J. and Bernard, J., *Soho Night and Day*, London, Secker & Warburg, 1966.

Offe, C., *Disorganized Capitalism*, Cambridge, Polity Press, 1985.

Ogilvy, D., *Confessions of an Advertising Man: The All-Time Best Seller about Advertising*, revised edition, London, Pan, 1987.

Packard, V., *The Hidden Persuaders*, London, Longmans, Green & Co., 1957.

Paglia, C., *Sex, Art and American Culture: Essays*, London, Viking, 1993.

Parmar, P., 'Queer Questions', *Sight and Sound*, September 1992, p. 35.

Pearson, J. and Turner, G., *The Persuasion Industry*, London, Eyre & Spottiswoode, 1965.

Peiss, K., *Cheap Amusements: Working Women and Leisure in Turn-of-the-Century New York*, Philadelphia, Temple University Press, 1986.

Photographer's Gallery, *Out of Fashion: Photographs by Nick Knight and Cindy Palmano*, London, Photographer's Gallery, 1989.

Piore, M. and Sabel, C., *The Second Industrial Divide: Possibilities for Prosperity*, New York, Basic Books, 1984.

Plant, R., *Equality, Markets and the State*, Fabian Tract no. 494, London, Fabian Society, 1984.

Platt, J., *London's Rock Routes*, London, Fourth Estate, 1985.

Plummer, K. (ed.), *The Making of the Modern Homosexual*, London, Hutchinson, 1981.

Poggioli, R., *The Theory of the Avant-Garde*, trans. G. Fitzgerald, Cambridge, MA, Harvard University Press, 1968.

Porter, R., *London: A Social History*, London, Hamish Hamilton, 1994.

Poster, M. (ed.), *Selected Writings, Jean Baudrillard*, Cambridge, Polity Press, 1988.

Radway, J., *Reading the Romance: Women, Patriarchy and Popular Literature*, Chapel Hill, NC, University of North Carolina Press, 1984.

——'Reception Study: Ethnography and the Problems of Dispersed Audiences and Nomadic Subjects', *Cultural Studies*, October 1988, vol. 2, no. 3, pp. 359–76.

Ransome, A., *Bohemia in London*, London, Chapman Hall, 1907.

Rees, H. (ed.), *The Graphic Beat: London/Tokyo*, vol. 1, Tokyo, P.I.E. Books, 1992.

Rentoul, J., 'Individualism', in R. Jowell, S. Witherspoon, L. Brook (eds), *British Social Attitudes: The 7th Report*, Aldershot, Gower, 1990, pp. 167–82.

Rifkin, A., *Street Noises: Parisian Pleasure, 1900–40*, Manchester, Manchester University Press, 1993.

Riley, D., *'Am I That Name?' Feminism and the Category of Women in History*, Basingstoke, Macmillan, 1988.

Rimmer, D., *Like Punk Never Happened: Culture Club and the New Pop*, London, Faber & Faber, 1985.

Roper, M., *Masculinity and the British Organization Man since 1945*, Oxford, Oxford University Press, 1994.

Rose, C., *Design after Dark: The Story of Dancefloor Style*, London, Thames & Hudson, 1991.

Rutherford, J., 'Who's That Man?' in R. Chapman and J. Rutherford (eds), *Male Order: Unwrapping Masculinity*, London, Lawrence & Wishart, 1988, pp. 21–67.

Salvoni, E. with Fawkes, S., *Elena: A Life in Soho*, London, Quartet, 1990.

Samuel, R., 'The Lost World of British Communism', *New Left Review*, November–December 1985, no. 154, pp. 3–53.

Savage, J., 'Tainted Love: The Influence of Male Homosexuality and Sexual Divergence on Pop Music and Culture since the War', in A. Tomlinson (ed.), *Consumption, Identity and Style: Marketing, Meanings and the Packaging of Pleasure*, London, Comedia, 1990, pp. 153–71.

———*England's Dreaming: Sex Pistols and Punk Rock*, London, Faber & Faber, 1991.

Schwartz, F., 'Management Women and the New Facts of Life', *Harvard Business Review*, January 1989, no. 1, pp. 65–76.

Scott, J., *Gender and the Politics of History*, New York, Columbia University Press, 1988.

Segal, L., *Slow Motion: Changing Masculinities, Changing Men*, London, Virago, 1990.

Seidler, V., *Recreating Sexual Politics: Men, Feminism and Politics*, London, Routledge, 1991.

———(ed.), *The Achilles Heel Reader: Men, Sexual Politics and Socialism*, London, Routledge, 1991.

Sheppard, F. (general editor), *Survey of London: The Parish of Saint James, Westminster*, vols xxxi–xxxii, London, Athlone Press, 1963.

———(general editor), *Survey of London: The Parish of St Anne, Soho*, vols xxxiii–xxxiv, London, Athlone Press, 1966.

Shields, R., 'Social Spatialization and the Built Environment: The West Edmonton Mall', *Society and Space*, 1989, vol. 7, pp. 147–64.

———*Places on the Margin: Alternative Geographies of Modernity*, London, Routledge, 1991.

———(ed.), *Lifestyle Shopping: The Subject of Consumption*, London, Routledge, 1992.

Sigsworth, E., *Montague Burton: The Tailor of Taste*, Manchester, Manchester University Press, 1990.

Simmel, G., 'Fashion', *The International Quarterly*, October 1904, vol. x, no. 1, pp. 130–55.

Sinfield, A., *The Wilde Century: Effeminacy, Oscar Wilde and the Queer Moment*, London, Cassell, 1994.

Smith, P., *Discovering the Subject*, Minneapolis, University of Minnesota Press, 1988.

Smyth, C., *Lesbians Talk Queer Notions*, London, Scarlet Press, 1992.

Sontag, S., *Against Interpretation and Other Essays*, New York, Dell, 1979.

Spencer, N., 'Menswear in the 1980s', in J. Ash and E. Wilson (eds), *Chic Thrills: A Fashion Reader*, London, Pandora, 1992, pp. 40–8.

Stedman Jones, G., 'Working-Class Culture and Working-Class Politics in London, 1870–1900: Notes on the Remaking of a Working Class', in G. Stedman Jones, *Languages of Class: Studies in English Working Class History 1832–1982*, Cambridge, Cambridge University Press, 1983, pp. 179–238.

Stedman Jones, G. and Feldman, D., 'Introduction', in G. Stedman Jones and D. Feldman (eds), *Metropolis London: Histories and Representations since 1800*, London, Routledge, 1989.

Steedman, C., *Landscape for a Good Woman: A Story of Two Lives*, London, Virago, 1986.

——*Childhood, Culture and Class in Britain: Margaret McMillan, 1860–1931*, London, Virago, 1990.

Students and Staff of Hornsey College of Art, *The Hornsey Affair*, Harmondsworth, Penguin, 1969.

Suleiman, S., *Subversive Intent: Gender, Politics, and the Avant-Garde*, Cambridge, MA, Harvard University Press, 1990.

Summers, J., *Soho: A History of London's Most Colourful Neighbourhood*, London, Bloomsbury, 1989.

Taki and Bernard, J., *High Life, Low Life*, London, Unwin, 1982.

Thames, R., *Soho Past*, London, Historical Publications, 1994.

Thatcher, M., *The Downing Street Years 1979–90: First Volume of the Memoirs of Margaret Thatcher*, London, HarperCollins, 1993.

Tomkinson, M., *The Pornbrokers: The Rise and Fall of the Soho Sex Barons*, London, Virgin, 1982.

Tomlinson, A. (ed.), *Consumption, Identity and Style: Marketing, Meanings, and the Packaging of Pleasure*, London, Routledge, 1990.

Tosh, J., 'Domesticity and Manliness in the Victorian Middle Class: The Family of Edward White Benson', in M. Roper and J. Tosh (eds), *Manful Assertions: Masculinities in Britain since 1800*, London, Routledge, 1992, pp. 44–73.

——'What Should Historians Do with Masculinity? Reflections on Nineteenth-Century Britain', *History Workshop*, Autumn 1994, no. 38, pp. 179–202.

Tunstall, J., *The Advertising Man in London Advertising Agencies*, London, Chapman & Hall, 1964.

Urry, J., *The Tourist Gaze: Leisure and Travel in Contemporary Societies*, London, Sage, 1990.

Victoria and Albert Museum, *Catalogue of the W.H. Smith Illustration Awards 1987*, London, Victoria and Albert Museum, 1987.

Virilio, P., *The Aesthetics of Disappearance*, trans. P. Beitman, New York, Semiotext(e), 1991.

Walker, J., *Cross-Overs: Art into Pop, Pop into Art*, London, Comedia, 1986.

——*Art in the Age of the Mass Media*, revised edition, London, Pluto, 1994.

Walkowitz, J., *City of Dreadful Delight: Narratives of Sexual Danger in Late-Victorian London*, London, Virago, 1994.

Warde, A., 'Gentrification as Consumption: Issues of Class and Gender', *Society and Space*, 1991, vol. 9, pp. 223–32.

Weber, B., *Looking Good: A Guide for Men*, London, Angus & Robertson, 1979.

——*Hotel Room with a View: Photographs by Bruce Weber*, Washington, Smithsonian Press in association with Constance Sullivan Editions, 1992.

Weeks, J., *Coming Out: Homosexual Politics in Britain from the Nineteenth Century to the Present*, London, Quartet, 1977.

Weir, S., 'Ringing the Changes', *New Socialist*, May 1986, no. 38, p. 2.

West, D., 'From T-Square to T-Plan: The London Office of the J. Walter Thompson Advertising Agency, 1919–1970', *Business History*, 1987, no. 29, pp. 199–217.

——'Multinational Competition in the British Advertising Agency Business, 1936–1987', *Business History Review*, Autumn 1988, vol. 62, no. 3, pp. 467–501.

Whimster, S., 'Yuppies: A Keyword of the 1980s', in L. Budd and S. Whimster (eds), *Global Finance and Urban Living: A Study of Metropolitan Change*, London, Routledge, 1992, pp. 312–32.

Williams, K., Cutler, T., Williams, J., Haslam, C., 'The End of Mass Production?' *Economy and Society*, August 1987, vol. 16, no. 3, pp. 405–39.

Williamson, J., *Consuming Passions: The Dynamics of Popular Culture*, London, Marion Boyars, 1986.

Willis, P., 'Notes on Method', in S. Hall, D. Hobson, A. Lowe, P. Willis (eds), *Culture, Media, Language: Working Papers in Cultural Studies, 1972–79*, London, Hutchinson, 1980, pp. 88–95.

——*Common Culture: Symbolic Work and Play in the Everyday Cultures of the Young*, Milton Keynes, Open University Press, 1990.

Willis, S., *A Primer for Daily Life*, London, Routledge, 1991.

Willmott, P. and Young, M., *Family and Class in a London Suburb*, London, Institute of Community Studies, 1960.

Wilson, E., *Adorned in Dreams: Fashion and Modernity*, London, Virago, 1985.

Winship, J., *Inside Women's Magazines*, London, Pandora, 1987.

——'A Girl Needs to Get Street-Wise: Magazines for the 1980s', *Feminist Review*, 1987, no. 21, pp. 25–46.

Withers, J., *New British Graphic Designers*, Kyoto, Japan, Kyoto Shoin, 1991.

Wozencroft, J., *The Graphic Language of Neville Brody*, London, Thames & Hudson, 1988.

——*The Graphic Language of Neville Brody 2*, London, Thames & Hudson, 1994.

York, P., *Style Wars*, London, Sidgwick & Jackson, 1990.

Zukin, S., *Loft Living: Culture and Capital in Urban Change*, Baltimore, Johns Hopkins University Press, 1982.

INDEX

139–44; identities of 25, 30, 205–6; interviews with 184–9; languages of 181

Young Britain (Euromonitor) 106

young fogeys 105

young people 37–8, 106

young women 24, 29, 30, 123, 173–4

Yours or Mine 167

youth: culture 33, 37–8, 41–2, 45, 70, 105, 109, 112, 132, 154–5; market 29, 37–8, 85, 86–7, 105–6; and the media 33; television 109; unemployment 41

Youth Lifestyles (Mintel) 106

yuppie 25, 105, 123, 170–5

Zawada, Zed 18, 174

Zeitgeist 6

Zola, Emile 191